CREATING AZTLÁN

Creating Aztlán

CHICANO ART, INDIGENOUS SOVEREIGNTY,
AND LOWRIDING ACROSS TURTLE ISLAND

DYLAN A. T. MINER

THE UNIVERSITY OF ARIZONA PRESS TUCSON

The University of Arizona Press
www.uapress.arizona.edu

© 2014 The Arizona Board of Regents
All rights reserved. Published 2014

Printed in the United States of America
22 21 20 19 18 17 8 7 6 5 4 3

Cover designed by Leigh McDonald
Cover art adapted from the Aubin Codex © Trustees of the British Museum.

Publication of this book was made possible in part by a grant from the Andrew W. Mellon
Foundation.

Library of Congress Cataloging-in-Publication Data
Miner, Dylan A. T., 1976– author.
 Creating Aztlán : Chicano art, indigenous sovereignty, and lowriding across Turtle
Island / Dylan A.T. Miner.
 pages cm. — (First peoples: new directions in indigenous studies)
 Includes bibliographical references and index.
 ISBN 978-0-8165-3003-8 (pbk. : alk. paper)
1. Mexican American art. 2. Indian art. 3. Aztlán in art. 4. Colonization in art. I. Title.
 N6538.M4M56 2014
 704.03'97—dc23

 2014007749

♾ This paper meets the requirements of ANSI/NISO Z39.48-1992 (Permanence of Paper).

N'zhibiiamawaan oniijanisanaanig enji-niizhwaaso-aanike-bimaadiziwinan wiikwaji'owaad ji bagidendaagoziwaad.

Dedicated to the seven generations, both past and future, who struggle for a world without oppression.

Ticmactilia tlen chihchicome huahcapameh, cena tlen panotoc huan tlen panotihualaz, tlen tequitizceh pan tlaltepactli axcanah ica cualantli.

Dedicado a las siete generaciones, ambos en el pasado y en el futuro, tienen que luchar por un mundo sin opresión.

Contents

List of Illustrations . ix

Acknowledgments . xiii

Introduction. Indigenizing . 3

Part I. Tlilli: Theorizing Aztlán

Chapter 1. Remembering: Utopian Migrations through Aztlán 23

Chapter 2. Naming: Aztlán as Emergence Place 53

Chapter 3. Claiming: Claiming Art, Reclaiming Space 82

Part II. Tlapalli: Visualizing Aztlán

Chapter 4. Reframing: Aztlán and La Otra Frontera 113

Chapter 5. Creating: Creating Aztlán, Finding Nepantla 144

Chapter 6. Revitalizing: Aztlán as Native Land 169

Postscript. Returning: Jack Forbes, Mestizaje, and Aztlán 212

Notes . 221

Works Cited . 245

Index . 263

Illustrations

Figures

1. Dylan Miner, *Anishnaabensag Biimskowebshkigewag* (*Native Kids Ride Bikes*) 5

2. Anonymous (Mexica), Codex Boturini (Folio 1), ca. 1530–1540 ... 27

3. Frédéric de Waldeck after Anonymous (Mexica), facsimile of Mapa Sigüenza 27

4. Anonymous (Mexica), Codex Aubin 28

5. Anonymous (Mexica), Huitzilopochtli bundle from Codex Boturini (Folio 4), ca. 1530–1540 33

6. Theodor Galle after Jan van der Straet, *America*, ca. 1580 41

7. John Disturnell, Disturnell's Treaty Map 46

8. Emanuel Martínez, *Mestizo Banner* 57

9. Antonio Bernal, Del Rey mural, right wall 102

10. Antonio Bernal, Del Rey mural, left wall 102

11. Mario Castillo, *Peace-Metafísica* 103

12. George Vargas and Martín Moreno, *CitySpirit* 114

13. Vito Jesús Valdéz and James Puntigam, *The Cornfield* 114

14. Map of Southwest Detroit 116

15. Nora Chapa Mendoza, *Employment Agency* 122

ix

x • *Illustrations*

16. Nora Chapa Mendoza, *Los Repatriados* 124

17. Ernesto Todd Mireles, Aztlán flag 127

18. Marcos Raya, *Homage to Diego Rivera* 139

19. Malaquías Montoya, *Viet Nam Aztlán* 155

20. Santa Barraza, *La Virgen* 164

21. Carlos Cortéz Koyokuikatl, *Anišinabe Waki-Aztlán*
 (Truman College). .. 174

22. Carlos Cortéz Koyokuikatl, *Anišinabe Waki-Aztlán*
 (Uptown People's Community Center) 175

23. Carlos Cortéz Koyokuikatl, *Orgullo Itzachilatleka* 179

24. Favianna Rodríguez, Jesús Barraza, and Estria Miyashiro,
 Resist US Imperialism .. 184

25. Favianna Rodríguez, *We Are Not the Enemy* 188

26. Favianna Rodríguez, *We Resist Colonization* 189

27. Favianna Rodríguez, *Not in Our Name* 190

28. Favianna Rodríguez, *Fight Patriarchy*. 192

29. Favianna Rodríguez, *Fight the Climate Crisis* 193

30. Melanie Cervantes, *Las Brown Berets* 201

31. Dignidad Rebelde, *EZLN Women's Revolutionary Laws* 203

32. Melanie Cervantes, *Indigenous Women Defending Land
 and Life Since the Beginning of Time* 205

33. Jesús Barraza, *Indian Land* 209

Color Plates

1. Frédéric de Waldeck after Anonymous (Mexica), facsimile of Mapa Sigüenza

2. Anonymous (Mexica), Codex Aubin

3. Emanuel Martínez, *Mestizo Banner*

4. Antonio Bernal, Del Rey mural, right wall

5. Antonio Bernal, Del Rey mural, left wall

6. Mario Castillo, *Peace-Metafísica*

7. George Vargas and Martín Moreno, *CitySpirit*

8. Vito Jesús Valdéz and James Puntigam, *The Cornfield*

9. Nora Chapa Mendoza, *Employment Agency*

10. Nora Chapa Mendoza, *Los Repatriados*

11. Malaquías Montoya, *Viet Nam Aztlán*

12. Santa Barraza, *La Virgen*

13. Favianna Rodríguez, Jesús Barraza, and Estria Miyashiro, *Resist US Imperialism*

14. Dignidad Rebelde, *EZLN Women's Revolutionary Laws*

15. Melanie Cervantes, *Indigenous Women Defending Land and Life Since the Beginning of Time*

16. Jesús Barraza, *Indian Land*

Acknowledgments

This text has been written, at least in part, while I lived in many colonized and unceded Indigenous territories, both on Turtle Island and throughout the world. The ideas I develop in *Creating Aztlán* emerged during my youth in Anishinaabeakiing, or as I spell it, Anishinaabewaki (Michigan), and later expanded while I was living in Tiwa territory along the Río Grande (New Mexico). *Creating Aztlán* was then completed after I returned to Anishinaabewaki to work as a professor at Michigan State University. In the time between, sections of this text were compiled and edited during my expansive lowriding across Turtle Island (including colonized and unceded lands in the United States, Canada, and Mexico), Scandinavia, the British Isles, continental Europe, and Australia. In each of these places, I have tried, to the best of my ability, to learn from and with local communities in a way that, I hope, strengthens the ideas I develop in this book. I thank each of these individuals and communities for their wisdom and strength, as well as their willingness to share in dialogue. While the ideas in this book are collective and collaborative in origin, any faults or shortcomings are solely my own.

In this way, let me begin by offering a humble gift of *semaa* to the following individuals and spirits for their help in seeing this book come to fruition. First, I must thank the earth and the knowledge that she has so kindly shared with me. Although I was raised in the woods, I never realized how sacred, profound, and intimate earth-based knowledge is until I finally completed this book. In fact, I only wish I would have listened as a child more closely to the teachings of Niimaamaaki and Nokomis. Nonetheless, Niimaamaaki and Nokomis never turned their backs on me or anyone else willing to listen to their stories. When faced with a grave intellectual impasse in my intellectual work, I decided to take some time away from

xiii

xiv • *Acknowledgments*

life and slowly walk the contours of the earth. Within a few days, I was gifted the ideas needed to move forward and complete the book you hold in your hands. For this knowledge, I must thank the Noopimiimanidoog or forest spirits. By spending time in the woods, I learned about Aztlán, our Indigenous relationships to the land, and what migration and emergence stories really are.

In this same way that the spirits must be thanked, the ancestors must also be acknowledged as the intellectual core of my work. In many ways, their ideas are my writings' axis mundi. Their spirit, nonetheless, inflects this text and my ideas in general. I am especially grateful to my grandparents Germaine and Basil Miner (Michif) and Nancy and Theodore Torkelson, as well as my grandparents-in-law, Delfina and José Torrez (Xicano-Genízaros).

My parents, siblings, and nieces and nephews also need a thank-you. As I work to decolonize my life and my children's lives, I am frequently reminded of the importance of this work when my father's eyes tear up every time I speak about the ancestors or introduce myself in Michif or Anishinaabemowin.

Additionally, the artists whose work is discussed in this book (as well as those whose work is not, but should be) must be profusely thanked. In a world of expanding capitalist control, I believe that artists are among the few remaining individuals capable of confronting capitalism at its base. In this way, my collaborators and friends in Justseeds artists' collective, and all the Indigenous and non-Native artists I have worked with over the years, hold a special place in my heart.

I must thank my dissertation committee: Dr. Holly Barnet-Sánchez, Dr. Kirsten Pai Buick, Dr. Ray Hernández-Durán, Dr. Rafael Pérez-Torrez, and Dr. David Craven (who has since walked into the spirit world).

In Anishinaabewaki, my colleagues at Michigan State University, especially the Residential College in the Arts Humanities (RCAH), must be thanked. RCAH and its students provided a conducive environment in which to work through ideas dealing with art, activism, and indigeneity. I would like to thank the Chicano/Latino Studies PhD students who enrolled in my doctoral seminar, "Art and Anti-Colonialism," on some of whose dissertation committees I serve: Ernesto Mireles, Nora Salas, José Moreno, and Luis Moreno, the world's first PhD in Chicano studies.

Also, a shout out to the crew that gathered at Espresso Royale, including Pero Gaglio Dagbovie, Benjamin T. Smith, and Jerry García, among others. *Un abrazo* to the friends who come to la Casa Calabaza for dinners and Sunday brunch, especially John Monberg and Terese Guisatao

Monberg. *Chii miigwetch* to Don Lyons, Elizabeth Guerrero Lyons, Ahz Teeple, Gabriela Ríos, Emily Sorroche, Alphonse Pitawanakwat, Doug Debassige, James West, George Roy, and all those from Lansing's urban Native community.

Finally, I must thank my daughters, Reina Santana Merina Theo Torrez-Miner and Mexica Tiahui Mazatzin Kona Torrez-Miner. Since knowledge is both an honor and a responsibility, I do not mean to burden you, but this story is now yours to share. It is your responsibility, among others, to tell Aztlán's story and assert Xicano (and Michif) sovereignty. In the spirit of your ancestors (Xicano, genízaro, Michif, and settler alike), you must continue to work for a more just and equitable world, however you envision it. My love and support for you is unwavering.

Finally, I must thank my partner, the beautiful and intelligent Dr. Estrella Torrez. Since the age of fifteen, our lives have traveled in parallel and interconnected ways that I have never been able to fully understand. From our earlier lives as punk kids to our present life as post-punk parents and academics, my heart will forever be yours. It was in your parents' garage that I built my first lowrider bicycle, where it still remains.

Parts of chapters 4 and 6 were published previously as "Straddling *la otra frontera*: Revisioning Chicana/o Art History Through MiChicana/o Visual Culture," *Aztlán: The Journal of Chicano Studies* (spring 2009) and "Aztlán, Anishinaabewaki, Ixachilan: Radical Hemispheric Indigeneity and the Liberation of Art through the Graphic Work of Carlos Cortéz Koyokuikatl," in *Comparative Indigeneities of the Américas* (Tucson: University of Arizona Press, 2012). Miigwetch to my editors at the University of Arizona Press, as well as the First Peoples: New Directions in Indigenous Studies series for believing in this project.

CREATING AZTLÁN

INTRODUCTION

Indigenizing

In this book, we will be lowriding across Aztlán, an Indigenous Xicano[1] territory, and into Anishinaabewaki, the traditional homelands of the Ojibwe, Odawa, and Potawatomi. From this perspective, lowriding, a contemporary yet Indigenous practice, serves as the ideal metaphor to understand the structure of this book. For many participants in lowrider culture, the process of lowriding engages traditional migration patterns, yet employs late-capitalist machinery to traverse colonized landscapes. While our ancestors moved slowly from one place to another, establishing deep roots along the way, contemporaneity and coloniality presuppose that we must hurriedly rush from place to place. Instead of hastening from one place to another, lowriding, as an Indigenous[2] ontology, actively engages the process of slow-movement. Through this intentional slowness, lowriding seamlessly repositions us between various temporalities, moving among multiple spaces and in and out of disparate social structures. Lowriding becomes methodology and framework as we investigate Aztlán and Chicano art, as well as migrate across Turtle Island or the Americas.

In a similar fashion, I wrote *Creating Aztlán* as an attempt to freely and intentionally migrate across multiple temporalities, engaging precolonial indigeneities alongside colonial, modern, and contemporary Xicano responses to colonization. Although historical in orientation, my research disavows colonial notions of linear temporality and, instead, engages Chicano art from a perspective that is diachronic and couched in Indigenous notions of time. In this fashion, I engage colonial-era *amoxtli*, Chicano

4 • *Introduction*

Movement artworks, and contemporary Xicano artistic practices in a way that acknowledges historical change yet does not presuppose Western developmentalist linearity. As both an artist and intellectual, much of my writing employs creative approaches to structure, allowing connections to be made across time and space. Similar to Anishinaabe writer Jim Northrup, "I rely on the oral tradition to tell my story, so I move from one topic to another."[3] Unlike the work of a proper historian, I cover cultural and intellectual practices that span five centuries by migrating across time and space. *Creating Aztlán*, the book you hold in your hands as well as the process of affirming Xicano sovereignty, is itself a creative work.

Lowriding across Turtle Island-the Americas

During the process of writing this book, I built a few dozen lowrider bicycles in collaboration with Native youth in the United States and Canada. Through this ongoing project, known as *Anishnaabensag Biimskowebshkigewag (Native Kids Ride Bikes)* (figure 1), I imagine community collaboration and contemporary cultural practice as the locus to maintain Indigenous knowledge. Much like academic research, these artistic collaborations incorporate the help of community youth and elders and teach the significance of movement and migration (lowriding), as well as employ the centrality of storytelling to the development of Indigenous knowledge. Through our collaborations, we collectively built Indigenous bicycles, frequently riding them together. As we rode as a unit, and continue to individually ride, I was reminded of the importance of land within Indigenous communities, even within those urban detribalized and frequently diasporic communities where many find themselves (such as the Xicano community). Mishuana Goeman (Tonawanda Senena) discusses the importance of land within Indigenous notions of place, territory, and sovereignty. She emphasizes "how the use of land is a resistance to a conception of fixed spaces; Indigenous artists, storytellers, word warriors, elders, youth, medicine men and women, and scholars utilize the word land differently with vital and various meanings."[4] In *Creating Aztlán*, I also see land differently than those in settler-colonial society. I utilize Aztlán in a way that moves through various Indigenous spaces, regardless of what colonial juridical power may say about Xicano indigeneity or sovereignty. As artists, youth, scholars, and elders, we are each crucial to Indigenous sovereignty as we "teach the future generations about their peoples' intimate relationship to the land."[5] Indigenous place, what many call land, is not isolated to the

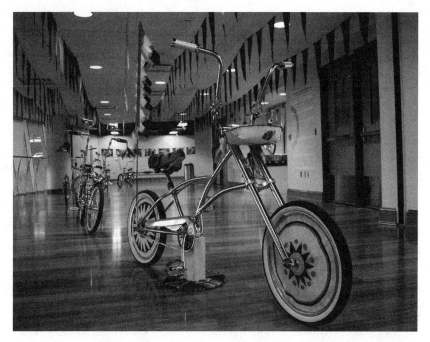

Figure 1. Dylan Miner, *Anishnaabensag Biimskowebshkigewag (Native Kids Ride Bikes)*, 2011. LookOut! Gallery, Michigan State University. Photo courtesy of the author.

existence of reservations. Aztlán is one of these enunciations of Indigenous land, but one tied to a colonized and detribalized people.

Cycling across distinct Indigenous and settler territories, I became aware that my body remains in constant cultural flux, yet persists as Indigenous. Across Turtle Island-the Americas, Native individuals and communities maintain their respective sense of who they are and what their history should be via embodied practices and artistic expressions. By building Indigenous bikes, the youth and I collectively confronted coloniality, as Anibal Quijano and Walter Mignolo name the social process of inequitable settler-Indigenous relations.[6] As practiced by Xicano artists, Aztlán is about the reaffirmation of Xicano indigeneity. By building bikes, we upheld Indigenous sovereignty in a profound way: we worked collectively and, in turn, built community.

My interest in lowriders began during my youth in rural Michigan, where I was raised alongside Mexican and Xicano migrant workers. Constructing lowrider bicycles as a child, I stopped building them as a teenager, not returning to them until an Indigenous Canadian curator invited me to

6 • *Introduction*

participate in an exhibition for contemporary Indigenous artists working with the bicycle as artistic medium.[7] For this exhibition, I decided to revisit the lowrider bicycle, commencing my own homeward migration by creating a lowrider based in contemporary Michif (Métis) aesthetic systems. From this initial moment of reclamation, I began envisaging the bicycle as a specter of anticolonial resistance intimately tied to sustainable transportation. The metaphor of the bicycle is multivalent and complex, one which led me toward Aztlán, the theme of this book. Moreover, lowriding across time, space, and sovereignty becomes the theoretical methodology to interrogate Aztlán and Xicano notions of time and space.

Throughout 2010 and 2011, I spent substantial time researching sustainable and Indigenous modes of transportation, particularly the ways that mobility was and is utilized by Indigenous peoples of the U.S.-Canada borderlands. Since this book is about migrations and Xicano relations to land, transportation seemed to always link my thoughts back to the ideas in this book. As part of this project, I was awarded an Artist Leadership fellowship from the Smithsonian's National Museum of the American Indian (NMAI) in Washington, DC. After spending time in NMAI archives, I subsequently returned to my home in Michigan to collaborate with Native youth and elders, building a series of lowrider bicycles based on the sacred Anishinaabeg teachings known as Niizhwaaswi G'mishomisinaanig (Our Seven Grandfathers).

Although collective projects are always difficult, this ongoing collaboration taught me that community-based engagements offer significant challenges and considerable opportunities for collective intellectual development. The materials we employed in Anishnaabensag Biimskowebshkigewag combined ancestral knowledge with contemporary technologies, concretizing Indigenous culture in the guise of lowrider bicycles. For my collaborators and me, these bikes materialized Indigenous knowledge in the present.

At first glance, however, one could argue that these lowrider bikes are simply *hybrid* or *mestizo* cultural artifacts. After all, they combine Indigenous and settler ways of knowing via Xicano popular culture. In dominant Chicano studies discourse, when Xicano artistic practices combine multiple signifying systems, they are inherently mestizo, and therefore, as many Chicano studies scholars maintain, not entirely Indigenous. In much of this scholarship, *mestizaje* serves as a counter to Anglo-American essentialized authenticity, becoming canonical in the process. From this perspective, mestizaje is the disavowal of purity, both colonial and Indigenous.

While I understand a need for this critical form of mestizaje, this book materializes what in Latin America was known as *indianismo*, a term that

contrasted with state-organized articulations of indigeneity (*indigenismo*) and mestizaje. Indianismo is an Indigenous formation that is community-centered. José Antonio Lucero notes that "despite their differences, both hispanidad and mestizaje reproduced and reinforced the homogenizing logic of the nation-state, which stigmatizes the ethnic differences of the present, even while it glorifies the Incan and Aztec civilizations of the past."[8] Xicano indigenism, breaking with Mexican indigenismo and the logics of mestizaje, develops more accurately as an extension of indianismo. These are ideas I have learned while working with community, not just from academic texts.

As you will see in this book, no matter how *transcultural* or hybrid Chicano art may appear, it nonetheless prolongs a mode of Indigenous artistic practice. These bikes, as art objects, operated in the same way. Indigeneity is not a stagnant cultural category; rather it represents the inextinguishable right of Indigenous peoples to self-determine who they are, how they govern themselves, and how they define their own knowledge and aesthetic systems. Neither Mexica, Spanish, Mexican, nor Anglo-American hegemony can exterminate Xicano indigeneity or sovereignty. At the same time, Xicano incorporations of Nahua or Mexica epistemologies are quite distinct from their top-down and colonizing usage by the Mexican nation-state and its ruling classes.

Much like my interventionist collaborations with Indigenous youth, *Creating Aztlán* is an indigenist intervention into settler ontologies and colonial political formations that attempt to render Xicano presence as immigrant (and therefore settler), as opposed to Indigenous in orientation. While mestiza consciousness has considerable merits, performing an undeniable role during the 1990s, it also serves to disenfranchise Xicanos as an Indigenous people. Inversely, this work is grounded in the claim that Chicano history must be understood as Indigenous history. Chicano art is a unique form of contemporary Indigenous visuality. Using a methodology described by LeAnne Howe (Choctaw), *Creating Aztlán* serves as a Xicano "tribalography," an argument I extend in chapter 1.[9]

This book is my attempt to demonstrate the ongoing importance of Aztlán for contemporary Xicano society, regardless of its epistemological changes throughout time. By investigating the way that artists engage Aztlán, I follow the Indigenous logic put forward by Michif (Métis) revolutionary leader and martyr Louis Riel who, on the eve of his state-sanctioned assassination, declared that "My people will sleep for one-hundred years, but when they awaken it will be the artists who give them back their spirit." As homage to Riel and his ideas, this book is about the process of giving spirit back to an Indigenous people denied Indigenous sovereignty through

8 • *Introduction*

settler-coloniality. The foundational story of Aztlán, as well as the work of the artists I discuss, serves to reclaim a Xicano Indigenous spirit.

I begin this book with the preceding stories about lowriding and Xicano indigeneity to situate my own narrative within the larger framework of the text. I do this because, as many Indigenous readers will recognize, Indigenous knowledge is located not solely in the writing of academic texts or stored away in museums and archives. Rather, Indigenous knowledge emerges from the quotidian experiences we share with one another, often coming from a first-person perspective. This knowledge is found in our reciprocal moments together and the ability to reconstruct these experiences as teaching stories. These stories are knowledge. They are teaching moments. Stó:lō educator Jo-ann Archibald (Q'um Q'um Xiiem) names this type of pedagogy as "Indigenous Storywork."[10] For Archibald, Native peoples do not only teach their children, they story them as well. To tell any story, such as this book, I must begin with my own, which is what I have done. This story is now yours to share and reshape. Once you know the story, it is your collective responsibility to tell it.

The origins of the story you are about to read, which masquerades as an academic manuscript, began over twenty-years ago when, as a teenager, I encountered Aztlán through my interest in lowrider bikes. During this period, my understanding of Aztlán came through my interaction with the Aztlán Bicycle Company, the preeminent distributor of lowrider bicycles and lowrider bicycle products during the 1990s and early 2000s.

Since that initial moment of recognition, I have built dozens of lowrider bikes, including many for gallery and museum exhibitions across Turtle Island. My recent NMAI-funded collaboration with Indigenous youth served to bring together the realities of transborder indigeneities, a concept that I investigate in this book. By making lowrider bikes, an aboriginal Xicano tradition, I have built strong connections across many Indigenous lands and territories.

Throughout all this, artists and activists, myself included, create Aztlán in our own individual and collective ways. In return, this book demonstrates why Aztlán is still relevant today and how Xicano artists have created Aztlán, an irreducible notion of Indigenous territoriality and sovereignty.

Origins and Movements

I arrive at this study as someone involved in Xicano, Native, and antiauthoritarian politics who came of age during the late 1990s. I see this project as

reflective, extending the Chicano Movement into the present. I turn my intellectual gaze toward Aztlán in hopes of finding an emancipatory construct with enduring relevance today. By basing *Creating Aztlán*, the book you hold in your hands, in the "emerging" discipline of Indigenous studies, I position Xicanos not as "illegal" or undocumented immigrants but as an aboriginal people firmly situated in this hemisphere. This position has precedence in the work of Indigenous scholars like Jack D. Forbes (Powhatan-Renape and Delaware-Lenape), who wrote in 1973 (but publicly discussed in the early 1960s) that Xicanos are the largest Indigenous nation on Turtle Island. While this perspective is countered by other Indigenous scholars like Patricia Penn Hilden (Wallowa Nez Perce), the 2010 Census identifies "Mexican American Indians" as the fourth largest tribal group in the United States.[11] While this only acknowledges self-identity, we cannot simply dismiss this large group of people and their stories. As such, this book is predicated on the idea that Xicanos are an Indigenous people. The indigenist and Indigenous perspective from which I write, one based in my own Michif ontology and experiences being raised in a Xicano community, is crucial in framing the book's larger argument vis-à-vis Indigenous visuality and Xicano visual sovereignties.

Despite the fact that his ideas were not originally aimed at the particularities of the Chicano Movement, the Marxist writing of Mexican philosopher Alberto Híjar Serrano may be applied to fit my discussion of politically motivated Chicano art. When discussing the political imbalances in the life and work of muralist Diego Rivera, Híjar argues that

> Those presently engaged in the complexities of socialist liberation do not have time to pause for reflection. . . . Rivera might have lacked theoretical consistency and partisan orientation, but neither is an ideological or practical defect when one contributes as many open-ended possibilities as he did.[12]

What Híjar brings to this book (and to larger discussions of Chicano art) is that even with all the inconsistencies and troubles that haunt the Chicano Movement, its relationship to contemporary radical politics remains strong. Artists, in particular, are commonly inconsistent in their ideas, a stance that should not be viewed as wholly problematic.

As my present research with Aztlán attests, the Chicano Movement was not simply about "nationalist" exclusion; rather, it developed in a way that allowed for different factions engaged in anticolonial and anticapitalist insurrection to simultaneously envision Aztlán. While nationalists were often the most visible Movement participants, we must be cautious not to

reduce the various nationalisms of the Chicano Movement into a singular one of exclusion and heterosexist machismo. After all, Indigenous "nationalisms" or sovereignties are not linked to the same limitations as Western nation-states and capitalist economics. If we are to fulfill Aztlán's vision, we must move beyond colonial thinking and structures.

As George Lipsitz argues in "Not Just Another Social Movement," the Chicano Movement "was an effort to convince people to draw their identity from their politics rather than drawing their politics from their identity."[13] By turning away from hegemonic forms of identity politics, Lipsitz observes how the Movement produced previously unexplored identities and social structures, ones that contrast settler-colonial views and neoliberal governance. In fact, I feel that Lipsitz's generativity still diverges greatly from dominant modes that historicize the Chicano Movement as exclusionary.

If we listen solely to hegemonic narrations of the Movement, especially its most significant epistemological artifact, Aztlán, the transformative and transgressive nature of Chicano art is replaced by an art history judged merely on artistic qualities or surface aesthetics. Regrettably, this is what often happens to the artistic work of revolutionary artists and intellectuals, as they are incorporated into the canon and stripped of their revolutionary potentialities.[14] The works I discuss in *Creating Aztlán* are not simply conferred because of their artistic content, but more importantly because they also urge new political and social ontologies. Accordingly, Chicano art is a unique philosophical modality that proposes new ways of being in the world that is linked to older forms of indigeneity.

In response, the task of critically engaged intellectuals and artists is to point out the deficiencies of past movements without stripping these movements of their radical potential. This, of course, becomes increasingly difficult to do when we see ourselves as part of, or as the heirs to, certain emancipatory agendas. How, then, do we intimately explore the intricacies of historic events without either vilifying or heroicizing their participants and esteemed cultural workers? Unfortunately this dialectic is one that many activist-intellectuals have struggled with, as have I throughout the writing of this book. Hopefully, I have neither reduced art to polemic nor removed it from its larger emancipatory potential. Ultimately, the reader will decide.

Even though revisionist Chicano Movement intellectuals such as Emma Pérez, Dionne Espinosa, Elizabeth "Betita" Martínez, Gloria Anzaldúa, Dionicio Valdés, and Jorge Mariscal, among countless others, have been attentive to the sexism, homophobia, nationalism, and regional biases of the Movement, the shortcomings of the Chicano Movement and the literature addressing its historicity do not nullify the utopian desires of those

individuals who collectively identified with it.[15] As such, I continue the radical possibilities of the Chicano Movement and Aztlán, in particular, as theoretically expressed via a dense narration of Chicano art history and visual culture. This activist-oriented project develops through a variety of tactics, some coterminous, others tangential.

Most important to this emancipatory project is the analysis of Chicano art and culture, placing it in dialogue with lesser-known and emerging Xicano artistic and cultural work. By entering these differing voices in dialogue, and concurrently addressing the cultural history of the Chicano Movement, *Creating Aztlán* reveals the importance of Aztlán as an organizing principle but, more importantly, explicates how Xicanos reclaim and self-determine place, space, and utopian thought within the Xicano imaginary. Through this intervention I hope to demonstrate that the Chicano Movement continues to resonate today, particularly in the wake of the 2006 and 2007 Immigration Rights movement and, as I complete this book, Arizona's apartheid-style policies, which criminalize the presence of Brown and Red bodies and their knowledge. Ongoing attacks on Indigenous and "immigrant" communities demonstrate that a project of this sort is needed, possibly more today than ever before.

Return to Aztlán

Allow me to briefly return to my biography and connect to the Chicano Movement and Xicano politics. Personally I am not Xicano; I am Michif or Métis, an Indigenous person of mixed ancestry with deep ancestral roots in Indigenous and settler communities of the U.S.-Canada borderlands (Michigan, Minnesota, Ontario, Alberta, and Manitoba). I was raised in a rural community alongside significant numbers of Xicanos, most of whom followed the South Texas–Michigan migrant stream. These shared experiences shape this project and my personal understanding of Xicanisma. As a Michif person, I see many similarities in our communities' postcontact Indigenous lifeways and therefore seek sanctuary in the earth-based quotidian practices of Aztlán. Although a child of the so-called middle class, at seventeen I briefly labored alongside my future in-laws hoeing in the *betabel* and working in the fields. By learning to labor, to borrow from Paul Willis's famous study, I substantiated my commitment to both the Michif and Xicano communities, commitments that remain at the core of this project.[16]

Like the migratory (lowriding) experiences that precipitated Xicano northward migrations to fill agricultural and industrial labor demands in

the *norte*, my father's family migrated as *voyageurs* across arctic, boreal, and woodland North America before permanently transgressing the illegitimate U.S.-Canada boundary line. Through this migration, my family left behind the aboriginal and migratory lifestyle of the backcountry for one in an expanding and industrial Detroit. Before our early-twentieth-century border crossings into the United States, my family was among a group of Michif and Anishinaabeg who, in response to the shifting U.S.-Canada border after the Treaty of Ghent, left Drummond Island (which had just become part of the United States) to reestablish their lives in Penetanguishine and Parry Sound, Ontario. Like our Xicano and Indigenous Mexican relations, my family was split by the geopolitical violence of the border.

Born and raised in rural Michigan, I occasionally crossed the U.S.-Canada border for family reunions and summertime holidays. Coming of age in the 1990s and politicized within the Chicano and antiglobalization movements, the chant "We didn't cross the border, the border crossed us" reminded me of my own familial experiences with borders and their painful slicing through Indigenous lifeways. These words evoked a profound and painful connection with the struggles of the Xicano community. After all, along *la otra frontera*, as I call the U.S.-Canada border, many Native peoples share the experience of being violated by geopolitical boundaries that circumscribe their abilities to visit family, travel without documentation, and harvest in traditional ways. During my formative years in Anishinaabewaki, the place I still call home, I migrated between various cultural contexts (Xicano-Anglo, rural-urban, Native-white, etc.), eventually wandering into the transformative politics of MEChA (Movimiento Estudiantil Chicana/o de Aztlán) at a moment when Xicanos were experiencing a renewed Indigenous consciousness. *Creating Aztlán* is based in my own experiences as a Michif artist engaged in radical Xicano politics. It merges these intellectual and lived experiences in a way that situates Chicano art history within a series of radical potentialities and Indigenous ontologies.

This book situates my own complex and heterodox thinking about indigeneity within the confines of Xicano cultural practice. I do this by tracing the multiple strains of Aztlán, the legendary homeland of the Mexica, in hope of maintaining the global anticolonial trajectory of the late 1960s. By understanding the nuances of Aztlán, *Creating Aztlán* facilitates an awareness of the Chicano Movement by looking at the artistic and cultural utilization of Aztlán as a utopian and revolutionary gesture toward Indigenous sovereignty. My investigation simultaneously culminates and commences in March 1969, when Xicanos from across Turtle Island gathered in Denver to discuss the social, political, and economic demands facing

Indigenizing • 13

their respective communities. This meeting, known as the Chicano Youth Liberation Conference, created an anticolonial and indigenist framework for the Chicano Movement. It was at this particular gathering that young Xicanos established a paradigmatic plan of action that synthesized local Xicano experiences by collectively striving for *national* self-determination.

The author(s) of El Plan Espiritual de Aztlán, the main edict to emerge from the conference, focused on the class-based oppression of Xicanos but positioned their analysis and demands by applying Indigenous and Meso-american tropes within a contemporary North American context. Although poet Alurista is generally acknowledged as the draftsman, the Plan was issued anonymously. In this document, Aztlán, the "mythical" place of origin of the Mexica, became the metaphor used to refer to the collective and autonomous sovereignty of Xicanos.[17] Why did Xicanos desire to construct their late-capitalist identities by converging on the imagery and mythology of precontact, yet not precolonial, Indigenous history?

Commencing with this question, *Creating Aztlán* contends that Aztlán performs a liberatory function for artists and activists while positing four interrelated, although not entirely coterminous, arguments with Aztlán at the core. For the most part, this text is a history of Chicano art and visual culture that narrates radical Chicano politics, intellectual histories of Aztlán, and utopian Indigenous thought. It declares Xicano sovereignty throughout. By addressing Xicano activism and cultural practices, I attend to the multivalent roles that Aztlán plays within the Xicano community and the various ways that artists have articulated Aztlán within their own visual art. Moreover, investigating how and why artists and activists invoked Aztlán allows us to continue implementing the concept as a metaphor for liberation and sovereignty.

Second, because of my anticapitalist perspective and indigenist reading of Xicano artistic practices, I believe that the issues discussed in this book are informed by Indigenous and antihierarchical political projects that may likewise inform present and future antiauthoritarian and Indigenous movements. The Nehiyaw (Cree) name my community, the Michif or Métis, as Otepemisiwak. In their language, which our ancestors also spoke, Otepemisiwak translates as "the people without bosses," in reference to our nonhierarchical social relations. In the same way that clan identities inform many Indigenous ontologies, this particular identity directly impacts my own worldview and therefore immediately influences how I read Chicano art.

Additionally, following the work of Xicana and Native feminists, I present a critique of the false binary between Chicano nationalism and Xicana feminism, one based in Indigenous feminisms and queer epistemologies, as

a way to reframe Aztlán and Xicano sovereignty. Finally, as you will hopefully see, I have extensively incorporated Midwest Chicano history and cultural studies in dialogue with more widely known figures, images, and texts. In this fashion, I present a revised historical narrative that accepts the differences and nuances within the Xicano community, yet does not alienate these non-Southwestern voices and histories. Instead of foregrounding this argument, I integrate it throughout the book, including both a specific chapter about Michigan Chicano art history (chapter 4) and a section on an individual midwestern artist, Carlos Cortéz Koyokuikatl. In addition to these specificities, I likewise assimilate these Indigenous and Midwest stories throughout the writing, including the methodologies, epistemologies, and other modalities that influence the book itself.

Throughout *Creating Aztlán*, I infer that by building a space for themselves within the binary structure of U.S. racial politics, Xicanos destabilized "Indian" identity, but did so as an Indigenous people. In this way, Xicano nationalists asserted their "national" and Indigenous identities through the conglomeration of Indigenous and "mestizo" narratives. Accordingly, Alurista wrote in El Plan Espiritual de Aztlán:

> With our heart in our hands and our hands in the soil, we declare the independence of our mestizo nation. We are a bronze people with a bronze culture. Before the world, before all of North America, before all of our brothers in the bronze continent, we are a nation, we are a union of free pueblos, we are Aztlán.[18]

However, as Sheila Contreras contends in *Blood Lines,* within a short period Alurista revised the preamble into a poem for *Nationchild Plumaroja.*[19] In its new iteration, Alurista moved away from its initial male-centeredness and further developed the plan's assertion that Xicano sovereignty was an Indigenous project with socialist underpinnings. In the new text, bronze becomes red, a color that intimates an Indigenous phenotype and a socialist polity. Alurista has re-signified the settler-colonial logic of mestizaje.

The ambiguity of Alurista's 1969 narrative reclamation of Aztlán, as well as its reference to nonhierarchical structures of power, appears obvious. However, while the plan's author(s) invoked Aztlán for its permanent indeterminacy (able to deal with sexual difference, racial mixing and transculturation, and working-class oppression at the hands of capital), many within the Chicano Movement transformed Aztlán into a heterosexist and patriarchal site that proved unable to deal with the intricacies of contemporary Xicana and Xicano experience. Structural limitations and

colonized thinking contained the potential of Aztlán within the Chicano Movement. Thankfully, queer and feminist theorists have rightfully criticized this patriarchal Aztlán in order to dismantle its colonial perceptions of race, gender, and sexuality. Unfortunately, contemporary academic discourse commonly reifies Aztlán's representation from a misinformed and monovocal articulation.

In contrast, in this book I contend that even during the so-called *machista* and nationalistic apex of the Chicano Movement (and believe me these were and are real issues), there were simultaneous counternarratives that articulated Aztlán as an inclusive site from which to speak and enunciate a revolutionary and Indigenous Xicano sovereignty. As such, *Creating Aztlán* uses Aztlán as the emergence site, both literally and metaphorically, from which to analyze Xicano histories and cultures from an Indigenous and antihierarchical perspective. By lowriding across Aztlán and into other Indigenous territories, Xicano artists reclaim a sense of self that colonial regimes have tried to destroy.

In turn, I utilize methodologies established by contemporary Native intellectuals including, but not limited to, Linda Tuhiwai Smith (Maori), Robert Warrior (Osage), Andrea Smith (Tsalagi), and Scott Lyons (Anishinaabe), as well as their Indigenous-identified Xicano peers. *Creating Aztlán* explores the ways that Aztlán is not applicable simply to the historical specificities of the Xicano community of the 1960s, but has ongoing implications today. I do this by covering five main areas: 1) the history and historiography of Aztlán; 2) a dialectical intervention in utopian thought; 3) the development of Xicano sovereignty that does not extinguish other Native sovereignties; 4) the trajectory of Chicano art history along the U.S.-Canada border; and 5) the pertinence of Midwest Chicano history and art to Chicano studies.

As an engaged work of Indigenous art history, I turn to the practices of four Movement artists, as well as three of their contemporary descendents (what artists Melanie Cervantes and Jesús Barraza call "future ancestors"). By critically writing about their art, I maintain that Aztlán unites Xicanos with other Third and Fourth World peoples in a radical act of opposition and solidarity. Throughout, Aztlán serves in more heterodox ways than usually identified. Within their respective corpora, these artists incite the aura of Aztlán as a site of resistance and affirmation, paraphrasing the title of the preeminent exhibition of Chicano art (*CARA: Chicano Art, Resistance and Affirmation*, 1995). By "creating" Aztlán, even if only in their artwork, artists transform this Indigenous concept from an elite Mesoamerican narrative to one that creates community and sovereignty for a

detribalized Indigenous people. Within the works of each respective artist, Aztlán embodies a unique and particular structure that allows for nuance and intricacy, instead of simplification and categorization. The decision to write about these particular artists speaks to my intention to include regional and aesthetic diversity, while also connecting a new generation of artists with their artistic ancestors. While different artists could be included, I have decided to keep the number limited to make the text both readable and accessible.

Structure of *Creating Aztlán*

Since time immemorial, artists have been at the forefront of radical social movements. Artistic articulations of sacred lands are common for many colonized and Indigenous people, particularly as they struggle to decolonize their respective societies. Routinely, visual culture, fused with literary and performance-based arts, has played a significant role in how various nations (although not necessarily nation-states) have articulated a particular sense of place and postcolonial sovereignty.

The way artists create Aztlán is paramount to understanding Xicano indigeneity. From its earliest extant utterances in the postcontact Meso-american codices through contemporary Xicano applications, cultural representation plays a central role in constituting and developing how we understand Aztlán. As such, an intervention like *Creating Aztlán* is crucial for better understanding pre-Cuauhtemoc, colonial, and contemporary Xicano cultural and artistic practices vis-à-vis Aztlán. By critically interrogating Aztlán, we begin to more thoroughly understand Xicano cultural history in relation to larger Indigenous and Latino narratives of oppression, resistance, resiliency, and survivance.

Turning to the artistic practices of the Chicano Movement (including those artists working today who see themselves as continuing its legacy), I initiate my research by asking: What was the Aztlán that the Chicano Movement spoke of and where did it originate? How do artists and activists invoke Aztlán through visual and textual means? In what different ways have artists used Aztlán to signify sovereignty? How does the Xicano Aztlán, as a recontextualized construct, differ from that evoked by the Mexica themselves? What radical possibilities does Aztlán hold? In what ways can Chicano and Indigenous studies speak to one another? And finally, can Aztlán be conceptualized in terms of a "socialist utopia," as studied by Frederic Jameson and, if so, what interventions may Aztlán make?

Indigenizing • 17

With these questions in mind, in *Creating Aztlán* I briefly flesh out the genealogy of Aztlán. The book maintains a bifurcated structure, with aspects of each section melding into the other. I have used the Nahua concept of *tlilli tlapalli* to structure this book. The first four chapters are conceptualized as Tlilli (Red); the next four are housed under the rubric Tlapalli (Black).

Those familiar with Indigenous Mesoamerican thought will recognize the way Nahua and other Indigenous cultures couple two ideas to create a dualistic singularity. Like the yin-yang of Eastern cosmology, Mesoamerican thought sees everything as having two opposing sides, an Indigenous dialectic, if you will. The most well-known application of this duality is found in the concept *in xochitl in cuicatl*, a practice that became the *flor y canto* (flower and song; events where poetry and music were performed) of the Chicano Movement. Tlilli Tlapalli, or better *in tlilli in tlapalli*, directly translates as "red and black," but more specifically relates to the sacred knowledge embedded in the codices and other Indigenous texts. This red-black couplet, an Indigenous dialectic, serves as my device to partition *Creating Aztlán* into two sections: one historical and theoretical, the other primarily art historical, critical, and analytical.

Of course, the colors red and black are also theoretically woven into the narrative of Aztlán. Not only do these colors reference the sacred knowledge embedded in the codices (or Mesoamerican books), red and black are also the colors of anarchism and most revolutionary movements. This epistemological structure, based in two simple colors, becomes a larger metaphor for a radical and indigenist turn in Chicano studies.

I begin *Creating Aztlán* (chapter 1, "Remembering") with a historical discussion of the role of Aztlán in Mesoamerican codices and expand this intellectual history into the late-colonial period with an analysis of postcontact chronicles and colonial documents. By investigating Indigenous and colonial manifestations, in addition to nineteenth and twentieth-century ones, I reveal how Aztlán, named as such, discursively recedes from popular history during the late-colonial period before reappearing within the nineteenth and twentieth centuries. Although Aztlán's nomenclature diachronically shifts, an Indigenous utopia, one often read through Thomas More's *Utopia*, remains firmly planted within Xicano imaginaries. From this discussion of Indigenous (yet colonial) chronicles, I turn to discussions of space and its colonization. Central to this chapter is also a retheorization of utopia, not as an idyllic and perfect society, but as a place for ongoing dialogue. It is this rereading of utopia that forms the intellectual backbone of the book.

Chapter 2 ("Naming") continues with the notion of utopias and how utopian thought relates to Aztlán within the Chicano Movement. Along these lines, *Creating Aztlán* addresses the way utopias also merge with European ideas of pre-Cuauhtemoc Mesoamerica and the fifteenth-century colonization of New Spain, before extending and expanding these utopian ideas into contemporary discourses. Central to chapter 2 is showing how Aztlán functions as a form of emergence place, an Indigenous story often tied to ethnogenesis, which appropriately names Xicano sovereignty. I demonstrate how, once Xicanos had emerged from Aztlán, as had their Mexica forebears, Aztlán reconfigures space as a mode of storytelling. Consequently, I unite Aztlán with new utopian ideals, ones linked with Indigenous and anticapitalist ontologies. I do this by interrogating how utopianism has played out in radical political contexts, particularly in the Chicano Movement. Evoking theorists such as Lefebvre, Baudrillard, and Jameson, this chapter engages existing discourses on utopia/dystopia as a mode of situating Aztlán in dialogue with larger and expansive intellectual traditions. Moreover, the chapter commences with a discussion on the ways that Indigenous feminists challenge patriarchal and nation-state readings of Indigenous "nationalism."

Using figures like Fanon, chapter 3 ("Claiming") attends to negative assumptions of nationalism and the reclamation of Xicano "intellectual sovereignty," as Robert Warrior calls this type of project. Paramount to this reclamation was an artistic and cultural movement intimately tied to emancipatory projects of the period, ones coupled with land-based struggles. Looking at murals and other forms of Xicano culture, I demonstrate how art functioned in the movement to help reclaim Xicano autonomy. This chapter likewise shows the very real linkages between Xicano and American Indian struggles during the 1960s and how these movements collectively reclaimed space, place, and cultural sovereignty. Embedded in this discussion is an engagement with Fanon's ruminations on violence, on top of a historiography of Chicano art. The first section "Tlilli: Theorizing Aztlán" ends by looking at how historians and critics have written Chicano art.

Then we make a structural move, transitioning from the first section (Tlilli) into the second (Tlapalli). While the first three chapters are primarily historical and theoretical, without significant visual examples, the second part of *Creating Aztlán* deals directly with individual artists, artworks, and specific regional expressions of Aztlán.

Chapters 4 ("Reframing"), 5 ("Creating"), and 6 ("Revitalizing") respectively resolve to explore particular artists and the manners that they encouraged Aztlán. In this fashion, *Creating Aztlán* demonstrates how Chicano

Movement participants used artworks and visual culture to envision Aztlán inside the omnipresent settler nation-state we call the United States. By analyzing the corpora of lesser-known artists, including Carlos Córtez Koyokuikatl and Nora Chapa Mendoza, as well as the Xicano Development Center, *Creating Aztlán* articulates how a multifaceted narrative of Aztlán emerged.

Chapter 4 looks directly at histories and practices in Detroit, Michigan, a city uniquely located along the U.S.-Canada border. Chapters 5 and 6 examine seven artists to parse out interesting ways that artists take up Aztlán.

Accordingly, a critical reading of a small number of images from each of these artists aids in understanding how they worked with (or as) activists to generate Aztlán as "the space of liberation so fondly yearned for."[20] In essence, these culminating chapters allude to how Aztlán functions not as an easily attainable future but rather as a constant "beyond" that enables the transgression of current late-capitalist hierarchies and imbalances. By turning to three younger artists (Favianna Rodríguez, Melanie Cervantes, and Jesús Barraza) in Chapter 6 ("Revitalizing"), we see the importance of expanding this discourse across time and space, as well as seeing Aztlán's continued relevance today.

Through all of this, *Creating Aztlán* serves to document how Aztlán maintains a radical potentiality based in Xicano sovereignty and indigeneity. By attending to the preconquest past in hopes of redirecting a postcapitalist (yet Indigenous) future, I posit that Aztlán performs a utopian utility. Following Fredric Jameson's writing on utopia, Aztlán "come[s] to us as barely audible messages from a future that may never come into being."[21] In the case of Aztlán, however, understanding where these messages come from is as important as the actual "audible messages" themselves. As such, it is imperative to inquire how the past shapes both our present and future, in addition to seeing how artists envision and create these particularities for the future.

While new archaeological or anthropological research into Aztlán's geographic location may aid in the speculative research currently circulating, this book in no way argues for or against Aztlán as being located at any specified geographical coordinate. On the contrary, *Creating Aztlán* takes as its core how Aztlán is played out and why it continues to be performed during different historical moments to a multiplicity of peoples, looking closely at art and visual culture. Through this historical critique and analysis, I anticipate a more succinct understanding of the ambiguities and implications that each respective Aztlán has embodied.

The reader will notice that I have named each chapter using gerunds: indigenizing, remembering, naming, claiming, reframing, creating, revitalizing, and returning. All eight of these chapter titles are drawn directly from Maori intellectual Linda Tuhiwai Smith's seminal book *Decolonizing Methodologies: Research and Indigenous People*.[22] In this significant work, Smith lays the foundation for future Indigenous scholarship by advocating for a series of twenty-five Indigenous projects. Notwithstanding her employment of the concept *testimonies*, each of Smith's twenty-five projects becomes an action-word aimed at countering dominant and colonial forms of knowledge and their hegemonic control of academic knowledge. By using Smith to frame the book's chapters, I hope to show how the Chicano Movement and artists' investigations of Aztlán were already doing what Smith intellectually advocates decades before she wrote these significant words. By establishing this book along these lines, I also hope to situate *Creating Aztlán* within the growing Indigenous studies community. By doing so, we continue to create Aztlán within the shell of the old world, to borrow from the ideologies employed by artist Carlos Cortéz Koyokuikatl.

PART ONE

Tlilli

Theorizing Aztlán

CHAPTER ONE

Remembering

Utopian Migrations through Aztlán

In many ways, Indigenous people are the original lowriders. If you believe Western science, our ancestors slowly migrated to Turtle Island-the Americas tens of thousands of years ago, slowly dispersing across the continent. Indigenous communities have their own stories of how they got be in the place they currently live. These stories are generally more intriguing and include community knowledge embedded with larger life-lessons that need to be practiced. Either way, both stories, Western and Indigenous, are about intimately knowing the land where one lives and moving slowly into that place. To lowride across time and space, we begin to pay attention to the environment around us. Lowriding, as an Indigenous way of moving through the world, contrasts with the speed needed to succeed in the contemporary, capitalist world. It is fundamentally anticapitalist.

According to Xicano storytelling, the birthplace of the lowrider automobile is either in East Los Angeles, an urban Xicano community, or Española-Chimayó, rural Xicano communities in the Sangre de Cristo mountains of New Mexico. The stories of how Xicanos emerged in East Los Angeles and emerged in Española-Chimayó vary, based on whom you speak to. Whatever story you hear, it includes the process of slow migration into the territory. This migration/lowriding pre-dates the existence of the automobile. Although created sometime in the late twentieth century, decades after lowrider cars, lowrider bicycles are the epitome of contemporary Indigenous movement. They are simple machines with two wheels.

The wheels must be kept moving if the bike is to remain upright. Constant rotations of the wheels keep the rider in a stable and mobile position. When the wheels stop rotating, the bike becomes static and the rider will eventually fall to the ground. This could be read as an Indigenous story about the need to maintain equilibrium in the world. Unlike the desire of a traditional cyclist, whose hope it is to move as quickly as possible, the lowrider's only goal is to move as slowly and as intentionally as viable. Lowriding is about moving through space, while being cognizant of the journey and migration itself.

This chapter, traversing great expanses of time and space, begins in Aztlán and moves slowly southward toward Tenochtitlán. Traveling southward for more than two centuries, we will eventually return north in search of Aztlán (or El Dorado or Cíbola). Throughout this migration or lowriding story, both southward and northbound, our relationship to place must always be acknowledged. Nearly a millennium prior to its evocation in the Plan Espiritual de Aztlán, Aztlán served as the foundation of Mexica or Aztec political ideology. By tracing the genealogy of this place, we lay the foundation for seeing Aztlán as the emergence place, a common ontological origin of Indigenous societies, of the Xicano people. Although structurally distinct from its Xicano articulation, understanding the pre-Cuauhtemoc Mexica version initiates a better understanding of its contemporary circulation.[1]

The story goes like this: sometime in the twelfth century, the Mexica were directed by their divine *teotl* or deity, Huitzilopochtli (some translate his name as Left-handed Hummingbird), to leave their utopian paradise—or so it is frequently presented—and migrate southward.[2] Although history usually remembers them simply as the Aztecs, the Mexica were one of seven tribal groups dwelling in Aztlán, an island riddled with caves. As one of seven tribes, the Mexica were the only society to follow the advice of Huitzilopochtli and leave Aztlán at this time. The other clans subsequently migrated to found different city-states in Mesoamerica. According to the codices, Huitzilopochtli, the spiritual energy of sun and war, advised the Mexica to leave Aztlán and head south in search of a new home.

For over 250 years, the Mexica traversed or lowrided across the continent searching for a site to permanently settle. To find that location, Huitzilopochtli prophesized that they must encounter a divine apparition. Eventually in 1325 CE, in what is now Mexico City, Mexica elders encountered what they were searching for: an eagle perched on a nopal cactus feasting on the body of a serpent. Viewing this miraculous sight, elders noted that Huitzilopochtli's prophecies had come true. Following the advice of their divine teotl, the Mexica founded a successful, albeit hierarchical

and imperial, society at this location among other Nahuatl-speaking cultures. Tenochtitlán, as this city was known, quickly became the largest urban environment in the Western hemisphere. In many regards, as I will later explain, Tenochtitlán served as a mirror to their site of origin, Aztlán. Although distinct in their geographic locations, both Aztlán and Tenochtitlán shared certain epistemological affinities, ones the Mexica both explored and exploited.

But the hegemon in Tenochtitlán would not rule eternally. Less than two hundred years after its founding, Spanish *conquistadores*, coming in the name of *their* Great Spirits (both Christ and King), would colonize and subjugate the diverse Indigenous populations of Anahuac, the name given to the area in the Valley of Mexico governed by the Mexica. Part and parcel to the violence unleashed against the Native populations were the overt attempts to annihilate Indigenous epistemologies and ontologies. Although the completion of this colonial project proved unsuccessful in many ways, its core, the devastation of Indigenous knowledge systems, was triumphant in that nearly all pre-Cuauhtemoc era texts were burned in an act of ethnocentric rage and Christian idolatry. Through the processes of epistemological warfare and subsequent library demolition, the irreplaceable narratives of the Aztlán migration story, once encoded in the codices and brought to life through their performance, sadly vanished from popular Indigenous history. In response, generations of historians have attempted to decipher the historicity of Aztlán: Where was it located and what did it signify?

Aztlán as Tribalography

Among pre-Columbian scholars, as well as within the Xicano intellectual community, there are two general opinions on the historicity of Aztlán. One faction believes that Aztlán was a historic place from where the Mexica physically migrated south to the Valley of Mexico. The other camp hypothesizes that Aztlán operated primarily on the discursive level as a device to legitimate Mexica colonization and its political rule in Central Mexico. Unfortunately, positioning the primacy of Aztlán in such a binary fashion does little to move the discussion beyond the limitations of existing frameworks.

Art historian Elizabeth Hill Boone maintains that Aztlán's potential lies in its ability to challenge existing binaries, an idea with which many Xicano intellectuals agree. Boone argues "we must move away from this narrow position if we are to increase our understanding of the migration accounts. If we can cease seeing the migration story as history, other opportunities for

understanding the documents and Aztec culture in a larger sense become open."[3] Accordingly, Aztlán enables new ways of explicating Indigenous history and, using the language of Gerald Vizenor, survivance.[4] We could say that Aztlán becomes indeterminate in its transcending of Western notions of history as social science. While writing about contemporary Native North America, LeAnne Howe (Choctaw) proposes tribalography as the way to redress this Western division. She writes that

> Native stories, no matter what form they take (novel, poem, drama, memoir, film, history), seem to pull all the elements together of the storyteller's tribe, meaning the people, the land, and multiple characters and all their manifestations and revelations, and connect these in past, present, and future milieus (present and future milieus mean non-Indian).[5]

By existing beyond Western disciplinary knowledge, Aztlán decolonizes contemporary Xicano thought by engaging with tribalography, an aboriginal praxis.

Because Aztlán only appears in a handful of extant sixteenth-century documents, all of which were created postcontact, attempts to create a conclusive and documented response to this historicity has proven difficult. During the early colonial period of the sixteenth century, Spanish and criollo administrators commissioned "ethnographic" studies of Indigenous histories and geographies. These studies were frequently written in the form of an aboriginal codex, the accordion style *amoxtli* that Mesoamerican peoples prominently developed. Unlike pre-Cuauhtemoc codices, which were destroyed in mass by zealous colonial ideologues, these postcontact texts were an amalgam of both Indigenous and European form and function.

Of the manuscripts produced during this period, seven substantially narrate the Aztlán and migration narrative, including the Codex Boturini, Mapa Sigüenza, Codex Aubin, Codex Mexicanus, Codex Azcatitlan, and the similar Codices Telleriano-Remensis and Vaticano-Ríos. The multiple visualities of these codices range from those heavily influenced by European materiality and representational conventions to those almost wholly Mesoamerican in both materiality and style.

Codex Boturini (figure 2) is considered the most authoritative and has been often called the Aztlán Annals or the Tira de la Peregrinación.[6] These descriptive names are appropriate for the Codex Boturini because it includes an extended visual narrative of the Aztlán migration account. Mapa Sigüenza (figure 3), as its name implies, is a more cartographic representation than Boturini, while the Codex Aubin (figure 4) contains

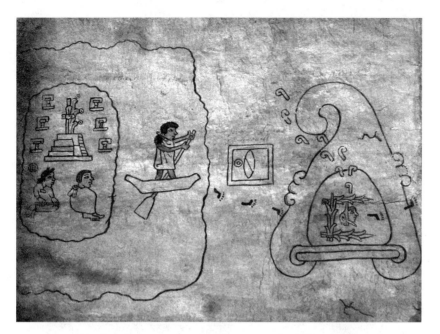

Figure 2. Anonymous (Mexica), Codex Boturini (Folio 1), ca. 1530–1540. Ink on amate paper. Located in the Museo Nacional de Antropología, Mexico. Photo courtesy of Wikimedia Commons.

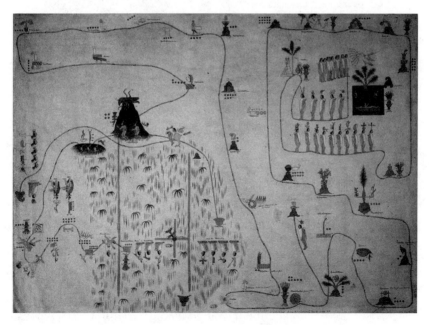

Figure 3. Frédéric de Waldeck after Anonymous (Mexica), facsimile of sixteenth-century Mapa Sigüenza, ca. 1829–1831. Photo courtesy of Newberry Library.

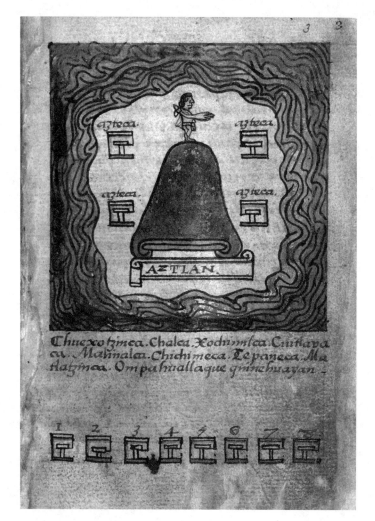

Figure 4. Anonymous (Mexica), Codex Aubin. Ink on European paper and bound in leather, 1576. Photo courtesy of the British Museum.

script in both Spanish and Nahuatl. Analyzed collectively, these three texts substantially document the migration narrative and its particularity. Missing from these codices, however, is any capacity to historically determine whether or not Aztlán and the migration narrative is history or myth, categories already problematized by poststructuralist historians like Hayden White and Boone, as well as Indigenous writers like Howe.

Remembering • 29

I believe that within these Indigenous visual narratives, Mexica scribes embedded the cartographic codices with an Indigenous time-space, what Bakhtin calls "chronotope." During the early colonial period these codices were performed in front of an audience. When the performances associated with the texts were absent, as they disappeared during the colonial period, the information embedded within the texts became deficient in fully articulating the knowledge held within the amoxtli. Boone, the premier scholar on the subject, describes the role of performing the codices:

> Aztec historians didn't just consult them quietly in libraries or offices, nor did they read the histories to themselves, as we might do with a historical text or reference work. Instead, the pictorial histories are closer to being scripts, and their relation to their readers is closer to being that of a play's script to its actors. The Aztec pictorial histories were read aloud to an audience, they were interpreted, and their images were expanded and embellished in the oration of the full story. The pictorial histories were painted specifically to be the rough text of a performance.[7]

With both the church and Crown as patrons, the scope and content of the colonial-era codices was usually a reciprocation of viceregal demands and Native respondent desires, an audience who did not see Aztlán as Indigenous dignitaries once had.

Of the migration codices, many collapse the tripartite points of origination (Aztlán, Chicomoztoc, and Colhuacan) into a monolithic site, a fact that continues to complicate how Xicanos conceptualize Aztlán. Although each of these sites was a unique place within most pre-Cuauhtemoc migration narratives, many historians minimize these three distinct places into one common site.

This conflation has created some difficulties within contemporary Xicano discourse, with the three sites becoming indistinguishable. In one of the most often-cited Xicano engagements with pre-Cuauhtemoc versions of Aztlán, Michael Pina conflates Aztlán with Chicomoztoc. He writes that "the narrative of Aztlán recounts the events of the peregrination of the Aztec people from a northern homeland of Aztlán to the founding of their Tenochtitlan empire. Aztlán . . . is also referred to as Chicomoztoc, place of the seven caves."[8] Again, Boone notes:

> The migration always begins in Aztlan, from where a group of tribes, usually eight, leaves for the journey to the Valley of Mexico. They travel to a series of places, punctuated by Teculhuacan, Coatepec, and Tollan,

and reach the Valley of Mexico, where the Mexica are expelled from Chapultepec and their ruler sacrificed at Culhuacan.[9]

She continues: "The pictorial annals' insistence on an Aztlan departure might seem at odds with several prose accounts that name Chicomoztoc as the place of origin and the well-known illustrations in [Diego] Durán's history that show tribal couples seated in seven caves, followed by the migratory leaders moving forth out of a cave."[10] As these differing accounts attest, the oral and written narratives are neither authoritative nor precise when representing Aztlán's place in Mexica history. This indeterminacy enables discursive and political debates between Xicano and Mexican scholars. Many Xicano activists and intellectuals have located Aztlán in the present-day U.S. Southwest, while Mexican scholars often position Aztlán across the Río Grande/Río Bravo in Northern or Central Mexico.

In *L'origenes des aztèques*, Christian Duverger argues that Aztlán was an ideological construction that emerged *after* the Mexica formation of Tenochtitlán, not prior to it.[11] Using Western linear temporality, which contrasts with Indigenous circularity, this perspective is innovative in that it supposes that the Mexica did not necessarily migrate south, but rather invented Aztlán as an ideological form to facilitate their hegemonic and imperial rule in Mesoamerica. I find this notion highly interesting and, in many ways, instructive when thinking about both the codices and Xicano political projects.

Using this line of thought, the Mexica may have utilized the Aztlán narrative as a tool to materialize and describe what historians call ethnogenesis. Ethnogenesis is the process of understanding when groups of humans begin to understand themselves as a distinct people. For Indigenous people, ethnogenesis is generally tied to creation, emergence, and migration stories. For Xicanos, Aztlán is this tribalographic story of emergence. Aztlán is directly linked to the emergence of both the Mexica and Xicanos as distinct peoples.

Duverger believes that Mexica historians molded Aztlán as an a posteriori construction, allowing them to ideologically establish themselves as a dominant society in the Valley of Mexico. Accordingly, Aztlán functioned to legitimize Mexica imperial expansion throughout an "imagined community" of Nahua speakers, if we can borrow from Benedict Anderson's writings on modern nation-states.[12] Following this perspective, the manner that the Mexica enunciated Aztlán was directly related to the ideological goals of the elite to establish and maintain a social order in the region.

Prior to European incursions into Turtle Island-the Americas, the Mexica constructed their hegemon on principles similar to European colonial modalities. In this way, Mexica elites used the Aztlán narrative, at the

discursive level, to distribute their divine right to rule over the Valley of Mexico and to subjugate other Indigenous peoples in the region. They did this by alternating between their cultural assimilation of Toltec advances (such as sedentary living, agricultural food systems, and the spiritual preference to Tlaloc) with Chichimeca practices (including migration stories, warrior sociality, and the veneration of Huitzilopochtli).

For the Mexica confederacy, Aztlán was articulated, not by commoners or laborers, but by *tlacuilome* (academically trained scribes) within the elite-lore of the Valley of Mexico. As part of the formation of hegemonic social structures, Aztlán established the legitimacy of the Mexica regime, one where visuality and performance played equally important roles. Conceptually, Aztlán served at the core of Mexica ethnogenesis, a function it would similarly perform centuries later as it helped materialize Xicano peoplehood or sovereignty.

Center of the World

Richard Fraser Townsend argues that Tenochtitlán's ceremonial precinct "was at once the most crucial space in the empire, as well as the most sanctified: it was, in effect, a microcosm of the city and a microcosm of the universe."[13] While Tenochtitlán's main ceremonial precinct existed in real space, Aztlán, at least immediately prior to European settlement, remained subjugated to representations of space and representational space, drawing from Henri Lefebvre's seminal work, *The Production of Space*. Here Lefebvre distinguishes between what he calls "representational space," "representations of space," and "spatial practice," as the respective domains that collectively constitute social space.[14] For Lefebvre, all space is social. He divides social space into categories that articulate how space is either perceived, conceived, or lived.

In this way, *spatial practice*, the way that human societies activate space, relates to humans' daily routines and quotidian experiences within urban and rural spaces. Spatial practice establishes a sense of social cohesion through the dialectical naturalization of space as being seemingly neutral. *Representations of space* are the scientific (and bureaucratic) ways of controlling space through modes such as maps, models, and diagrams. *Representational space*, which drives my interest in Aztlán as an object of study, has to do with our symbolic imagining of how space may be used. Sometimes representational space is codified, at other times it is not. Through the codices and in the work of artists, Aztlán migrates/lowrides

between these two nodes. Since time immemorial, artists have been active in symbolically and spatially creating this realm.

For the Mexica, Aztlán operated similarly to Tenochtitlán's ceremonial center in its spiritual and metonymic significance, simultaneously operating at all three of Lefebvre's spatial categories. For Boone, the circularity of Mesoamerican thought allowed Aztlán to stand in for and represent Tenochtitlán, one space tangible, the other only available in representation.

That is to say, these two social spaces served to bookend Mexica civilization: Aztlán as the emergence place, Tenochtitlán as the end-place of migration. Boone suggests that "Aztlan and Tenochtitlan are similar in bracketing all the action. Technically, one begins the story and the other ends it, but *they are the same place*. The Mexica leave Aztlan, are transformed, and return to their point of origin" (italics mine).[15]

As Boone attests, Aztlán, like (or rather, as) Tenochtitlán, is a metonym for the entire Mexica social structure. Recognizing the reciprocity between Aztlán and Tenochtitlán is crucial in understanding the importance of Aztlán and in contextualizing its future significance as an anticolonial device for sovereign Xicano indigeneity. But to perform as a metonym, Aztlán first must be "activated" by human presence; it must be brought into being as the locus of Mexica spiritual identity. Federico Navarrete goes so far as to argue that "the Mexica (or their predecessors) had a cosmic center, symbolized in the codices by the temple in the middle of the island of Aztlan or by a tree growing on it (both symbols of an *axis mundi*)."[16]

From this perspective, Aztlán served as the sacred site at the center of the Mexica universe, much like it serves as the axis mundi for Xicano sovereignty. As the codices demonstrate, particularly Codex Boturini, both Aztlán and Tenochtitlán performed the role of the axis mundi. It was literally the center of the universe. For Tenochtitlán to replace Aztlán as a new axis mundi, the codices visually depicted and actually performed this transition. Operating as visually rhetorical devices, the Aztlán codices use pictorial space to intimate the complexities of emergence, migration, and social transformation. Aztlán exemplifies a group's coming into being; it is at the core of Mexica ethnogenesis. Likewise, Aztlán performs the emergence myth and foundation narrative for Xicano sovereignty centuries later.

Tlacuilome usually depicted this evolution of the universe's center at Aztlán to its center at Tenochtitlán. In Codex Boturini, for instance, the scribes depict a bundle that embodies the divine spirit of Huitzilopochtli (figure 5). This bundle is humbly carried by the Mexica as they migrate south. In fact, many of the Aztlán codices depict Huitzilopochtli held inside a sacred bundle. By transporting this sacred bundle from one site to

Figure 5. Anonymous (Mexica), Huitzilopochtli bundle from Codex Boturini (Folio 4), ca. 1530–1540. Ink on amate paper. Located in the Museo Nacional de Antropología, Mexico. Photo courtesy of Wikimedia Commons.

another, the codices document the metaphorical transition/lowriding of the axis mundi from one location (Aztlán) to another (Tenochtitlán).

Inversely, Aztlán was activated through the performances of *in xochitl in cuicatl*, literally meaning flower and song. By performing the codices, particularly the Aztlán narratives written within them, tlacuilome not only "read" the text, but likewise *activated* them by adding supplementary and irreplaceable knowledge not directly inscribed on the *amatl* of the codices. Therefore by performing the codices or amoxtli, Mexica scholars fully galvanized the visual or written knowledge of these migration texts in a modality where the performance supplemented the visual text. Aztlán was located in the space created by the performance. Aztlán was transformed from a site within representational space to one that existed within real space.

In his discussion of the migration narrative codices, Navarrete alludes to the role that performance occupied to fully complete the texts. When discussing the textual elements within Codex Aubin, he asserts that "Aubin provides a clue as to how the other codices were read aloud."[17] Codex Aubin, of course, is the manuscript that includes both Spanish and Nahuatl writing alongside the Indigenous visual narrative. Although one may argue that by inscribing the Codex Aubin with Nahuatl and Spanish

script its performance became static, the incorporation of text nonetheless informs how these migration narratives were part of larger ceremonial performances. This position is verified by Boone, who describes Aztlán as a space that combines performance, ritual, and ceremony.[18]

Navarrete expands Boone's arguments but complicates the role of orality and performance in the enactment of Aztlán:

> Indeterminacy was also an integral part of the working of a visual narrative discourse that was meant to be accompanied by concurrent oral recitation, since many of the elements in the page needed an explanation by the narrators. We can assume that this oral explanation varied greatly according to which audience it was being presented to, and that therefore the visual narrative had to leave sufficient room for different, even contradictory, readings.[19]

Navarrete supports my analysis that the Aztlán codices are incomplete without their complementary performances. And without these performances, Aztlán was never made real in the social space of Mesoamerica. By performing the codices, however, tlacuilome located Aztlán at the center of the universe.

When Aztlán was enacted through tlacuilome performance, these performative engagements in turn evoked metonymic Nahua cosmological systems similar to the metonymic structures of Tenochtitlán. Diana Taylor argues that in xochitl in cuicatl were used to recount communal and individual histories and past glories.[20] As Boone and Navarrete indicate, Aztlán was a significant part of the pantheon of Mesoamerican performance-based practices that dealt with the history and glory of Mexica sovereignty. Taylor continues: "Through embodied performance, Amerindian groups perpetually reenacted the primal story of conflict and sacrifice. Performance, in this broadest sense, was the fundamental iterative act of existence itself, endlessly recreating the original act of *creation*."[21] By performing Aztlán, the Mexica drew on creation stories and expressed an ideological position that supported their imperial rule. In xochitl in cuicatl is a Nahua-specific form of tribalography, one maintained (yet articulated in the contemporary) by Xicanos.

Utopia as Dialogue

In 1516, Sir Thomas More (1478–1535), an ardent supporter of the Roman Catholic Church, published his vision and critique of what many have

inadequately understood as an "ideal" society. *Utopia*, as More would name his imaginary island landscape, was rooted in the Greek *eu* (not) and *topos* (place). By choosing the Greek etymology "no place," perceived as an *undetermined space* that could never be, More enabled a discursive open-endedness that the evocation of a *specified place* would not have allowed. More structured his tome into two "books" or sections. "Book I" was envisioned as a conversation between the fictive, semiautobiographical character Raphael Hythloday and the civil servant Peter Gilles. "Book II," the most frequently cited, is a descriptive exegesis on the social, cultural, and political practices of the inhabitants of Utopia, a small fictional island society. It is in this text that More connects his Utopia with concurrent colonial excursions transpiring during his life.

Hythloday, "out of his desire to see the world," was involved in the colonial expeditions of Amerigo Vespucci, the figure whose name so prominently reinscribed Indigenous land into "America."[22] Although we rarely connect the writing of More's *Utopia* with the larger colonization of Turtle Island-the Americas, it is particularly informative to connect the utopian discourse in which More engaged with the larger colonial imaginary. Without the colonization of Turtle Island and the ideological production of "America," More's creation of Utopia would have remained entirely outside the larger European worldview. That is to say, there is a reciprocity between Utopia, "America," and settler-colonialism.

The exploratory reporting of Cristobal Colón, the infamous Christopher Columbus, arrived in Lisbon on March 4, 1493, in the guise of a form letter. Within two years, Latin, Spanish, Italian, and German editions of his writings from the New World, complete with woodcut illustrations, were available throughout continental Europe. Of course, as we are now aware, neither the text nor the accompanying illustrations were entirely truthful in how they represented Indigenous life-worlds to a European audience. Rather, these visual and textual practices were embedded with ideological underpinnings that both facilitated and were facilitated by the colonial project. Since artists representing Turtle Island-the Americas had no lived experiences in which to compare their artistry, the accuracy of visual images was not their main purpose. As William C. Sturtevant makes clear, "assessing the accuracy of European representations of Native Americans requires consideration of the prevailing stylistic traditions in which the artists worked."[23] Implicitly, Sturtevant demonstrates that European artists, as well as authors, were unable to transcend the structural limitations of their time. Having no experience with Indigenous people, European writers and artists projected their own desires onto an otherwise empty signifier. More

was no exception in this regard; however, unlike his peers, More's exotic other place was in fact "no place" and its fictional base already established.

Written in the early sixteenth-century, a time when Turtle Island-the Americas were ripe in the imagination of continental Europe, More's *Utopia* was a product of this period and must to be understood as such. Reading *Utopia* in this way enables us to see how it stands in for the unnamed territories of the Western hemisphere. Alicia M. Barabas writes that, for More, "the New World, that which informed navigators and missionaries, was one of these points of influence."[24] Inversely, Donna Pierce notes how More's text, held in the personal collection of Bishop Fray Juan de Zumárraga (the first bishop of New Spain), was used in the catechism of Indigenous populations.[25] So the function and application of More's *Utopia* had real world relevance for how colonization and catechization transpired on Turtle Island-the Americas. Nonetheless, representative of his social experiences as a Catholic Briton, More did not view *Utopia*, the antithesis to Europe, as a universal remedy to Europe's structural troubles.

As Clarence H. Miller warns in the introduction to the 2001 Yale University Press edition, "More's *Utopia* should not be read (as it often has been and sometimes still is read) as presenting More's notion of a purely positive and desirable society."[26] Utopia, as frequently happens, is condensed to a monolithic romanticism. As a place that has never been and can never be, More's Utopia skirts the desires placed on it by subsequent generations of intellectuals, artists, and activists. Even if Miller warns that we must not read the text as a "desirable society," Utopia nonetheless functions ambiguously enough to be molded to certain revolutionary desires. These utopic specters have had dire consequences on how critics have placed these discursive constructs on Aztlán—ones that are inappropriate.

Much like the corpora of Marx and Engels (or as I posit Aztlán itself), which have been loosely constructed to allow for a multiplicity of positions to arise, *Utopia* is important not so much for what it is but rather for the discourses and potentialities it enables. In the 1964 Yale University Press edition, Edward Surtz points to the dialogic potentials of utopia. Much as I do, Surtz wonders: "Is the success of *Utopia* due to dialogue?" He continues:

> After all, dialogue is symbolic of open-mindedness, humility, and inquiry. Somehow or other, More succeeds in involving readers in the dialogue. It is no accident that *Utopia* ends with challenges. Is the Utopian view of war, religion, and communism really absurd? Is the Utopian vision really hopeless and unachievable? *Utopia* therefore is an open-ended

work—or, better, a dialogue with an indeterminate close. More asks the right questions—which can never be answered fully.[27]

As Surtz attests, and as articulations of Aztlán bring to the fore, the possibilities of utopia lie not in their connections to colonial discourses and projects (which all Western epistemologies touch upon), but instead in their ability to open up new fields of inquiry and demonstrate the importance of this work. Analogous to Marx's "permanent indeterminacy," as David Craven notes of Marx's continued relevance, Surtz indicates that More's potential dialogue is located in its "indeterminate close."[28] This indeterminacy and capacity for dialogue is where Aztlán fits ideally within this utopian vein.

Problematically, much like Marx as read through Lenin and Mao, or Aztlán as posited by heterosexist "nationalists," More's *Utopia* is frequently circumscribed by its surface qualities and theoretically collapsed to produce its mere opposite: dystopia. Utopia, even a socialist or indigenist Xicano utopia, must never be reduced to the superficiality of its products or practices, as has frequently and repeatedly been the case. Throughout this text, I argue that utopic spaces, much in the vein of More's original manuscript, do not enunciate a monolithic, all-encompassing solution to social ills; rather, these non-distinct spaces are sites that enable critical inquiry and dialogue among competing positions. It is at this juncture that a redefinition of utopia (and by extension Aztlán) must begin if we are to fully understand Aztlán's potential.

Utopian and Colonial Exploration

Throughout history there has been some confusion, due to the conflation of Aztlán (place of origin) with Chicomoztoc (a stop during the migration), about the meaning and location of Aztlán. With this confusion, both Aztlán and Chicomoztoc are generally employed to signify the Mexica migration's place of emergence. However, once these complex myths were integrated into settler-colonial and Iberian epistemologies, they incurred a variety of changes, manipulations, and mutations over a few centuries. Once Aztlán entered the purview of the Spanish and criollo settler-colonial administration, it became formally entangled in contemporary issues of edenic landscapes and then-contemporary cultural projects, such as Thomas More's *Utopia*.[29]

In addition to the codices, the writing of Fray Diego Durán also crucially informed colonial knowledge about Aztlán. Relying on the oral narratives

of Indigenous subjects, Durán pieced together a textual ethnography on the history and lifeways of Mesoamerica. The reliability of his informants, as well as the multiple levels of editing and authorial intention, affected the consistency of Durán's narrative. In *Historia de las Indias de Nueva España e Islas de Tierra Firme*, published in 1581, Durán only briefly touched on the migration narrative. Durán wrote:

> The only knowledge of their origins that I have obtained from my Indian informants tells of the seven caves where their ancestors dwelt for so long and which they abandoned in order to seek this land, some coming first and others later until these caves were totally deserted. The caves are in Teocolhuacan, which is also called Aztlan, "Land of Herons," which we are told is found toward the north and near the region of La Florida.[30]

From Aztlán's initial European utterance, Durán begins to conflate the multiplicity of locations between Aztlán and Tenochtitlán by describing Aztlán as the same as Teocolhuacan (Colhuacan), as well as the land of the seven caves (Chicomoztoc). Embedded within this version is Durán's attempt to place Aztlán within a Ptolomaic coordinate system or European mapping structure. By contending that Aztlán lay near "La Florida," Durán positioned an Indigenous construction of time-space (Aztlán) within the colonial and imperial realm of cartography (New Spain).

While Aztlán may have once existed within the geography of real space, by the time Durán consulted with his informants, it existed solely in the two-dimensional realm that Lefebvre calls "representation of space." Although Aztlán still held symbolic and cosmological meaning through representational space, by Durán's time Aztlán had ceased to affect social or spatial practice. Durán attempted to translate Aztlán's indeterminacy into settler-colonial language connected to cartography and narrative. As was recently suggested, this colonial cartographic project was connected to a Eurocentric construction of space, one unable to fully apprehend non-Western visuality, temporality, or spatiality.

When discussing Hernán Cortés's map of Tenochtitlán, Barbara E. Mundy states that "the Cortés map encodes the city with rational, geometrical based projections, whose norms were understood throughout Europe, where the map was widely legible."[31] Indigenous notions of space did not easily map onto Western cartographies, which makes Aztlán and Xicano articulations of it all that much more important.

While early colonial attempts were made to map New Spain, contrasting notions of space challenged settler-colonial control. Mundy demonstrates

that the ambition to create a uniform cartography disintegrated when the imperial administration relied on Indigenous and "mestizo" mapmakers to document otherwise "uncharted" Indigenous lands. These maps, such as those created for the Relaciones Geográficas, a cartographic project where New World subjects mapped their local environs, did not operate as "universal" projections of space, as European administrators would have wished, but functioned as complicated visual artifacts that drew from Indigenous visual, spatial, and temporal traditions. When Indigenous subjects were asked to map their respective territories, the resulting maps corresponded to multiple spatial relations. Mundy writes that "what the maps best show us is the indigenous world—not its inhabitants, still reeling, no doubt, from the blows of conquest, reshaped their once insular maps to keep pace with the rapid changes in their understanding of the surrounding world."[32]

Even if colonial administrators were unable to get a unified map of New Spain, the presence of Aztlán in early Spanish chronicles and post-Cuauhtemoc amoxtli established a desire to investigate and "rediscover" the lost utopian lands to the north. Just as Durán conflated the Indigenous narratives of Aztlán and Chicomoztoc, so too was the desire to find Aztlán intimately linked to European notions of utopia. The mention of the "seven caves," which appears in Durán's chronicle, parallels Iberian *reconquista* notions of seven sacred cities. During this period among the Portuguese, the seven Cities of Antilia were reportedly discovered by Catholic bishops who fled across the Atlantic following the Muslim "invasion" of the Iberian Peninsula.

When Durán's *Historia* was distributed across the Iberian Peninsula, Aztlán and the seven caves of Iberian lore were merged with European ideas in true contact zone fashion.[33] These topics were also widely circulated in New Spain. According to David J. Weber, "when reports reached Mexico in the late 1530s of seven cities to the north, Coronado willingly risked his life and his wife's fortune to find them."[34] As Coronado's willingness attests, the desire to find Aztlán, or its multiple synonymous namesakes, and its riches was widespread during this period.

Similarly, the "seven caves of Chicomoztoc" was seamlessly integrated into popular notions of Aztlán, while the reconquista narrative of the Cities of Antilia was unified in the seven cities of Cíbola. The articulation of these discrete and diverse narratives became, in the writings of the chroniclers, a mono-vocal desire to "discover" the wealth of this utopic New World settler-colony. While the early colonial period saw many expeditions in search of the lost city, these excursions shortly faded when few riches were uncovered. It is during this period, early in the sixteenth century, that large-scale

engagements with Aztlán, named as such, cease. In Aztlán's place we begin to see the emergence of stories about Cíbola, El Dorado, and other parallel mythologies of wealthy lands and utopic spaces.

These narratives were so notable that between 1513 and 1542 at least eight expeditions were sent north into the present-day United States. Many of these exploratory missions were intent on locating the utopian cities of gold located north of Mexico City. In 1538, Franciscan cleric Fray Marcos de Niza, with the assistance of an African slave Esteban, traveled north in search of Cíbola.[35] The expedition returned to Mexico City with imaginative descriptions of this previously "unseen" utopia. Upon his return, Fray Marcos described one of the seven golden cities as "the greatest and best of the discoveries."[36] Marcos continued, writing that "he saw a temple of their idols the walls of which, inside and outside, were covered with precious stones."[37] As can be imagined in the colonial vision of the day, these fictitious descriptions aroused popular dialogue about "undiscovered" utopian spaces far to the north.

The fictive histories projected by Fray Marcos supplanted prior visions of the utopian Cíbola. After all, Marcos had "seen" this paradise and therefore served as an authority on the subject. As David Rojinski points out in *Companion to Empire*, More's *Utopia* was not a serious attempt to faithfully represent Indigenous peoples of the Americas; rather, it was a work of fiction that had far-reaching discursive, as well as political, implications.[38] In this way, Vasco de Quiroga, the first bishop of Michoacán and member of the second Audiencia, saw More's *Utopia* as his guiding force. *Utopia* led him to establish religious hospitals to convert Indigenous subjects.

Analyses of More's *Utopia* reveal that much of what More wrote paralleled circulating discourses about newly discovered—at least in the European imaginary—cultures in Mesoamerica. These discourses largely drew from More's initial text and augmented it with popular notions of Aztlán, Cíbola, and a variety of other imaginary sources. According to Georges Baudot, the foremost writer on the utopian imaginary in colonial New Spain, secular clergy turned to popular, biblical, and eschatological texts to establish the "New World" according to Catholic ideas. Baudot writes that the Franciscans "had to produce an image of the Amerindian in accordance with the monogenetic view of the Scriptures, which did not contemplate the presence of these people on the earth."[39]

Part and parcel to the colonial project of producing the Mexica (and all Native populations of the hemisphere) as noble savages was envisioning Turtle Island-the Americas as the Garden of Eden. An edenic territory, as perpetuated through visual culture and language, was one passive and

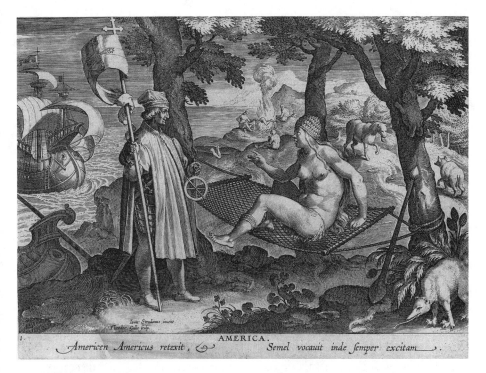

Figure 6. Theodor Galle after Jan van der Straet, *America*, ca. 1580. Engraving. Image courtesy of Print Collection, Miriam and Ira D. Wallach Division of Art, Prints and Photographs, New York Public Library, Astor, Lenox and Tilden Foundations.

"naked," awaiting Europe's arrival. In his text *Inventing America*, José Rabasa applies Geertzian "thick description" to the 1638 etching *America* by Jan van der Straet (also known as Johannes Stradanus, figure 6). For Rabasa, this print displays how Europeans discursively emptied the Western hemisphere, so that they could subsequently fill it with their own imaginaries.[40] He writes that "the essence and destiny of Europe is symbolized by the historical actor, whereas the American continent is confined to a series of separate, individual representatives wandering without direction or meaning. . . . It becomes merely a "naked body" for the inscriptions and longings of a European imagination."[41] This invention of "America," in the hemispheric sense, was done both visually and discursively. To properly present the Americas as a utopic place, it needed to be placed within a European discourse already being articulated about such places. This

discourse usually revolved around the location of a Christian Eden, as well as the growing interest in utopic landscape painting.

Concurrent with the investigation of America was the Western European development of a landscape painting tradition. In a book on the landscape in Western art, Malcolm Andrews discloses that "it was in the fifteenth and early sixteenth centuries that landscape assumed a more independent role in paintings and in some few cases seemed to have become almost wholly emancipated as a genre."[42] So it is no coincidence that the discussion of Turtle Island-the Americas, or more specifically Aztlán (and its other edenic nomenclature), are articulated through the guise of idealized landscape. According to Andrews, a landscape "is what the viewer has selected from the land, edited and modified in accordance with certain conventional ideas about what constitutes a 'good view.'"[43]

Additionally, Andrews uses the important work of John Barell, W. J. T. Mitchell, and others to posit that landscape art, much like other Renaissance conventions, is covertly political and articulates the accession of material possessions by elite, owning classes.[44] Again, Andrews writes that landscape "has from early on been implicated in nationalist, imperialist and socio-economic ideologies, and often most potently so when, superficially, least touched by suggestions of any political agenda."[45] So the inclusion of Aztlán, Cíbola, or El Dorado, within early- and late-colonial discourses on utopia was already colored with the ideological implications of evoking it as an edenic landscape. By turning to cartographic representations of Aztlán and the utopic lost lands of the north, this edenic place was turned into an "amenity," available for consumption and ownership by criollo elites and other European colonials, an idea that worked its way into nineteenth-century mapping.[46] Just like settler-colonial logic elsewhere, Indigenous peoples' stories and lands were both taken and then claimed by the settler-society.

Colonization of (Social) Space

Part and parcel to the subjugation of Indigenous societies is the colonization of space. In lieu of physical violence, although physical and philosophical violence are infinitely reciprocal, the colonization of space is frequently undertaken at epistemological and ontological levels. In conjunction with the subordination of Indigenous knowledge, as well as the appropriation of lands, is the marginalization of previous spatial constructions. Reclaiming one's own collective access to land is at the base of Indigenous anticolonial

struggles. For Fanon, colonial regimes, either official or de facto, always produce bifurcated social spaces.

On one side exists the colonizing force (which will most likely include Indigenous and cross-blood elites); on the other dwells the Indigenous peasants and working-classes. While mestizaje and hybridity are historical facts, they often serve to mystify the non-dialectical nature of settler-colonialism. "The colonial world is a world cut in two," writes Fanon. He continues: "The zone where the natives live is not complementary to the zone inhabited by the settlers. The two zones are opposed, but not in the service of a higher unity."[47] Using a negative dialectic, Fanon positions the two "zones" of the colonized world in constant tension. In comparison with the African colonial world about which Fanon writes, the segmentation between Indigenous and European social structures was not as distinct in colonial New Spain, although social space was frequently maintained along "ethnic" lines.

In her analysis of the Relaciones Geográficas, Barbara Mundy contends that Native mapmakers represented an entirely different space than did Spanish and criollo cartographers. She writes that the "indigenous artists of the Relación Geográfica corpus had a wholly different relationship both to pictorial images and to indigenous iconography than did the Spanish and Creole colonists who made other maps in the corpus."[48] Mundy posits that settler-colonial and Indigenous cartographers understood space in quite distinct manners. In this way, Mundy concurs with Fanon that the colonial world was bifurcated. Indigenous and settler societies inhabited space differently, employing their own relationships to land. There were Indigenous and settler spatial practices, which saw land from oppositional perspectives.

Even though the Relaciones Geográficas demonstrate an excellent example of Indigenous communities maintaining epistemological and visual sovereignty, the representation of space was inevitably colonized. The following citation from Mundy speaks to the relationship between Indigenous space and the colonial administration. She writes:

> "New Spain" filtered through to its Indigenous inhabitants in the ways that Spanish colonists looked at the landscape and through the exercise of power by the viceregal government, the embodiment of New Spain. Official power made itself felt in possessing the landscape, at least implicitly, and then giving it away with land grants. It also asserted itself in renaming communities with names that were represented in alphabetic script, thereby undermining local representations of the landscape, which formerly were able to capture space with a net of their own toponyms.

If we look at the Relación Geográfica corpus and concentrate not just on the indigenous maps . . . we can see an erosion of the power of indigenous communities to represent themselves to the colonial government with maps of their own imagining and making. . . . For New Spain to be mapped as López de Velasco envisioned, it meant that indigenous self-representations had to be suppressed.[49]

Part of this Indigenous suppression, then, was the continued and sustained colonization of aboriginal spatial constructions throughout Turtle Island-the Americas. The colonization of spatial production—that is, the alteration of how Native peoples envisioned themselves within the natural environment and body politic—facilitated the preservation of colonial political structures. So for Xicanos to indigenize and decolonize their relationship to land counters centuries of colonial spatial domination.

Mapping Aztlán

As a unique entity, Aztlán disappeared from the discursive search for a New World utopia by the mid-sixteenth century. It nevertheless served as the impetus for exploratory and colonial missions to the northern borderlands of New Spain. When expeditions to the north failed to legitimate the oral histories of an "undiscovered" utopia, cartographers jumped into the game and began to position "The Ancient Homeland of the Aztecs" (La Antigua Residencia de los Aztecas) in a variety of geographic locations through a multiplicity of names. Cartographers, including Francisco Alvarez y Barreiro (1727), Bernardo Miera y Pacheco (1778), and Alexander von Humboldt (early 1800s), located the Mexica place of emergence in Euclidean space. Although their authorial intentions are ambivalent, the contemporary reception of the maps and their subsequent re-articulation was linked to a project of asserting a Mexican national identity vis-à-vis the nation-state. By locating Aztlán within Mexico, land that settler-colonial elites still longed to own was directly related to notions of Mexican nationhood.

Later, as Anglo-Americans moved west during the early nineteenth century, Aztlán was likewise re-evoked and integrated into U.S. political and social structures. Nineteenth-century Anglo-American historians were interested in locating Aztlán within archeological space. In *The Origin of the North American Indians*, published in 1844, John McIntosh places Aztlán as far north as British Columbia.[50] Aztlán also appears in William Prescott's important book, *The Conquest of Mexico* (1843), published

during the U.S. takeover of northern Mexico. In 1885, less than forty years after its imperial acquisition of northern Mexico, William Ritch goes so far as to write a history of New Mexico called *Aztlán: History, Resources and Attractions of New Mexico*. Written to mythologize and exoticize New Mexico, *Aztlán* hoped to attract Anglo-American settlers to the region, a perspective countered by Aztlán's subsequent indigenist evocation by Xicanos.[51]

In 1905, Thomas Dennison used phonology to explain the relationship between the Mexica and Indo-Iranian people, publishing *The Primitive Aryans of America*. Dennison, more so than any other U.S.-based writer, addressed the multiple locations of Aztlán and attended to the complexities of Aztlán. Two years later, William Hartmann published *Wooed by a Sphinx of Aztlán*, an autobiographical text that advocates Manifest Destiny and the exoticization of Indigenous societies in the U.S. Southwest.

In 1848, the United States and Mexico officially ended the Mexican-American War with the signing of the Treaty of Guadalupe Hidalgo. With this treaty, approximately one-half of Mexico's land base was ceded to the United States with the guarantee that Mexicans (including Indigenous peoples within its geopolitical boundaries) now on the U.S. side could continue their social practices and institutions without structural interruption. While the implications for Mexicans living in the newly acquired U.S. territory were omnipresent, the faults of the treaty were soon realized when, in December 1850, John Russell Bartlett met with Pedro García Condé in El Paso. They discovered that the Disturnell map, the map officially attached to the Treaty of Guadalupe Hidalgo, was highly inaccurate in geographically defining the newly established southern border.[52] Misrepresenting El Paso and the southernmost coordinates of the new border by one hundred miles, the inaccuracies of the Disturnell map created huge problems between the two settler nation-states. In 1853, La Venta de la Mesilla, known in the United States as the Gadsden Purchase, rectified the errors by purchasing this disputed territory.

More than a century and a half later, Disturnell's Treaty Map (figure 7) would reemerge among the ideas of Xicano activist-intellectuals. This time, however, Xicano intellectuals evoked the map as evidence for the existence of Aztlán, as an identifiable real space. In the late 1990s and early 2000s, Patrisia Gonzales and Roberto Rodríguez were gifted a copy of the Disturnell map by Hopi elder Thomas Banyacya.[53] This map, and its subsequent interpretation and dissemination as part of Gonzales and Rodríguez's Aztlanahuac Project, would elucidate Aztlán's legacy to a new generation of Xicano students and activists raised after the Chicano Movement. The map

Figure 7. John Disturnell, Disturnell's Treaty Map (Mapa de los Estados Unidos de Méjico), 1847.

served at the core of Gonzales and Rodríguez's generative and indigenist research agenda that inserted Xicanos into hemispheric Indigenous studies.

Banyacya, the holder of the map, was a Hopi leader and activist originally from the traditional village of Moencopi, located at Third Mesa. Banyacya attended boarding school at Sherman Indian School, a BIA school in California, before matriculating in Oklahoma's Bacone College to run track.[54] Well-educated, Banyacya was unflinching in his advocacy for Indigenous sovereignty, refusing to get a U.S. passport because his national citizenship was Hopi and not U.S. American. During the 1960s, Banyacya was actively involved in Indigenous sovereignty and human rights struggles throughout North America and Europe. He worked particularly hard to eradicate uranium mining on Native lands and to ensure the proper teaching of traditional spiritual knowledge. In 1967, Banyacya was invited to participate in Reies López Tijerina's conference at the University of New Mexico. At this time, there was a growing solidarity between Xicano and American Indian activists across the continent. Peter Nabokov writes that both Banyacya and Tijerina were intimately linked through their ideas about and evocation of prophecy.[55]

Similar to the collectivity of the Chicano and American Indian movements that arose in the San Francisco Bay area with pan-Indigenous organizations like Indians of All Tribes, Xicano and American Indian solidarity developed during the 1960s in New Mexico as well. As proponents of Xicano indigeneity, Gonzales and Rodríguez both identify as Indigenous and see their intellectual work as responding to settler-colonial knowledge. They came to work with the Disturnell map in a way that tied this document to other forms of Xicano tribalography, asserting Xicano sovereignty while linking it to the struggles and stories of other Indigenous peoples throughout Turtle Island-the Americas.

For many decades, Banyacya had securely archived the Disturnell Map before sharing it with Xicano activists. Banyacya believed that this document was irreplaceable because it verified what the Hopi already knew: Xicanos were their kin and they shared common migration stories. Significantly, on the Disturnell Map, in approximately the Four Corners region of the United States (the area where New Mexico, Colorado, Utah, and Arizona converge), small text clearly reads "La Antigua Residencia de los Aztecas." While transgressive to some, the idea that Mesoamerican hereditary lines have archaeological roots in what is now the United States was nothing new to Banyacya. Supported by the map, Hopi prophesy states that Indigenous peoples from the South would return home to the North, disavowing colonial borders in the process. For Banyacya, as well as for

Gonzales and Rodríguez, Xicanos were an aboriginal people whose migration patterns fulfilled Hopi prophesy.

The indigeneity of Xicanos, as well as their ongoing struggle for colonial recognition, is complex and difficult. Gonzales and Rodríguez have been at the forefront of this intellectual movement, helping establish an Indigenous caucus within the National Association for Chicana and Chicano Studies (NACCS), while Gonzales's first academic book, *Red Medicine*, addresses the reclamation of Indigenous ceremony as a decolonial project.[56]

On September 25, 1998, Gonzales and Rodríguez wrote their syndicated column, *Column of the Americas*, with the title "1847 Map Ends Immigration Debate." This journalistic essay evoked the Disturnell map to discuss Xicano indigeneity and the fallacies of settler-coloniality. According to Gonzales and Rodríguez, "this map incontrovertibly proves that rather than being foreigners, Mexicans (and Central Americans, who were also Nahuatl-speaking peoples) are indigenous to Arizona, New Mexico, Colorado and Utah."[57] Using a document that fortified U.S. control over Mexican and Indigenous lands, Gonzales and Rodríguez repositioned Aztlán as a mechanism to counter ongoing xenophobic, settler-colonial discourse. Gonzales and Rodríguez flip the map's original purpose of fixing U.S. and Mexican geopolitical boundaries by using it to fortify Xicano sovereignty in North America.

In this way, the Aztlanahuac Project raises significant and unanswerable questions about the role of cartography in both Indigenous land claims and in the historicity of Aztlán. Importantly, the map evokes the question: Why would John Disturnell, the "maker" of the map in question, choose to articulate the "Ancient Homeland of the Aztecs" on a document used to quantify new national borders? While an analysis of the map begins to illuminate possible responses, it still leaves larger discursive questions.

It has been pointed out that prior to Antonio García Cubas's creation of a national map in 1856, Mexico had no single national map. In his book on maps and the Mexican state, Raymond B. Craib writes that "a national map offered a symbolic affirmation of the political reality of an entity whose very existence was at the time increasingly called into question: a unified and sovereign Mexican nation-state."[58] Although Craib argues that the creation of a *carta general* in 1856 offered a "symbolic affirmation" of a unified Mexico, I reason that Disturnell's map served as a *carta provisional*, which facilitated the construction of a hegemonic and "unified" Mexican nation-state.

First created in 1828, the Disturnell map appeared in at least twenty-four editions, in both English and Spanish, before going out of print in 1858. In

a rare booklet discussing Disturnell's ambiguous cartography, Jack D. Rittenhouse discloses that Disturnell "was no skilled cartographer, no eminent geographer, [nor a] topographic engineer who surveyed the West. Instead, he was a businessman—a publisher of guide books and maps."[59] The economic motivations for Disturnell's mapmaking are apparent. Moreover, it must be noted that Disturnell did not even create the map that bears his name. Instead, he purchased preexisting copper etching plates from the firm White, Gallagher & White and appended, edited, and altered them as needed.[60] The 1828 White, Gallagher & White map—the plates Disturnell purchased that are now considered the "first" edition Disturnell map—was a response to "market demand in Latin America for a map with all the legends and place names in Spanish."[61] These maps were not autonomous or national cartographic projects but developed alongside larger U.S. political and economic factors in Mexico and throughout Latin America. Lacking a national map, Disturnell's map provisionally served that purpose.

When the 1847 Spanish-language edition (12th edition) was attached to the Treaty of Guadalupe, it included the text "La Antigua Residencia de los Aztecas." If, as Craib suggests, Mexico established a "unified nation-state" through mapping, it described the recently lost northern Mexican territories as the "Ancient Homeland of the Aztecs" to cement a sense of national birthright to these lands, which were transferred to Washington, DC, in 1848. When attached to the Mexican version of the Treaty of Guadalupe Hidalgo, "La Antigua Residencia de los Aztecas" positioned a settler-colonial sense of ownership over land ceded to the United States one year later. While the Mexican nationalism of this period cared little about living Natives, it did draw its legitimacy from the pre-Cuauhtemoc past, one with origins in Aztlán.[62] This denial of contemporary Indigenous people and their own self-governance, while simultaneously taking Native lands and stories, is a common settler-colonial practice. Reading the maps critically, then, we recognize that even though this territory legally became U.S. territory, inscribing what is now the Four Corners region as "La Antigua Residencia de los Aztecas" discursively claimed ownership of this territory for the Mexican nation-state.

That contemporary Xicano intellectuals evoke this map, already a palimpsest of narratives and of ownership claims, highlights the complex and multiple ways that Xicanos learn about Aztlán. Using this document, alongside oral histories and migration stories, Gonzales and Rodríguez reread dominant political texts from an Indigenous and indigenist perspective. In this process, they help rewrite settler narratives and continue the reclamation of squatted lands and colonized knowledge systems. Published

in multiple editions, Disturnell's map displayed multivalent narratives, which Gonzales and Rodríguez applied toward anticolonial ends. However, by combining this map with the stories of living Indigenous knowledge keepers, Gonzales and Rodríguez redirect the function of the map away from its initial purposes. They invert the power of the nation-state by focusing on the narrative power of Indigenous stories and sovereignties.

Similarly, by turning to specific artworks and intra-ethnic cultural practices as examples of how Aztlán was (and may continue to be) constructed, we begin to see how conventional discourses on Aztlán fail not only when applied to works that fall inside the Chicano canon, but particularly when applied to artworks and other cultural production motivated by Xicano Indigenous sovereignty. Through these particular examples, we see how Aztlán, articulated either as a geographic space or as a mere trope, does not fully acknowledge the potential for Xicano sovereignty. Through this critique, Aztlán posits a radical agenda, based on the writings of activist-intellectuals like Cherríe Moraga, Rafael Pérez-Torres, and Daniel Cooper Alarcón, among others, from which we may fully engage the emancipatory potential of Aztlán without falling victim to an ahistorical and poststructural ambiguity.

This radical (yet Indigenous) agenda is intimately tied to the land. Using Aztlán to create stories and relationships with other Indigenous people, it commences a move beyond linking it to the boundaries of Western nation-states. Leslie Marmon Silko (Keres-Xicana) writes:

> The people and the land are inseparable, but at first I did not understand. I used to think there were exact boundaries that constituted "the homeland," because I grew up in an age of invisible lines designating ownership. In the old days there had been no boundaries between the people and the land; there had been mutual respect for the land that others were actively using. This respect extended to all living beings, especially to the plants and the animals.[63]

For Xicanos, Aztlán is this "homeland" and, as we will see throughout *Creating Aztlán*, challenges these invisible lines designating ownership.

Conclusion

By thinking through Aztlán, we begin to redefine our understanding of space and the human role within each respective Aztlán. Writing about the Xicano Aztlán, performance theorist Alicia Arrizón bluntly states that

"the term 'Aztlán' redefines space."[64] In its redefinition of space, for both the Mexica and the Xicanos, Aztlán redirects an Indigenous relationship to the world.

But how exactly does Aztlán redefine space? On the one hand, Aztlán was redefined through a variety of pictorial and performative practices, including its representation within the codices and through tlacuilome performance. On the other hand, Aztlán redefined how the Mexica saw themselves in pre-Cuauhtemoc Mesoamerica. Although Xicano artists have used both oral and written documents, in addition to the codices themselves, without these performances, the Xicano Aztlán is (thankfully) a shadow of its former self. This colonial rupture with its initial imperial function allowed Xicano artists and intellectuals to create Aztlán outside the imperial constraints of Mexica politics. Indigenous in origin and function, the post-1969 Xicano Aztlán became an aboriginal neologism that was a new evocation of a pre-Cuauhtemoc concept. It was a new place of emergence.

What this reveals is that without an understanding of Mexica performance (which was destroyed through colonizing acts of biological and cultural genocide), Xicano artists and activists construct an entirely distinct Aztlán, although one linked to pre-Cuauhtemoc epistemology and ontology. It should come as no surprise, then, that the innovative and significant manifesto El Plan Espiritual de Aztlán begins by demonstrating that Xicanos are a distinct Indigenous people with a postcontact ethnogenesis, much like the Michif (Métis) of the U.S.-Canada borderlands.

By returning to precolonial tropes, yet articulating them within a contemporary context, Aztlán followed what Frantz Fanon clearly identifies as an anticolonial move to not isolate one's nation into precolonial fictions. In a "brief manifesto," Eric Cheyfitz uses Fanon's critique of colonialism as the basis for developing an Indigenous philosophy beyond the limits of capitalism. Implicating Fanon for his ability to transcend capitalism's limitations, Cheyfitz articulates Indigenous kin-relations with the land as a network that allows indigeneity to move past capitalist models of the nation-state as the highest political formation. Cheyfitz writes:

> This Indigenous, or kinship-based, relationship to land, which is antithetical to dominant Western ideas of social and economic life, increasingly stressing privatization, presupposes democratic forms of governance, based in consensus, that are antithetical to the representational governmental forms of Western capitalist democracies, located as they are in a majoritarian notion of power within which minority rights are formally but not necessarily substantively recognized.[65]

Aztlán uses this relationship to go beyond capitalist and neo-liberal "democracy" and settler-colonial relations to the land. As Alurista begins El Plan, Aztlán is forged "in the Spirit of a New People." But Alurista's new people are not a *settler* people—they are a new *Indigenous* people. One where kin relationships are created with the earth, and we move beyond capitalist machinations and imagination. This indigenist stance is particularly apparent in Alurista's decision to develop a growing sense that Xicanos are Native peoples. Although originally calling Chicanos a "bronze people" with a bronze culture, as Sheila Contreras points out, Alurista quickly shifts this focus on mestizaje and reaffirms Xicanos as a Red people, employing the concept both in terms of indigeneity and for its reference to nonhierarchical governance. As Contreras aptly contends, "when Alurista published *Nationchild* [in 1972], 'Red' had been recently appropriated, transformed into a powerful tool of cultural and political opposition by American Indian activists. Alurista's choice to change his terminology is an acknowledgment of the American Indian Movement and inscribes Chicano nationalism as a parallel struggle for recognition and repatriation."[66] Although maybe not "Indians"—a unique colonial construct based in a constructed relationship to the settler-colonial nation-state—Xicanos are nonetheless an Indigenous nation. Aztlán is the form that Xicano sovereignty and Indigenous nationhood takes.

CHAPTER TWO

Naming

Aztlán as Emergence Place

Indigenous relationships to the land are vital, both for day-to-day realities of subsistence and for the continuance of ontological and political systems. From an Indigenous perspective, land is not purchasable, especially not Indigenous land. Land cannot be commoditized. Clara Sue Kidwell (Choctaw/Anishinaabeg) and Alan Velie write that "American Indian identity is, as it has always been, their association with land on which they live."[1] Of course, through the structural and epistemological processes of colonization, this intimate land-based relationship has often been ruptured. For Xicanos, this is particularly disconcerting, as disenfranchisement, detribalization, and diaspora have disconnected Xicanos from sacred lands. Nonetheless, "the relationship of American Indian societies to land is also essential to the process of historical adaptation and change."[2]

For Xicanos, this adaptation and change was often faced via forced linguicide, detribalization, and, more recently, the economic necessity of migrating across international borders for wage-labor. While lowriding is a slow process, quick and frequent movements across the land are a response to capitalism, colonialism, and globalization. Aztlán serves, among its many functions, to fill the void violently enacted by centuries of colonial domination and exclusion. By remembering and naming their initial place of emergence, Xicano activists reclaim their own humanity and sense of sovereignty. Through intergenerational memory, which goes back to the beginning of time, Indigenous stories confront colonial amnesia.

Anthropologists speak of *ethnogenesis*, the moment when people see themselves as a distinct society. For Xicanos, that genesis has three particular moments, each intimately tied to Indigenous notions of land. The first occurred in the eleventh or twelfth century when the Mexica left Aztlán looking for the particular place identified in Huitzilopochtli's prophecy, which they found at Tenochtitlán. The second transpired in 1848 with the signing of the Treaty of Guadalupe Hidalgo, ceding nearly half of Mexico to the United States. This second process violently separated families and communities, forcing many people from their lands and languages.

The third transpired nine centuries after the Mexica migrated away from Aztlán, when Alurista returned Aztlán as the site of Xicano sovereignty. Separated by nearly a millennium, these individual moments intimately link various Xicano land claims and speak to a people emerging from the underworld into the earthly domain of humanity. Their individual stories also position Xicanos as a people thoroughly connected to the land herself.

As emergence stories, these three narratives about Aztlán are vital to understanding Xicano society and its place within Indigenous North America. Keres-Xicana writer Leslie Marmon Silko discusses the Laguna Pueblo people's emergence story, in which a spring near Paguate village in New Mexico "functions on a spiritual level, recalling the original Emergence Place and linking the people and the springwater to all other people and to that moment when the Pueblo people became aware of themselves as they are even now. The Emergence was an emergence into a precise cultural identity."[3] She continues, noting that "the Pueblo stories of Emergence and Migration are not to be taken as literally as the anthropologists might wish."[4] Xicano creation likewise evoked water, this time in the form of an island in a lake, to similarly bond people with the land.

For both Xicanos and the Mexica, Aztlán served as the conceptual Emergence point in which both Indigenous societies "became aware of themselves" as a distinct people, to use Silko's language. When we envisage Aztlán from this position, we become more aware of its ideological underpinnings but also enable its deeper and more nuanced implications of a peoples' emergence. Diné philosopher Marilyn Notah Verney positions Native societies' relationship to land as the metaphysical and ontological distinction between Indigenous and settler belief systems. She writes that "almost all Indigenous creation stories relate to the land. The creation story of American Indians is that Mother Earth gave birth to the people."[5] Like the *sipapu* of Puebloan emergence, Aztlán gave birth to Xicanos, as a unique Indigenous people. By coming from the land, the land herself remains sacred and un-ownable.

In Indigenous Mesoamerican thought, the cave is seen as the birthplace of humanity. Not only did humans emerge from caves, so too were the earth and sun birthed in its darkness. As such, the earth and sky were bound together via passageways to the underworld, a place where humans entered the Fifth Sun. Therefore, the continued adoration of caves, which during the early period of contact included the pre-Cuauhtemoc practice of bloodletting, maintains the sanctity of the cave as the place of emergence of Indigenous societies.

So, in 1969, with the writing of the Plan Espiritual de Aztlán, Xicanos metaphorically reemerged from Aztlán, reclaiming their indigeneity as well as their relationship to the earth. Aztlán continued to occupy a spiritual space within Xicano epistemology and political thought, although it was bound to emancipatory actions.

Contrasting with settler-colonial notions of hybridity, Aztlán was an assertion of Xicano indigeneity and sovereignty. In "Being Indigenous," Taiaiake Alfred (Kanien'kehá:ka) and Jeff Corntassel (Tsalagi) write that

> Indigenousness is an identity constructed, shaped, and lived in the polit-
> icized context of contemporary colonialism. The communities, clans,
> nations and tribes we call Indigenous peoples are just that: Indigenous to
> the lands they inhabit, in contrast to and in contention with the colonial
> societies and states that have spread out from Europe and other centres of
> empire. It is this oppositional, place-based existence, along with the con-
> sciousness of being in struggle against the dispossessing and demeaning
> fact of colonization by foreign peoples, that fundamentally distinguishes
> Indigenous peoples from other peoples of the world.[6]

The Xicano emergence from Aztlán, as a political, ideological, and spiritual endeavor, is not an isolated event. Rather, this emergence is lived directly in relationship to centuries of settler-colonialism and capitalist-oriented Manifest Destiny. Returning to ancient and irreplaceable Indigenous story-ways does not somehow disavow contemporary realities; rather, their evocation is the implicit acknowledgment of those ongoing colonialities. As Alfred and Corntassel attest, indigeneity likewise intimates a consciousness of struggle.

Organizing Aztlán

As Henry G. Cisneros, voice-over narrator for the film *Chicano!: History of the Mexican American Civil Rights Movement*, explains: the name Xicano

is "an ancient Mexican word that describes the poorest of the poor, but they wore the name with pride."[7] Although no one knows definitively the root of the word Xicano, this declaration demonstrates the connection between both Indigenous ("ancient") history and working-class ("poorest of the poor") struggles. In some ways, Cisneros's manner of describing the word Xicano fits ideally into the way the Plan Espiritual de Aztlán evokes Aztlán as both Native and class-based.

The Chicano Youth Liberation Conference, the gathering where the Plan was written, served as the site where Xicanos from multiple gender, class, and regional backgrounds converged to work out these differences through dialogue and exchange. In oral history testimony, Alurista recalls that his essentialized notions that tied Xicanos to the Southwest were shattered at the conference. Fittingly, he affirms that Xicanos came from all corners of Turtle Island, including the Midwest and Pacific Northwest. As Alurista remembers, "I did not know there were Chicanos in Kansas."[8] Alurista, like many of his Southwest contemporaries, was unaware that Xicano communities were prominent throughout Turtle Island, not only in the U.S.-Mexico borderlands.[9] It must be noted, however, that forced diaspora, as a response to the economic realities of capitalism and colonialism, do not somehow void Xicano claims of Indigenous sovereignty. They do, however, make understanding Xicano sovereignty more complicated.

The National Chicano Youth Liberation Conference was held in Denver, Colorado, March 27–31, 1969, and organized by the Crusade for Justice. Coordinated by former boxer Rodolfo "Corky" Gonzáles, the Crusade for Justice was one of the so-called cornerstones of the Chicano Movement. The conference events took place at the Crusade headquarters and, according to Armando Navarro, approximately fifteen hundred activists participated in conference events.[10] What differentiated the Chicano Movement, which fully became a "social movement" at this conference, from the preceding actions of the Mexican American generation was its inherent focus on the intersection of class and Indigenous identity. Although discussions of nationalism were contentious during this period, the Movement amplified Xicano indigeneity to a national level.[11]

It was in this time and place that Emanuel Martínez, a Colorado-based Xicano artist presently working with incarcerated youth, created his untitled serigraph, which has become known as the *Mestizo Banner* (figure 8). Martínez is also known for creating the "Tierra o Muerte" images in support of the Alianza de Pueblos Libres and land grant movement in northern New Mexico and southern Colorado. Although advocating a Mestizo identity, during the late 1960s this move, much like Alurista's initial call in the Plan,

Figure 8. Emanuel Martínez, *Mestizo Banner*. Serigraph, 1969. Image courtesy of Emanuel Martínez.

was a militant break from hispanidad and a move toward Xicano radicalism as Indigenous sovereignty. Over time, it would be pushed even further.

In this way, the Chicano Movement was organized as an international(ist) social movement. The earlier Mexican American generation was isolated to particular barrios and geographical regions and was assimilationist in scope. The distinction between these two movements was that the Mexican American movement was local, while the Chicano Movement became both regional and (inter)national in scope. Moreover, the Chicano Movement advocated a position that transcended assimilation and moved toward today's indigenist struggles and articulations of sovereignty.

The Chicano Movement was simultaneously local and global. Ignacio García writes that "when the students and youthful activists arrived, they were anxious to be molded into a movement at the national level. Until the conference, there were movement efforts in California, Texas, Arizona, and New Mexico, but no national movement."[12] Although inaccurate in arguing that Xicanos were "molded" into a movement, opposing their very agency in self-determining their own actions, García is accurate that the Denver conference enveloped the totality and convergence of the various Chicano movements.

In fact, the revolutionary caucus of the conference went so far as to formulate the role that the Chicano Movement would play globally. According to the statement of the revolutionary caucus, "Because of who we are, our nationalism becomes an internationalism that does not deny the human dignity of any other people, but accepts them as brothers."[13] The statement continued:

> We are oppressed first because we are Chicanos, because our skin is dark. But we are also exploited as workers by a system which feeds like a vulture off the work of our people only to enrich a few who own and control this entire country. We suffer a double oppression. . . . But its oppression is not limited to us. It is a world system of oppression responsible for the misery of the mass of humanity. We will not attain what is rightfully ours, or our democratic rights of self-determination without having to overturn the entire system. We will have to do away with our oppressor's entire system of exploitation.[14]

Although male-centered in its application of the term "brothers," the revolutionary caucus distinguished and embraced the Wallersteinian global connectivity of capitalist exploitation. Xicano activists understood that coloniality had an intimate relationship with capitalism, the darker side of modernity. From an anticolonial orientation, the Chicano Movement worked within the same anticapitalist agenda as the student movements in Paris or Mexico City; the antiwar movement in the United States; early feminist activities throughout the Western world; the anticolonial movements throughout Africa, Latin America, and Asia; and the American Indian and Red Power movements on Turtle Island.

The reciprocity between Aztlán as a manifestation of Chicanismo (which is later re-signified as Xicano indigeneity or sovereignty) and class struggle is an important one, often obscured by the perceived "nationalist" agenda of the Movement. The statement released by the revolutionary caucus

reciprocally positions these two social constructions. Xicano nationalist struggles were concurrently anticolonial and anticapitalist. Revolutionary Xicano sovereignty and self-determination were predicated on the confrontation of capitalism, a point that Carlos Cortéz Koyokuikatl, among others, directly investigates in his artwork. Xicano nationalism was a form of place-based anticapitalism. It is an Indigenous ontology outside the constraints of either the nation-state or capitalist economics.

In the words of literary critic Eric Cheyfitz, Indigenous philosophy allows us to think beyond capitalism's limits.[15] Looking at Indigenous activism across Turtle Island-the Americas, Cheyfitz establishes that

> if the United States specifically and the developed world more broadly wants to move beyond the limits of capitalism's imagination and its current destructive form of neoliberal globalization, a particular moment in the history of the modern nation-state, which began its trajectory with the European invasion of the Americas in 1492, then this Westernized world must begin to think seriously in terms of the philosophies that were providing balanced models of social life when unbalanced Europeans arrived violently more than five hundred years ago.[16]

Corresponding, in the 1976 novel *Heart of Aztlán*, nuevomeXicano (a Xicano from New Mexico) author and activist Rudolfo Anaya embraced the dialectic between Xicano indigeneity and class. As Chon A. Noriega and Wendy Belcher point out

> Anaya's novel—published in the latter years of the Chicano civil rights movement—weaves together the communal and the personal through the narrative about labor relations, social protest, ethnic identity, and pre-Columbian spirituality. Indeed, the protagonist first learns of Aztlán at a meeting of striking union members![17]

The fact that Aztlán is integral to working-class organizing is crucial to how Xicanos, as a proletarianized and detribalized aboriginal people, organized during the mid-twentieth century.

Again, Alurista's writing quickly reveals this relationship. In *Nationchild Plumaroja*, Alurista writes that

> we are free and sovereign to determine those tasks which are justly called for by our house, our land, the sweat of our brows, and by our hearts. Aztlán belongs to the Creator who brings nourishment to the seeds, and

brings rain and sun to the fields to give people crops for food, and not to the yankee empire. we do not recognize capricious borders on the Red Continent.[18]

Alurista conceptualizes how indigeneity, class struggle, sovereignty, kin relations to the land, and national liberation seamlessly merge in an emancipatory project known as Aztlán. Of course, initially the Plan called Xicanos a mestizo culture. However, as Sheila Marie Contreras notes, "Alurista's revisions to the text originally presented in 1969 at the Denver Youth Conference reveal an attempt to negotiate the space between American Indian resistance and Chicana/o indigenist nationalism, while at the same time drawing authority from the realms of contemporary politics and forgotten spiritualities."[19] Alurista and others reclaimed Xicanos as a sovereign Indigenous nation.

In spite of this, one of the failures of mestizo discourse—and this is true about the initial draft of the Plan—is that it commonly dismisses the compound and dynamic disposition of Indigenous identity and subsumes this into stagnant and a priori biological objects. Instead, as Jack Forbes put forward, Xicanos are "de-Indianized" Natives, to borrow from the vocabulary of anthropologist Guillermo Bonfil Batalla.[20] While some Xicanos are racially mixed, this does not extinguish Xicano indigeneity.

One month after the Chicano Youth Liberation Conference, a colloquium was held in Santa Barbara, California, to address the necessities and experiences of Xicanos in higher education. In *Beyond Aztlán*, Mario Barrera notes that the "conference and the resulting plan were in many ways an attempt to elaborate on the themes and goals raised at the Denver Youth Conference and in the *Plan Espiritual de Aztlán*."[21] Conference participants produced El Plan de Santa Barbara, which articulated an outline for institutionalizing Chicano studies, as an academic and activist discipline, within the university. Moreover, this particular plan arranged for a single national student organization in place of multiple single-issue groups.

In Santa Barbara, Xicano students converged under the acronym MEChA (Movimiento Estudiantil Chicano de Aztlán). Placing Aztlán within the name of the primary Xicano student organization, MEChA asserted its identity as an organization for Xicanos, as an Indigenous people of mixed descent. Although an acronym, the organization's name served as a double entendre in that *mecha* is also the Spanish word for wick, with its logo prominently featuring an eagle with lit dynamite in its talons. This linguistic double signification is extremely important, as activists saw themselves as both committed constituents of the Movement as well as its revolutionary spark.

Naming • 61

In the minds of many activists, a mecha was chosen for its ability to spark an incendiary movement, yet it also symbolized the inability to control the fire lit from this source. The process of naming, a sacred ceremonial act in many traditional societies, demonstrates how *mechistas*, as members of MEChA are known, envisioned themselves not as vanguards of Chicanismo, but as agitators who ignited the sparks of resistance. In turn, the Movement organically grew (as a fire) outside their care. MEChA, as the wick to a new fire, likewise recalled the important New Fire Ceremony, a sacred Nahua spiritual celebration marking the beginning of a new calendar year. The Mexica calendar consists of two ways of tracking time, the *tonalpohualli* and *xiuhpohualli*, and these two systems are reset every fifty-two years. This process of resetting was marked with a New Fire ritual. MEChA, as the igniter of fire, refers directly to this new beginning. One could also look at the importance of fire within other Indigenous worldviews, such as the *ishkode* within Anishinaabeg thought. In all cases, fire is tied to new beginnings; however, this commencement is always linked to the Indigenous past and present.

While multiple organizational names were up for debate, in the end Movimiento Estudiantil Chicano de Aztlán was chosen over the Chicano Alliance for United Student Action (CAUSA). Seeing themselves as Indigenous and their homeland as Aztlán (without the boundaries of a settler-colonial nation-state), Xicano students preferred MEChA for its double-meaning, and its direct reference to aboriginal land rights and the lighting of a New Fire. This important decision situated the Movement within a radical indigenist framework, one which prefigures contemporary indigenism as practiced within international political institutions such as the United Nations.

Prior to consolidation of the student groups in Santa Barbara, different regions of the United States had various Xicano youth organizations that articulated their own localized philosophies. In October 1967, Reies López Tijerina called Xicano youth activists to a summit in Albuquerque, New Mexico, the city Rudolfo Anaya calls the "Heart of Aztlán." Hopi nationalist Thomas Banyacya was in attendance, as was José Angel Gutiérrez, the Tejano activist associated with the Mexican American Youth Organization (MAYO). Gutiérrez advocated that Xicanos should use the term La Raza to self-identify, as the term Chicano had not gained widespread acceptance at that point. At this Third and Fourth World gathering, the sparks were ignited for the 1969 National Chicano Youth Conference, as well as for what would become La Raza Unida Party, the Texas-based political party.

By the time of the Chicano Youth Liberation Conference, Xicano student and youth organizations were active throughout Turtle Island, with solidarity networks extending into Mexico and Canada. In Texas, there

was the Mexican American Youth Organization (MAYO or MAYA, Mexican American Youth Association). In California and New Mexico there was also a group known as United Mexican American Students (UMAS), while California hosted various chapters of the Mexican American Student Confederation (MASC). California professors were primarily associated as the Chicano Coordinating Council on Higher Education (CCHE), the organizers of the Plan de Santa Barbara. Off-campus, these groups organized in barrios and *colonias*, including areas of the country with large Xicano communities, such as Illinois and Michigan. When these respective organizations came together in Denver, the diverse organizing principles of the various Xicano organizations were centralized into a (inter)national Indigenous alliance. Coming together under a single banner, Xicano activists did not produce a monolithic structure for the Movement, but instead created a network in which autonomous mechistas could interact and work in solidarity. The conference likewise facilitated the development of rhizomatic structures by establishing intentional group interaction.

As an organization, MEChA was founded on the principles of two fundamental documents: El Plan Espiritual de Aztlán, written at the Denver conference, and El Plan de Santa Bárbara, written in Santa Barbara. With the writing of these texts, MEChA, and the Chicano Movement as a whole, constructed a framework for its liberatory struggle. Written with conscious ambiguity, so to avoid creating a monolithic and orthodox solution to the problems confronting Xicanos, El Plan de Santa Bárbara advocated community education, organizing, and self-determination. MEChA's primary purpose, as articulated in Santa Barbara, was based in the community. The Plan states that "we do not come to work for the university, but to demand that the university work for our people."[22] While some proto-nationalist sectors of the Movement chastised the university as a "white" institution, the framers of the Plan de Santa Barbara recognized the role that higher education could play within the liberation of the Xicano people. According to the Plan, as published by *La Causa*, "the inescapable fact is that Chicanos must come to grips with the reality of the university in modern society. . . . The role of knowledge in producing social change, indeed revolution, cannot be underestimated."[23] Some activists infiltrated mainstream institutions, founding Chicano studies and other ethnic studies programs. Others established parallel and autonomous institutions, including D-QU in California and the Academia de la Nueva Raza in New Mexico.

MEChA institutionalized Chicano studies, while helping countless first-generation college and university students deal with the complexities of that structure. To this day, MEChA chapters are active throughout Turtle

Island-the Americas. Although certain MEChA chapters have been riddled with sexist and homophobic practices, others have posited an overtly feminist and pro-queer agenda. MEChA, like many Movement organizations, simultaneously countered and replicated the dominant ideologies and practices of contemporary capitalist society.

Naming the Xicano Nation

When read aloud in Denver, El Plan Espiritual de Aztlán reanimated the sovereignty of Chicanismo, forging a unified voice and movement. Emphasizing indigeneity by presenting provisions for an independent Xicano nation, the framers linked Aztlán to Third and Fourth World struggles for liberation, the Black civil rights movement, and American Indian struggles for sovereignty. F. Arturo Rosales writes that El Plan Espiritual de Aztlán "posited separatism."[24] Although misguided in calling the Plan separatist, this unprecedented assertion fashioned Xicanos as an autonomous and sovereign Native nation by engaging in radical rhetorical tactics that returned to Indigenous history yet joined in solidarity with internationalist struggles.

During the Movement, as has been rightly critiqued, many activists saw Aztlán as an exclusionary space. Critic and poet Alicia Gaspar de Alba writes:

> For nearly 40 years, the myth of Aztlán, or the lost land, has been at the core of a Chicano male identity and has had a formative influence not only on Chicano psychology, but on Chicano cultural production as well. Based on racial pride, historical awareness, brotherhood, cultural unity, and the claim to nativity to the land base of the Southwest, the myth of Aztlán calls for the reclamation of "the land of our birth," a lost or stolen motherland that was taken involuntarily, and that the Chicano "hijos de Cuauhtémoc" were destined to redeem through the political as well as the cultural manifestations of El Movimiento. In this gendered relationship to land (or homeland), sexual politics is clearly articulated into the ideology of Aztlán and its representation in the arts.[25]

This particular Aztlán, one that I hope this book challenges, was male, straight, and located within the U.S. Southwest. For many, Aztlán became a form of cis-gendered, heterosexual, Chicano-male hegemony. It was monolithic and essentializing. It reestablished hierarchical structures based on gender, geography, and sexuality, while dismissing Xicana, non-Southwestern, and queer voices.

During the Movement, as well as today, artists and activists employ Aztlán within complex signifying systems in ways that are more multifaceted than they are often credited with being. Indigenist Xicano artists and activists express a multiplicity of anticolonial modalities, each depending on an array of experiences and tendencies. For this reason, rereading Movement visual art, especially artworks and practices that evoke Aztlán as the trope of liberation, enables us to broaden our understanding of radical Xicano politics and Indigenous sovereignties.

Although poet Alurista (pseudonym for Alberto Urista) is commonly recognized as the individual to excavate Aztlán, Lenape-Delaware historian Jack Forbes should likewise be credited for the re-evocation of Aztlán, claiming he taught this concept in his Native studies courses before the Plan was written.

In *Cantos al Sexto Sol*, Alurista asserts that he began his formulation of Indigenous Xicano sovereignty by turning to Buddhist and Hindu spiritual writings.[26] From this distinctly non-Christian religious orientation, Alurista maintains that after the eastern spiritual influence, "I started researching my Mayan-Toltec roots. When I got to Denver in March 1969, I arrived with that kind of consciousness. . . . We were already talking about a Chicano nation. We could not have a Chicano nation without a name."[27] Although merging two temporally and geographically distinct Indigenous societies into one Mayan-Toltec entity, Alurista recognized the very real power embedded within the process of naming. Linda Tuhiwai Smith (Maori) writes that naming "is about retaining as much control over meaning as possible. By 'naming the world' people name their realities. For [Indigenous] communities there are realities which can only be found in the indigenous language; the concepts which are self-evident in the indigenous language can never be captured by another language."[28]

Just as the Chicano Movement named itself with its own ontology (Chicanismo-turned-Xicano indigeneity), so too did it name and therefore claim Aztlán as the collective Indigenous place of emergence. As Rudolfo Anaya writes, "The ceremony of naming, or self-determination, is one of the most important acts a community performs."[29] Anaya continues: "The naming ceremony creates a real sense of nation, for it fuses the spiritual and political aspirations of a group and provides a version of the group's role in history. These aspirations are voices by the artists who recreate the language and symbols that are used in the naming ceremony."[30]

As an artist interested in the process of anticolonial nation-building, Alurista turned toward the cosmopolitan recreation of Xicano language and symbology. It was from Mesoamerican, Native North American, and

Eastern spiritual positions that Alurista penned the preamble of El Plan Espiritual de Aztlán. In addition to these poetic and creative sources, Armando Rendón cites two English-language texts that served as influential sources for Xicano nationhood. In *Chicano Manifesto*, published in 1971, Rendón posits that "references to Aztlán as the place of origin of the Mexican Indian peoples are negligible in North American chronicles. Two of the most easily attainable texts by historians in the United States are William H. Prescott's *History of the Conquest of Mexico* (1843) and Alvin M. Josephy, Jr.'s *The Indian Heritage of Mexico* (1968)."[31]

As Rendón intimates, these two texts were circulating among Movement activists. Rendón likewise notes that Alurista attained, at least partially, his knowledge of Indigenous Mesoamerican histories from English-language books available in the United States. The 1968 publication of *The Indian Heritage of Mexico* played a significant role in how Xicanos engaged Indigenous historiography in relation to their contemporary anticolonial situation in the United States.

At this time, other texts were likewise being published on Aztlán, as a specific place in Mexico. In 1969, *National Geographic*, the popular ethnographic publication, published an article on the community of Mexcatitán, Nayarit. In this article, W. E. Garret calls the community a "Mexican Venice."[32] In addition to describing its similarities with the Italian city, Garret discusses the importance of Aztlán and points to the similarities between Mexcatitán and historic descriptions of Aztlán.

At the same time that Garret published for Anglophone audiences, Mexican and Spanish-language scholars demonstrated a renewed interest in Aztlán as an archaeological site. In 1962, Gutierre Tibón published an article on the lexical similarities between Aztlán and certain sites in Northwestern Mexico. Disagreeing with Garret, Tibón argues that "Mexcatitán cannot be Aztlán because the primitive motherland of the Aztecs is represented in the codices as a hill with the twisted peak, where they encountered a cave."[33]

It is within this context of growing popularity that Aztlán performs a significant function in the writings of poet Alurista. Although he does not use Aztlán in writing until 1969, Alurista was using the notion in his unpublished poetry at least two years prior.[34] Aztlán was particularly important for artists who, like Anaya attests, helped reimagine the Xicano community as an Indigenous *nation*. Within this process, art plays a quintessential role in envisioning Indigenous sovereignty. Following Louis Riel's linking of artists and spirit, art becomes an engaged way of awaking a colonized people and giving them back their spirit.

66 • *Tlilli*

Stirred by the growing sentiments of Third and Fourth World liberation, as well as by student activism, Xicanos reemerged from Aztlán as a people recently awakened from colonial slumber. Through the work of poets such as Alurista, as well as those individual artists and collectives discussed in the second half of this book, the spirit of Xicano peoplehood became an enunciation of a unique Indigenous people with a collective ethnogenesis and shared cultural history.

As Alurista clarifies, Aztlán names the Xicano nation via an Indigenous concept that should not be confused with the Western political formation of nation-states. Kanien'kehá:ka (Mohawk) political scientist Taiaiake Alfred writes that "the Native concept of governance is based on what the great student of indigenous societies, Russell Barish, has called 'primacy of conscience.' There is no central or coercive authority, and decision-making is collective."[35] He continues: "The indigenous tradition sees government as the collective power of the individual members of the nation; there is no separation between society and state."[36] The Xicano nation is not another manifestation of a Western nation-state. This, I believe, is where I begin to differentiate my ideas from critics of Xicano nationalism. Indigenous nationalism or peoplehood helps us conceptualize nationhood beyond the limits of the nation-state, as Eric Cheyfitz so aptly notes of Alfred's writing.[37] Literary critic Rafael Pérez-Torres contends that

> Aztlán marks less a wholeness than a heterogeneity of the subject position Chicana/o in terms of identity, geography, history, psychology, spirituality, and nationality. It is impossible to ignore the nomadic role Chicanos and Mexicanos have played within a diasporic history of the United States.[38]

This nomadism, more aptly positioned as an Indigenous migration narrative or lowriding, is located in the work of Carlos Cortéz Koyokuikatl, who draws implicit connections between Xicanos and their Anishinaabeg kin, an issue that I will explore in chapter 5.

Daniel Cooper Alarcón notes that "when understood as a palimpsest, Aztlán ceases to be ahistorical and insists upon an examination of the past, a study that will reveal not only the complexity of Aztlán, but of Mesoamerican history that was used as a resource by Chicano nationalists."[39] As a palimpsest, Aztlán carries with it generations of stories.

In his poem "The History of Aztlán," Alurista considers:

> aztlán, aztlán
> a call for justice

aztlán, aztlán
a call for freedom
aztlán, aztlán
a call for nationhood
dedicated to the humanization
of man and woman
dedicated to the preservation
of earth and sun
rooted in brotherhood and sisterhood
rooted in collective labor and self-sacrifice[40]

Not only does Alurista name Aztlán a call for "humanization," he specifically identifies both male and female roles within this process. It is the actualizing of Xicano humanization that makes Aztlán crucial, not to mention the ways that artists create Aztlán in their own vision. As an Indigenous palimpsest, Aztlán cannot be erased; neither can the indigeneity of Xicano sovereignty. Both are never-ending stories.

Performing and Storying Aztlán

An important aspect of the multilayered history of Aztlán is the way Xicano indigeneity performs space. To emerge from Aztlán, Xicanos must likewise perform it as a site of sovereignty. Just as Aztlán lost its function because Mexica elites stopped performing the codices, and particularly the Aztlán narrative, so too must Xicanos perform Aztlán if it is to remain relevant. When we stop performing our own sovereignties, they stop existing.

As an "imaginary space occupied by memory and desire," as Alicia Gaspar de Alba calls it, Aztlán enables the performance of certain embodied presentations. For the Mexica, just as for contemporary Xicanos, there was a "relationship between texts, textuality, and performance," as theatre scholar W. B. Worthen makes clear.[41]

But texts, textuality, and performance cannot be isolated from larger categories of space and place. As Henri Lefebvre articulates in *The Production of Space*, embodied human performances are the activities that activate otherwise abstract spaces.[42] These bodily performances, as the social experiences of humans, are both constituted by and constitutive of the social space in which they operate. "For the spatial body," writes Lefebvre, "becoming social does not mean being inserted into some pre-existing 'world': this body produces and reproduces—and it perceives what it reproduces or

produces."[43] Just like all beings, Indigenous people activate their respective life-worlds by moving through them and therefore performing them. Lowriding assists in the activating of this world.

In *New World Orders*, anthropologist J. Jorge Klor de Alva argues that Xicano identities are nothing more than ciphers. Using mestizaje as his unifying framework, Klor de Alva is critical of the manner in which social beings have evoked mestizaje as a transgressive site. He concludes: "In the end, we are forced to acknowledge that the cipher-space *mestizaje* may be capable of infinite variation, but today, as in the past, it continues to be both a dangerous site and a wellspring of creativity."[44] Critical of mestizaje, Klor de Alva positions it as an empty signifier, capable of receiving infinite identities and therefore empty of meaning. He goes on to state that "the shift from Chicano to 'Xicano' implies a broadening of the Chicanos' ethnic identification to include not only the indigenous peoples of Mexico—as in the 'Plan Espiritual de Aztlán'–but all native peoples of the Americas as traditional 'children of the earth.'"

I believe it is fruitful to conceptualize Xicano identities and their relationship to Aztlán as ones that *perform space*. Xicana theatre critic Alicia Arrizón writes that "the term Aztlán redefines space" and, using the language of third space feminism, "Aztlán performs the border space."[45] For Arrizón, Aztlán problematizes binary constructions of spatiality prominent within dominant settler-colonialism. Turning to Xicana visual and performance art, Arrizón maintains that

> as a site of creative and political intervention, Aztlán both signals the heterogeneity of the subject and authorizes an alternative way of knowing that may offer a fantastic epistemological system. Aztlán dramatizes and enacts the complexity of power as a mode of differentiation, a hierarchical structure, and a system of defense.[46]

It is through Aztlán, as a multivalent chronotope, that Xicano artists and activists perform radical social politics. Aztlán, the manifestation of Indigenous space, transgresses colonial spatial categorizations.

As the cases of the Relaciones Geográficas and the Disturnell map indicate, mapping is one modality wherein settler-colonial institutions attempt to exercise their control over Indigenous bodies and lands. Cartography and affiliated processes of dividing geographic space between settler-colonial nation-states is at the core of colonial governance. Inversely, Aztlán provides radical potentiality to the liberatory performance of space. According to Michel de Certeau, "what the map cuts up, the story cuts across."[47] Aztlán is a story, it is not a map. As such, it is based in an Indigenous ontology.

In *Indigenous Storywork,* Jo-ann Archibald (Stó:lō) identifies that "sharing what one has learned is an important Indigenous tradition. This type of sharing can take the form of a story of personal life experience and is done with a compassionate mind and love for others."[48] Aztlán, a site that continually evades a Eurocentric knowledge system embedded in cartographic structures, is embodied in narrative storytelling forms of visuality and performance.

Dwight Conquergood posits that "de Certeau's aphorism . . . points to transgressive travel between two different domains of knowledge; one official, objective, and abstract—the 'map'; the other practical, embodied, and popular—the 'story.'"[49] Telling stories, as Anishinaabe writer Gerald Vizenor maintains, is an active Native epistemology. He recognizes that "the story doesn't work without a participant. There has to be a participant and someone has to listen. I don't mean listening in the passive sense."[50] Both telling stories and listening to them are processes that require active participation.

Moreover, it is at the level of the "story" that Aztlán is performed. We may not be able to locate Aztlán on the colonizer's "modern" maps, but, as artists have done, its stories have permeated Xicano cultural history at all levels. Aztlán is both performed and told as a story. When speaking of the importance of stories, Anishinaabe storyteller Basil Johnston writes that

> Language was a precious heritage; literature was no less precious. So precious did the tribe regard language and speech that it held those who abused language and speech and truth in contempt and ridicule and withheld from them their trust and confidence. . . . Ever since words and sounds were reduced to written symbols and have been stripped of their mystery and magic, the regard and reverence for them have diminished in tribal life.[51]

Stories are a key component to indigeneity, and they are paramount to the continuance of Indigenous sovereignty.

The magic and mystery of Aztlán is not diminished when written and, in fact, its oral performance works directly against Aztlán's mystification. By way of both oral and written narratives, as well as visual art, Aztlán's significance is firmly situated in a space where the precarity of visual language meets the preciousness of the spoken word.

Aztlán speaks to the transformative capabilities that exist within social spaces. Edward Soja writes that "spatiality exists ontologically as a product of a transformation process, but always remains open to further transformation in the contexts of material life. It is never primordially given or fixed."[52]

Aztlán is neither "primordially given or fixed" and, as we have seen, changes over time. In its indeterminacy, Aztlán serves as an emancipatory or utopic space. Xicano performances and stories within this space are likewise not predetermined or permanent. Since Aztlán corresponds to Indigenous notions of spatiality, it is fertile to address how artists perform it and tell its stories. In this creative and artistic fashion, new stories unfold.

Redefining Utopia(s)

As an Indigenous conceptualization of place and governance, Aztlán offers an alternative to progressive models of the nation-state or mass utopianism. In some ways, Aztlán's indeterminacy is more closely allied to More's usage of "utopia" than it is with most contemporary notions of the term. Instead of conceptualizing utopias as hermetically sealed containers within which social relations are maintained without any inter-human strife, Thomas More's *Utopia* did not entirely restrict inequitable social relationships; nor was it purely circumscribed by these social interactions, as occurred in Europe and was subsequently instilled in the Americas.

For More, utopia was not a panacea, as it is commonly understood. Instead, utopias are dialogic and malleable spaces capable of minimizing institutional hierarchies. When addressing the pedagogical implications of utopianism, David Halpin points out that "although social harmony and stability, allied to democratic practice, are the hallmarks of life on Utopia, its society is not entirely egalitarian."[53] Halpin likewise observes that "intellectuals, for example, are excused from normal work-regulations so as to devote their lives to study."[54] Class-based divisions, such as those between manual and intellectual labor, are not the only social stratifications present on More's Utopia. Halpin continues: "Utopia's attitude towards women is patriarchal."[55] Without violating the structural limitations of his own epistemological base, More's *Utopia* preserved traditional class and gender relations, even when describing a slightly improved social order. More was unable to think beyond the social norms of his reality, just as many of us are unable to escape the discursive control of capitalism and settler-colonialism. Whereas we can always look back and condemn colonial practices (which, in fact, we should), the larger structural limitations within which More wrote limited his own prefigurative abilities to see the world. Because Indigenous ontologies do not have capitalist origins, they are ideal sites to think past capitalism and colonialism and their limitations. In this way, Aztlán is an attempt to move beyond coloniality, to borrow from Cheyfitz.

It is difficult for us, as human beings living under global capitalism, to escape the parameters of our respective societies. In turn, we come to utopia, not as it was originally proposed by More, but rather through the pretext of our own experiences under settler-colonialism. These experiences are encapsulated by late-capitalist globalization. In this way, post-1969 articulations of Aztlán are not unilaterally tied to the Mexica Aztlán (as some static pre-Cuauhtemoc manifestation in the twentieth century), but instead Aztlán is informed by centuries of conquest and capitalist expansion, as well as by Indigenous and "mestizo" responses to this colonial project. Nonetheless, conquest and change cannot extinguish Xicano indigeneity

Living in a post-Cold War era of expanding global capital, as we presently do, the contemporary hegemonic battleground has moved away from a well-managed and professionalized war on communism toward current outright wars on terror and immigration. Central to both current wars has been the ongoing attack on Indigenous sovereignty. Using racialist logics and paternalistic governance models, Xicanos and other Native peoples have been stripped of Indigenous rights to self-determination.

Consequently, discussions of utopia commonly conjure the specter of a bygone epoch of outdated and outmoded systems of class politics. For both conservative and progressive political persuasions, utopia signifies the codification of state socialism. Although entirely misleading, this reductionist equation (utopia equals communism) calls attention to the manner that utopian epistemologies and thinking *from* utopic spaces, to appropriate Walter Mignolo's "border gnoseology," remain intellectually marginalized in the present political and intellectual climate.[56]

In "The Politics of Utopia," Fredric Jameson notes that "'utopian' has become a code word on the left for socialism or communism; while on the right it becomes synonymous with 'totalitarianism' or, in effect, with Stalinism."[57] Jameson continues: "The two uses do seem somehow to overlap, and imply that a politics which wishes to change the system radically will be designated as utopian."[58] Effectively, communism (meaning state-run socialism) is part and parcel to totalitarianism and tyrannical governance.

The Chicano Movement, which sought both large-scale reformation as well as the dismantling of capitalism via Xicano sovereignty, is directly compatible with Jameson's typology of utopia. Alicia Gaspar de Alba, in her discussion of the "embodied aesthetics" of Chicana art, maintains that a utopia is "a place that is not a place, an imaginary space occupied by memory and desire."[59] Here, utopic spaces are the receptive sites in which we place certain *radical* imaginaries (past, present, and future). Aztlán is one such place where collective Xicano desires for full cultural citizenship,

self-determination, national liberation, and aboriginal sovereignty are situated and dialogically worked out.

The codification of utopia as (state)socialism must never be its definitive application, a vantage with which Marx himself would agree. Following Darren Webb, Marx was not simply a "utopian thinker," but was pragmatic in his analysis of capitalism. This becomes apparent in the now (in)famous and commonly mistranslated aphorism, the Eleventh Thesis on Feuerbach, in which Marx argues that "the philosophers have only interpreted the world in various ways; the point, however, is also to change it."[60]

According to the Eleventh Thesis, Marx attempted to concretize systemic changes. According to Webb, Marx was not simply a "utopian system-builder," but advocated a complex and nuanced dialectic between theory and practice.[61] In this dialectical and dialogic space, an appropriate translation to the Eleventh Thesis becomes important. By thinking about the dialectical relationship between theory and practice, a form of Freireian praxis, Marx did not position theory and practice in an unmitigated antagonistic relationship. Inversely, this alternative translation maintains that radical theory and practice must simultaneously coexist, in contrast to the preeminence of either unreflective action or "inactive" theory.

With this action-based theory in mind, it is important to note that Marx and Engels rarely used the notion of utopia in their writing. Ruth Levitas remarks: "The term utopia is in fact hardly ever used by Marx and Engels other than as the adjective 'utopian,' generally in the terms 'utopian socialism' and 'utopian communism.'"[62] Yet even if Marx and Engels cannot be properly identified as utopian, they are nonetheless at the core of contemporary utopian discourse. In fact, Marx, Engels, and Thomas More are all central figures in our understanding of Aztlán, if simply because they so thoroughly theorize utopia(s).

So, in this sense, if utopia is about the production of an otherwise unnamed space, either real or imaginary, Marx and Engels were actively involved in the production of utopias, even if they rarely use the term in their own writing.

Marxist literary critic Mikhail Bakhtin believed that all literary genres are dialogic. Various chronotopes (time-space) engage in dialogue with other "texts" without producing a temporal heterogeneity. Likewise, utopias are dialogues between competing and contradictory points of view. From this perspective, utopias are not simply synthetic products, but are the dialectical tension between two competing perspectives.[63] What this means is that utopian spaces and projects are never complete. It is their transitory nature and permanent indeterminacy that makes them utopian in the first

Naming • 73

place. In much the same way that many Indigenous languages focus on actions, while European languages fixate on objects or nouns, so too is utopia embedded in active processes, rather than being passive and object-based. Utopias are always being assembled and function as processes. They are not the final outcome. This is one of the reasons why lowriding, as a process and not a thing, serves as the framework for understanding Xicano sovereignty and this book. By lowriding and participating in slow migrations, movement across time and space becomes the point of this book. *Creating Aztlán* is about the journey, not about the final destination.

Early in his career, Jean Baudrillard worked diligently with the notion of utopia. Even though Baudrillard's later corpus wavers on the absurd, his early texts address emancipatory projects in France. In 1967, alongside such notable French theorists as Henri Lefebvre and Hubert Tonka, among others, Baudrillard helped found the ultra-Left journal *Utopie*. The Utopie group, as the editorial collective was known, interrogated the relationship between post-Marxist theory, direct action, and radical urbanism. In a May 1967 article, "Utopie dialectique," Baudrillard argues that utopias are dialectical and always present in the form of social processes. He writes: "Utopia is the phase of theoretical construction, but it is absolutely indissociable from the other phases and can only exist as part of dialectical utopia. It is through dialectical utopia that we can elaborate, outside and within the present system, an urban thought."[64] For Baudrillard, utopias, or more precisely "dialectical utopias," are always in tension with existing regimes and social structures. This, by and large, is what makes them utopian.

Utopias are not harmonious social orders, but instead serve as "stratified and heteroglot" systems.[65] Static, Western definitions of utopia are inadequate for an Indigenous concept as theoretically fertile as Aztlán. As a matter of fact, most critics and historians erroneously consider utopianism to be a simplistic worldview that hopes to create an idyllic future. Utopias are not innocent. As a utopian site, Aztlán is neither ahistorical nor apolitical. Instead, utopias are dialogic in origin and do not necessarily "reinforce" dominant social norms, but can actually critique and transform them in a dialectical manner. Emerging from Aztlán, Xicanos created a utopia in dialogue with other Indigenous and revolutionary struggles.

Emerging to Give Spirit

For the Mexica, Aztlán and Tenochtitlán were mirror images of one another, the former serving as the place of emergence, the latter becoming

the prophetic site of migration. At the behest of Huitzilopochtli, Tenochtitlán's foundation was initiated by the re-creation of Aztlán in the middle of Lake Texcoco. For Xicanos, a similar storied relationship to Aztlán links Chicano history to the stories of Huitzilopochtli; this is tied to the ongoing polity of Indigenous peoplehood and finally to the legacy of Indigenous sovereignty. As a utopian narrative, Aztlán binds Xicano peoplehood to the hemisphere, what many call Turtle Island, in a way that disavows settler-colonial narratives of Mexican immigration and dismantles colonial epistemic transformations.

As a "call for justice" and "call for nationhood," as Alurista wrote in "The History of Aztlán," Aztlán migrates through multiple time periods, various cosmologies, and multiple signifying systems. Through all of this, however, Aztlán serves to cement Xicano identity in opposition to settler-colonial acquiescence, the myth of mestizaje, and Anglo-American dominance. By reemerging from Aztlán in 1969, Xicanos moved to attain a sense of Indigenous sovereignty that did not conform to recognition from the Bureau of Indian Affairs. Although recognized as an Indigenous people by the International Indian Treaty Council, the first Indigenous nongovernmental organization with consultative status to the United Nations Economic and Social Council, Xicanos never moved to gain recognition from the U.S. government. Instead, choosing to gain recognition from Indigenous communities and nations, Xicano nationhood sought acknowledgment from other self-determined Native nations. Accordingly, Xicano sovereignty is founded in mutual identification with Indigenous nations as an important and crucial aspect of Xicano peoplehood. It does not seek colonial recognition.

Dene political scientist Glen S. Coulthard argues that authentic postcolonial Indigenous governance goes beyond colonial relationships birthed in state recognition of Indigenous sovereignty. The recognition process, controlled by settler regimes, maintains a system of colonial dominance that "rests on its ability to entice Indigenous peoples to come to identify, either implicitly or explicitly, with the profoundly asymmetrical and non-reciprocal forms of recognition either imposed on or granted to them by the colonial-state and society."[66] Inversely, Coulthard maintains that "instead of ushering in an era of peaceful coexistence grounded on the Hegelian ideal of reciprocity, the politics of recognition in its contemporary form promises to reproduce the very configurations of colonial power that Indigenous peoples' demands for recognition have historically sought to transcend."[67] Aztlán, as a model, is significant in the ways that it asserts Xicano sovereignty but does so outside the parameters of settler coloniality.

Xicanos emerged from Aztlán in 1969, following its utterance from the lips of poet Alurista (and professor Jack Forbes). Never fully engaging in the colonial recognition structures, visual artists transformed Aztlán from an ambiguous empty signifier to a tangible articulation of Xicano sovereignty. Couched in radical utopian thought, artists evoked Aztlán in the form of a decolonial visual art. Through Aztlán, Xicanos emerged from the under-world of colonial domination, became a new aboriginal people, and found the dialectics of utopian thought.

Recalling Louis Riel's nineteenth-century prophetic pronouncement, artists, through their creation of Aztlán in the visual world, gave Xicanos back their spirit. Just as Riel prophesized that artists would be the ones giving spirit back to his people, the Michif of the U.S.-Canada borderlands, it is no coincidence that MEChA, the Xicano student movement of Aztlán, employed the motto *"por mi raza habla el espiritu"* (the spirit speaks for/ from my people). Using spirit to speak for the people, artists gave strength to the Xicano people. Aztlán gave that spirit a place and a name.

Feminism as Nationalism

Many Xicano artists are beginning to move beyond the settler-colonial logics of patriarchy and the nation-state. Utopian thought informs this maneuver, while it is based in Indigenous ways of knowing. As we know, the ongoing discourse within the Chicano and American Indian move-ments and their legacies have been riddled with nationalism, sexism, and homophobia. Although much debate surrounding these issues has taken place since the late 1960s, little or no resolution has occurred. On the contrary, the same social problems that faced Indigenous communities in the 1960s remain entrenched in their contemporary struggles. Active and critical reassessments of the Chicano Movement (and its shortcomings) help facilitate the construction of future movements that will not succumb to these same limitations and disappointments. However, it is important to remember that these shortcomings were never universal within the Move-ment or in how Xicanos articulated Aztlán.

Jorge Mariscal still sees the Movement as a site of social transformation, albeit one commonly co-opted by those who attempt to discredit it. Mariscal writes that "'Chicano nationalism' had become the *cucui* or bogeyman. . . . My desire to understand 'nationalism' in a Chicano/a context was piqued when a Hispanic bureaucrat used the term *nationalist* to discredit a group of Chicano/a staff, students, and faculty committed to contesting elitism and

structural racism."[68] He "realized then that the positive contributions of the Movement had become hostage to a scholarly preoccupation with a single ingredient of its complex ideological mixture—the nationalist impulse."[69]

But why is the "nationalist impulse" something to be feared? Can't Xicano sovereignty truly exist? And can't it propose forms of governance outside the limits of the nation-state? In the following section, I briefly discuss the validity of both sides of the debate: the Chicano Movement as a heterosexist, homophobic collective of male desires (which most definitely existed) and the Chicano Movement as a much larger and inclusive internationalism that moves toward Xicano sovereignty.

In his 1971 seminal text, *Chicano Manifesto*, Armando B. Rendón defined *machismo* as the heart of the Chicano Movement, circumscribing the Movement with inequitable gender relations. Although he attempts to remove male-centeredness from machismo, he nonetheless naturalizes machismo as a principle of Chicanismo. Rendón writes: "The essence of machismo, of being a macho, is as much a symbolic principle of the Chicano revolt as it is a guideline for the conduct of family life, male-female relationships, and personal self-esteem."[70] For Rendón, machismo "can no longer relate merely to manhood but must relate to nationhood as well."[71]

In turn, Xicana critics rightfully call this thinking and action into question. Cynthia Orozco argues that "the Chicano movement was a nationalist struggle for the liberation of the Mexican people in the United States, though class struggle was a conscious component among various sectors. It must be clear that this movement did not attempt to end patriarchy."[72] If we turn to Rendón as the example par excellence of the totality of the Chicano Movement, then Orozco's proposition is entirely accurate. However, as I attempt to show through *Creating Aztlán*, if we interweave divergent narratives from multifarious segments of the Movement, then we realize that Orozco's enunciations (and Rendón's machismo) oversimplify the complexities of the struggles for Xicano and Indigenous liberation.

For instance, *El Grito del Norte* was a Chicano Movement newspaper produced in solidarity with the land grant movement in Northern New Mexico. *El Grito*'s cofounder Elizabeth "Betita" Martínez locates the newspaper and the activists involved in the subsequent Chicano Communications Center (CCC) in opposition to the orthodox sectarianism of the August Twenty-Ninth Movement (ATM).[73] She writes:

> For the Chicano movement, ATM adopted Stalin's definition of a nation and affirmed Chicanos were a nation—not just a national minority, as other left formations believed. That position was a major reason, I was

later told, why ATM rejected the bilingual book published in 1976 by the CCC, *450 Years of Chicano History in Pictures* (reprinted later as *500 Years of Chicano History*). The book did not declare Chicanos to be a nation; the CCC people were not yet convinced of it.[74]

It is important to note that Martínez specifically states that CCC was *not yet* considering Xicanos a nation, but in many ways she was preparing to do so. Moreover, ATM adopted a Stalinist perspective on the nation, one at odds with Indigenous nationalisms. Instead of a nationalism based in the nation-state, Xicana feminists developed alternative notions of nation and territoriality in Northern New Mexico. Enriqueta Vásquez was particularly active in this regard.

The views espoused by the editorial collective of *El Grito del Norte* did not argue for an exclusionary ethnic, national identity. On the contrary, the Chicano Movement presented by the writers, artists, and editors of *El Grito* was simultaneously a working-class and feminist movement, and one that used art and cultural production to create radical social change. *El Grito del Norte* was published in Española and Las Vegas, New Mexico, between 1968 and 1973 by a cadre of Xicano and non-Xicano revolutionary activists. The initial founders and editors of *El Grito* were activist Elizabeth "Betita" Martínez and Movement lawyer Beverly Axelrod.

In addition to local insurgents, many activists relocated to Northern New Mexico to create a newspaper in solidarity with the activities of the Alianza Federal de Mercedes (later known as the Alianza de Pueblos Libres). The Alianza was a Xicano organization, identifying as "Indo-Hispano," that fought to recover lands lost through North American swindling, both governmental and private, after the signing of the Treaty of Guadalupe Hidalgo in 1848. The leader of the Alianza was Reies López Tijerina, a working-class evangelical preacher who had conducted missionary work throughout the U.S.-Mexico borderlands. Tijerina arrived in northern New Mexico in 1959 and by 1963, along with working-class nuevomeXicanos, formed the Alianza. Within three years, a critical mass had been reached in northern New Mexico, with over 20,000 Alianzistas in the region.[75] Much like the land-based struggles discussed in the next chapter, Alianzistas rose in arms to regain communally held lands taken by extra-juridical settler-colonial means.

El Grito had a predominately Xicana staff and clearly expressed a feminist vision. Early in the Chicano Movement, *El Grito* published feminist texts written mainly by Enriqueta Longeaux y Vásquez and Betita Martínez. In 1971, Martínez issued a call to action for radical Xicanas,

while simultaneously confronting Movement machismo. In the June 5 issue of *El Grito del Norte* she wrote that

> we must help Chicanas to overcome feelings of inferiority that many have, or feelings that they can perform only certain kinds of work and should not be involved in making decisions outside the home. Unfortunately, these feelings are often encouraged by machos who fail to see that we need *every Chicana and Chicano* in this struggle. Because many men of El Movimiento do this, even men who call themselves "revolutionary," there has been much talk recently about *La Chicana's* role. The fact is, nothing could be more truly Chicana than the Chicana who wants to be more than a wife, mother, housekeeper.[76]

In addition to its anti-macho and pro-feminist stance, *El Grito* operated from a nonpartisan position. According to Betita Martínez, the paper "began in 1968 as a vehicle to support the Alianza. It soon expanded to cover the Chicano movement in urban areas, workers' struggles, and Latino political prisoners, along with a broad spectrum that ranged from the Black liberation movement to Mexican student protest to radical whites."[77] For Martínez, an important goal of the paper was to voice an international, anticolonial solidarity. She continues by stating that it was a "combination of what could be called liberatory or revolutionary nationalism with internationalism [that] made *El Grito* very unusual among the dozens of more nationalist Chicano movement newspapers."[78] This "liberatory or revolutionary nationalism" was in fact very much oriented toward an anarcho-indigenist approach in that it rejected Stalinist rhetorics of nationalism.

Although Martínez maintains that *El Grito del Norte* was a feminist exception to the heterosexist Movement newspapers, a thorough investigation reveals that other Movement publications likewise addressed the crisis of inequitable gender dynamics in the movement or the failures of the Chicano movement(s) to dismantle patriarchy. In March 1971, the feminist publication *Hijas de Cuauhtemoc*, taking their name from a revolutionary feminist press active in Mexico during the 1910s, began publishing a newspaper. According to Ana Nieto-Gómez and Adelaida del Castillo, the editors of *Encuentro Feminil*, another Xicana feminist publication founded in 1973,

> the goal of *Hijas de Cuauhtemoc* was to inform the Chicana about herself through history, by reporting Chicanas' political activities in the communities, and by educating her to the socioeconomic condition that she must

deal with as a woman in a minority culture of an oppressive society. In addition, the newspaper reflected an unrecognized resource—Chicana minds, Chicana creativity, Chicana art, Chicana action, and Chicana obligations. In other words, the newspaper would become a concrete and positive example of combining women's ability and Chicano know-how—Chicana style or more appropriately described as *Chicana Power!*[79]

Although frequently subjugated by machismo, cries of "Xicana Power" were heard across Turtle Island-the Americas. Eminent historian Vicki Ruiz acknowledges the inherent sexism of the Chicano Movement, but subsequently reinscribes this period with the active agency of young Xicanas. "Picking up the pen for Chicanas became a 'political act,'" writes Ruiz.[80] She continues: "Women also founded and edited newspapers—*El Grito* (Betita Martínez); *Encuentro Feminil* (Adelaida del Castillo and Ana Nieto Gómez); *Regeneración* (Francisca Flores); and *El Chicano* (Gloria Macias Harrison). Through their writings, Chicanas problematized and challenged prescribed gender roles at home (familial oligarchy); at school (the home economics track); and at meetings (the clean-up committee)."[81] Of course, these were not the only sites where Xicanas performed an essential responsibility in movement social change. In fact, if we investigate the cultural practices occurring outside the territorial hegemony of the U.S. Southwest, we uncover a plethora of movements where gender dynamics were not as unilateral as "traditional" histories narrate.

According to the mandates of Chispa, a Xicano student organization at Michigan State University, "Chispa's goals have been achieved by making others aware of our bilingual/bicultural attributes, having recognition be given to our real existence, and by reaching out to our brothers and sisters to reach our goal of Chicano Progress through Education."[82] The gender inclusivity—demonstrated by the manner in which Chispa relates to both Xicanas as sisters and Xicanos as brothers—reveals an awareness of the complexities of race, class, and gender operating within the Xicano community, particularly outside the Southwest. In fact half of the *Voces del Norte* editorial committee, a "Raza Art and Literary Journal" also published in Michigan, were women.[83] While this definitely does not assume a feminist or gender-equitable agenda, it does begin to problematize the assumptions that most Movement publications were "narrow nationalist" or that "nationalism" denotes an a priori homophobic, sexist, and myopic politics.

On the contrary, the Xicano nationalisms that developed in the Chicano Movement were highly nuanced and extremely complex, while not entirely unproblematic in their political and cultural practices. Of course, there

were overtly sexist, homophobic, and insular factions of the movement, not to mention those that were more masked in their reproduction of patriarchy. However, significant numbers of organizations and movements were also aware of the direct relationship between gender oppression and the larger capitalist and settler-colonial subjugation of Xicanos. When discussing the iconography of the Chicana/o movement and the 1968 student movement in Mexico City, queer sociologist Edward McCaughan writes that these divergent factions "inevitably revealed the contradictions of class, race, and gender within the movements."[84] Nonetheless, McCaughan is cognizant of, as Karen Mary Dávalos asserts, "the mandate of nationalism."[85] That is, "the ideologies that make nationalism a success, specifically, patriarchy, homophobia, and essentialist visions of 'race.'"[86] Inversely, this Western nationalism, with its focus on the nation-state, is countered by many Native and Xicana feminists, who see this distinction as a manifestation of colonialism. Onyotaa:ka (Oneida) sociologist Lina Sunseri articulates an Indigenous nationalism that is feminist in orientation. For Sunseri, "Aboriginal women have had an important role in the 'national' struggle and their roles have not been free of contradictions and obstacles. Colonization of the Americas ultimately transformed all structures, including Aboriginal gender relations."[87] Furthermore, Queer Xicana poet Cherríe Moraga localizes nationalism within the Chicano Movement when she writes that

> the nationalism I seek is one that decolonizes the brown and female earth. It is a new nationalism in which la Chicana Indígena stands at the center, and heterosexism and homophobia are no longer the cultural order of the day. I cling to the word "nation" because without the specific naming of the nation, the nation will be lost (as when feminism is reduced to humanism, the woman is subsumed). Let us retain our radical naming but expand it to meet a broader and wiser revolution.[88]

Through their Indigenist and feminist nationalisms, both Sunseri and Moraga adhere to certain anticolonial and Indigenous frameworks that conflict with Western patriarchy, colonial practices, and settler-colonial nationalism. As Moraga makes clear, her heterodox, queer, and feminist form of nationalism places the Indigenous Xicana (who she names as "la Chicana Indígena") as the center of the world or axis mundi.

Along these lines, McCaughan "begins to reveal the role of art in shaping and projecting the then emerging politicized identity of those who saw themselves as part of the Chicano movement."[89] McCaughan goes on to argue that one-fifth of Movement visual expressions were feminist in scope.

For him, these images explicitly functioned to abolish "patriarchy and machismo."[90] If twenty percent of the visual expressions produced as part of Chicano Movement incorporated "feminist imagery," as McCaughan contends, it is hard to entirely codify the Movement as a site of heterosexist "nationalism."[91] Although one-fifth of the Xicano visual culture analyzed by McCaughan is a small percentage of images to specifically address feminist issues, especially since over one-half of the population is female, it begins to demonstrate that these issues were actively debated and challenged during the Movement.

In "Revolutionary Sisters," Dionne Espinosa investigates the complex role of Xicana Brown Berets in East Los Angeles. She uncovers that Xicanas

> began to interpret that position in a way that, on the one hand, incorporated the expected identity role—which at times made them appear to have accepted a subordinate position—and on the other hand, also began to revise those expectations to support their identities as Chicana revolutionaries.[92]

The Chicano Movement was a course in which multiple social identities were constructed and contested in a way that facilitated the utopian creation of Aztlán. As we look back at the failures of the Movement, homophobia and heterosexism definitely protrude as main faults of the period, just as they persist today.

On the contrary, as Jorge Mariscal asserts, "'narrow and chauvinistic nationalism' certainly existed in many Movements' organizations but its meaning was widely disputed and its predominance rarely unchallenged so that it often was forced to compete with the inclination to build international and domestic coalitions."[93] In the end, Aztlán and its creation in the art of Chicano Movement artists were always dialogic (and, as I attest, utopian). Through the process of lowriding we are not stuck in one simplistic Aztlán but can travel across many.

CHAPTER THREE

Claiming

Claiming Art, Reclaiming Space

When Indigenous and colonized people engage in cultural reclamation and language revitalization, there is often a concern that these efforts can become a form of fundamentalism. The history of decolonization movements shows, as pointed out by figures like Frantz Fanon, that this is one of the pitfalls of decolonization. In *X-marks: Native Signatures of Assent*, Anishinaabe theorist Scott Richard Lyons calls into question the actions of those individuals he names "Culture Cops," Native fundamentalists who attempt to circumscribe and control Indigenous identities and cultural practices. For Lyons, Native communities should be weary of these "enthusiastic reclaimers of culture, often young, male, and educated, frequently with urban roots, who straddle a fine line between supporter and condemnation in the name of cultural revival."[1] He continues on, maintaining that "like elders, they passionately believe in the power and worth of traditional culture but they possess a certain inflexibility and zeal that one doesn't often encounter with elders."[2] This is a concern shared by, among others, anticolonial thinkers like Fanon and Aimée Césaire.

In many ways, the Native fundamentalists that Lyons thoughtfully writes against are similar to the Xicano activists who have been deemed "narrow nationalists." Lyons writes that "sometimes revivals can deny the hybridity and interactions inherent in cultures."[3] He adds that "cultural revivals can

Claiming • 83

actually work against the positive self-esteem that one would reasonably expect to result from the proud reclamation of traditions. This can happen when cultural elites emerge and relentlessly 'correct' their peers or decry certain cultural forms as 'inauthentic.'"[4] Lyons's desire to move beyond fundamentalism is valuable and timely. For many federally recognized tribal nations, cultural essentialism and blood quantum, mixed with ongoing settler-colonialism, have had dire effects on the ability of Indigenous communities to self-determine.

However, in contrast to the ways American Indian fundamentalists are seen as denying "hybridity" among Native cultural practices and political processes, I believe the inverse has become the fundamentalism in Chicano studies. Accordingly, mestizaje and hybridity have become its new fundamentalism (even if its practitioners may likely deny this).

In the place of reclamation is commonly the veneration of mixedness and transculturation. This means refocusing on mestizaje, not as the reality of violent and institutionalized colonization or systematic detribalization (as I understand it), but as a form of anticolonial and poststructural ambiguity. Although I find significant faults in evoking mestizaje as an anticolonial modality, or even as a form of identity itself, Lyons's warning against Indigenous fundamentalism—and the ways that colonized societies are just as apt as colonizing ones to create exclusionary social practices—is warranted. We must be cautious about all fundamentalisms, even when notions of "hybridity" become fundamentalist.

As we engage with Xicano indigeneity and the ways that artists have created Aztlán within their work, it is crucial to recognize that the artists in this text are not fundamentalists vis-à-vis Aztlán. Instead, they individually and collectively employ Aztlán and its relationship to Xicano indigeneity as a powerful anticolonial modality. Likewise, we must be cautious in understanding this fine line between reclamation and idolatry and clear that our desire to reclaim Xicano indigeneity and sovereignty does not create a new orthodoxy.

With this in mind, this chapter investigates notions of art and culture, as well as the related links between citizenship and the nation-state. These discussions are then linked to subsequent conversations on Chicano art, especially muralism, and the ways that, by claiming art as a critical component of Xicano identity, artists and activists reclaim colonized spaces and affirm sovereignty. I end "Claiming" with a discussion on writing about Chicano art. This historiographical conversation is crucial to *Creating Aztlán* because it places the book, as well as the ideas within it, into larger intellectual trends and themes. *Ándale*, let's continue lowriding.

Aztlán, Culture, and Citizenship

Art and visual culture have been at the core of Chicano Movement activities and must be analyzed without alienating them from their quintessential political radicalism. Functioning counter-hegemonically, the Movement was largely a critique of and opposition to U.S. settler-colonialism and its ongoing processes of colonialism, capitalism, and Manifest Destiny. As I have shown in previous chapters, Aztlán, as initially produced in El Plan Espiritual de Aztlán, was an overtly political project with broad national, international, and indigenist intentions. For many Xicano activists, Aztlán demonstrates that the Chicano Movement was about the construction of Indigenous sovereignty and "cultural citizenship," in solidarity with global resistance movements.[5]

Writing from San Diego, *"el ombligo de Aztlán,"* in 1971, Alurista wrote:

> In the end, the Liberation of Chicano Land and the Unification of Pueblos Libres; the liberation and unification of Aztlán will integrate Earth's Community of National Independence without physical or spiritual borders to divide it. . . . The Chicano Struggle for National Liberation from Northamerikan Colonization is not alone on earth, China, Vietnam, Cambodia, Chile, Cuba and all National Liberation Fronts rally to the sacrifice of Tezcatlipoca.[6]

For Alurista, the creation of Aztlán is about solidarity building with other Third and Fourth World nationalisms or peoplehoods. Xicano sovereignty is relational with other sovereignties. As Quetzalcoatl's opposite, Tezcatlipoca is the *teotl* (spirit or deity) often associated with the Smoking Mirror. In one version of the Mexica creation story, Tezcatlipoca is Quetzalcoatl's eternal enemy who turns himself into the sun, only to be knocked from the sky during an epic battle. Alurista envisions Tezcatlipoca as all that is wrong with capitalist society. He must be sacrificed for the sake of humanity. Pre-Cuauhtemoc thought is employed to counter Western capitalist ideals.

Furthermore, as Xicano artists clearly articulate in their manifestos—such as the one written by Malaquías Montoya and Lezlie Salkowitz-Montoya—artistic practice is linked to the social construction of identity. As Xicano artists were rightfully aware, art and culture are at the core of what makes us human.

This is exactly what Alurista articulates when he writes that "Northamerika is at war not with 'communism,' 'socialism' or even 'heathenism,' it is at war with the humanization of the species and the elemental forces of the earth."[7] From an Indigenous perspective, to be human is to have an

intimate relationship with nonhuman beings and spirits, as well as with sacred land. For Alurista, as with other Xicano artists, "Northamerikan" capitalist colonization retards Xicano development and disavows Indigenous humanization. As he writes elsewhere, "Xicanos were not quite as human as Anglo-Americans. Since they were not considered quite as human, the correlate notion that Xicanos did not merit the same treatment under the law . . . was simply the logical extension of white . . . male supremacy."[8] Alurista proposes that the Chicano Movement, especially its projection of Aztlán, contrasted with North American patriarchal settler-colonialism in a way that fully humanized the colonized and exploited people of Aztlán.

Since culture and artistic practices play a foundational role in Alurista's humanization and liberation projects, we must spend some time conceptualizing culture. Of course, our definitions of culture must never be prescriptive, as Lyons warns us. Instead, defining culture becomes a complex project because it is a term that anthropologists, literary critics, cultural theorists, and art historians define in different and, at times, contradictory fashion.

Raymond Williams, author of the seminal *Keywords: A Vocabulary of Culture and Society*, affirms that "culture is one of the two or three most complicated words in the English language."[9] This is highlighted in Andrew Edgar's entry in *Key Concepts in Cultural Theory*. Edgar writes that culture "entails recognition that all human beings live in a world that is created by human beings, and in which they find meaning. Culture is the complex everyday world we all encounter."[10] Edgar presents a Western, anthropocentric perspective on culture, one that Indigenous societies would find fault with.

Anthropologist Clifford Geertz offers a structuralist definition of culture. He writes that "as interworked systems of construable signs . . . culture is not a power, something to which social events, behaviors, institutions, or processes can be causally attributed; it is a context, something within which they can be intelligibly—that is thickly—described."[11] In much the same way that Geertz writes that cultures are "interworked systems of construable signs," Stuart Hall maintains that culture is an entirely indeterminate *process* and therefore produces meaning through its codifiability. Hall views all cultural expressions as "popular." He writes that "popular culture is one of the sites where this . . . struggle for and against a culture of the powerful is engaged: it is also the stake to be won or lost *in* that struggle. It is the arena of consent and resistance."[12]

For Hall, culture, much like utopia, is an indeterminate and contestable process. In *Culture and Truth*, Renato Rosaldo writes that culture (delegated to *culturally* marginalized Others) and citizenship (associated with the dominant social classes) are frequently at irreconcilable odds. Traditionally, culture is the status of women, the colonized, Indigenous peoples,

and working classes, while art (only available to citizens) is associated with privilege. As Rosaldo makes clear, "people in metropolitan centers classify them [elites in the peripheries] as civilized, in contrast with Indians and cultural minorities, who are cultural, not 'rational.'"[13] From this dominant perspective, as an Indigenous people, Xicanos have culture but lack art and citizenship. In response, this book intentionally discusses Chicano art and Indigenous sovereignty, both categories that seem to exclude indigeneity, at least from the perspective of those "people in metropolitan centers."

Culture, as irrationality, contrasts with the rationality of citizenship.[14] In this sense, problematizing an outmoded anthropological definition of culture, Rosaldo contrasts those who have culture with those who maintain full status as citizens. The challenge for the Chicano Movement became, then, how do working-class Xicanos, as an Indigenous people, maintain their "culture," while also claiming their rights as citizens of a settler-colonial nation-state or, at times, asserting their own Indigenous sovereignty? This was one of the dualistic and antagonistic capacities of Aztlán.

It was through the interstices of an unconcealed radicalism and re-evocation of Indigenous presence that Xicanos positioned themselves as citizens of both the United States and their own sovereign nation, Aztlán (even if they were not fully recognized as either citizens or as "Indians" by the BIA, harkening back to Glen Coulthard). Today's ongoing immigration discourse demonstrates how Latino migrants and immigrants are deemed "illegal" and therefore lack the rights of U.S. citizens.

Aztlán enabled Xicanos to exercise their rights as citizens whose existence pre-dates the formation of the United States nation-state, while also asserting Xicano sovereignty. This project of explicating both Xicano indigeneity and U.S. citizenship, however, is incomplete, as can be seen through ongoing anti-immigration legislation and anti-Latino educational reform (such as English-only legislation, President George W. Bush's discriminatory No Child Left Behind act, or the ongoing anti-ethnic studies legislation in Arizona). With citizenship still uncertain and recognition by the Bureau of Indian Affairs doubtful, Xicano activists reinvigorated Aztlán as the base to establish legitimacy to citizenry claims.[15]

By addressing the cultural-turned-artistic practices of the Chicano Movement, we explore how and why artists and activists embraced Aztlán. In the edited volume titled *Latino Cultural Citizenship: Claiming Identity, Space, and Rights*, William V. Flores and Rina Benmayor, and authors from the Latino Cultural Studies Working Group, expand Rosaldo's concept of cultural citizenship. For Flores and Benmayor, "cultural citizenship names a range of social practices which, taken together, claim and establish

a distinct social space for Latinos in this country."[16] Whereas I rhetorically understand the desire for Latinos to establish their cultural citizenship in the United States, as an Indigenous people Xicanos emphasize their right to something else: sovereignty.

Cultural difference and citizenship, traditionally constructed as binaries, are not opposed. Instead "difference [can be] seen as a resource, not as a threat."[17] Cultural practices and artistic production recurrently enter the realm of the political, addressing issues of sovereignty, difference, and citizenship. For Xicano and other Indigenous artists, art-making affirms and galvanizes Indigenous political, social, and intellectual sovereignty. George Lipsitz has acknowledged that Chicano art was not simply about "community-based art-making," but that the production of visual and performative art necessitated a form of "art-based community-making."[18] Above and beyond culture, art builds community and, by extension, helps Indigenous nation-building. Through the process of making art, artists create Aztlán. But as colonized and detribalized people, Xicanos are seen to have culture and not art.

As Arnold Hauser makes apparent in *The Philosophy of Art History*, "neither the public of folk art nor that of popular art is able or willing to treat art as art."[19] By arguing that the folk and popular classes produce art as merely culture, Hauser affirms the status of non-elites (makers of folk or popular art) as noncitizens. If art-making and citizenship are mutual, then citizenship, either of an autonomous Indigenous nation or of a colonial nation-state, is predicated on the humanistic ability to make art. To make art is to possess citizenship. To make Indigenous art is to give spirit to your people. Art, Aztlán, and sovereignty go hand in hand.

In 1981, Alurista went against narrow nationalist practice by clarifying that "'Aztlán belonged to those who worked it' (not only to Xicano workers)."[20] This radical proposal can be seen across Turtle Island-the Americas, where sovereign Indigenous nations are moving away from blood quantum as the only marker for tribal enrollment and toward citizenship. Aztlán simultaneously helps formulate and problematize Xicano culture, both in the United States and as a sovereign Indigenous entity. Aztlán helps us move beyond colonial ways of using biology as the only category of asserting aboriginal belonging.

Culture, Custom, and Traditionalism

In addition to the tension between sovereignty and cultural citizenship, the reorganization of Xicano and Native artistic and cultural projects were

driving forces for the Chicano and American Indian movements. Although certain factions were retrograde in their desire to return to a fundamentalist precolonial and pure past, most anticolonial Indigenous projects embrace contemporary forms while referencing precapitalist practices. Rarely are artists naïve enough to return to a fictive past. As creative thinkers, artists help envision more open and egalitarian worlds, instead of closing them off in doctrinaire ways. Even when evoking precolonial modalities, most artists acknowledge their own role in constructing a new world, one couched in utopian visions.

Accordingly, anticolonial Indigenous art is the dialectic between non-Western aesthetic forms merged with contemporary artistic programs. This synthetic application of divergent signifying systems presents us with an alternative to the false binary between "tradition" and "modernity" (also challenging more recent notions of "contemporaneity"). Xicano artists of the 1960s and 1970s knew this and used it to the advantage of their community. Tomás Ybarra-Frausto notes that "the linkage of indigenous thought to contemporary reality gave the Chicano movement mythic and psychic energies that could be directed toward its political and economic goals."[21] Ybarra-Frausto proposes an engagement with Indigenous history that finds an analogy in the quotidian philosophy of the Aymara, an Indigenous society from the Andes and Antiplano region of South America. For the Aymara, "*Qhiparu nayraru uñtas sartañani.*" That is, by looking back, we will move forward. This revolutionary way of thinking, employing the double meaning of revolution, goes against Western linear thought. In addition, since we have been thinking about lowriding, we can envision how the revolutions of a bicycle's wheels are needed for the bike to remain in motion. Revolutions are needed to maintain order.

Looking into Indigenous histories, while moving forward, Aztlán conceptualizes time in a circular fashion that connects otherwise disparate times and peoples, linking Xicanos with the Aymara of the Andes and Anishinaabeg of the Great Lakes. By lowriding, we can slowly and intimately relate to one another. Our stories are all connected. Moreover, these continental Indigenous connections are crucial.

Xicano and Native activist-artists frequently employed a Fanonian approach to cultural expressions. According to Fanon, "Culture has never the translucidity of custom; it abhors all simplification. In its essence it is opposed to custom, for custom is always the deterioration of culture. The desire to attach oneself to tradition or bring abandoned traditions to life again does not only mean going against the current history but also opposing one's people."[22] What Fanon indicates is that culture is a changing

system of signification in which meaning is established based on its particular social context. Therefore, the meaning of "traditional" practices during the 1960s and 1970s was quite different than those "traditions" as they were practiced prior to settler-colonialism or during the nineteenth century. Artists of the Chicano Movement played with images to both exploit and challenge the dominant reception of Indigenous visuality. In fact, the changing function of Aztlán is part of the living and active qualities of culture, not the stagnancy of custom.

Certain symbols easily understood by the Anglo-American imaginary as "Indian" or "Mexican" (often using the politically correct parlance, Hispanic) were constantly evoked, albeit critically, within Chicano art. By doing so, artists likewise altered the meaning of these objects. Moreover European forms, styles, and materials were regularly incorporated into cultural expressions (such as community murals), even if the overall theme and message of the visual text was an overt critique of Euro-American hegemony.

The artists that emerged during the Chicano Movement, such as those discussed in part two of this book ("Tlapalli"), demonstrated a transitional movement in Xicano life. Re-interpretation of "traditional" knowledge and culture became a contested site for many activists. After all, what constitutes "tradition" is in fact the isolation of the cultural practices of one particular time period. Taiaiake Alfred (Kanien'kehá:ka) points out that "we must acknowledge the fact that cultures change" and are not stagnant pools that never drain.[23] Instead, notions of tradition, modernity, and culture are processes that require reflection and critique. As such, artists engaged in Indigenous cultural and spatial reclamation must acknowledge the process of colonialism and its harmful effects on colonized communities. If we do not recognize this, we are becoming the fundamentalists that Lyons fears.

Instead of fundamentalism, Indigenous art and culture are not isolated categories for the simple reproduction of ethnic identity. Again, Alfred recognizes that traditionalism "demands cultural give and take with nonindigenous people—respect for what both sides have to contribute and share."[24] Moreover, "tradition" must always be contested and questioned. It is not an a priori expression that must be rediscovered through a progression called decolonization; rather, like utopias, traditionalism is a contested space. Traditions are dialogic. For Howard Adams (Michif), a dismissal of modernity and contemporaneity (and an alignment with tradition) is a failure to recognize one's true potential.[25] Correspondingly, Adams asserts: "The idea that a return to traditional Indian customs and worship will free us from the shackles of colonial domination is deceptive—a return to this kind of traditional worship is a reactionary move and leads to greater oppression,

rather than liberation."[26] In this way, the practice of Indigenous spiritual and cultural lifeways means little if it is not linked to counter-hegemonic political and aesthetic projects. It means nothing without sovereignty. As we will see in the following three chapters, artists intellectually vacillate between these two poles, opening up new potentialities in the process. Aztlán's potency is grounded in its ability to navigate all these spheres.

On Violence and Reclamation

One of the most successful strategies of Indigenous resistance during the late 1960s and early 1970s was that of reclamation. Aztlán is one of these reclaiming projects. In an attempt to counter the legacy of social and economic marginalization, American Indian and Xicano activists initiated the long and arduous process of decolonization by (re)claiming their own histories, identities, and Indigenous social structures.[27] It is important to note that in *Decolonizing Methodologies: Research and Indigenous Peoples*, Linda Tuhiwai Smith (Maori) places "claiming" as the first of her "Twenty-Five Indigenous Projects," even if she argues they appear in no particular order.[28]

By claiming and reclaiming, Xicano and American Indian activists preceded Smith by nearly three decades. Employing direct action tactics, Brown Pride and Red Power activists recurrently avoided the employment of physical violence. When violence was used, it was primarily Indigenous defense against state violence, which gave settler governments an excuse to escalate the deployment of violent state repression. Nonetheless, violence was habitually avoided by Indigenous activists. Regardless, the role of violence and its function in the anticolonial struggle is one addressed by Frantz Fanon.

Fanon, the Martinique-born psychologist and anticolonial freedom fighter, maintains that decolonization is by necessity a "violent" act, although one enacted through acts of compassion. In his seminal text, *Wretched of the Earth*, Fanon asserts that "national liberation, national renaissance, the restoration of nationhood to the people, commonwealth: whatever may be the headings used or the new formulas introduced, decolonization is always a violent phenomenon."[29] For Fanon, the extermination of an oppressive colonial system is inevitability an antagonistic and therefore violent undertaking. To dismantle a violent system, violence is the unfortunate result.

Although critics have long debated the significance of Fanon's "violence," in this context I apply it to mean a radical shift, one that utterly

transforms the racist and patriarchal nature of settler-colonialism. Living in an era when new juridical definitions criminalize "attacks" on nonliving objects as acts of violence, any discussion of violence becomes contentious. While I do not generally advocate violence, I believe that the specter of armed resistance by Indigenous communities can be justified, as the Oka Crisis (Canada, 1990), Zapatista Insurrection (Mexico, 1998) or Elsipogtog (Canada, 2013) demonstrate.

Immanuel Wallerstein's reading of Fanon is important to consider. Wallerstein asserts that "the idea that fundamental social change never occurs without the use of force was not a new one. All the radical emancipatory traditions of the nineteenth century had believed that the privileged never cede real power voluntarily; power is always wrenched from them."[30] He continues, stating that "therefore, the use of violence, not as sociological analysis but as policy recommendation, was coming into question."[31]

Across Turtle Island-the Americas, this "revolutionary" transformation occurs when Third and Fourth World peoples dispose of settler-colonialism and replace it with community sovereignty and self-determination. What happens after, however, is entirely unknowable, provoking fear within the status quo and its settler-colonial support system.

For those in power, these revolutionary Indigenous actions are viewed as inherently "violent" deeds. By way of this interpretation, violence does not necessarily imply an action that results in human injury, but one in which individuals collectively demand their rights and the ability to control their own social environment.[32] As the Black Panthers asserted in 1968, "We do not claim the right to indiscriminate violence. We seek no bloodbath. We are not out to kill up white people."[33] For Indigenous anticolonial struggles of the twentieth and twenty-first centuries, violence was a last ditch response to impending settler-colonial state violence. According to American Indian Movement documents, the organization's "role has been a peaceful one, to work within the system toward its goals, unless pushed by counterforces into a militant stand."[34] Following the global implications of 1968, Indigenous nations no longer allowed settler-colonial governments to violate their sovereignties.

Nonetheless, the Black Panthers, Brown Berets, and AIM were respectively represented by and in the mainstream media as inarticulate, gun-toting thugs out to wreak havoc on all members of white society. As history clarifies, nothing was further from the truth, as the Panthers were in fact made up of university students, many with advanced degrees. MEChA, the Brown Berets, and AIM were more interested in establishing community-based projects than in direct confrontations with settler-colonial power.[35] For

Fanon, as well as for AIM and the Brown Berets, violence was the process of anticolonial recuperation, not the process of engaging in direct bodily harm against settler society. Unfortunately, the latter definition has been applied within mainstream historical accounts to obscure the objectives of Xicano, other Indigenous, and anticolonial movements. These inaccurate histories disregard colonial structural violence and instead fixate on isolated instances of counterviolence, as if these instances were the rule.

Anticolonial reclamation, following the ideas of Fanon, was not simply a return to some fictive precolonial past. Rather Black, Xicano, and American Indian groups reconstructed and molded new social and ontological systems based on the realities of their own lived experiences. Of paramount importance to this struggle was the recuperation of colonized spaces, both literal and metaphorical. After centuries of forceful placement in racialized ghettos, barrios, and on reservations, the late 1960s saw Third and Fourth World peoples rise up in new modes of resistance.[36] The Vancouver-based Native Alliance of Red Power (NARP) utilized a five-point program for self-determination. Their document parallels similar programs developed by the Black Panthers and the Young Lords, a Boricua organization in New York City. For NARP:

Red Power is the spirit to resist
Red Power is pride in what we are
Red Power is love for our people
Red Power is coming together to fight for liberation
Red Power is Now![37]

After centuries of oppression, assimilation had taken its toll on Indigenous communities and, beginning in the 1960s, radical approaches dismantled settler-coloniality. In many ways, these radical movements differentiated themselves from mainstream civil rights groups of the period. Donna Hightower Langston names these newly formed anticolonial movements in the United States as "power groups." She posits that "power groups responded to the limits of civil rights groups with more radical rhetoric and actions. Numerous Power groups advocated Black Power, Brown Power, Red Power, and Radical Feminism."[38]

Feminist Haunani-Kay Trask (Kānaka Maoli) maintains that Indigenous rights differ from the rights of other colonized people. In *From a Native Daughter*, Trask writes: "Our daily existence in the modern world is thus best described not as a struggle for civil rights but as a struggle against our planned disappearance. For example, in the United States, the 'vanishing

Indian' has steadfastly refused to vanish, resisting all manner of genocide."[39] It is important to recognize that during the Red Power and Brown Pride period, frequent dialogue pushed the Movement's agenda. As primary documents attest, "AIM's presence is a direct response to a call from the Indian people, and AIM will shoulder the blame, deserved or not, for political actions by Indian people."[40]

While African Americans in the South were legally relegated to spaces demarcated as being for "coloreds," the same occurred to Xicanos across the U.S. Southwest and other Indigenous people throughout Turtle Island-the Americas. Although the individual subjugations of Blacks, Xicanos, and American Indians were ultimately distinct in their ethnohistorical specificity, they collectively disclosed many of the same root causes and encounters. For Xicanos, forced segregation frequently turned violent through acts of mob "justice." According to historians William D. Carrigan and Clive Webb, "the danger of lynching for a Mexican resident in the United States was nearly as great, and in some instances greater, than the specter of mob violence for a black person in the American South."[41]

Native people also faced this threat, bearing the brunt of this country's largest mass execution, in 1862, when thirty-five Lakota were hanged on a single day. While Anglo-Americans attacked Blacks and Xicanos, the suppression of tribal communities was much more pervasive, occurring at the base of Native societies through legal, religious, and educational endeavors. U.S. and Canadian federal policies against First Nations and American Indians were ones of complacency and manipulation. Ward Churchill maintains that the federal government, backed by the rulings of the U.S. Supreme Court, reserved the right to encroach and seize Indian land without repercussion.[42] In addition to the physical disenfranchisement of Native peoples and the criminalization of Indigenous ceremonies, church- and state-operated boarding schools advanced policies that "traditional" Indigenous practices were illegal — unless Native peoples coalesced to hegemonic demands for proper behavior. By the mid-1960s, these violent acts against Native people were still common. In response, young urban Indians (including Xicanos) saw the need for renewed confrontations with U.S. hegemony and settler-colonialism. AIM, NARP, and organizations with similar ideologies advocated for the basic rights of American Indian and Xicano people.

Sharing analogous experiences of racialized violence in the United States, civil rights-era power struggles among Blacks, Xicanos, and American Indians likewise shared many of the same methodological approaches and direct-action tactics. The most common shared practice was the reclamation of space and cultural identity, a decolonizing methodology according to Smith.[43]

Reclaiming Native Spaces

In October 1967, leaders from the Xicano, American Indian, and Black Power movements met in Albuquerque at the inaugural convention of the Alianza Federal de Pueblos Libres, a northern New Mexico organization that rose in arms to demand access to appropriated communal Xicano lands near Tierra Amarilla.[44] The list of attendees was impressive and indicates the significance of Third and Fourth World alliances during this period. Attendees included Hopi elder Thomas Banyacya, SNCC leader Ralph Featherstone, United Slaves' Maulana Ron Karenga, and Alianza leader Reies López Tijerina, among countless others.

Transpiring in the "Heart of Aztlán," much of the conference was conducted in Spanish. Ralph Featherstone led a chant for "*poder negro*" (Black Power), while Ron Karenga made statements of solidarity in Spanish. At the conclusion of the two-day event, all groups in attendance signed an agreement of "Peace, Harmony, and Mutual Assistance."[45] With the title outlining the main precepts of the document, it is clear that both solidarity and the recovery of a sense of belonging fueled much of this mutual aid. In addition to creating networks with other Third World radicals, American Indian and Xicano sovereignty was predicated on a relationship with the land.

From the armed struggles at Wounded Knee to the courthouse raid in Tierra Amarilla and from the establishment of autonomous community centers to the popularity of community murals in urban centers, a sense of place was at the core of both the Chicano and American Indian movements. Xicano literary historian Rafael Pérez-Torres maintains that "land lies at the heart of the Chicano movement."[46] But one's relationship to the land depends on one's local environment. For instance, Indigenous connections to land are quite different for a Xicana in East Los Angeles or an urban Anishinaabeg in Minneapolis than for a rural nuevomeXicana in northern New Mexico or for a Hopi living at Wàlpi or First Mesa. How then, did the Chicano and American Indian movements address the issue of land and territoriality within their struggles to regain their traditional lands, if at all?

First and foremost, Indigenous struggles took the form of reclamation. Although some communities and activists struggled to attain acceptance into mainstream "American" society, many within these movements labored for collective self-determination and sovereignty. All facets of communal governance, from local political decision-making to the production of alternative education systems and curricula, were recuperated as a tactic to combat the long process of Anglo-American colonialism. Langston writes that the Red Power movement differed from struggles within the Black

community in that Native peoples were not seeking the end of segregation and the acceptance by whites, but rather requesting the termination of settler-colonial and racist federal policies that stripped them of their legal rights and sovereignty.[47] Appropriately, she writes that "one major difference was that their focus was less on integration with dominant society, and more on maintaining cultural integrity. While African Americans had been denied integration, American Indians had faced a history of forced assimilation."[48] Moreover, she continues arguing that a "central focus of their activism was on gaining enforcement of treaty rights, not civil rights."[49] Xicano history integrates a complex mixture of both experiences, including forced assimilation and racialized segregation. In turn, the Chicano Movement was both about asserting Indigenous sovereignty and gaining civil rights as U.S. citizens. This is particularly true in how many Xicanos evoked the Treaty of Guadalupe Hidalgo and affiliation to the *mercedes* (or land grants) as aspects of Indigenous title.

Aboriginal or Indigenous rights campaigns (including the Chicano and American Indian movements) are not generally built around individual civil rights, but on collective communal empowerment. The shared rights of Indigenous people can be seen in the 2007 United Nations Declaration on the Rights of Indigenous Peoples, which uses the term "collective" on four separate occasions. According to the preamble: "Recognizing and reaffirming that indigenous individuals are entitled without discrimination to all human rights recognized in international law, and that indigenous peoples possess collective rights which are indispensable for their existence, well-being and integral development as peoples."[50] As can be seen in the remainder of the Declaration on the Rights of Indigenous Peoples, the focus on Indigenous rights emphasizes their collective nature.

Collectivity and Indigenous self-determination also appear in the proclamation issued by the Indians of All Tribes or in El Plan Espiritual de Aztlán. According to Howard Adams (Michif), self-determination and sovereignty begin at the local level and subsequently develop into a national identity. He asserts that, "beginning at the neighborhood level, nationalism helps to unite the social actions of native people through mass participation, and therefore grows naturally from the struggles of the people, not from indoctrination through ruling-class ideology. Radical nationalism is created by the people, who, by participating in the struggle, make the nation a reality to everyone, and, in turn, make the nation part of their personal experience."[51] Indigenous sovereignty does not need the recognition of settler-colonial jurisprudence. Rather it comes organically from the community and the participation of Native people.

While "nationalism," especially in academic circles, conjures up notions of right-wing despots moving toward fascism, the same is not true for Indigenous and anticolonial nationalisms. Corky Gonzáles, leader of the Crusade for Justice, a Denver-based Xicano organization, told *La Voz del Pueblo* that

> if you take the definition of socialism or communism, or any one of those "isms," they are defined by white Western European ideology. The only difference is that your definition can be the same if you go back to "communism" or "familyism" or "tribalism" — because it relates to the same thing. It relates to sharing. It relates to the people controlling the state and not the state controlling the people. . . . If you want to relate what we're doing, Chicanismo, as socialism — fine.[52]

Abenaki scholar Lisa Brooks proposes an Indigenous nationalism. In "Afterword: At the Gathering Place," in *American Indian Literary Nationalism*, Brooks writes that

> I have a different kind of nationalism in mind, which I hope lies in concert with the calls of those within: a nationalism that is not based on the theoretical and physical models of the nation-state; a nationalism that is not based on notions of nativism or binary oppositions between insider and outsider, self and other; a nationalism that does not root itself in an idealization of any pre-Contact past, but rather relies on the multifaceted, lived experiences of families who gather in particular places; a nationalism that may be unlike any of those with which most literary critics and cultural theorists are familiar.[53]

For Indigenous women, this critique of nationalism becomes even more complex because, as women, they must also commonly combat their exclusion from mainstream white feminism, as well as fascist nationalism and settler-colonialism. Of course, neither Indigenous feminism nor nationalism is constrained by the same limitations as their settler-colonial counterparts. Oneida sociologist Lina Sunseri writes: "It is precisely this anti-colonial, liberation struggle to which I refer when I speak of nationalism. . . . Within this framework, and within an Aboriginal context, nationalism means a process to revitalize the different institutions and practices of our various Nations. An Aboriginal perspective on nation and nationalism differs from a Western one because its basis for nationhood is not rooted in notions of territoriality, boundaries, and nation-state."[54] She goes on to differentiate:

As in some other anti-colonial liberation struggles, Aboriginal women have had an important role in the "national" struggle and their roles have not been free of contradictions and obstacles. Colonization of the Americas ultimately transformed all structures, including Aboriginal gender relations. Prior to this, women in most Aboriginal societies enjoyed a large amount of status and power.[55]

For Indigenous people, particularly Native women, nationalism develops a uniquely Indigenous perspective, one that is linked to the land and, hopefully, one that dismantles patriarchy.

Taiaiake Alfred (Kanien'kehá:ka) proposes that all anticolonial resistance will take on a "nationalist" character, due to its attempt to subvert the dominant social order. Alfred writes that Indigenous resistance seeks "to achieve self-determination not through the creation of a new state, but through the achievement of a cultural sovereignty and a political relationship based on group autonomy reflected in formal self-government arrangements in cooperation with existing state institutions."[56] For Xicanos, Indigenous sovereignty takes the form of Aztlán.

For this reason the reclamation of traditional Indigenous territoriality was and is crucial to sustained Xicano anticolonialism. During the 1960s and 1970s, activists claimed Alcatraz and other sites as the core for political, spiritual, or economic reclamation. Urban Xicano communities also reclaimed otherwise abandoned and ignored community spaces through the use of mural painting. One important example is Antonio Bernal's painting at the UFW center in Del Rey, California. In this mural, Bernal painted an indigenist history of Third World struggles in the United States. Young artists and activists employed mural painting to metaphorically reclaim space.

In addition to localized movements and the activities of the Indians of All Tribes to reclaim Alcatraz, a similar activity in Davis, California, successfully reclaimed an abandoned military base for Indigenous pedagogical uses. On a site initially used to train state-sponsored imperialists, activists established a pan-Indigenous university for American Indian and Xicano students in 1971. Until its closure in 2005, D-QU was the only tribal college in California.[57] The pedagogical focus and institutional premise of D-QU was a radical indigenist curricula based on community needs and Indigenous knowledge systems. While many Xicano and American Indian community members saw themselves as divided nations, D-QU was a pan-Indian institution that bridged the gap between the American Indian and "mestizo" (what Gerald Vizenor calls "cross-blood") societies in the

United States, Canada, and Mexico. In much the same manner that I weave Xicano and Native histories into a common and shared narrative, so too did D-QU connect Xicano and American Indian histories as a single story of indigeneity and anticoloniality.

In November 1970, a cohort of aboriginal activists jumped a fence at a recently abandoned U.S. Army communications relay facility. Upon entrance, the activists built a teepee and, after five months of living on the land, were given its legal title. The activists induced a little-known legislation that allowed Native people to reclaim any unused federal lands (similar reasons were used in the occupation of Alcatraz). Officially founded in 1971, D-QU aligned its curriculum with the radical anticolonial rhetoric and activities of the time. By the mid-1970s, Anishinaabe leader and AIM cofounder Dennis Banks became university chancellor, even though Banks only held an associate's degree. Banks's selection as chancellor demonstrated D-QU's commitment to and radical solidarity with Native struggles, articulating a specific strand of Indigenous youth radicalism prominent during this period.

As the only tribal college in California, D-QU held a special role for Native peoples along the Pacific Coast. Unfortunately, over time, D-QU was unable to shift its focus with changing social and civic attitudes. Subsequently, in 2004, the university lost its accreditation and began evicting students in the spring of 2005. The university was founded by Indigenous activists looking to restore and reclaim their identities within settler-colonial hegemony, and the university remained an activist space upon its closure. When the university ceased operations in spring 2005, approximately twenty students were evicted. Not to be denied an education, they remained in their dorms after university officials shut down electricity and gas in an attempt to force students from the premises.[58] Since that time, D-QU has struggled to reopen. Following the loss of accreditation, Arturo Apodaca, one of the students who initially squatted on an abandoned military base, was appointed president by Judge Dave Rosenberg. Jack Forbes, one of the main proponents in the early days of D-QU, names this juridical process "a rebel takeover," calling into question the factionalization that occurs in revolutionary Indigenous movements.[59] As of 2014, the university's attempts to reopen have been plagued by factionalization.

What the future holds for D-QU remains unknown. What is known, however, is that by reclaiming the physical lands where D-QU resides, Xicano and American Indian peoples established an autonomous university built around Indigenous sovereignty and pedagogical frameworks. To this day, elders continue teaching youth in an activist setting, even without

accreditation. This divisive yet unresolved situation has been transpiring since 2005 and points to the complexities of sustaining structural change when settler-colonial institutions remain intact. Aztlán, the story of Xicano emergence, bonds these students to Indigenous territoriality, employing direct action and community-based art practices to reclaim a colonized military base. By doing so, D-QU still exists outside the limitations of settler-coloniality.

Murals as Indigenous Form

Around the same time that the power movements swept across Turtle Island-the Americas, muralism materialized as an exciting art form that exhibited aesthetic sovereignty while allowing local communities to reclaim contested space and local histories. Xicano artists turned to the mural because it was seen as an art form that descended from the Mexican mural tradition, as highlighted in the work of Diego Rivera, José Clemente Orozco, and David Alfaro Siqueiros. Indigenous peoples in the U.S. Southwest and Pacific Northwest also had rich mural painting traditions. In the Mexican mural tradition, Xicano artists saw an existing practice that brought together Indigenous aesthetics with avant garde strategies, a point art historians have rightfully noted. In her groundbreaking book, *Walls of Empowerment*, Guisela Latorre writes that "Chicana/o artists employed the monumentality of the public mural to disseminate an iconography radicalized in large part through its indigenizing qualities. These murals cited indigenous culture in a multiplicity of ways and for a variety of different reasons, yet composed part of an aesthetic that continuously sought to firmly establish Chicanas/os' sociopolitical place in U.S. territory."[60]

The dialectic between sovereignty and U.S. citizenship was furthered through the centrality of mural painting as a tactic to reclaim colonized space. Mural painting, beginning with marks on cave or cliff walls, is an ancient form practiced by nearly all societies. By working in this medium, contemporary Indigenous artists referenced their collective cultural past while establishing an entirely new aesthetic articulation. Xicano artists employed muralism almost entirely within the public sphere, a point that Latorre acknowledges in *Walls of Empowerment*. While the Mexican masters painted primarily interior murals for government agencies, Xicano and American Indian muralists generally painted exterior works prominently placed in community spaces. These murals cultivated a unique Indigenous aesthetic directed at their own community.

Of particular importance, at D-QU as well as throughout oppressed communities, was the application of murals as a way to reconstruct falsified history and repossess colonized community spaces. Alongside the development of global Third and Fourth World resistance was what many have identified as the "Community Mural Movement." Although government agencies and private corporations possessed large amounts of capital to construct and demolish buildings at will, the community mural movement was a community-based attempt to redefine communal spaces for marginalized populations.

What developed was a global network of both academically trained and self-taught artists who reclaimed colonized public space as a way to also claim their Indigenous identities and histories. Eva Sperling Cockcroft and Holly Barnet-Sanchez note that the Chicano "mural movement differed in many important ways from the Mexican one." It was not sponsored by a successful revolutionary government, but came out of grassroots struggle by the people themselves against the status quo. Victor Sorell points out that murals "are not, then, exclusionary landmarks either in their authorship or in their ultimate accessibility and appreciation."[61] Instead, they are popular art forms accessible to all.

In *Community Murals: The People's Art*, Alan W. Barnet recognizes that the community mural movement "developed during the late sixties and early seventies mainly in the big-city ghettos and barrios throughout the nation where human creativeness struggled against racism and poverty."[62] In the same way that the world caught fire during the 1960s, artistic practices likewise changed forever. Cultural critic T. V. Reed posits that "while Chicano movement artists worked and continue to work in many media . . . most historians and critics note a special affinity between the Chicano Movement and the community mural movement."[63] The mural was a Xicano expression of community history and the articulation of local autonomy. This uniquely Xicano practice drew on Indigenous aesthetics and visuality. Latorre attests that "the coupling of Indigenist iconography with the community mural seemed like the perfect marriage between content and artistic format. While both muralism and Indigenism created new symbolic and physical spaces for the articulation of a Chicana/o identity, they also functioned as dialectical components belonging to a unified system of visual signifiers."[64]

Likewise, Shifra Goldman demonstrates that the reclamation of Xicano indigeneity was foundational in Chicano art's iconography.[65] Articulating Xicanisma as an Indigenous ontology was central to the production of Chicano art as an authentic anticolonial form. Goldman and Tomás

Ybarra-Frausto state that the use of "pre-Columbian motifs in Chicano art served to establish pride and a sense of historical identity for the artists and the communities they addressed."[66] Latorre adds that "Indigenist imagery in muralism was meant to function as a metaphorical and tangible platform where Chicana/o artists could carve out spaces for the articulation of cultural citizenship and decolonizing creative expressions. The space, site, and location of a mural were as critical to its production as its style, iconography, and subject matter."[67]

Of particular importance to our discussion is Antonio Bernal's 1968 untitled mural (figures 9 and 10) painted on the exterior of an abandoned drugstore in Del Rey, California. Like many public artworks, this mural's site specificity was paramount to its aesthetic function. Its site was selected because of its location near dozens of migrant farmworker camps, as well as the building's recent conversion into a Xicano community theatre by Luis Valdés. It was here that Valdés founded El Teatro Campesino, an activist theatre troupe that operated in the Brechtian tradition, using drama as an organizing tool.[68]

The Del Rey mural, as Bernal's untitled painting is commonly known, is considered by many to be the first Xicano community mural, painted the same year as Mario Castillo's *Peace-Metafísica* (figure 11) in Chicago. Not only did this mural reclaim an abandoned pharmacy and transform the site into a community center, but the iconography of the mural also produced a revolutionary visual language based on contemporary Indigenous realities. The mural was painted in two parts, to the right and left of the center's main entrance. The image to the left is rarely reproduced, yet draws on Mesoamerican mural painting. The right firmly represents prominent figures in the Chicano and Third World movements. On the left panel, eight Mexica figures dance in a procession, moving from left to right toward the community center's entrance. Although seven of the figures are men, they are being led by a woman *danzante*. The linearity and composition of this panel are replicated on the opposing panel about the Movement.

On the right wall, we see seven analogous male figures also being led by a powerful woman. While the left panel conveys a sense of Indigenous history, the right panel constructs solidarity with Black radicalism. In this image, Bernal has painted eight figures, moving right to left: Dr. Martin Luther King, Jr.; Malcolm X, wearing a Black Panther T-shirt; Reies López Tijerina, holding in his hands a copy of the Treaty of Guadalupe Hidalgo; César Chávez, carrying a United Farm Worker's flag symbolizing a *huelga* or strike; Joaquin Murrieta, a legendary freedom fighter who fought against Anglo-American colonialism in nineteenth-century California; Pancho Villa

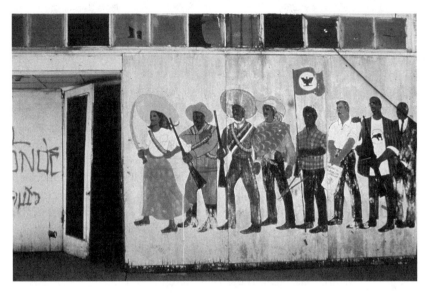

Figure 9. Antonio Bernal, Del Rey mural, right wall. Exterior mural in Del Rey, California, 1968. Image courtesy of Luis Valdez and Teatro Campesino, photo courtesy of Robert Sommers.

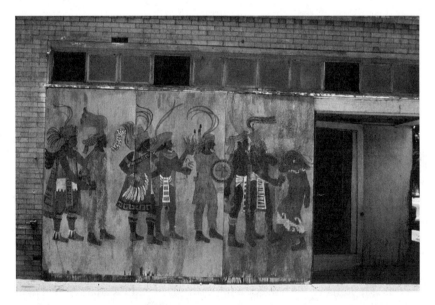

Figure 10. Antonio Bernal, Del Rey mural, left wall. Exterior mural, 1968. Image courtesy of Luis Valdez and Teatro Campesino, photo courtesy of Robert Sommers.

Figure 11. Mario Castillo, *Peace-Metafísica*. Exterior mural in Chicago, 1968. Photo courtesy of Mario Castillo.

and Emiliano Zapata, leaders of the Mexican Revolution who have become symbols of land reclamation; and finally, La Adelita, the anonymous female warrior figure who fought alongside men in the Mexican Revolution. In the complexity and number of figures, which draw on important Xicano and African American icons, Bernal visually aligns these Third and Fourth World movements, connecting Xicano radicalism with Black activism.

Although male dominant in its reclamation of history, an issue that Yolanda Broyles-González discusses in regard to the Teatro Campesino, this mural nonetheless illustrates the community-based recuperation of space, time, citizenship, culture, and art. With these cultural and political shifts, this community mural brings Aztlán to life in a manner that transcends any sort of tangible expression. Through the reclamation of land, educational institutions, cultural sites and artistic media, Xicano activists posited a sovereign Aztlán in opposition to Anglo-American hegemony. This relationship between Aztlán, Xicano sovereignty, and Indigenous visuality are paramount to the function of Xicano muralism. Latorre recognizes the power of Aztlán within this framework. She writes that "the notion of a Chicana/o nation was further radicalized by its denomination as Aztlán, an indigenous nation. But indigeneity was not just a component of the Chicana/o nation; it was the very means by which Chicanas/os transformed

themselves from a 'minority' to a nation."[69] Visuality was crucial in this transformation, possibly "the most powerful means by which to disseminate ideas about nation building."[70]

Writing Chicano Art

The intellectual core of the Chicano Movement developed on both sides of the U.S.-Mexico border, as Xicano indigeneities recurrently lowride back and forth across geopolitical borders. During this incendiary period of Xicano activism, Jacinto Quirarte, the first art historian to publish on Chicano art, was living in Mexico and completing his PhD at the Universidad Nacional Autónoma de México (UNAM). Later, Quirarte worked as an instructor at the American School in Mexico City and served as Dean of Men at the Universidad de las Américas before being hired as faculty at the University of Texas, Austin.[71] Despite his supportive writing, Quirarte received harsh criticism from the Chicano Movement, as well as from academically trained art historians. Each side believed that Quirarte was too partisan, a stance viewed negatively within scholarly art historical discourse during this period.[72] Regardless of these opinions, Quirarte's seminal *Mexican American Artists*, the first book-length study of Chicano art history, included a theoretical section on then-contemporary Chicano art.

Following in Quirarte's wake was Marxist art historian Shifra Goldman. Early in her career, Goldman collaborated with Xicano literary critic Tomás Ybarra-Frausto, most known for his work theorizing *rasquachismo* and its relationship to Chicano art. By positioning Chicano art as a multifaceted "movement," one that is deserving of multiple circumscribed periods, Goldman demonstrated that Chicano art was worthy of sustained academic study.

Painter César Martínez, like many of the artists involved in the Chicano Movement, also wrote on Chicano art. Appropriately, Martínez called artists, critics, and historians to task, both within and outside the Movement. For Martínez, "the formal diversity of what has been exhibited under the banner of Chicano art precludes it from being defined as an art movement in the usual sense, but its history is more interesting than any academic definition could be." He continues: "Since it emerged as a cultural extension of the *Movimiento Chicano* there have been numerous attempts to formalize it along politically ideological lines in the form of manifestos, but these never fully took hold because they tended to be exclusive."[73]

Nonetheless, Martínez argues that among those identified as Chicano artists "most remained loyal to the Movimiento."[74] Unlike many of today's

critics who discuss Movement art as monolithic, during this period artists, historians, and critics acknowledged multiple aesthetic and political positions simultaneously circulating.

The mid-1970s through the mid-1980s was the most productive and dialogical phase, in a Bakhtinian sense, in the construction of a Chicano art historical canon.[75] Over and above Goldman's articles in contemporary art and academic journals such as *New Art Examiner* and *Art Journal*, she also published extensively within Movement publications.[76] These essays, published for Xicano audiences, significantly contributed to the overall study of Chicano art history. In Chicano Movement publications, which included texts as diverse as manifestos, critiques, reviews, responses, and histories, Xicano activists engaged in dialogue about the function and rationale of Chicano art. In *Arte Chicano*, Goldman and Ybarra-Frausto indicate that

> the newspapers, magazines, and journals that emerged were a richly nurturing medium in which fledgling writers and artists of the new national movement could try their wings, and the maturing artists and writers could be recognized much more before their acceptance by the dominant cultural institutions.[77]

By way of this "nurturing medium," in some ways an Indigenous form of mentorship and collaboration, artists and critics expanded Chicano art dialogue in Xicano publications and venues.

From slick professional magazines aimed at upwardly mobile individuals to photocopied or mimeographed zines produced in one's apartment, Xicano magazines were published across Turtle Island beginning in the late-1960s.

One of the first publications to be associated with the Chicano Movement was the Berkeley-based *El Grito*. Edited by anthropologist Octavio Romano-V., *El Grito* billed itself as "A Journal of Contemporary Mexican American Thought." Founded in 1967, *El Grito* focused primarily on the social sciences and contained little information about the visual arts, even as it published literature and reproductions of art. Significantly, in the fall of 1972, *El Grito* included a section titled "Five Styles of Chicano Art." It included reproductions of illustrations by Malaquías Montoya, Edel Villagómez, Ramsés Noriega, Dennis Martínez, and Carmen Lomas Garza.[78]

By the mid-1970s, a number of publications emerged that specifically addressed Xicano arts, including visual, literary, and performance practices. *ABRAZO*, a publication of the Movimiento Artístico Chicano (MARCh), was published in Chicago between 1976 and 1979. During this three-year

span, MARCh published two issues of the journal. As the editors wrote in the first issue: "The goal of this publication, ABRAZO (embrace) is to serve as a medium of artistic expression for Latino artists and art groups, especially those of the Midwestern and Great Lakes States."[79] Artist Carlos Cortéz Koyokuikatl wrote a column for *ABRAZO* titled "El Machetazo."[80] In his usual confrontational fashion, Cortéz Koyokuikatl exclaims that

> in these days of rising liberation movements, another priority should be the liberation of art. Free it from those who use it as another means of differentiating themselves from those who are of the 'lowah clahses' and bring it back to where it originated and where it belongs, among the people.[81]

Cortéz Koyokuikatl maintains that art must be liberated from its capitalist base. Cortéz Koyokuikatl's position found analogous articulations across Turtle Island-the Americas.

In a publication by the Raza Arts and Media Collective (RAMC), George Vargas argues for a hemispheric solidarity among subjects of the anticolonial world. Vargas writes that, "needing innovators and producers of positive change, Xicanos and other Third World peoples must create a common consciousness based on a proven humanism; we must not stop trying to prove our humanism to those who are inhuman."[82] Recalling Alurista's position that Aztlán was a move toward Xicano humanity, Vargas also distinguishes Chicano art as a means toward this goal. Vargas positions the Chicano and Third World movements as struggles in which art serves at the foundation of establishing humanity.

This radical vision of Third and Fourth World solidarity is equally reiterated in the premiere issue of the *Chisméarte* (occasionally spelled *Xhisméarte*), a Los Angeles magazine in which muralist Carlos Almaraz made public his manifesto "The Artist as Revolutionary." Almaraz maintains that art, not just Chicano art, must directly reflect our late-capitalist experiences.[83] For Almaraz, art cannot be reduced to a culturally bound, and therefore Eurocentric, universality. More than anything else, Almaraz argues, artists must critique hegemony, as well as their role in its reproduction. He writes that "it is not only the responsibility of the artist to give form to what he [*sic*] considers beautiful, to what he considers to be viable both visually and intellectually, but it is also his responsibility to give form to that which he and his public might find offensive or even ugly."[84]

Almaraz demonstrates that art's revolutionary potential is in its oppositional capability. Artists cannot simply maintain hegemonic apparatuses; they must oppose them.

But as can be seen by Almaraz's gender-centrism, even the most radical Chicano Movement documents on art intermittently reproduced the dominant gender dynamics of the period. This absence of Xicana voices was challenged by *Chisméarte*, which published two articles by Sybil Venegas. These articles, "Conditions for Producing Chicana Art" and "The Artists and Their Work: The Role of the Chicana Artist," addressed the responsibility of the Xicana artist.[85] In the former, Venegas states that

> if Chicano art has been considered a long neglected entity within the realm of "Art History," certainly the attention given to the women artists of la Raza is a long time coming. Yet, if one examines closely Chicano art today and the many new expressions coming from the barrios, Chicana art is a strong voice emerging from this previously male-dominated field.[86]

She expands these ideas in the latter essay, maintaining that "in addition to the already established role of the Chicana artist in defining Chicano identity, the Chicana artist must also acknowledge the recent changes affecting the Chicano community and through her art offer the solutions necessary to these specific changes."[87] Venegas agrees that the main role of the artist, particularly the Xicana artist, is that of a philosopher and activist.

The same year that these articles were published, Marcella Trujillo Gaitan wrote "The Dilemma of the Modern Chicana Artist and Critic" for *De Colores*, a quarterly "Journal of Emerging Raza Philosophies." Predominantly addressing Xicana literary issues, Trujillo Gaitan maintains that Chicano art is about affiliating with the people. She writes that

> Chicano artists and writers must continue to create and to communicate with the grass roots people, and in doing so, will reach the universal masses who identify with their contemporary situation whether in this country or other countries, whether in this or another historical moment, for art has its own laws which transcend the artist, his/her time and even ideology that brought forth his/her art.[88]

Much like male Xicano activists, Trujillo Gaitan upholds that art, although operating within undeniable historical parameters and structures, maintains certain "universal" qualities.

Although many Movement texts on aesthetics are contradictory and incongruous, as are some of my ideas in *Creating Aztlán*, they nonetheless expand the parameters of existing and discursive fields. They enable new ways of seeing the world. As Italian Marxist Antonio Gramsci made

clear, "worldviews are rarely consistent; they typically involve a contradictory amalgam of ideas."[89] The Chicano Movement was no exception to Gramsci's truism. While occasionally contradictory, Movement discourse remains vital for continued academic and political interventions. In this way, it is dialogical and utopian, employing the term as I have previously described it.

The most widely publicized debate on Chicano art was published in *Metamorfosis*, a journal affiliated with the University of Washington's Chicano Studies Department. Over the course of four years (1980–1983), three articles, written by four authors, addressed the significance and meaning of Chicano art. The first two essays, written by Malaquías Montoya and Lezlie Salkowitz-Montoya, and Shifra Goldman, respectively, were reprinted in *Chicano Art History: A Book of Selected Writings*.[90] The third, which appeared a few years later, was written by Luís J. Rodríguez, but received less critical attention than the previous two articles.

In "A Critical Perspective on the State of Chicano Art," Montoya and Salkowitz-Montoya situate Chicano art in opposition to U.S. hegemony. While Chicano art is produced in solidarity with working-class and anticolonial movements throughout the globe, Montoya and Salkowitz-Montoya believe that Anglo-American hegemony constructs Chicano art as "anything created by persons with a Spanish surname."[91]

One of the predicaments haunting the essay by Montoya and Salkowitz-Montoya is the way that they reduce art into binary distinctions. For them, if an image is exhibited at an elite museum, then that particular artist has by definition been co-opted. This co-optation process, according to the authors, continued and expanded to a point at which "Chicanos started to emulate Anglo society and thus started to divert the Movement and what was basic to it."[92] Fortunately, Shifra Goldman counters this perspective in her retort, simply titled "Response: Another Opinion on the State of Chicano Art." She contends that "Chicano artists should feel free to utilize any of the contemporary formal discoveries of Euro-American art—abstract expressionism, Pop, Op, Funk, photorealism, etc. as long as they do not permit themselves to be drawn into experimentation for its own sake (art-for-art's-sake) or into the sterility of endless variations of the formal means."[93] She continues:

> The only valid conclusion possible is that there is no betrayal to the Chicano movement involved in the flexible and experimental use of technology and style if it is infused with a Chicano vision and world

view. It is also to be remembered that the so-called Euro-American style owes a great debt to the Third World from the nineteenth century to the present.[94]

Goldman acknowledges that inciting cultural apartheid is futile, even if it radiates from an anticolonial vantage point. Goldman further argues that it is not Chicano art that is burdened with being co-opted; rather, it is a false representation.

Instead of looking at where an object is being exhibited, or the approaches an artist utilizes, one must critically address that object itself to determine its co-optation. Goldman writes that "slickness, emptiness, static ideas and forms, repetitiousness, superficial novelty are some of the measuring devices."[95] According to Goldman, for an artwork to be co-opted, it must be purely façade. Instead of opening up new possibilities, as all art must do, these co-opted objects are purely superficial. They become a form of artifice instead of art.

Montoya and Salkowitz-Montoya make two significant claims that conflict with critical reviews of their *Metamorfosis* essay. In fact, these are the most important elements to be gleaned from their essay. The first point is that "Chicanos are not an isolated culture," but are in dialogue with other colonized and oppressed peoples.[96] Unfortunately, for many critics this imperative becomes buried within the tone of the text. As I will show when I discuss Montoya's artwork, his childhood in a multiracial working-class community fomented his Third World identity, one which rises in experiences such as this.

Second, like Diego Rivera (as argued by Híjar Serrano), Montoya and Salkowitz-Montoya allow for countless possibilities of what constitutes "Chicano Art." For them "a definition of 'Chicano Art' was never intended because to have done so would have restricted the artist."[97] Here, one of the more prominent Xicano artists, Malaquías Montoya, demonstrates that Chicano art must be an open-ended field able to contain many things. However, because of the tone of the article, which at times appears accusatory, the reception of this article was perceived as "narrow nationalist," even though a more thorough investigation brings to light its complications and contradictions. Importantly, as you will see in my writing on Montoya, his nationalism was intimately linked to internationalist solidarity.

With these written dialogues circulating within the Xicano arts community, we can see how artists envisioned their collective and individual practices. Since the 1960s, Xicano artists have asserted their citizenship, while

also claiming Aztlán as a nation. They have reclaimed space by painting murals and creating autonomous universities.

In the second half of this book, "Tlapalli," we will see specific examples of Chicano art and activism along the U.S.-Canada border, as well as examples of how specific artists articulate and reframe Aztlán as an Indigenous homeland. To this point, we have lowrided across Turtle Island, using Aztlán as our vehicle—a vehicle that will continue to be used for the creation of an Indigenous Xicano nation.

PART TWO

Tlapalli

Visualizing Aztlán

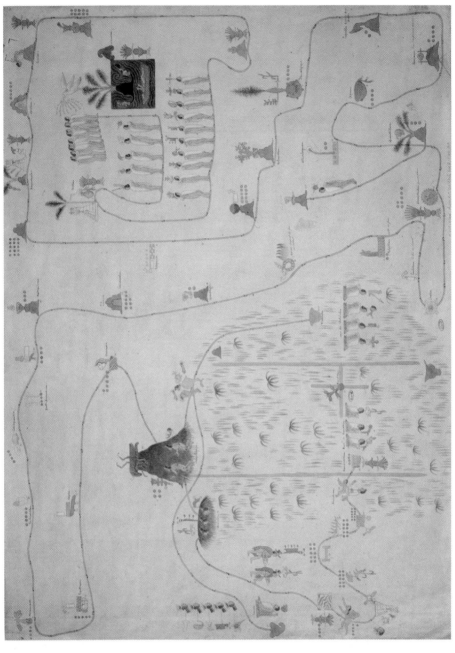

Plate 1. Frédéric de Waldeck after Anonymous (Mexica), facsimile of sixteenth-century Mapa Sigüenza, ca. 1829–1831. Photo courtesy of Newberry Library.

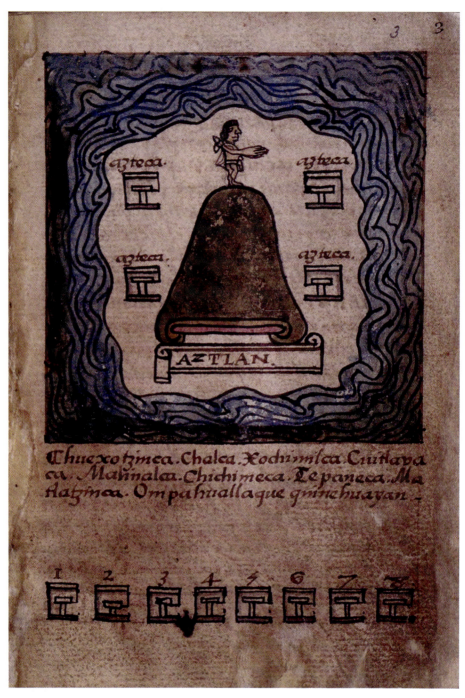

Plate 2. Anonymous (Mexica), Codex Aubin. Ink on European paper and bound in leather, 1576. Photo courtesy of the British Museum.

Plate 3. Emanuel Martínez, *Mestizo Banner*. Serigraph, 1969. Image courtesy of the artist.

Plate 4. Antonio Bernal, Del Rey mural, right wall. Exterior mural in Del Rey, California, 1968. Image courtesy of Luis Valdez and Teatro Campesino, photo courtesy of Robert Sommers.

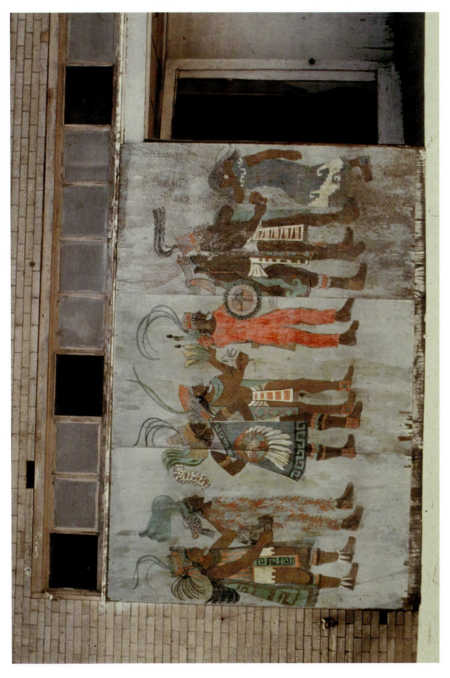

Plate 5. Antonio Bernal, Del Rey mural, left wall. Exterior mural, 1968. Photo courtesy of Luis Valdez and Teatro Campesino, photo courtesy of Robert Sommers.

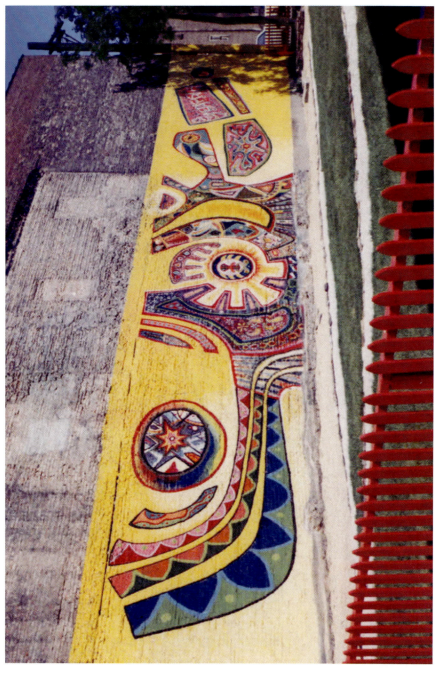

Plate 6. Mario Castillo, *Peace-Metafísica.* Exterior mural in Chicago, 1968. Photo courtesy of the artist.

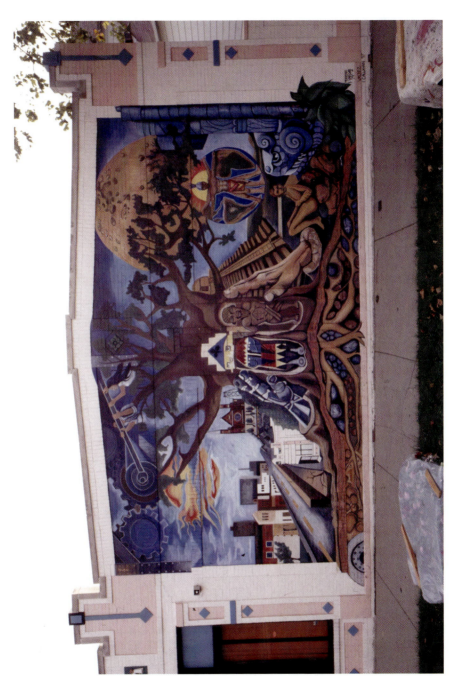

Plate 7. George Vargas and Martín Moreno, *CitySpirit*. Exterior mural in Detroit, 1979. Photo courtesy of George Vargas.

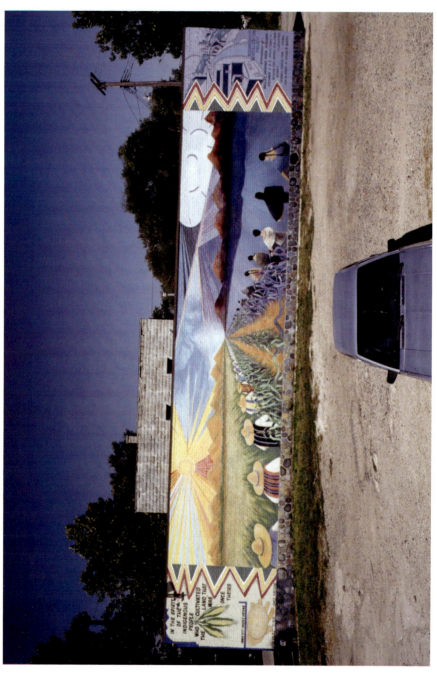

Plate 8. Vito Jesús Valdéz and James Puntigam, *The Cornfield*. Exterior mural in Detroit, 1997–1998. Photo courtesy of Vito Jesús Valdéz.

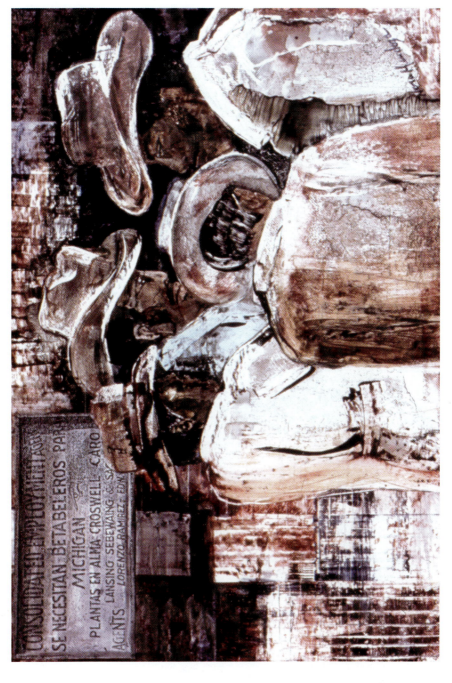

Plate 9. Nora Chapa Mendoza, *Employment Agency*. Mixed media painting, 1990. Image courtesy of Nora Chapa Mendoza.

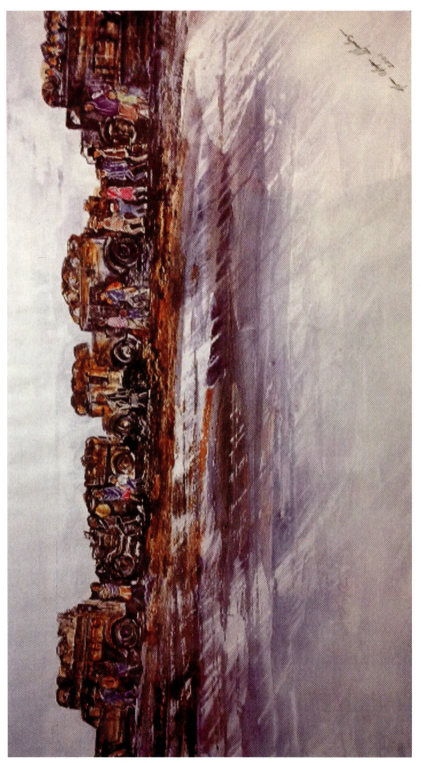

Plate 10. Nora Chapa Mendoza, *Los Repatriados*. Mixed media painting, 2001. Image courtesy of Nora Chapa Mendoza.

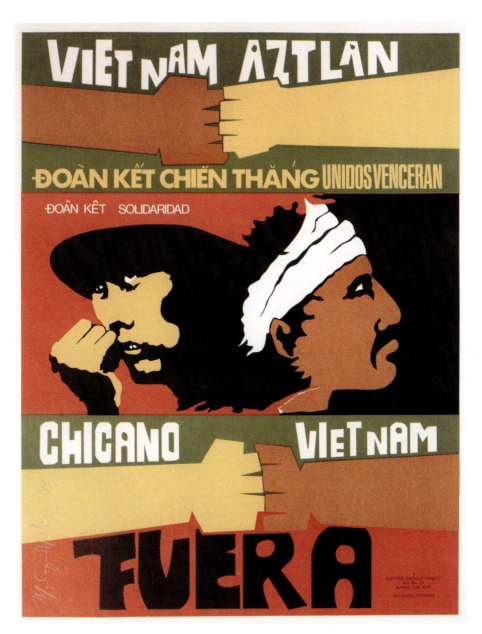

Plate 11. Malaquías Montoya, *Viet Nam Aztlán*. Offset lithograph from original serigraph, 1972. Image courtesy of Malaquías Montoya.

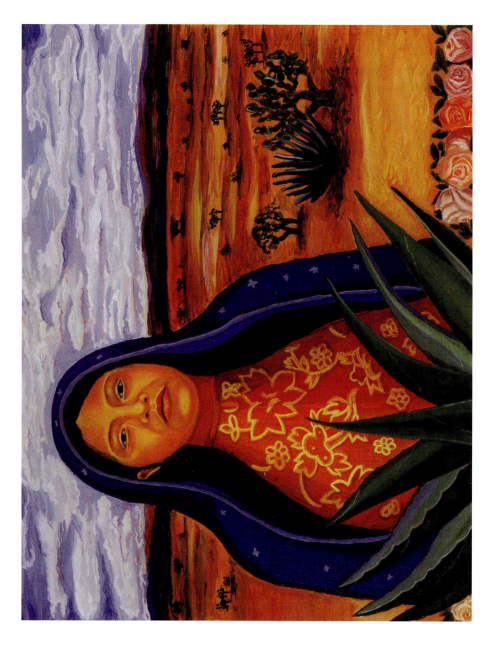

Plate 12. Santa Barraza, *La Virgen.* Oil on metal, 1990. Image courtesy of Santa Barraza.

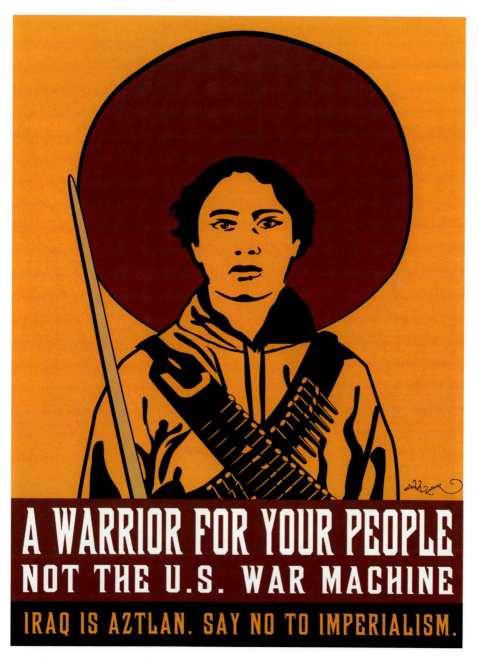

Plate 13. Favianna Rodríguez, Jesús Barraza, and Estria Miyashiro, *Resist US Imperialism*. Serigraph, 2003. Image courtesy of Favianna Rodríguez.

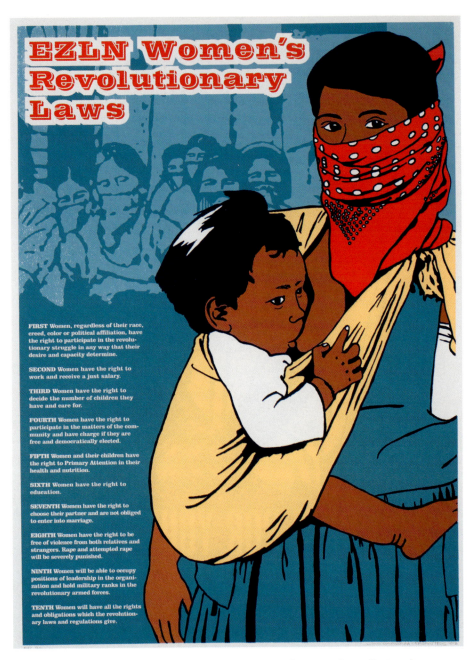

Plate 14. Dignidad Rebelde, *EZLN Women's Revolutionary Laws.* Serigraph, 2007. Image courtesy of Melanie Cervantes and Jesús Barraza.

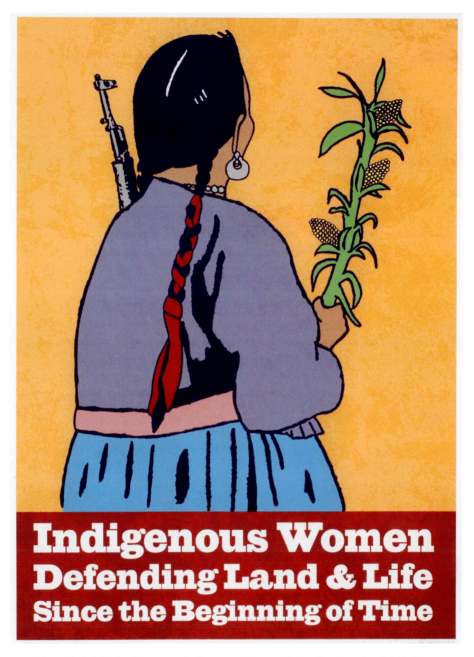

Plate 15. Melanie Cervantes, *Indigenous Women Defending Land and Life Since the Beginning of Time*. Serigraph, 2009. Image courtesy of Melanie Cervantes.

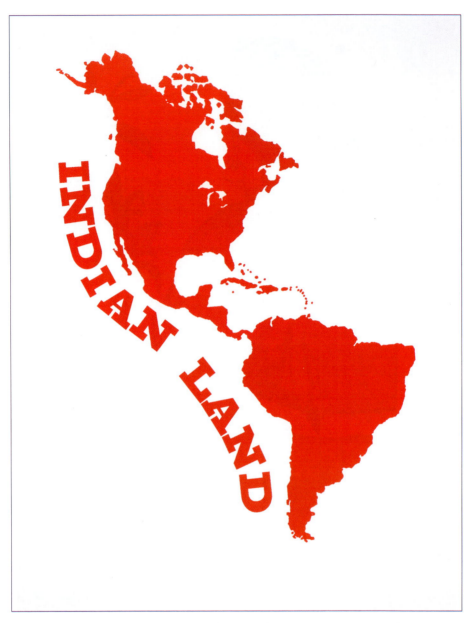

Plate 16. Jesús Barraza, *Indian Land*. Serigraph, 2004. Image courtesy of Jesús Barraza.

CHAPTER FOUR

Reframing

Aztlán and La Otra Frontera

In the summer of 1979, artists George Vargas and Martín Moreno were commissioned by the Hubbard Richard Agency to paint a mural in the heart of the Xicano community of Detroit. Created a full decade into the Chicano Movement, this mural, *CitySpirit*, is one of the only surviving exterior murals in Michigan from the this era (figure 12). Nearly twenty years after *CitySpirit* was painted, another mural, *The Cornfield* (1997–98), went up across the street (figure 13). Situated within one kilometer of *la frontera norteña* with Canada, these murals speak to a specific Xicano experience in Anishinaabewaki (Ojibwe, Odawa, and Potawatomi territory) or the upper Midwest. It is this specific MiXicano (or Michigan Xicano) experience, as described through the murals and other visual culture, that I use to revision the historiography of Chicano art. As I shall demonstrate, although the histories and experiences of Xicanos in the upper Midwest and the U.S. Southwest are similar, the Midwest community must be contextualized and understood distinctly to properly understand its importance. I therefore attempt to problematize naturalized assumptions about Chicano history and cultural studies in an attempt to reframe the discourse on Chicano art histories. As historian Dionicio Valdés notes, the legacy of the U.S.-Canada border, one which historically displaced Anishinaabeg and Michif communities, haunts MiXicanos, just as the U.S.-Mexico border does Mexicans, Xicanos, and other Indigenous peoples to the south. Moreover, Xicano indigeneity outside the U.S. Southwest raises issues of

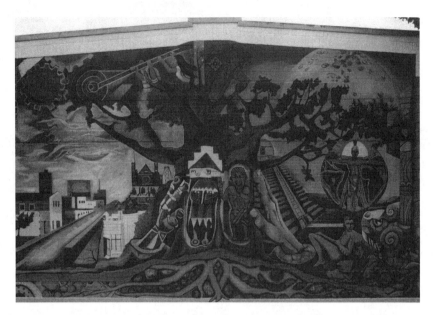

Figure 12. George Vargas and Martín Moreno, *CitySpirit*. Exterior mural in Detroit, 1979. Photo courtesy of George Vargas, reproduced with permission from the artist.

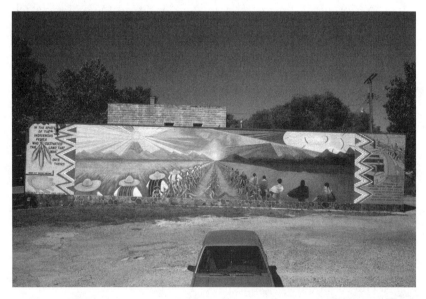

Figure 13. Vito Jesús Valdéz and James Puntigam, *The Cornfield*. Exterior mural in Detroit, 1997–1998. Photo courtesy of Vito Jesús Valdéz.

Reframing • 115

migration and diaspora. Issues I see, from an Indigenous perspective, are intimately related to lowriding.

To understand how Xicanos got to Michigan, just as other Indigenous and diasporic people have moved across Turtle Island-the Americas, is to understand a story of lowriding. To do this, let us shift gears, to use a cycling metaphor. As we've seen, lowriding is about slow movement, in which the lowriders themselves get to know the space and move through it in intentional ways. Along la otra frontera, this slow movement commenced at the beginning of the twentieth century, when Xicano and Mexican laborers came to work in the agricultural and automobile industries. Since that time, lowriding has continued. Similarly, beginning in the 1950s, Anishinaabeg migrants moved to Michigan from Canadian First Nations in large numbers, recruited by the auto industry. These parallel migrations, of two distinct Indigenous populations converging in rural and urban centers, created Xicano and Anishinaabeg communities that blurred on the boundaries. As my work with youth attests, not to mention my own kin-networks, many urban-Native youth in Michigan have mixed Xicano-Anishinaabeg identities—a community I have begun calling the Xicanishinaabeg.

CitySpirit, the mural that I will discuss in depth, is situated in close proximity to the base of the international Ambassador Bridge (figure 14); it is the busiest international commercial border in the world. The bridge crosses south to Windsor at the only location in the continental United States where U.S. territory is north of Canada. Anglo-American popular culture pejoratively speaks of Mexico as being "south of the border," and since Southwest Detroit is north of the U.S.-Canada border, this problematic vernacular adage complicates the study of the Xicano community of Detroit. The unique geography of this "borderlands" site plays a significant role in constructing meaning among members of the local Xicano, Native, and Latino community. This region around Detroit, called Waawayeyaattanong or Zagaajibiising in Anishinaabemowin, has a long history of Indigenous and cross-blood resistance.

As a site-specific work of art, *CitySpirit* is important because it situates MiXicano art within a regional framework of the Xicano experience and, more importantly, because it functions as an utterance that creates Aztlán for Detroit Xicanos along la otra frontera, the U.S.-Canada border. For this reason, local artistic and cultural practices must be compared and contrasted with other Xicano and Mexican visual art, especially Diego Rivera's mural at the Detroit Institute of Arts. In this chapter, I include a discussion of the visual production of Nora Chapa Mendoza and the Xicano Development Center (XDC), an anarchist and indigenist organization that is

116 • *Tlapalli*

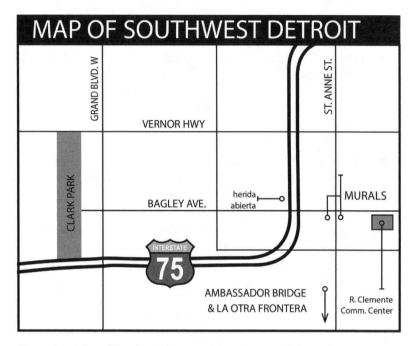

Figure 14. Map of Southwest Detroit. Map courtesy of the author.

currently inactive. Through this discussion I explain how these diverse visual forms speak to an experience (un)like any other. With a history of agricultural and industrial labor, the Xicano communities in Michigan and Detroit have suffered a level of oppression similar to, if not worse than, the oppression faced by other Xicano communities across Turtle Island. Due to the particular class-based social position of most MiXicanos, these regional experiences relate to larger issues of labor activism and anticapitalist resistance movements. One of my objectives is therefore to show that a MiXicano Aztlán is produced through the construction of solidarity with other Indigenous and working-class peoples in the region and throughout the Third and Fourth Worlds. It is definitely not the hegemonic version that so many Xicanas and Xicanos have called into question.

At present, knowledge of the cultural and artistic history of the MiXicano community prior to the Chicano Movement is somewhat sparse. There exist small holdings of archival material housed primarily at Michigan State University and the University of Michigan. However, little is recorded of the specific visual artists working in the region during the early twentieth century. According to a biography by Yolanda Broyles-González, famed

Tejana musician Lydia Mendoza toured Michigan farmworker *campos* with her family as a child.[1] Although only one example, Mendoza's presence in the state demonstrates, at least superficially, that during the early to mid-twentieth century there did exist a cultural network that linked MiXicanos with other Xicanos and Mexicans. This network was bolstered by the numerous cultural and civic institutions established in Detroit and other Xicano communities during the 1920s and 1930s.[2] These institutions will be discussed later in this chapter.

In terms of the visual or fine arts, little was documented or collected before the late 1960s. Material specifically addressing the art historical and visual legacy of the community needs to be more fully uncovered and analyzed. I turn to art of the Chicano Movement for multiple reasons. One is accessibility: since many activist artists are still practicing today, the Movement era in Chicano cultural history is the ideal time period for an initial investigation into the history of MiXicano art, as the artists can be interviewed and can provide oral history and archival material.

In this chapter I have chosen to discuss the work of Nora Chapa Mendoza, George Vargas, Martín Moreno, and the Xicano Development Center because these three individuals and this single organization were influential in producing and disseminating a uniquely MiXicano visual culture to a national audience. Vargas and Moreno were two of the most widely established muralists in Michigan from the Movement. As I put forward in the last chapter, murals helped reclaim Xicano spaces and, therefore, the murals along la otra frontera offer additional knowledge about Xicano and Indigenous histories of migration and sovereignty. I investigate the specificity of the Detroit murals to clarify these earlier arguments.

Additionally, since Vargas and Moreno both have relocated to the Southwest, they have received recognition outside the region yet remain indebted to their experiences in the Midwest. Art historian Vargas's book, *Contemporary Chican@ Art: Color and Culture for a New World* (2009), has proven to be an important text in the study of Chicano art histories. I include Mendoza because of her commitment to larger activist projects and her importance within Chicano art history, while the XDC provides us with a framework within which to position a radical MiXicano political praxis. Each of the individuals and organizations examined in this chapter thus plays an irreplaceable role within the larger narrative of Chicano art history, although most are nearly absent from larger Chicano art histories. My arguments are grounded in art historical and formal analysis in hopes of fully inserting MiXicano visual culture into both Chicano studies and art history discourses.

118 • *Tlapalli*

Following the approach explicated by Xicana feminist Chela Sandoval, I evoke a multiplicity of tactics from a variety of methodological standpoints. Sandoval calls this multivalent positionality "differential consciousness." For her, this oppositionality enables intellectuals (as well as artists and activists) to draw from disparate ideological frameworks of past movements and paradigms without being fully locked into a monolithic, doctrinaire field. According to Sandoval, this "tactical subjectivity" has the "capacity to recenter" without succumbing to partisan fragmentation.[3] For this reason, I believe that an informed application of multiple approaches will best address the complicated cultural practices in Michigan. As Italian Marxist Antonio Gramsci so adeptly wrote from prison: "Worldviews are rarely consistent; they typically involve a contradictory amalgam of ideas."[4] Such is the case with the work addressed here, as well as this book itself. These ideas can also be seen in Alberto Híjar Serrano's writing, which I cited in the Introduction. Aztlán does not need to be without contradiction. As a utopian site, it is contradictory by definition. However, it is in this antagonistic space that new ideas and practices emerge.

Through the application of ostensibly paradoxical paradigms, I see this chapter as reframing the discourse on Chicano art and culture by problematizing the Southwest-centrism and by critically analyzing prominent MiXicano artworks. My application of differential consciousness can be viewed in my engagement with visual culture created in alliance with multiple political projects. It is for this reason that my analysis attends to both the potentially conciliatory narratives of George Vargas, Martín Moreno, and Nora Chapa Mendoza and to the overtly radical aesthetics of the Xicano Development Center. By way of both reformist and revolutionary political approaches, MiXicanos have asserted their sovereignty along la otra frontera. Not surprisingly, by interrogating the idea of la frontera, vis-à-vis Gloría Anzaldúa, we are also implicating Aztlán and Xicano notions of place, but ones that emerge from an indigenist ontology.

Nora Mendoza, the XDC, and MiXicanismo

In terms of iconography within Chicano art, Aztlán is one of the most habitually evoked themes. However, painter Nora Chapa Mendoza only occasionally positions Aztlán within her visual language as a theme that is visually manifest. On the contrary, for Mendoza Aztlán serves as an Indigenous unifying device that connects her work with other Native and Latino artists throughout Turtle Island-the Americas. Curator Ursula R.

Murray describes Mendoza as "soft-spoken yet articulate," adding that she is "passionate about the conditions confronting the poor of North, Central and South America, our migrant workers, those disenfranchised by industrialization and capitalist interests, our undereducated children, and our hungry land-working 'campesinos.'"[5] This passion, or rather compassion, that Murray documents is manifest in an enunciation of a distinct vision of Aztlán that does not alienate non-Xicanos but rather constructs a complex network of social alliances that strive for social justice. This may in fact be the hallmark of MiXicano culture; it is nationalist, yet at the same time it is also receptive to mainstream ideas, ideologies, and aesthetics. Xicano sovereignty does not need to replicate the exclusionary policies of the settler-colonial nation-state.

Although she does not usually represent Aztlán in her work, this is not to say that Mendoza is disinterested in the role that Aztlán plays for Xicanos, especially those in Michigan. Quite the opposite is true, as Mendoza is involved in Xicano and other Indigenous spiritual practices and cultural struggles in both the United States and Mexico. Since the 1980s, Mendoza has actively practiced Mesoamerican and Native North American spiritual lifeways. She does not participate in a condescending or new age manner, but rather displays an earnest solidarity with anticolonial Indigenous struggles throughout the continent. In many respects, Mendoza proposes a dialectical Aztlán that embraces working-class struggles and the diasporic realities of transnational migration but is locked within an alternative indigeneity.[6] Migration and diaspora, therefore, become a common trope for Aztlán within her body of work. We could say that Aztlán is a longer and older story, itself a form of Indigenous knowledge about lowriding.

As a self-taught artist, Nora Chapa Mendoza received training similar to that of the first generation of Xicano artists in the Southwest. An analysis of the history of Chicano art demonstrates that the majority of these first-generation artists, even those trained within the university system, maintained a working-class identity and were often viewed as operating outside of or in opposition to mainstream art markets. However, if we discuss Mendoza's work solely in relation to her being self-taught, it is possible—and this frequently happens with Chicano art—that we presuppose her status as a "vernacular" or "outsider" artist and are then forced to operate in a reductive manner.[7] I believe it is instructive to position her work within the framework of a regional history and observe the manner in which she articulates specific narratives related to it. In other words, Mendoza's works are individual utterances that are specifically oriented toward a MiXicano audience. For this reason, the work of Mendoza often receives inaccurate

readings by those who assume a generalized Latino or "Hispanic" context. Inversely, Mendoza's work exists across Xicano and other Native visualities.

Accordingly, Mendoza mediates between the lived realities of the working-class Michigan Xicano community and the fine art market of metropolitan Detroit. Her trajectory as a practicing artist is one of "middle-class" economic mobility, but it is a mobility tied to an oppositional consciousness. Born in a one-room, dirt-floored *chante* in South Texas, Mendoza was only four when her mother died of tuberculosis.[8] After spending time in Texas as a migrant worker, she ended up in Detroit when her husband moved to the city to work. It was not until later in life, when she was in her forties and divorced, that she began her career as a visual artist. *When* Mendoza began making artwork is of importance to our discussion here, particularly in relation to *where* she began making it. Place, and Mendoza's unique relationship to it, is imperative. In the language of contemporary art, curators speak about "creative placemaking." Indigenous artists have always been creatively making places, and Aztlán, in particular, is a place that can move with the forced and noncoerced migration of Xicanos. Mendoza takes Aztlán with her wherever she goes. It travels with her as she lowrides across time and space. As a land base, it is not limited by Western notions of territoriality. As we understand and push the limits of Indigenous sovereignties, we must be cautious not to be contained by settler-colonial ways of demarcating land.

During her period of initial art making, Mendoza was living in the Great Lakes region, what we should call Anishinaabewaki, traditional Anishinaabeg lands. She was not making artwork as a response to the localized lived reality of South Texas, as was Santa Barraza or other artists from Kingsville, Texas; rather, Mendoza's art making emerged out of her experiences as a Xicana living in Anishinaabewaki.[9] Grounding my arguments in an oppositional consciousness and indigenist framework, I see it as paramount to not privilege one field over another but rather to investigate bodies from different positions. This complex positionality frequently turns to notions of place and space, as well as land, to properly situate Xicano bodies. Henri Lefebvre argues that "space is permeated with social relations; it is not only supported by social relations but also producing and produced by social relations."[10] Mendoza's work posits Aztlán (as a Xicano chronotope) as a unique social space permeated by conflicting social relations. How this mutually constitutive process operates in Michigan is of great importance. In Mendoza's work and that of other artists discussed in subsequent chapters, the social relations of class mediate how MiXicanos identify and construct their culture. Additionally, migration and cultural change are at

the forefront of MiXicanidad. Xicanos, especially artists and workers, are lowriding across colonized lands in a move to indigenize and liberate them.

For this reason, three factors remain essential to the interpretation of Mendoza's oeuvre: migration, labor, and the articulation of MiXicanidad. Yet these three individual factors, as part of a complex social identity, cannot be disentangled from the others within her artwork. Like many Xicano artists, Mendoza works in a broadly defined narrative style, yet she does so as a critique of existing master and meta-narratives, even those being articulated from within the Xicano community. In the early 1990s, Mendoza worked on a series titled "Migrant Workers." Works from this series were published as greeting cards to raise funds for the United Farm Workers and as illustrations for Dionicio Valdes's *Al Norte: Agricultural Workers in the Great Lakes Region, 1917–1970.*[11] From this series, we are able to discern the regionally specific strands within her work. An initial reading of *Employment Agency* (figure 15) reveals the narrative of four people, presumably Xicano, standing near text that reads *"se necesitan betabeleros para Michigan"* (beet pickers needed for Michigan). This is followed by a list of six Michigan cities where beet fields and processing plants were located. The denotation, or noncoded iconic message, of the narrative is obvious: it is a simple telling of the working-class traditions of the campo, of the manner by which Xicano and Mexican workers were exploited by Anglo-American employment agencies, and of the integral role that Xicano workers played in the development of Michigan agriculture. However, this reading, as well as associated analyses, is unfortunately reductive and unable to deal with the critical manner by which Mendoza acts as an intermediary between existing Xicano histories and their revisioning. Here the coded iconic message within her work utters, to those able to understand its language, a narrative not usually apparent in contemporary Chicano or art historical discourses.

In 1990, the year this image was painted, literary critic Ramón Saldívar published *Chicano Narrative: The Dialectics of Difference,* in which one illustration shows a Texas office that recruited *betabeleros* for work in Michigan. The caption reads: "Migrant farmworkers and hiring agents gathering at an informal employment agency advertising work in Michigan for 'beet pickers' in Corpus Christi."[12] Although Saldívar is adept at merging Marxist criticism with Xicano literary texts, the inclusion of this particular image in *Chicano Narrative* appears arbitrary, as there is little talk of Michigan in the book.[13]

As an artist who revisions dominant Xicano narrativized histories (that is to say Xicano stories), Mendoza uses this photographic reproduction as

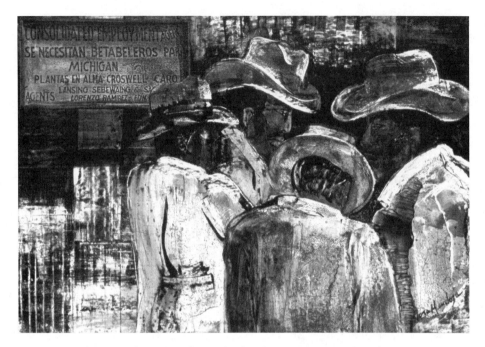

Figure 15. Nora Chapa Mendoza, *Employment Agency*. Mixed media painting, 1990. Image courtesy of Nora Chapa Mendoza.

the source material for the painting *Employment Agency*. However, instead of using the photograph for its basic illustrative nature, as Saldívar apparently does, Mendoza procures the image for its site-specificity and initiates a rearticulation of a particularized MiXicano (art) history. Of the cities that appear on the sign—Alma, Croswell, Caro, Lansing, Sebewing, and Saginaw—the writing of George Vargas places two of them, Saginaw and Lansing, as centers of Xicano art production in the state.[14] I myself was born in Alma and raised in Caro, and I attended numerous *bailes* in Sebewing and Saginaw. Presently, I teach at Michigan State University and live in East Lansing. I have witnessed the fact that to this day each of these cities maintains a vibrant Xicano community, all established and developed in response to the economic needs of the area.

Employment Agency begins formulating a more inclusive Xicano visual narrative, one that includes otherwise marginalized Xicano iconography. If, as Rafael Pérez-Torres maintains, "land lies at the heart of the Chicano movement," Mendoza speaks of a place not commonly included in mainstream Xicano discourse.[15] Although this place is not easily recognizable as

Aztlán, works such as those that Mendoza created for Roberto Rodríguez and Patrisia Gonzales's Aztlanahuac Project demonstrate Mendoza's rectification of a Southwest-centric Aztlán by inserting Michigan into a dialogue with other popular narratives. In other words, by living in a place without a critical mass of Xicano bodies, Mendoza and other MiXicano artists produce work that is multilayered and transcends easily discernible readings.

Employment Agency, like most contemporary art (as well as like Aztlán as a concept), functions as a palimpsest, with Mendoza reinscribing localized meaning onto a preexisting photograph contemporarily circulating within the Xicano community. For example, while within Saldívar's *Chicano Narrative* the linguistic signifiers of the cities in the photo simply serve as tropes for the role of migrant labor within Chicano history and literature, Mendoza redirects these signifiers and embeds within the painting certain regional histories and identities. While certain elements in the original photograph, such as the dirt "sidewalks," clearly appear to show a location other than Michigan, Mendoza has excluded these elements from her work, visually and textually placing it within the geographic specificity of Michigan.

Employment Agency also begins to articulate the role that class identity and MiXicano sovereignty play within the MiXicano community. A more recent painting, *Los Repatriados* (figure 16) speaks directly to the role that migration (lowriding) plays within the history and culture of the region. On a non-coded level, as the title attests, this image retells the narrative of the forced deportation of Mexicans and Xicanos from Michigan, as well as other locations in the United States, during the 1920s and 1930s. This image identifies the truckloads of Xicanos being driven back to Mexico because of Depression-era joblessness in the United States. Here we see the actual process of migration (lowriding), which within this image is read as the deportation of Mexicans (as well as Xicanos) and their forcible exclusion from the perceived opportunities of industrial Detroit. The coded iconic message is paramount to its proper reception. While knowing the general history of the deportation activities within the region is important to the interpretation of this work, knowing community history becomes even more relevant to decoding the work from an insider's perspective.

Beginning in 2001, a group of Detroit Xicanos, including Mendoza, began conducting oral histories in the city's Xicano community in an attempt to deconstruct, reconstruct, and document its history. While Xicano families have been living in the city for generations, many of their ancestors and relatives were forcibly deported to Mexico as part of the so-called repatriation activities. According to Paul Taylor, an economist

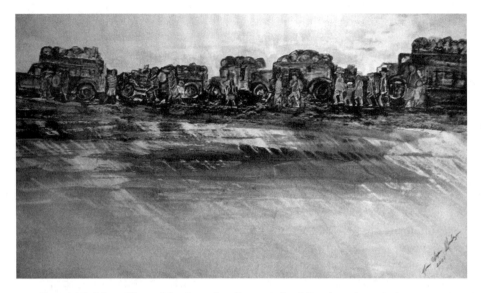

Figure 16. Nora Chapa Mendoza, *Los Repatriados*. Mixed media painting, 2001. Image courtesy of Nora Chapa Mendoza.

who studied Mexican labor during the Great Depression, a disproportionate number of the "repatriates" came from the Midwest, and Michigan in particular. This is highlighted in the work of the Los Repatriados Committee and Fronteras Norteñas.[16]

The community's response to the alienating practice of repatriation was overwhelming. Although numbers have never been analyzed, oral histories tell of numerous community members returning immediately to Michigan after their deportation to Mexico. So what Mendoza is doing with *Los Repatriados* is coded beneath the obvious image of *repatriación*: here we are simultaneously viewing the deportation and the subsequent return migration of Xicano and Mexican laborers. It is this specific regional articulation that is aimed at revisioning current discourses in Chicano cultural studies. To understand this lowriding you must know the community's history; that is its story. Like the return migration of Xicanos to Aztlán, as prophesized by the Hopi, this lowriding is cyclical movement to Mexico and back to Michigan. While settler-colonial society envisions a one-directional migration narrative, Indigenous societies see migrations as circular. So, even after being deported (many of these deportees were Xicanos whose ancestors had been within the United States prior to it becoming a nation-state), many completed their lowriding migration by coming back to Detroit.

Reframing • 125

It is important to note that Mendoza produced artwork for *Cantos al Sexto Sol*, a book produced in conjunction with the Aztlanahuac Project, and she also appears in Roberto Rodríguez and Patricia Gonzales's documentary film *Amoxtli San Ce Tojuan*. Both of these projects by the well-known Xicano public intellectuals position Chicano history within a framework of continental indigeneity. Mendoza's collaboration demonstrates her indigenist positionality and identity as a Xicana-Indígena.

Similarly, Mendoza engages Aztlán from her position as a former migrant worker living outside of the U.S. Southwest—"Aztlán Ocupado," as Armando Navarro attests.[17] Like other sacred sites hallowed by Indigenous peoples, Aztlán (as an emergence and migration story) functions as an axis mundi for Mendoza, but one with its focus on process and journeys, as opposed to a particular site within real space. If the Mexica considered Aztlán and Tenochtitlán to be alternate versions of the same concept, Mendoza envisions Aztlán as the actual movement between these two places. Aztlán is forged in the process of lowriding. Because she lives and works in Michigan, Mendoza's connection to place is very much about the migrations and movement between places. Just as the Anishinaabeg migration story tells of their arriving in the Great Lakes from the "land of the morning sun," the Xicano Aztlán is also about ethnogenesis and coming into peoplehood or nationhood (even along the U.S.-Canada border).

By analyzing both *Employment Agency* and *Repatriados*, we begin to understand how the MiXicano community views its localized (working-class, Indigenous, and migrant) histories in the region. Mendoza positions her work within a certain art world paradigm, while cultural projects of the Xicano Development Center, on the other hand, develop similar themes. However, the XDC is not interested in the closed parameters of fine art. Their visual and community-organizing work is important for a variety of other reasons. I focus here on their articulation of Aztlán in opposition to the essentialist discourses that have been posited by numerous scholars of Chicano history and literature.[18] While the concept of Aztlán is multivalent, depending on its spatial, temporal, and political deployment, the XDC and its crossover membership in the Movimiento Estudiantil Xicana/o de Aztlán (MEXA or more often MEChA) at Michigan State University, evoke an anarcho-indigenist conceptual framework within which power may be contested. The XDC was a direct-action community organizing collective active during the mid-1990s. They conducted many successful organizing efforts in Lansing, Detroit, and the surrounding areas and, after a period of inactivity, reconstituted their not-for-profit status in 2008.[19] By using recent theoretical refigurations, such as those produced by Cherríe Moraga or

126 • *Tlapalli*

Rafael Pérez-Torres, the XDC applies Aztlán to speak of an interstitial space where power is uprooted and "true" liberation enacted. For members of the XDC, as for Mendoza, Aztlán is an anticolonial and indigenizing process as opposed to a physical site. This radical proposition pushes the boundaries of Aztlán as a manifestation of Xicano sovereignty.

In 1997, Michigan State University hosted the MEChA national conference. Although many of the discussions and sessions were problematic in terms of their individual stances on the "Xicano nation," the conference as a whole attempted to address the failures of nationalism and the manner that sovereignty could be reengaged without reenforcing the geopolitics of settler-colonial nation-states. The first page of the conference program quotes from Emiliano Zapata's anarchist Plan de Ayala and displays the computer-generated graphic of a flag of the so-called nation of Aztlán (figure 17). The flag, a solid black field with white text (or possibly red in a color reproduction), begins to position the nonterritorial Aztlán in alliance with an anarchist and Indigenous agenda, one very much aligned with the working-class identity of MiXicanos. The text within the image simply reads AZTLAN, with the first letter of the text surrounded by a circle, symbolically standing in for the nonhierarchical structure that Aztlán must engage and enact if it is to serve, as Rafael Pérez-Torres argues, "to name that space of liberation so fondly yearned for."[20]

Beginning in 2004, MiXicano activists and XDC members Nora Salas and Ernesto Todd Mireles began to lay the groundwork for a broadly defined anarcho-nationalism. This indigenist "nationalism" expands on the radical labor activities of anarcho-syndicalism by extending the concept of collective self-governance in the workplace to the "national" level. This attempt to reinscribe Aztlán with a radical Indigenous identity, as well as a rearticulation of socialist praxis through a Xicano framework, is tied to a MiXicano class-consciousness that did not simply end with the collapse of the Chicano Movement but continues in the contemporary cultural practices of the Michigan Xicano community.

Mireles and Salas were prefiguring a form of anarcho-indigenism, an Indigenous mode of praxis commonly tied to the work of Taiaiake Alfred (Mohawk) and Glen Coulthard (Dene). Alfred names this "ancient war ritual" Wasáse, a Rotinoshonni (Haudenaushaunee) word used to describe "a ceremony of unity, strength, and commitment to action."[21] Alfred continues, writing that "if we are to free ourselves from the grip of colonialism, we must reconfigure our politics and replace all of the strategies, institutions, and leaders in place today."[22] For Alfred, this occurs through Wasáse, a form of anarcho-indigenism. In the Great Lakes, this anarcho-indigenism

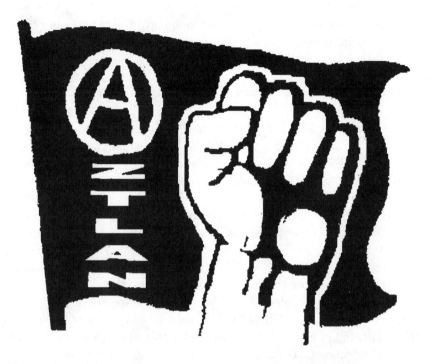

Figure 17. Ernesto Todd Mireles, Aztlán flag. From MEChA (MEXA) National Conference, 1997. Image courtesy of Ernesto Todd Mireles.

is located in both Xicano and Anishinaabeg political structures, as well as within their newly developed kin-relationships.[23]

These Indigenous and indigenist radicalisms located in the work of Mendoza and the XDC have opened spaces for future nonessentializing Xicano political organization, social production, and Indigenous sovereignty. Moreover, these intellectual activities prefigured ideas now circulating in Indigenous politics by at least a decade. Through their radical political and cultural activities, these individuals in Anishinaabewaki-Michigan have been able to create a feeling of home in spite of certain economic, linguistic, and cultural exclusions. After all, Aztlán is in us all; we just need to claim it and exert its sovereignty. These MiXicano artists and cultural workers have staked their claim, even if their work is often disregarded in national forums. By lowriding northward, Aztlán as Xicano sovereignty is extended and expanded. This expansion, however, does not impede Anishinaabeg sovereignty (or other Indigenous sovereignties); rather, it complements it. Creating Aztlán in a way that does not overwrite other

MiXicano Art

The existence of a Xicano artistic canon is still very much in question, although the canon is being strengthened by recent publications, such as the A Ver series from UCLA, as well as recent exhibition catalogues documenting the Xicano avant-garde. Although certain artists have achieved mainstream notoriety, as highlighted by the popularity of ASCO in contemporary art publications, Chicano art history has yet to be fully written. The recording and documentation of Xicano murals, for instance, has received virtually no attention outside California and the Southwest. In recent decades, California Xicano murals have been addressed by art historians Holly Barnet-Sánchez and Eva Cockcroft, among others, while archival documentation by Judith Baca and her *comadres* at the Social and Public Art Resource Center (SPARC) has created a clearinghouse of public art. Guisela Latorre's book *Walls of Empowerment* is an excellent example of the new direction that Chicano art history is taking.[24] In her introduction, Latorre recounts a conversation with muralist Judy Baca. During this conversation, Baca thanks Latorre for continuing to work on murals, especially since Xicano murals have lost their cachet.

Apart from these developments, the documentation of murals by Xicano artists has received little consideration. As Rita González points out, "few monograph publications and scholarly articles detail the work of individual artists."[25] The fate of Great Lakes and Midwestern Xicano murals is particularly serious, with little to no attention paid to the individual artists. In fact, there is virtually no art historical analysis of Midwest murals and muralists, the only exception being the scant research on the Xicano murals in Chicago. Much of this research was conducted twenty years ago and not a single monograph in UCLA's A Ver series investigates a non-Southwestern Xicano artist (although some do investigate Latino artists outside the region).

In 1987, Chicago's newly established Mexican Fine Arts Center Museum (now the National Museum of Mexican Art) hosted an exhibition titled *The Barrio Murals / Murales del Barrio*. As curator René Arceo Frutos writes in the catalogue, the exhibition sought to highlight "the contributions that Mexican muralists have made to the Chicago mural scene."[26]

This exhibition, occurring at the zenith of the community mural movement, documented the history of Xicano and Boricua murals in Chicago.

Tracy Grimm, formerly of the University of Notre Dame's Institute for Latino Studies, maintains that "relatively few institutions have initiated archival projects to find and preserve" Latino visual art and associated ephemera.[27] In turn, MiXicano art history is very much in peril of vanishing without immediate changes in documentation and exhibition. Founded in 2001, Artes Unidas, a statewide coalition of Xicano and Latino artists supported by the Michigan Council for Arts and Cultural Affairs, could possibly serve as the impetus for that change. Unfortunately, they have been unable to attain grant funding that would allow them to digitize the personal collections of Michigan Xicano and Latino artists. But where exactly does MiXicano visual culture fit within the larger discourses on Chicano, Latino, and Native American art history? This is a larger question without any definitive answer; however, as I propose, it is one that needs more conversations with contemporary Indigenous art.

Chicano Art: Resistance and Affirmation, known simply by the acronym CARA, was the first large-scale exhibition of Chicano art to be hosted by mainstream institutions. Traveling to ten cities across the United States from 1990 to 1993, it served as the stimulus for further exhibitions, criticism, and documentation. The exhibition included fifty-four murals, of which seven came from the Midwest (four from Chicago). Of the three remaining Midwest murals, two were painted in Michigan. While the Michigan murals thus made up approximately 6 percent of all those in the exhibition, their inclusion nonetheless points to the existence of a productive Xicano mural movement in the state.

Even so, the scholarship on Xicano visual and artistic production continues to neglect the existing artistic practices in areas outside the Southwest. Although regional absences and biases within Xicano art historical and curatorial work were pointed out early in the development of a Xicano canon, they have not been significantly addressed within the literature. As early as 1976, the journal *Aztlán* recognized the absence of academic material engaging historical and sociological concerns affecting Latinos in the Midwest with a special issue devoted to the Midwest. It was in this issue that Gilberto (Gilbert) Cárdenas published "Los Desarraigados," an article that examined the sociological impetus for Mexican migrations to the region. More recently, Cárdenas has been involved in administering and archiving Chicano art history and new developments, including those across Anishinaabewaki.

130 • *Tlapalli*

Yet even with the continued development and recognition of regionally specific Chicano histories, cultural studies and art historical scholarship in the area is still sparse. The most significant recent development in the field is the currently inactive Midwest Latino Arts Documentary Heritage Initiative at the University of Notre Dame's Institute for Latino Studies.[28]

As artists and cultural workers, both George Vargas and Martín Moreno, the *CitySpirit* artists, have in one way or another worked to demarginalize research on non-Southwestern Chicano art histories. As a graduate student at the University of Michigan, Vargas wrote his PhD dissertation on the history of Latino artists in Michigan and published an occasional paper for the Julian Samora Research Institute addressing Michigan-based Cuban American muralist José López. Vargas has since been hired at Texas A&M University-Kingsville, a hotbed of Chicano visual art. His scholarship no longer deals specifically with issues in MiXicano visual production, although his experiences in Michigan influence his art historical scholarship on Chicano art, in particular his book *Chican@ Art*.

Moreno grew up in the Sunnyside barrio of Adrian, Michigan. He spent his childhood working in the tomato fields and his early adulthood in the chemical and manufacturing industries.[29] He was one of the key figures in the community mural movement in Michigan. In 1978 he painted *Vibration of a New Awakening* in Adrian and in 1980 the *Latino Experience in Michigan*, an interior mural at Eastern Michigan University. Like Vargas, Moreno left Michigan at least in part because of the lack of exposure for Xicano artists in the state. He currently lives in Arizona, where he has gained recognition making art and working with Xicano youth.

Vargas served on the Raza Art and Media Collective editorial committee alongside noted Xicano and Boricua artists and intellectuals Ana Cardona, Jesse Gonzales, S. Zaneta Kosiba-Vargas, and Zaragosa Vargas. Although outside the scope of this book, the Raza Art and Media Collective, with its equitable gender relationship and its focus on the importance of visual art for Michigan Latinos, merits an expanded study. Quoting George Vargas, Karen Mary Davalos notes that the "rejection of a 'strict Chicano or Latino/Raza aesthetic' allowed Midwestern groups to support the Chicano nationalist project of self-determination . . . while remaining inclusive of artists whose identities were not Chicano."[30] In Chicago, MARCh (Movimiento Artístico Chicano) and art historian Victor Sorell have done an impressive job of documenting Movement art-making practice in that city. The National Museum of Mexican Art in Chicago and El Museo Latino in Omaha, as well as other museum and university Chicano studies programs, have also helped document and preserve Chicano art history in the region.

Regional and local Xicano histories cannot be completely removed from national and international narratives. In 1968, the same year that Antonio Bernal painted the Del Rey mural (the first recognized "Chicano mural" in California), Mario Castillo and youths from Chicago's Mexican barrio of Pilsen created a mural titled *Peace-Metafísica* on the exterior wall of the Halsted Urban Progress Center. According to the *Barrio Murals* catalogue, this was Chicago's first public mural since the WPA and the impetus for the Xicano mural movement in Chicago and throughout the country.[31] Over the course of the next decade, community mural movements emerged around the globe. Muralism, and its aesthetic use of Indigenous histories, became a marker of Xicano indigeneity and a signifier of sovereignty.

Murals and other forms of Xicano artistic production, including *CitySpirit*, became the site of resistance and a location for the rearticulation of Xicano sovereignty. Through highly adaptable visual forms, Xicano communities were able to position themselves and their histories on their own terms, often at odds with mainstream and settler-colonial perspectives. Public art allowed them to create a visible "home" or land base within the public sphere of an otherwise oppressive location. Public art concretized Aztlán along the U.S.-Canada border.

Like countless murals painted as part of the community mural movement, many Chicano Movement murals in Michigan expressed solidarity with working-class and Third and Fourth World peoples. Internationalist solidarity was a recurring theme that connected MiXicano murals to other community-based art-making practices, as well as to global anticolonial struggles. If we look at Martín Moreno's *Vibrations of a New Awakening*, we see expressions of cross-cultural solidarity with other working and oppressed peoples. In this nonextant exterior mural in Adrian, racially ambiguous laborers march in protest through the rows of a factory farm toward the hideous architecture of an industrial factory. As posited in *Vibrations*, the "awakening" of humanity occurs through the "universality" embedded in all working-class and oppressed peoples of the world. In other words, our struggle to awaken and to be accepted as equals is a universal struggle to become fully human. It is one of anticolonial solidarity. This mural connects us to both Alurista's and Vargas's earlier comments on the process of humanization for Xicano sovereignty.

This expression of solidarity was also present in Xicano poster production. In the essay "Not Just Another Social Movement," George Lipsitz states that the "internationalism, class consciousness, and solidarity with struggles for social justice among other aggrieved groups manifest in these posters reveal that the movement was an effort to convince people to draw

their identity from their politics rather than drawing their politics from their identity."[32] As Lipsitz asserts, Xicanos were forming their identities based on political praxis and not solely on identity and racial politics. This ethnogenesis allows Xicano sovereignty to be a radical one that isn't based simply in identity politics.

Aztlán in Detroit

While studies dealing with southwestern Xicano histories have commonly focused on race as the impetus for subjugation, research dealing with midwestern Xicanos has often treated class as the primary basis for Xicano inequality. In his study of Xicano and Mexican communities in urban and rural centers of the Midwest, Dennis Valdés emphasizes four reasons for a continued Xicano working-class consciousness:

> First, the experience of conquest and systematic subordination in the Southwest was not replicated in the Midwest. Second, the sharpest race-based historical division in the region has been between Black and White, rather than Mexican and Anglo. Third, because of the smaller and more scattered Mexican population, there were fewer opportunities for a tradition of mutual and systematic hostility based on racial features or competing identities to develop. Fourth, Mexican migration to the region remained overwhelmingly a function of employer demands for unskilled labor.[33]

As Valdés argues, the Xicano and Mexican migrations north (what I call lowriding) responded to the seasonal industrial and agricultural needs for manual labor. Migration and diaspora were linked to capitalist economic needs. This continued demand for labor positioned (and continues to position) midwestern Xicanos in a certain working-class location within the region. Xicanos are proletariatized and detribalized American Indians and their descendents. While recent oral histories tell oppositional narratives of specific racial and linguistic oppression,[34] Valdés's point is clear: the established discourses on race and class in Xicano studies are ineffective when applied to the specificity of Midwest histories.

To properly connect the regional history of Michigan Xicanos with those of the U.S. Southwest, we need to begin with the earliest migrations into the Midwest region. Initial *migrantes* came predominantly from Texas, mainly from in and around San Antonio, as well as from northern and north-central

Mexico. Zaragosa Vargas writes that the "Detroit Mexican community took form during and after World War I when Mexican immigrant workers, mostly those who had worked on Midwest railroads and in steel mills and foundries, settled in the city."[35] This pattern of settlement created huge colonias and barrios across Michigan in industrial cities like Saginaw, Flint, Pontiac, and Lansing, among others.[36] In many of these cities, especially Detroit and Lansing, Xicanos intermarried with urban Anishinaabeg. Today, both cities have significant populations of Xicanishinaabeg, Native people of mixed Xicano and Anishinaabeg ancestry. My 2012 installation at the Art Gallery of Windsor (*Dismantling the Illegitimate Border*), located across the river from Detroit, explored these shared histories. Members of The Raíz Up, a multiracial hip-hop collective based in Southwest Detroit, likewise explore these connections in their music and graffiti. This shared history and sovereignty still needs to be written.

From the very earliest stages of migration, the Xicano community in Michigan was subjugated by and subjected to the seasonal and economic peculiarities of the local labor market. While the economies in the Southwest had similar seasonal demands for workers, the cyclical nature of agricultural and industrial production in the Midwest made the region's employers reliant on *trabajadores del campo* in the summer and manual industrial laborers in the winter. Because the need for industrial labor was keyed to the harvesting and mining of raw materials, class and ethnic identities developed differently in the Midwest than in the Southwest.

According to Norman Humphrey, all "Mexicans," regardless of citizenship status, were perceived as working class, regardless of their prior class affiliation in Mexico or the Southwest. He writes that even skilled professionals "tended to become common laborers" once they moved north, "as a consequence of the specialized character of American production."[37] Unlike the severe phenotypical and "racial" oppression that Mexicans faced in the Southwest, the experience of Midwest Xicanos is predicated on a working-class identity similar (although not identical) to that of other working-class immigrant groups. Although Humphrey collapses the complexities of social identity into a monolithic class system, what may be taken from his position is that class, although not the only causality, must be addressed in tension with race, gender, and other social markers.

Much like the Xicano community in Los Angeles and countless other working-class communities of color, Detroit's Xicano community was spatially dissected into two separate parts when city planners ran an interstate highway through the heart of the barrio during industrial expansion. The highway slicing through the community has become, as Gloria Anzaldúa

might say, *una herida abierta*.[38] To this day the highway divides the real space of the barrio, with community residents and institutions situated on either side of this open wound.

Although Anzaldúa evoked the herida abierta to speak about the U.S.-Mexico border, not a highway, she also recognized its application to all borders: geopolitical, community, racial, gender, sexual, and class, among others. She writes that "borders are set up to define the places that are safe and unsafe, to distinguish *us* from *them*."[39] In effect, Southwest Detroit is the borderlands par excellence: situated between the United States and Canada, divided by the violence of the highway, marginalized by the regional Southwest-centrism of the Xicano community, and operating as a Brown- and Red-skinned neighborhood in the Black-white racial dynamics of a northern city.

Following the open-endedness of Anzaldúa's frontera, I expand our working definition of la (otra) frontera to incorporate the complexities of MiXicano experiences. After all, la frontera cannot be encapsulated simply by the geopolitics of the U.S.-Mexico borderlands. Michelle Habell-Pallán welcomes the significance and signification of the U.S.-Canada border in her reformulation of José Martí's concept of *Nuestra América*. Habell-Pallán writes: "As a scholar trained in the southwest, I had never conceptualized Canada as participating in a larger culture of the Americas. However, my analytical framework was changed forever during my first drive across the northwestern border" between Washington state and the Canadian province of British Columbia.[40] Likewise, many radical working-class midwesterners construct an imaginary Canada capable of unraveling U.S. capitalist-colonialism (which, of course, it cannot. Canadian prime minister Stephen Harper's neoliberal and anti-Indigenous agendas make this especially apparent). This imaginary is analogous to the way many Indigenous Mexicans and Central Americans envision the United States as enabling familial economic stability. It is through the concretization of this Canadian imaginary with the lived reality of the geopolitical border that la otra frontera is manifest. If fronteras are to remain theoretically relevant and fertile to our multifaceted intellectual and political projects, they must be reinvigorated to encompass otras fronteras, including la otra frontera with Canada. As an Indigenous people, Xicanos have never recognized settler-colonial boundaries, yet they are still socially and politically affected by them.

It was along this open wound, the violence enacted by the highway and the Canadian border, that MiXicano muralists concentrated their didactic, pedagogical, and organizational efforts as part of the Chicano Movement.

Reframing • 135

A few hundred meters away from the highway is situated one of the few extant murals in Michigan from, as George Vargas refers to it, the "Latino Mural Renaissance." At the corner of Bagley and Sainte Anne streets, artists Moreno and Vargas painted their outdoor mural. Although Chicano studies historiography habitually positions the late 1970s as the end of the Chicano Movement, Xicana anthropologist Karen Mary Davalos argues that in the Pacific Northwest the majority of Xicano murals were actually painted in the 1970s and 1980s and that "by 1974 the mural became one of the most popular visual forms throughout the United States."[41] In certain areas, such as the Northwest and Midwest, important Chicano Movement activities occurred well into the 1980s and even through the 1990s. As for Michigan, the late 1970s and early 1980s were the most active years for Movement artists. During this productive period, artists were not only manufacturing vast amounts of art but were also theorizing about the artist's role within the community and the significance of the physical location in which they constructed works.

The physical geography that *CitySpirit* occupies within the barrio is of utmost importance. Likewise, the position of the barrio in relation to the international border is essential when discussing local Xicano cultural practices. As if attempting to reconstruct the border experience *desde el sur al norte*, the real space of the barrio, with its physical placement "north of the border," can serve as a metonym for the Michigan Xicano experience. While the border is often used as a trope in Chicano studies, it functions here in a much more concealing manner. While Detroit's Xicano community may appear analogous to counterpart communities in the U.S. Southwest, upon closer inspection these similarities become superficial and localized structures, and identities need to be clarified.

In 1997–1998, nearly twenty years after the initial painting of the *CitySpirit* mural, Michigan artists Vito Valdéz and James Puntigam painted a larger mural across the street, simply entitled *The Cornfield*. Similar to *CitySpirit*, this public mural physically and metaphorically repositions Aztlán to the United States–Canada border. Valdéz led the restoration of *CitySpirit* in the same year. Although these two murals are stylistically and compositionally dissimilar, they both play a particular role within the community and help locate the cultural and physical space for the community frequently dubbed "Mexicantown."

Within one city block of these two murals are the main cultural institutions of the barrio. Immediately to the east is the Roberto Clemente Community Center, named after the famous Boricua baseball player. While nonmembers of the community refer to the area as Mexicantown,

the naming of the community center speaks to the Boricua history and thus the pan-Latino identity of the neighborhood.[42] To the south of the mural, toward the Detroit River and la frontera with Canada, is Sainte Anne de Detroit church. For George Vargas, the church performs a particular role in the community. He writes that "in recent history, the church has served as an organizing force in the Latino colonia."[43] At certain moments in the history of the barrio, Ste. Anne's has been instrumental as a meeting place and as a political force for Catholic Xicanos. Interestingly, Sainte Anne de Detroit was initially constructed in 1701, when Antoine Laumet de La Mothe, sieur de Cadillac, the first European to establish a settlement in the region, arrived in the area. Catholic Indigenous and settler-immigrant populations both attended mass, the same function the church provides residents today.

To the west of the mural, just across the street before reaching the highway, is the Bagley Housing Association (BHA) and its contemporary gallery space. While the gallery doesn't exhibit solely the work of local Xicano, Latino, and other Indigenous artists, the majority of its exhibitions feature the work of artists from Detroit and Michigan. The gallery's director, Ursula Murray, has worked with city and state agencies to create traveling exhibitions and corresponding catalogues of art by Michigan Latino artists.[44] A few miles to the west, directly down Michigan Avenue, American Indian Health and Family Services is one of three Native centers in the city.

La Casa de Unidad, located a few blocks away, was another important cultural space within the community. Founded in 1981, La Casa de Unidad stopped offering services in 2006, but hopes to reopen. They offered courses, hosted films and exhibitions, and served as the cultural core of the community. In *Mexicans and Mexican Americans in Michigan*, Rudolph Valier Alvarado and Sonya Yvette Alvarado write that "the nonprofit organization's mission is to provide southwest Detroit and other communities with the best available resources and programs which discover, develop, celebrate, and advance the Hispanic/Latino arts."[45] La Casa de Unidad also published collections of poetry and texts on the cultural history of the Latino and Xicano community in Detroit. Although not mainstream or large institutions, the BHA and Casa de Unidad have been pillars of the community by exhibiting individual and group shows, providing a space where artists can work with local youth, and developing artist networks within the city and state. Their particular histories need to be written and included in this discussion. Chilean exile, longtime Southwest Detroit resident, and musician Ismael Durán opened El Garage Cultural on Livernois Avenue to fill the void of La Casa de Unidad's absence. For the last few

Experiencing La Otra Frontera

years, El Garage has hosted music and art classes, as well as community events and concerts. In 2012 and 2013, I worked with community youths to build a Mexican work-trike that doubled as a mobile screenprinting studio.[46]

Experiencing La Otra Frontera

As this chapter began by placing *CitySpirit* and *The Cornfield* as sites that exert sovereignty along la otra frontera, I will close my arguments by returning to *CitySpirit* as a signifier of MiXicano experience. As previously stated, in the late 1970s Vargas and Moreno, with the organizational help of Carolina Ramón, painted this work, now one of the last remaining Movement-era murals in Detroit. *CitySpirit* drew from multiple influences while asserting itself at the heart of the Xicano barrio. It was named in allusion to its funding by the National Endowment for the Arts' CitySpirit Program. The mural, in its specific location in the real space of the community along la herida abierta, plays a certain function in asserting Xicano sovereignty and creating Aztlán for Detroit Xicanos.

In his work dealing with space and place in urban Chicano literature and culture, Raúl Homero Villa writes that "social commentators have long noted the importance of the barrio's internal 'geographical identity.' This identity, manifest in the unique conjunctural forms of its residents' cultural practices and consciousness, has been a vital mode of urban Chicano community survival against the pressures of a dominant social formation."[47] Through their "internal geographical identity," MiXicanos posit a unique form of localized consciousness, or as Sandoval would conclude, "differential consciousness." Like the visual production of Mendoza or the XDC, *CitySpirit* serves as a positive articulation of the community's cultural practices. In addition, *CitySpirit* contributes to the creation and maintenance of a Xicano home space along la otra frontera, a sovereign space we should call Aztlán. Blocks away from the fragmentation caused by the poorly (or cleverly) planned highway construction, the Xicano community has asserted a communal sense of identity and home with the painting of *CitySpirit* and *The Cornfield*. Using Villa's language, *CitySpirit* creates a specific "geographic identity" by using larger Xicano icons and references specific to the Detroit Xicano community. Many casual observers, Xicano and non-Latino alike, use the mural to identify the geography of the neighborhood and position themselves within the city. According to Vargas, thousands of those who have viewed the mural have no knowledge of the original artists or of the work's origins but appreciate it as a visual portrait of Mexicantown and of Detroit.[48]

CitySpirit was painted in an industrial-grade paint on the side of a building in the heart of Southwest Detroit. The painting is designed in a collage-like manner with images painted virtually onto one another within the picture-plane of the flat wall surface. The main focal point of the composition is a tree in the center of the painting. This tree extends downward toward the surface of the sidewalk and upward to the roof of the building on which it is painted. To the right-hand side of the painting are a variety of iconographic images relating directly to precolonial Mexico, while the left-hand side locates the mural firmly within the local community. The overall theme of the composition rearticulates the local Xicano history of Waawayeyaattanong or Zagaajibiising (Detroit), but it does so by way of a self-determined, community-based, visual sovereignty.

The iconography of *CitySpirit* draws directly upon the urban, pluriethnic, working-class history of Detroit, but it is grounded in an earth-based, agricultural Xicano labor history. According to Vargas,

> One of the most important models that [the artists] considered was Diego Rivera's *Detroit Industry* fresco cycle executed in 1932 and 1933 at the Detroit Institute of Arts. Its design features a historical and cultural portrait of the city of Detroit and the state of Michigan, from ancient to modern times. Inspired by Rivera's simple but accurate narrative of the agricultural, industrial and scientific technology of a contemporary era in Michigan, the two artists organized the design elements according to a symmetrical framework: a simple tree would unify the ancient and contemporary worlds.[49]

CitySpirit directly links Vargas and Moreno, as well as Detroit Xicanos, to Diego Rivera. Oral histories tell the story of Rivera's interaction with the parents of a certain Xicano artist still active in the community today. Accordingly, Diego Rivera's presence within Chicano art in the Midwest is not matched anywhere else in the United States.[50] In 1972, Chicago artist Marcos Raya created a "Chicano version" of Rivera's *Man at the Crossroads* (figure 18). Raya's 1973 painting is titled *Homage to Diego Rivera* and repositions Rivera's politics into twentieth-century Xicano and Latin American politics. Additionally, Martín Moreno and George Vargas both continue to evoke Rivera's Detroit Institute of Arts (DIA) fresco as a source of both artistic and aesthetic inspiration. In its founding principles, Artes Unidas, a coalition of Latino artists in Michigan, specifically recalls Rivera and Frida Kahlo as MiXicano cultural patrimony.

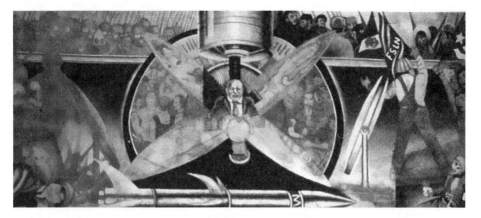

Figure 18. Marcos Raya, *Homage to Diego Rivera*. Exterior mural in Chicago, 1973. Image courtesy of Marcos Raya, photo courtesy of Timothy W. Drescher.

In *CitySpirit*, the iconography of a tree and its root structure dominates the composition, with the tree taking up nearly one-third of the visual space and the roots and mineral substrata extending the entire width of the working surface. Trees perform sacred centering roles in many Indigenous and traditional societies. They are the axis mundi. To either side of the tree are enormous hands giving strength and support to the base of the tree. Within its trunk are two ancient sculptural forms, one referencing Africa and the other Indigenous Mesoamerica. Here solidarity is established between the working-class peoples in the Black and Red/Brown communities of Detroit. Since Detroit has such a large African American population, this alignment seems appropriate with this cross-cultural solidarity still existing in today's Detroit. One such example is The Raíz Up, an Indigenous-identified, yet multiracial, hip-hop collective based in Southwest Detroit. Two of The Raíz Up's main organizers are Sacramento Knoxx, a Xicanishinaabe DJ, and Antonio Cosme, a graffiti artist of Xicano and Boricua ancestry.

To the right of the "Cosmic Tree" are icons delineating the Indigenous legacy of Mexico. Both earthly and sacred versions of Quetzalcoatl (who was both an actual human being and teotl) become manifest inside a representation of Da Vinci's *Renaissance* or *Vitruvian Man*, as well as the re-creation of an architectural Quetzalcoatl, an image frequently seen in Xicano murals. This plumed-serpent teotl (best translated as "energy," but frequently mistranslated as "deity") was one of the main spiritual figures in Mexica culture. In addition to the Quetzalcoatl of Mexica cosmology,

Vargas and Moreno include the Mayan Chac Mool figure, who according to George Vargas "represents a fallen warrior."[51] Like other Xicano muralists in the Southwest, Vargas and Moreno rearticulate multiple Mesoamerican and Native American iconographies within a single visual narrative. Through this symbology, Vargas and Moreno assert a diasporic Indigenous identity for Detroit Xicanos. This mural establishes the fact that although Xicanos have migrated to Detroit from the Southwest or Mexico, they are Indigenous to this continent and thus cannot be dehumanized as "illegal aliens." This assertion of belonging, as seen in much of the current cultural production being created in Mexicantown, helps fashion a sense of sovereignty within Southwest Detroit. As Shifra Goldman and Tomás Ybarra-Frausto write, the use of "pre-Columbian motifs in Chicano art served to establish pride and a sense of historical identity for the artists and the communities they addressed."[52] *CitySpirit*, elucidating a "historical identity" combined with a "geographical identity," is intended for a MiXicano audience and helps establish and maintain sovereignty along la otra frontera.

While the right side of the mural shows a Xicano interpretation of Indigenous Mexican histories, the left side portrays modern Mexicantown emerging as a major junction in this postindustrial city. This imagery underscores the strong presence of Xicano culture in Detroit while representing a critical part of the multicultural, multiracial population in Michigan. Contrasting with the right side of the image, the left side of the mural does not appear as heavy with collage-like imagery. In this portion of the composition, Vargas and Moreno have included many different elements of Mexicantown's built architectural landscape. For instance, they have depicted the Hubbard Richard building, the location where the mural is painted; Sainte Anne de Detroit church; downtown Detroit's Renaissance Center, recently renamed after an automotive corporation; and the Ambassador Bridge, the gateway through la frontera norteña.

Across the top of the mural are the dualistic representation of night and day as well as a man and woman controlling their own destinies, as symbolized by the industrial cogs. Here the homage paid to Rivera is apparent. Unlike Rivera's *Man and Machine* fresco, which uses images of laborers to represent his vision of a proletarian future, Moreno and Vargas have used laboring Xicanos to portray their familial ties to industrial labor, their communities' dependence on manual labor, and a continued working-class consciousness.

As previously stated, the focal point of the mural is the central element of a tree. According to George Vargas, the tree can be seen as a source of

energy, symbolizing the Cosmic Tree that featured prominently in Meso-american, Native North American, Egyptian, Christian, and Buddhist art. Vargas and Moreno use the tree in much the same way that Rivera uses a "tree structure" in his DIA frescos. Art historian Francis O'Conner has argued that the entire structuring of Rivera's DIA mural cycle, specifically his use of directionality, comes from the Mixtec Codex Féjerváry-Mayer.[53] In addition, the tree becomes an axis mundi that serves as the center of the Indigenous world, as well as signifies Aztlán. It connects the earthly domain with the supernatural. Just as Aztlán symbolized the center of the world for the Mexica, here the tree illuminates an Indigenous axis mundi which then leads us back toward Aztlán. The tree as the center of the mural and of the world intimates Aztlán as the place of emergence.

The use of the tree by Vargas and Moreno, as well as Vargas's allusion to it as the Cosmic Tree, is a direct gesture not only to Rivera and his use of directionality, but also to the Indigenous cosmology and artistic production of Anahuac. Once again, Vargas and Moreno assert the specific identities of Detroit Xicanos. Even though they are geographically distant from Mexico and the Southwest, they are able to incorporate, recontextualize, and rearticulate these Indigenous epistemologies regardless of global diasporas (lowriding). As cited earlier, Frantz Fanon acknowledges the difference between culture and custom. He writes that "culture has never the translucidity of custom; it abhors all simplification. In its essence it is opposed to custom, for custom is always the deterioration of culture. The desire to attach oneself to tradition or bring abandoned traditions to life again does not only mean going against the current of history but also opposing one's own people."[54] After all, these artists and activists are interested in constructing a vibrant culture, not purely reifying custom. This mural, among other artworks, moves Xicano sovereignty into the present and future.

Directly below the tree, spanning the entire width of the mural, are various mineral, root, and seed elements. The references here are multiple. The use of imagery in a Rivera-esque manner again connects directly to the *Detroit Industry* murals. On the north and south walls of the Garden Court, Diego Rivera used minerals to represent what he saw as the four races of humanity. Below each of these racially constructed figures, Rivera continued depicting the mineral substrata. In a pamphlet on *Detroit Industry*, Linda Downs writes that "gigantic hands grasp materials used in the production of steel, symbolizing both mining in particular and the aggressive drive to capture the riches of the earth in general."[55] For Vargas and Moreno, in contrast to Rivera, the hands do not pull minerals from the earth but instead grow organically from it. While Rivera expressed an unorthodox

proindustrial Marxism, Moreno and Vargas, as subjects of a late-capitalist settler-colonial United States, have seen the ill effects of industrialization on the earth and on all working peoples. Here, the artists have chosen instead to portray the minerals as remaining in the earth and thus sustaining the hand. The artists have taken an overtly ecological stance.

In an essay addressing *CitySpirit*, Vargas writes that "the unique geology of Michigan is pictured, a source of various minerals and fuels in the Great Lakes region. Iron ore provides steel which is used in the manufacture of automobiles, the state's leading industry."[56] Here the minerals, native to the region, stand in for the brown-skinned Xicano bodies. Iron ore, representing Xicano physicality and presence, positions Detroit Xicanos as an "organic" working-class community (not "illegal," as immigration proponents would have it) that works alongside other groups in this location that straddles la frontera norteña. Following Raúl Villa's assertion, the local (read Native) mineral elements, as well as specific references to the lived environment of the local community, are used to position a "geographical identity" for Detroit Xicanos. It is this identity that the communities in and around Mexicantown create in contrast to the "pressure of a dominant social formation."[57] Today, the mining of these minerals continues to transpire on Indigenous lands. This fact was made apparent when Anishinaabeg activists in Michigan's Upper Peninsula unsuccessfully challenged nickel and copper sulfide mining at Miigizziwasin (Eagle Rock). Other examples include the Canadian Idle No More movement or the 2013 Elsipogtog Mi'kmaq resistance to fracking in Nova Scotia. Each of these highlights that ongoing relationship between Indigenous bodies, Indigenous land, and the extraction of minerals.

In Rivera's *Detroit Industry*, the four "races" of humanity extract the materials from the earth, reproducing Rivera's epistemology of *Man (Being) Master of the Universe*, an ideology that he enacted in the infamous non-extant Rockefeller Center mural in New York (*Man at the Crossroads*) and subsequently replicated in Mexico City (*Man Master of the Universe*). In the DIA fresco cycle, Rivera used minerals to represent racial difference, with iron ore representing the Indigenous peoples of Turtle Island-the Americas. For Vargas and Moreno, the same metaphor applies, but it is enacted in a more radical manner. While Vargas specifies that iron ore is used to fuel the steel industry, the ore, referencing Rivera, also becomes the metaphoric Indigenous and "mestizo" body and her/his labor. In fact, "la raza de bronce," as expressed in El Plan Espiritual de Aztlán, translates in this mural, for Vargas and Moreno, into "the iron ore people." Since the ore operates as a trope for the Indian-turned-Xicano body, as long as the

Reframing • 143

ore remains in the earth the Native and cross-blood (Xicano) labor cannot be colonized and exploited. In a sense, leaving the minerals unmined signifies the anticolonial bodies and Indigenous polities of Turtle Island-the Americas. This simple visual device allows for a direct confrontation with the colonizing practices of capitalist economies and settler-colonial nation-states. Like the narratives of Mendoza, this MiXicano mural continues to attack the hegemonic narrative of both the Southwest Xicano experience and that of working-class, "immigrant" Detroit. With the iron ore, as the Xicano body, deposited solidly within the earth, the Xicano community is represented as having likewise solidified its sense of sovereignty in the city and along la otra frontera. *CitySpirit*'s location at the heart of Mexicantown and its recent restoration have ensured that the mural will continue to be a signifier of Aztlán and sovereignty for Xicanos along la otra frontera.

In the end, MiXicano visual culture acts as a reframing device within the barrio and establishes an organic sense of community, sovereignty, and Aztlán along the U.S.-Canada border. By turning to *CitySpirit*, as well as to the work of Mendoza and the XDC, we begin to reframe the omissions and absences in the development of an expanding Xicano artistic canon, one where Aztlán serves as the central organizing device or its axis mundi. Through the simultaneous problematization and resolution of la frontera, we begin to transcend the present discursive limitations of Chicano studies and open up new possibilities. After all, is it not this "opening up" that allows the borderlands to be so politically transgressive? And if it opens up, have Xicano artists and activists succeeded in opening up la frontera and declaring Aztlán for Xicano Indigenous sovereignty?

CHAPTER FIVE

Creating

Creating Aztlán, Finding Nepantla

If the artists in "Reframing" challenge Chicano art historiography by reterritorializing Aztlán along the U.S.-Canada border, the three canonical artists discussed in this chapter intimately articulate Aztlán in their visual corpora. This chapter's investigation is thoroughly tied together by discussions of aesthetics, internal solidarity, and a move toward new figurations on Xicano sovereignty. These artists lowride through Aztlán and migrate toward Nepantla, a Nahuatl term that references postcontact and colonized identity. Nepantla and Aztlán, respectively, elucidate the presence of coloniality and the anticolonial knowledge that remains centrally located in Indigenous epistemologies. For the three artists covered in this chapter, Aztlán is not the final destination for their lowriding journey. Instead, Aztlán, Nepantla, and lowriding are each open-ended processes, as opposed to easily definable entities or final destinations. Similarly, sovereignty is not an object or thing, but rather it is a movement, a process, a migration story. Sovereignty is a journey of lowriding across time and space and is the core of this book and of the artworks that I analyze.

Accordingly, I address the work of Gilbert "Magú" Luján, Malaquías Montoya, and Santa Barraza. These individual artists, two from California and the third from Texas, have been selected for multiple reasons. First, they are chosen because they, each in their own right, have been important figures in the Chicano Movement. Barraza and Montoya both have

monographs written about their work, but nonetheless remain understudied. Luján, who passed into the spirit world in 2011, has little written on his work. While each artist is highly recognized, the critical scholarship on their artistic practices, individually or collectively, nonetheless remains scant. By filling this void, "Creating" considers how these artists speak directly to Aztlán and, especially in the case of Barraza, begin to conceptualize a postcontact indigeneity in the form of Nepantla. In this way, each of their artistic practices is crucial in Creating Aztlán, by informing both the book you are reading and the process of establishing Xicano sovereignty.

An additional reason I have selected these artists is because each intimately engages Xicano epistemologies and cosmologies of place vis-à-vis Indigenous placemaking and aesthetic sovereignty. Their work is indigenist in orientation, as Latorre would argue, as well as fervently presents a form of Xicano indigeneity.

Aztlán's utility, of course, cannot (and must never) be reduced to an exercise in explicating the class or sexual identity of the artist that created it. Instead, Aztlán is an indeterminate palimpsest through which communal and personal ideologies are dialogically presented and contested. As the MiXicano artists discussed in the last chapter clarify, Aztlán helps establish a sense of sovereignty in an otherwise diasporic environment. Art history has not fully acknowledged this relationship between indigeneity and diaspora (lowriding). But as Aztlán helps us see, art allows for diversity of thought and style, even when it reconfigures Xicano or Indigenous sovereignty.

In a conversation with anthropologist David Graeber, *Artforum* editor Michelle Kuo states that "the legacy of critique within the art world seems to be all about structure and not about agency. It's as if there is no agency. And so many critics and artists arrive at this impasse because they are essentially stuck in those two categories."[1] Aztlán is a crucial framework that helps us mediate between structure and agency, looking at the particularities of individual artists in the process.

Chicano art has become a stand-in for Xicano political agency. While this is not inherently problematic, we must be cautious of reading works purely structurally. Instead of investigating the role that art and visual culture play in constructing identities, many artists and critics see these same identities as being an a priori construction. Because Indigenous artists play a critical role in asserting sovereignty, it must be noted that contemporary Xicano identities have been constructed, at least in part, by the way artists and cultural workers have assembled, reconfigured, and created Aztlán. The production of Chicano art and the parallel production of Aztlán have always been constitutive of one another. They are dialectical

in nature. As I presented in earlier chapters, George Lipsitz notes this reciprocity. He explains that "rather than thinking about Chicano poster art as 'community-based art making,' it is more productive to view it as a form of art-based community making."[2] Using contemporary vocabulary, Chicano art is about exerting Xicano sovereignty as a form of Indigenous ontology.

For each artist I discuss, I briefly situate their individual biographies, something frequently absent from Chicano art histories, before analyzing a small number of works within their broader corpora. By engaging in a close reading of a detailed number of artworks, I hope to demonstrate how each artist envisions, constructs, problematizes, and reifies Aztlán and, in turn, what this means to larger sociopolitical discourses on Xicano indigeneity. However, I offer a reading of their work from my own perspective.

As such, I am not entirely interested in the intentions of the artist; rather, I am concerned with the function Aztlán performs within their respective practices. By opening with an investigation of each artist's biography, we may understand how and why these individuals make certain choices within their art-making practice.

On the contrary, how each artist's work operates within social structures may diverge from what the artist sees as her or his "intentions." After all, as a practicing artist I am cognizant that when discussing previously created work, the supposed intentions of an artist or her/his understanding of them may have shifted and transmogrified (and will continue to do so) through time. Since art operates within a multiplicity of discourses, intentionality likewise shifts in reciprocation to discursive transformations.

While I find it essential to converse with artists about the intentions of their work, it is more telling to identify how these images maneuver within social, aesthetic, and political systems. In terms of *Creating Aztlán*, this indicates that interviews and written communication with artists and other prominent figures, although important, are coupled with an engaged interpretation and analysis of how Aztlán functions within the respective artwork and what this signifies. Since I am speaking and writing from a certain position, one that emerged from and remains within Xicano and Native activist circles, my interpretation of the following artworks most definitely demonstrates this positionality. Even so, in this and the following chapter I hope to articulate, as I've done in the previous four chapters, how each artist's respective Aztlán operates within societal structures and eventually how they dialogically help develop Xicano sovereignty in the face of ongoing settler-colonialism and assumptions of de-Indianization.

Mapping Aztlán Between Politics and Aesthetics

The work of Gilbert "Magú" Luján is quite literal in its imagining of Aztlán. Unlike artists who employ Aztlán at the level of a trope, Magú literally positions Aztlán within his painting's picture planes. The process of mapping becomes iconographically repeated within his visual texts, creating new signifying systems. Within Magú's corpus, Aztlán serves to mediate between the overtly political Aztlán of Alurista, Malaquías Montoya, or Carlos Cortéz Koyokuikatl (as we will see) and Nepantla, the postcontact site of transformation, as manifest in the visual works of Santa Barraza (as we will also see) or the writings of Xicana feminists like Gloria Anzáldua. Moreover, Luján includes Turtle Island, as an Indigenous understanding of North America, as an important site within his paintings. He even has a print titled *Cruising Turtle Island* (1998).

Luján was born in California to a migrant farmworker family in 1940. Shortly after his birth, his family relocated to East Los Angeles, where he spent his youth. Following high school, Magú saw the military as his only chance at upward mobility and international travel. Luján recalls that "I grew up in East LA. . . . Wore khakis and wore Pendleton shirts and Sir Guy shirts in high school."[3] His experience as a Xicano in East Los Angeles informs how Magú presents Aztlán as an Indigenous ontology in his work. In addition, lowriding literally becomes a common theme to represent Xicano ways of being in the world.

After returning from an enlistment in the Air Force, Luján attended university on the GI Bill. As a recipient of this federal program, Luján attended East Los Angeles College and later California State University, Long Beach. In 1971, Luján earned an MFA from the University of California, Irvine. It was the possibility of attending college, not a manifestation of patriotism, that served as the impetus behind Luján's enlistment in the Armed Forces. Luján remembers hearing "that if you served time you'd get a GI Bill and then you could go to school. . . . I know that was a definitely real reason why I joined the service."[4] Once at East Los Angeles College, Luján was motivated to study fine arts, particularly ceramics.

Though some individuals became artists through their involvement with the Chicano Movement, Luján's identity as an artist began "before the dramatic highlights of the political movimiento."[5] During the mid-1960s, Luján curated art exhibitions while at California State University, Long Beach (then known as Long Beach State University). His exhibitions were reasonably successful, and he soon established a name for himself in

metropolitan Los Angeles. Describing himself as a "cultural nationalist," Luján holds a complex and broad definition of "Chicano art."[6] Unlike many of the so-called narrow nationalists (or maybe they weren't as "narrow" as has been implied), Luján was welcoming of Anglo-Americans that had been raised in the Xicano community. For him, being Xicano was not biological, but rather a cultural identification based on shared experiences and kinship (just as Indigenous identities are for many tribal communities). For Luján, Chicano art speaks about or in reference to the Xicano experience in the United States. He states that Chicano art is "a reflection of who we are as a people."[7] He continues, stating that "the bottom line is that if it's done in the spirit of the Chicano experience, it's Chicano art. What if you're Anglo? Can you be a Chicano artist? I say, 'Yes.' Because if you grow up like some of the gringos that grew up with us that were so acculturated that they out-pachucoed everybody else, then they could make Chicano art, because Chicano art is not genetic."[8] Similar to the ways that Native tribal governments are rethinking citizenship requirements, Luján's progressive ideals transcend settler-colonial notions of racial identity. Neither Xicano identity nor Aztlán was prescriptive. They were organic enunciations tied to lived experiences.

Chicano art, like all art, is a philosophical manifestation that coalesces Indigenous and collective experiences into a visual language that is mutually intelligible. As such, for Luján art fulfills a basic human aesthetic need: art cannot and must never be reduced to polemic, although political partisanship is an important aspect. This tension between the political and the aesthetic is one that frequents Luján's artistic practice. In fact, Luján's work lowrides back and forth between these two fields.

Luján's role in the Chicano Movement, especially in constructing a nonessentialized notion of Xicano artistic practices and the role of Aztlán, is important for how it counters common misconceptions about Chicano nationalism. Luján actively constructed or "invented cultural images" to organically represent the Xicano community.[9] He states that

> when I joined [the artists' collective] *Con Safos* I found that these ideas that I had, selecting motifs from the barrio experience—like low-riders, graffiti, doilies, plants growing out of peoples' shoes, and pretty much funky art that people did with the means that they had. Again, these were not schooled efforts. These were efforts being done by looking at the community and seeing what we had produced that could be called art."[10]

As this *testimonio* displays, Luján constructed a Xicano aesthetic, one that often contrasted with the aesthetic and politic of his peers, based on what he saw around East Los Angeles.

In his work, Luján does not attempt to codify Aztlán, but allows it to be open-ended. He uses Aztlán as an Indigenous chronotope to mediate between aesthetics and larger signification. In this way, Luján's work is held in tension between utopian aesthetic desires and the pragmatic and revolutionary changes enacted by partisan art.[11]

For Mexican philosopher Alberto Híjar, this tension between engaged art and aesthetics functions as a "process initiated in epistemology that passes through the autonomy of aesthetics and culminates, as such, in the pleasing and painful articulation of a knowledge system via the forced construction of developed social relations."[12] Luján's work vacillates between polemic and aesthetic dimensions, acknowledging that neither exists autonomously. Luján writes that these two dialectical fields "must co-exist if we are to live in harmony and peace with others and ourselves by discussing ways to adjust to these often seemingly contradictory considerations."[13] Much like his contemporaries, Luján was interested in asserting Xicano sovereignty as a peaceful proposition. Through individual and collective art-making, Luján comes to terms with the tension between aesthetics and what he calls "propaganda."

In 1973, Luján founded Los Four with fellow artists Carlos Almárez, Beto de la Rocha, and Frank Romero. Although Luján was operating between the economically driven art market and activist-oriented "propaganda," to use his own words, the other members were ambivalent toward the basic tenets of the Chicano Movement, particularly Aztlán as a framework.[14] "I had that vision . . . about Aztlán," remembers Luján. "These guys would just kind of look at me like, 'Yeah, sure, Aztlán.' And they weren't buying it at the beginning."[15] But quickly enough, Almárez, de la Rocha, and to some extent Romero began making work in conjunction with the Chicano Movement, posing many unresolved concerns about their commitments to Xicano sovereignty. At that particular moment, Aztlán commenced operating as a centering device for both Luján and his art. Aztlán operated as his axis mundi or center of the world. This centering function performed the same role that it did for the Mexica, as well as for Luján's Xicano peers.

By 1974, Los Four had a pioneering exhibition at the Los Angeles County Museum of Art (LACMA), titled *Los Four: Almaraz, de la Rocha, Lujan, Romero*. This exhibition was the first showing of Chicano art at a mainstream museum in California and was the only one at LACMA until

Phantom Sightings: Art after the Chicano Movement in 2008. In 1972, two years prior to the Los Four exhibition, ASCO members Willie Herrón, Harry Gamboa, Jr., and Gronk spray-painted their names onto an exterior wall of LACMA. For Gamboa, the group performed this act "in reaction to the negative response of a museum curator to their query about the possibility of including Chicano art in museum exhibitions."[16] In turn, the "artists momentarily transformed the museum itself into the first conceptual work of Chicano art exhibited at LACMA."[17] In recent years, this work, and ASCO in general, has received considerable attention by contemporary curators and historians.

When Los Four received an exhibition at LACMA in 1974, Herrón, Gamboa, and Gronk, along with collaborator Patssi Valdéz—known collectively as ASCO—crashed the opening reception in their customarily performative fashion. Although the exhibition at LACMA catapulted Chicano art into the mainstream, Anglo-American art critics entirely misread the work and its proper context. Jacinto Quirarte notes that a "lengthy review in the *Los Angeles Times* acknowledged the importance of their work as Chicano art, but misunderstood the definition and sources."[18]

In this same way, Luján's work is frequently misinterpreted, even by Xicano audiences. If we closely read Luján's paintings and sculptures, as well as his larger installations, we see that the works exist in the interaction between the aesthetic form and Aztlán's discursive formation. Luján is not interested in simply representing Aztlán in simplified modes of time and space; rather Aztlán serves as a decolonizing trope that enables new epistemological systems.

His 1983 painting *Returning to Aztlán* depicts an Indigenous male *cholo* figure driving a postmodern *ranfla* from the pyramid structures of Teotihuacán northward into what is now the southwestern United States. Luján employs intense hues and utilizes primary colors almost exclusively. Moreover, he evokes the cholo figure as an image of survivance. As he puts it, "cholos are an example of defiance."[19] Here, this cholo figure maintains Indigenous practices and resists settler-colonial assimilation. It is not surprising that in many Latin American countries, "cholo" is the name given to urban Native populations. In the United States, a cholo is an urban Xicano with a particular style, culture, and community. In addition, the painting visually dismantles settler-colonial borders between U.S. and Mexican nation-states.

The landscape illustrates the scene from a northern vantage point looking southward. Since Luján was trained to utilize Renaissance perspective, particularly one-point perspective, it can be assumed that the viewers of

the artwork, myself included, are already situated in Aztlán and, therefore, gaze upon the northward migration of Xicanos from ancestral lands in Anahuac to their inherited lands to the north. The cartographic space of *Returning to Aztlán* is depicted in a landscape style, characteristic of many sixteenth-century Civitates maps of sacred Judeo-Christian sites. These Civitates maps used a single vantage point to document an entire city or region. Many of these maps did not depict a uniform geographic space; rather, they tell us as much about the cartographer and the viewer as they do about the actual site. This is due, at least in part, to their employment of Renaissance conventions of perspective, a point of view that the artist and viewer shared. When we look at these maps, just as when we look as *Returning to Aztlán*, we are positioned in direct relationship with the work.

As a depiction of a sacred Indigenous site, *Returning to Aztlán* positions the viewer not as a figure within the painting, but as the main source of meaning-making. Because the specific perspective of the painting plays an integral part in how the painting is to be appreciated, the maintenance and perpetuation of the Renaissance tradition of one-point perspective is kept intact. Utilizing Western artistic devises to confront settler-colonialism is one of the hallmarks of Indigenous contemporary art.

According to Marxist art historian John Berger, "the convention of perspective, which is unique to European art and which was established in the early Renaissance, centres everything on the eye of the beholder. . . . The visible world arranged for the spectator as the universe was once thought to be arranged for God."[20] In Luján's pictorial and painterly artwork, the viewer is meant to see the entirety of Anahuac (Mexico) and parts of Aztlán in a single view. This painting depicts a particular view observed from Aztlán. The viewer is not situated in Teotihuacán or Tenochtitlán watching mass emigration take place; rather, the viewer is already located in Aztlán watching an Indigenous peer lowride northward and toward the viewer. The lowriding cholo joins the viewer in Aztlán.

This painting, much like Luján's larger body of work, visually coalesces communal knowledge-systems. This visual form helps us understand Aztlán in Lujan's corpus. Much like the cyclical archetype wherein Aztlán and Tenochtitlán were understood as different manifestations of the same site, Luján demonstrates how this reciprocation goes both ways by also "Returning to Aztlán." Mary Pat Brady maintains that "Aztlán offers a counteraesthetics by calling attention to the ideologies of nationbuilding."[21] As such, this counter-aesthetic system develops into Xicano sovereignty through art-making. For Brady, the Movement constructed Aztlán on a predetermined or "opaque concept of space."[22] While Brady is accurate

in terms of how Aztlán functioned as a critique of both Mexican and U.S. forms of nationalism (i.e., nation-building), she oversimplifies the larger implications of Aztlán by referring to its opacity. As Luján's art-making and visual iconography highlight, Aztlán cannot be reduced to an "opaqueness of space," but is transgressive in its ability to question opacity. Rafael Pérez-Torres shows how visual artists use Aztlán as a complex signifying system, rather than collapsing Aztlán into simplistic notions of cartographic space. Pérez-Torres writes that "artists often evoke Aztlán in order to consider an ironic remapping of the United States, one that both recognizes and inverts the notion of margin and center. On the other hand, Aztlán challenges secured boundaries, confirmed norms, and social facts such as nation, citizenry, and home."[23]

In *Returning to Aztlán*, Luján documents the complex realities of Xicanos living in the United States, a settler-colonial nation-state, no longer identifying as "Mexican" or unable to meet enrollment requirements of a federally recognized American Indian tribe in the United States. Likewise, the painting points toward an inability and unwillingness to forget the Indigenous historical and social realities of Turtle Island. This work does not, as Brady supposes, refer to the opacity of space. It points toward its translucidity. Because art exists beyond language, either European or Indigenous, this and other paintings by Luján transcend the ability of the Xicano community to codify and systematize his work. For the artist, Aztlán takes shape in the dialectical "third space" between aesthetics and partisanship.

It is for this reason that in Gilbert "Magú" Luján's body of work Aztlán is employed not as a monolithic and doctrinaire determination, but forms a Xicano sovereignty that takes shape in and between the complexities of social and political thought and visual art. Since Aztlán functions as a site of anticolonial and communal experience, as Luján notes, its concretization must likewise be communal in nature.[24] How this visually materializes can be found in the articulation of an Aztlán that is located within a contemporary Xicano chronotope but is also located as a dialectical and dialogic space that necessitates human exchange. Aztlán exists somewhere between the political "mau mauing" of Xicano nationalists of the late-1960s and the "deeper psychic transaction" of artistic production.[25] Much like Navarette's maintenance about the Codex Azcatitlan or Craven's ideas about Marxism, Luján's Aztlán is permanently indeterminate. It is through this very indeterminate space that meaning takes form and form reciprocally creates meaning. This meaning, then, lowrides toward sovereignty.

An Internationalist Aztlán

While many artists of the Chicano Movement were only marginally involved in the activism of the era, the biography and work of Malaquías Montoya cannot (and must not) be removed from his political activities. For instance, when we discuss the importance of El Plan Espiritual de Aztlán and El Plan de Santa Bárbara, we remember it was Montoya's artwork that illustrated the cover of the Plan de Santa Barbara when published as a book. While the Plan de Santa Barbara articulated a strategy for Xicanos in higher education, the visual imagery of Montoya was included not simply to illustrate, as commonly happened during the period, but also to augment the complex textual dimensions of the Plan. Montoya's commitment to social justice did not wane with the presumed ending of the Chicano Movement; rather, Montoya has continued to produce socially engaged visual art for nearly four decades.

Montoya was born on June 21, 1938, in Albuquerque, New Mexico, and initially attended elementary school in Martíneztown, a working-class Xicano barrio. In the mid-1940s, the Montoya family moved to the San Joaquin Valley of northern California to work in the agricultural fields. For Montoya, this pluriethnic working-class experience instilled within him a complex understanding of solidarity, which served as the foundation for his version of Aztlán. As Montoya recollects, "I attended various schools in Albuquerque, New Mexico, and throughout the San Joaquin Valley, California. The importance of these . . . years was the exposure I had to different cultures—recently freed Japanese Americans, poor whites, African Americans and my own culture—Chicanos."[26] In many ways, Montoya's Aztlán emerges in response to his complex experiences of living, schooling, and laboring with working-class peoples of different ethnicities.

Following graduation from high school in 1957, Montoya enlisted in the Marine Corps, or as he likes to call it, "Chicano Trade School." He received an honorary discharge in 1960 and, like Luján, attended university through the GI Bill. Montoya first attended two junior colleges before enrolling at the University of California, Berkeley, in 1968. Montoya recollects the alienating process of attending university. He recalls that "wishing to pursue my artwork as well as to avoid authoritarian-oppressive situations, I began my higher education. . . . I encountered a more sophisticated type of oppression—one that was in many ways worse than prior situations because of being totally removed from those who shared the same roots as my own."[27]

Nonetheless, Montoya connected with students and activists who "shared roots" and became active in the Third World Liberation Front (TWLF), a radical student collaboration at San Francisco State University and the University of California. Between 1968 and 1969, TWLF performed one of the largest and most successful student strikes in the United States, when Xicano, American Indian, Black, and Asian American students requested an autonomous Ethnic Studies College, among other demands. This internationalism became an irreducible component of Montoya's practice.

Terezita Romo writes that "in its embrace of internationalism, Montoya's work has sometimes been compared with that of Francisco Goya and Käthe Kollwitz, who also exposed the suffering of the poor and the ravages of war in their countries, using prints to make these messages more accessible to the public."[28] She continues: "His role has an intrinsic and, I would argue, true artistic power. His role as an artist has not been to stand outside of humanity or history but to assume the responsibility to shape both, aesthetically and politically."[29]

In 1972, while employed as a lecturer in Chicano studies at the University of California, Montoya produced one of his most well-known and commonly circulated images: *Viet Nam Aztlán* (figure 19). Based on an original serigraph, the poster was nearly excluded from CARA because it was produced as a commercial lithograph and not a fine art print.[30] Nevertheless, this groundbreaking image produced an active dialogue among radical sectors in the Bay Area by asserting the similarities between the oppression and colonization of Vietnam and that of the Xicano community. Montoya saw Xicanos as an Indigenous nation whose sovereignty was based in Aztlán.

Montoya's composition places two fists, one brown and one yellow, across the top of the poster. These closed fists converge in a show of strength, unity, and solidarity, with similar, albeit larger and chromatically reversed, fists across the bottom of the image. The focal point of the composition is the two busts of the male figures placed centrally in the arrangement. The men, one understood as Vietnamese, the other Xicano, are respectively depicted in semiprofile and profile perspective and organically grow from one another. The black shadows and negative space of the Vietnamese peasant's face and hat become the hair and facial shadows of the Xicano. The visual reciprocity and connectivity of these distinct individuals demonstrate the way that Montoya understands the relationship between Xicano resistance movements and those throughout the Third and Fourth Worlds.

Like all posters, the inclusion of text and image produces a dialogue between the artist and audience. In this particular print, the bilingual Spanish-

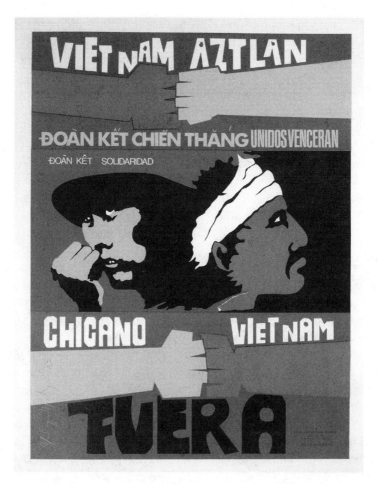

Figure 19. Malaquías Montoya, *Viet Nam Aztlán*. Offset lithograph from original serigraph, 1972. Image courtesy of Malaquías Montoya.

Vietnamese text includes translations of "Solidaridad" (Solidarity) and "Venceremos Unidos" (Together We Will Overcome). It demands that the United States military leave Indochina by including the text, in all capital letters, FUERA (OUT). Like many radical artists in the Bay Area, Montoya was aesthetically drawing from the visual language of Cuban posters.[31] Shifra Goldman acknowledges the relationship between Xicano posters and the Cuban poster aesthetic. She writes that "the link between Chicano oppression at home and United States imperialist actions abroad . . . had already been made politically; now it was brought home artistically.

Of particular importance were Cuban color and the relationship between form and content."[32] This aesthetic is located in Montoya's use of stark, flat color, and the reduction of his images to their most basic visual forms, both of which are seen prominently in *Viet Nam Aztlán*.

Poster archivist Lincoln Cushing locates five general themes in Cuban poster production: "National Pride," "Production and Resources," "Sports and Health," "Solidarity and Revolution," and "Education and Culture."[33] Although two of these themes, "Production and Resources" and "Sports and Health," are not generally found in Xicano poster art, for understandable reasons, the other three are identifiable categories in Montoya's work. *Viet Nam Aztlán* clearly fits into two categories: "National Pride," as it uses the notion of Aztlán, and "Solidarity and Revolution," through its demonstration of the shared oppression and resistance in both Viet Nam and Aztlán.

Overall, Montoya's entire artistic corpus operates within these two categories: Xicano Pride, and Solidarity and Revolution. In this way, Montoya uses Aztlán not as a nation-state, in rudimentary Marxist-Leninist fashion; rather, it speaks to the Xicano community-turned-nation operating in harmony and dialogue with larger internationalist struggles.

As Romo identifies, internationalism is a driving force in both the life and work of Montoya. Montoya foregrounds international anticolonial resistance as an inspiration for his visual art, as well as for the struggles for Xicano sovereignty. Montoya writes:

> Images of international struggle are important to our community. They bring solidarity and for this reason, my work is replete with international themes. My work attempts to serve as a bridge between our struggle and those of other countries. This helps to give us a better understanding of the world we live in and show us that we are not an isolated culture that failed but that we have a common antagonist that makes it necessary for us to unite.[34]

Solidarity, struggle, and internationalism form the basis for Montoya's seminal article, "A Critical Perspective on the State of Chicano Art." As previously noted, the complexities of his writing on Chicano art have frequently been dismissed in favor of an essentialized and ill-informed reading of this manifesto. For Montoya, similar to Luján, there is no definitive Chicano art, because attempting to characterize what is Xicano would ultimately circumscribe it and therefore limit its potentiality.

The production of Xicano culture did not occur in seclusion; it functioned in dialectical tension with colonized and colonizing forces. As Montoya writes with Lezlie Salkowitz-Montoya, "Chicanos were not an isolated culture that had failed within this imperialist society, but one in unity with others, who, in varying degrees, were also oppressed. The Movement came to mean the struggle of all Third World and oppressed people."[35] Based in his childhood experiences in the fields with pluriethnic working-class and oppressed peoples, as well as his involvement in the TWLF during the late-1960s, Chicano art becomes an art of solidarity and resistance.

What, then, does Aztlán signify, if it is not intended as a very isolated nation-state based on the biological Xicano (male) body? Although Montoya's Aztlán vacillates between a variety of positions, it operates primarily as a metonym for the Xicano community, broadly defined. Today, we would explain how this exerts Xicano sovereignty. Because of personal experiences within a multiracial society and his nuanced treatment of solidarity, Aztlán serves for Montoya as a site of resistance and affirmation. Through Aztlán, Xicanos critique, alter, and subvert present economic inequalities and social inequities. They resist settler-colonialism and assert indigeneity. It is the artist, functioning as a cultural critic and civil servant, who instigates and initiates radical social transformation. Montoya and Salkowitz-Montoya believe that "it is the responsibility of Chicano artists to show the importance of aspiring not for that material accumulation which is so unrealistic for most of La Raza and keeps so many crippled and enslaved, but for a system that truly provides the necessary things for everyone."[36]

It is by way of Aztlán, as a utopian space and as an Indigenous nation, that the Xicano artist begins to challenge capitalism, imperialism, and social stratification. It comes as no surprise, then, that Montoya's notion of utopia is not one that follows the post-Cold War confinement of utopia as a codification of state-socialism or the nation-state. On the contrary, Montoya is aware of the capabilities of utopias, but that, as Jameson has noticed, these sites exist somewhere in the beyond and serve as driving forces toward a better future. Montoya does not propose Aztlán as a unilateral utopia, but uses it as a potential liberatory site that may never come into being. In other words, Aztlán is simultaneously Xicano sovereignty, with all its potential inequities, as well as a dialogical space where Xicana and Xicano desires are contested, disputed, and held in tension.

In a 1946 article published in the anticolonial French newspaper *Combat*, Albert Camus wrote that

in the next few years the struggle will not be between utopia and reality, but between different utopias, each trying to impose itself on reality. It will no longer be a matter of choosing the least costly among them. My conviction is that we can no longer hope to save everything, but that we can at least try to save lives, so that some kind of future, if perhaps not the ideal one, will remain possible.[37]

Camus recognized the contradictions inherent in struggling for a more just and equitable society and the structural restraints inherent in that effort. Moreover, he was aware of the dialectical tension posed by utopias and utopian movements. In *Combat*, Camus acknowledged the utopian paradox and the ways that activists must mediate these ambiguities if utopias are to serve any real purpose. This, after all, is one of my main positions in *Creating Aztlán*, as Aztlán allows for a variety of Xicano utopias to struggle with and against one another, not in some imaginary world where inequities do not exist, but rather as a site where these parameters and problematics may be disputed, contested, and eventually shift existing discourses and social structures. Sovereignty is messy, but it is better than the settler-colonial alternative.

In *Artforum*, David Graeber describes the potential for utopian thinking to liberate society from totalizing structures. For him, utopias are not problematic, as long as they remain multiple and open-ended. He states that "we need one thousand utopias. There is nothing wrong with a utopia unless you have just one."[38] Following the Chicano Youth Liberation Conference, Aztlán became the name for Xicano sovereignty and for its utopia. Through artists' multivalent signifying we do not have a singular Xicano sovereignty, but we have many. Harkening back to Graeber, why can't we have one thousand Aztláns? As the work of Santa Barraza and Carlos Cortéz Koyokuikatl elucidate, Aztlán has given way to other Indigenous Xicano articulations of place, particularly Nepantla and Ixachilan. They name some of these other utopias—what I would call other Aztláns. Unfortunately, many artists and critics commonly try to focus on a single Aztlán and, based on its failures, attempt to undermine its validity. But why just one singular Aztlán?

Camus continued his complex utopian thinking when he wrote: "People like myself want not a world where murder no longer exists (we are not so crazy as that!), but one where murder is no longer legitimized. Here we are indeed utopian—and contradictorily so."[39] For Camus, utopias, much like the one initially proposed by Thomas More, cannot escape the nature of humanity's flaws. Utopian thought can only hope to make society a more

impartial place for the majority of its inhabitants, subjects, and citizens. Xicano sovereignty vis-à-vis Aztlán is one of these moves (or it is possibly one thousand of them).

Not surprisingly, Montoya is very much engaged with a Camusian utopian project. In his most ambitious project to date, *Premeditated: Meditations on Capital Punishment*, Montoya quotes directly from Camus. In the citation referenced by Montoya, Camus wrote:

> For there to be equivalence, the death penalty would have to punish a criminal who had warned his victim of the date at which he would inflict a horrible death on him and who, from that moment onward, had confined him at his mercy for months. Such a monster is not encountered in private life.[40]

For Montoya and Camus alike, structural and state violence are much more violent than any individual act, which directs us back to Fanon and his thoughts on anticolonial violence.

If nothing else, art serves an ideological function that operates somewhere between Brechtian agitprop maneuvers and a populist visual aesthetic. Accordingly, Montoya writes that "I must say my work is often referred to as propaganda art. I don't mind being labeled as such since I feel all work is propagandist in nature; it just depends who you want to propagandize for. From cave painting to the present, art has always spoken on someone's behalf."[41] But as anyone who has seen Montoya's work may attest, his humane treatment of the visual surface, his complex articulation of political issues, and his ability to work in a variety of print media must never be diminished to propaganda. Montoya is a masterful craftsman of visual texts that are not illegible but more timely in nature and, in fact, precisely on time. Inversely, propaganda is one-dimensional.

As Charles Loving attests, "Montoya is deeply ideological in the leadership role he fills for the Chicano Art Movement; he is iconoclastic, to American eyes, in his opposition to capitalism and imperialism; he is humanistic in his opposition to discrimination based on race, sex or class."[42] For all intents and purposes, it is Montoya's iconoclasm that is truly utopian, and it is through Aztlán that his utopianism is manifest. By turning to the theoretical writings of Albert Camus, Montoya connects Aztlán with an anarchist and Indigenous insurrection, one against state sanctioned execution and the establishment of a permanent regime. In the foreword to the English-language translation of *L'homme révolté*, Herbert Read acknowledges that "Camus's ideas come close to anarchism, for he recognizes that

revolution always implies the establishment of a new government, whereas rebellion is action without planned issue—it is spontaneous protestation."[43] It is in the unplanned processes and actions against tyranny—and through the writing of Camus and the visual expressions of Montoya—that Aztlán serves an uninterrupted liberatory function. As Montoya's visual language makes apparent, Aztlán is the Camusian "spontaneous protestation" that has resisted the tyranny of the state through grassroots internationalism and anticolonial solidarity. Since Indigenous sovereignties do not reproduce Western-style nation-states (although this happened through the BIA), Montoya's Aztlán is a permanent rebellion.

Aztlán, Tejas, and Nepantla

The Chicano Movement was dependent on artist-activists like Montoya and Luján to create a language of resistance and affirmation. Although many artists were needed to coalesce the visual production of the Chicano Movement, according to art historian Robert Henkes, Santa Barraza "is considered to be the backbone of the Chicano artists' movement."[44] One glance at the permanent collections that include works by Barraza and it is clear that she performs an irreplaceable role in the history of Chicano art. For instance, she has works in the Smithsonian, the National Museum of Mexican Art, the Fondo del Sol Visual Arts Center, and various university and public museums from Maine to California.[45] Prior to her return to South Texas, Barraza was a professor of painting at the School of the Art Institute of Chicago, the premier painting program in North America.

Santa Barraza was born the second of six children to Frances Contreras and Joaquín Barraza. As she explains, her "father wanted his children to have the opportunities that he never had . . . [while her] mother was a feminist who understood the limitations placed upon her as a woman."[46] In her paintings, Barraza recognizes structural limitations, and moves for their transgression. Raised in South Texas, Barraza was surrounded by the Indigenous Xicano spiritual and cultural practices of that region. These practices play an influential and unique function in her development as an artist. To this day, the ecology of South Texas is central in her visual art.

Like her mother before her, Barraza attended college at Texas Arts and Industry University (Texas A&I, which became Texas A&M-Kingsville in 1993). She enrolled in 1969, the moment that the Chicano Movement was expanding into a cohesive and national collective. Although only at Texas A&I for three semesters, it was in Kingsville that she first matriculated in

Mexican and pre-Columbian art history courses. Because of its location in the U.S.-Mexico borderlands, Texas A&I was a predominantly Xicano institution, and Barraza's experience there was representative of those demographics. During her tenure at Texas A&I, Barraza became acquainted with fellow Xicano artists working in the department: Amado Peña, Carmen Lomas Garza, and José Rivera, all of whom developed successful careers in the visual arts.[47] Barraza recalls that at Texas A&I "students would meet at the Student Union for lunch and would discuss various political manifestos, such as El Plan de Aztlán and El Plan de San Diego, along with the writings of the Flores Magón brothers."[48] With a radical educational experience that includes the work of prominent Mexican anarchists and radical Xicano texts, it is not difficult to recognize why Barraza fuses the ideological with the visual in her artwork.

Since Texas A&I did not offer a studio arts degree, Barraza transferred to the University of Texas at Austin (UT) in 1971. Although Xicano cultural politics were paramount to life in Kingsville, Austin was a different experience in the early 1970s. Since UT was an elite institution, the number of Xicano students enrolled in the university during the period was minimal, with faculty numbers even lower. Once enrolled at UT, however, Barraza was attracted to the course listings of Jacinto Quirarte, the only Xicano or Latino faculty member in either studio art or art history. As previously noted, Quirarte was a central figure, the point of emergence if you will, in the historiography of Chicano art. Being Quirarte's student was vital for Barraza.

According to Barraza: "In 1971, he offered the first art history course on Mexican American art to be offered in higher education in the United States. I was one of the first students to pursue formal study of Mexican American art in an Art History Department in an institution of higher education. We even used photocopies of Quirarte's manuscript, since his famous book, *Mexican American Art*, was in press being prepared for publication."[49] She continues on, noting that "it was at this time that my identity as a Mexican American became a focal point of my art."[50]

In the mid-1970s, following graduation and the birth of her daughter, Barraza joined a new Austin-based Xicano art-making organization called Los Quemados. The organization came together when Amado Peña and César Martínez, then working with the seminal collective Con Safos, felt "burnt out," as the name implies, and turned toward interacting with younger artists. Los Quemados, which literally means "the burnt ones," featured some of the most respected names in Chicano art, including Barraza, Carmen Lomas Garza, Carolina Flores, Amado Peña, César Martínez, Luis Guerra, José Treviño, Vicente Rodríguez, José Rivera, and Santos Martínez.[51]

Inside the collective, individual egos and the failure to address gender balance within the group sparked Barraza to leave, at which time she founded Mujeres Artistas del Suroeste (MAS) with Nora González-Dodson. In 1979, MAS organized the Conferencia Plástica Chicana, a key feminist arts gathering. This multidisciplinary conference was funded, in part, by the National Endowment for the Arts and the Texas Commission of the Arts. This important conference was organized by MAS, the University of Texas, Saint Edward's University, and Juárez-Lincoln University, a Xicano graduate school. It brought together individuals from both sides of the U.S.-Mexico border. Barraza writes that "it was also the first encounter between Chicano/Mexican American visual artists and North American art historians and Mexican visual artists and art historians. . . . It was a high-energy conference, stimulating visually and intellectually. Interestingly enough, all of the artists had similar roots and common concerns. Nevertheless, differences and divisions existed, based upon politics and geography."[52]

Although intentional in her recognition of regionality in the visual and intellectual discourses of the conference, these same differences mark Aztlán as being fruitful, since it is able to contain the works of diverse Xicano artists, without ceasing to be evocative in its Indigenous orientation. In terms of Barraza's visual language, Aztlán performs an irreplaceable element, even though she begins to conceptualize it in new ways, which reclaim new Indigenous epistemologies. In "Aztlán in Tejas: Chicano/a Art from the Third Coast," art historian Constance Cortéz writes: "Nowhere is the journey through Aztlán more evident than in the works of artists from Kingsville, a small ranching community located in South Texas."[53] Cortéz describes a "journey through Aztlán," referencing the migration narrative, or what I call Indigenous lowriding.

Being from Kingsville, like her comadre Carmen Lomas Garza, South Texas is forever imprinted onto Barraza's visual language. Of particular importance is her inclusion of imagery that signifies South Texas and plays with Indigenous placemaking. Beginning in the 1990s, Barraza includes familiar *curanderos* of the region, particularly Don Pedrito, ecological references to regional flora and fauna, and the incorporation of larger Mexican and Indigenous iconography.

The inclusion of these indigenist images does not indicate an essentialized perspective that Xicanos are somehow the noble descendents of the Mexica, as critics of Chicano Movement art assert. Rather, as Shifra Goldman acknowledges,

Santa Barraza's art represents a search: for her identity as a person raised in the atmosphere of a particularly oppressive region of "occupied America"; as a woman who chartered new territories for herself as a student, artist, wife, organizer, mother, and teacher; as an existential being looking simultaneously into her family background for her roots and into her deeper desires and fears for a sense of liberation and equilibrium; and as an emancipated modern woman whose wings carried her by stages out of the provincial life of a small Texas town to which she was accustomed.[54]

Ultimately, Barraza's work explores Xicano sovereignty in response to the realities of colonization combined with the creative and transformative power of Xicanas. In 1992, Barraza wrote that her paintings signify the "inner strength projected by mother images."[55] By turning inward, Barraza retains the feminine power of Indigenous womanhood, but does so by locating its transformative power in the relationship between femininity and the land. This is a form of Xicana feminist nationalism. Critic Laura E. Pérez offers important readings of Barraza's work, even if foregrounding mestizaje (an issue I will address in the Postscript). Pérez states that Barraza "recreates the votive tradition, correctly, as a pre-Columbian legacy as much as a Christian one, by framing the ex-votos through the use of Maya-like glyphs and the Mesoamerican visual conventions of the codex. Her work does not imitate codices but rather explores their logic and contemporary potential."[56] While cautious, stating that Barraza's work does not imitate the codices, Pérez nonetheless identifies how Barraza integrates Indigenous epistemologies into her work.

As I have shown in previous chapters, for many Xicano cultural workers, Aztlán is simultaneously about geographical space and its transcendence. Certain artworks, such as Barraza's 1990 oil on metal painting *La Virgen* (figure 20), firmly position Barraza's work in the site-specificity of South Texas, but do not isolate that locale into a monolithic articulation of Aztlán. Instead, much like the work of Nora Chapa Mendoza, Barraza offers this regional Xicanisma as one possible way of knowing, re-presenting, and creating Aztlán. By imparting it as such, Barraza allows her personal history, as well as South Texas histories, to be visually materialized. As Cortéz reminds us:

These artists from Aztlán share an extraordinary sense of this land. At the same time, they are acutely aware that the topography through which they travel goes far beyond any simple geographic designation or shared

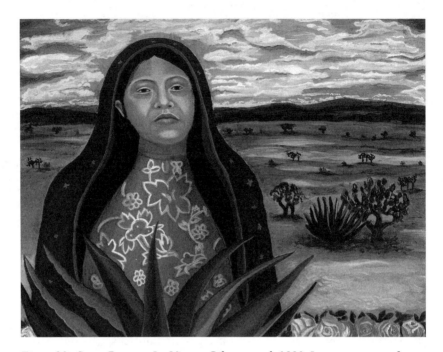

Figure 20. Santa Barraza, *La Virgen*. Oil on metal, 1990. Image courtesy of Santa Barraza.

set of experiences.... By critiquing these realities, their works go beyond the aesthetic—they reaffirm and give voice to those who share such experience while conveying an alternative reality to those who do not share these experiences. For other artists working on the Third Coast [the Gulf Coast], Aztlán can provide a stage on which to play out and explore memories born of family histories and legend. Spirituality, politics, and a basic exploration of human nature are all given context by an overarching sense of land, space, and time.[57]

Barraza evokes a meticulous visual topography to signify Aztlán. She does this in a manner where Aztlán serves as the stage to articulate personal, familial, and communal histories. Barraza demonstrates Aztlán's vibrancy through dialectical and dialogic relationships that engage Xicano sovereignty. In *La Virgen*, Aztlán is not a nation-state in the settler-colonial construct, but opens a multiplicity of readings and analyses that cannot be condensed to political structures such as the nation-state. When discussing the ways that queer and Native studies may mutually inform one

another, Tsalagi (Cherokee) feminist Andrea Smith, argues that "perhaps we can understand indigenous nationhood as already queered," a position firmly located in Moraga's "Queer Aztlán."[58] As I will show in the following chapter, Favianna Rodríguez and the collective Dignided Rebelde push this perspective even further. Aztlán and Xicano sovereignty, as a form of Indigenous self-determination, always challenges settler-colonial logics, including patriarchy and heterosexual normativity.

Furthermore, Rafael Pérez-Torres writes that "Chicano/a art helps to envision Aztlán and transform it into a dynamic cartography of being."[59] For Barraza, Aztlán—or Nepantla, as she begins to call this territory—not only transforms her personal humanity, but does so by rooting her visual language in the experiences of South Texas. These lived realities of South Texas are held in constant dialogue with the hegemonic narratives and visual language of contemporary art, also incorporating the language and traditions of Indigenous resistance in the U.S. Southwest and Mexico.

When Rosa Linda Fregoso and Angie Chabram critique the assumed heteronormative and patriarchal function of including Indigenous forms into the quotidian language of the Xicano visual vernacular, they misread work by artists such as Barraza. According to Fregoso and Chabram,

> by recuperating the mythic pre-Columbian past and reformulating this as the basis of our shared identity, Chicano academic intellectuals of the postcolonial condition failed to see that cultural identities have histories, that they undergo constant transformation and that far from being etched in the past, cultural identities are constantly being constructed.[60]

Fregoso and Chabram likewise fail to see how the inclusion of aboriginal forms, even pre-Cuauhtemoc forms, does not necessarily presuppose their stagnancy. Xicano artists, including Barraza, were very aware of the shifting meaning of images and their referents.

Inversely, indigenist feminists such as Barraza simultaneously draw from the "mythic pre-Columbian past," as well as critique it, and therefore operate outside Fregoso and Chabram's reductive analysis. Cherríe Moraga's "Queer Aztlán" evokes pre-Cuauhtemoc epistemologies as an act of countering heterosexist and patriarchal machismos.[61] Queering Aztlán serves, as the subtitle asserts, as a modality to "re-form the Chicano Tribe." Moraga attests that "the nationalism I seek is one that decolonizes the brown and female body as it decolonizes the brown and female earth. It is a new nationalism in which la Chicana Indígena stands at the center, and heterosexism and homophobia are no longer the cultural order of the

day. I cling to the world nation because without the specific naming of the nation, the nation will be lost."[62] Aztlán, as the name of the Xicano nation, remains powerful. For Moraga, as for Barraza (and other Xicana-Indígenas) the Indigenous Xicana body is the center of the world. It is the axis mundi. It is Aztlán, and it is also Nepantla and Ixachilan.

This incorporation of ancient symbology acknowledges the transformative and transforming nature of cultural expression. It does so by recognizing that nothing is static.[63] Queer poet and intellectual Gabriel S. Estrada turns to Mesoamerican cosmology as a way to deal with his "two-spirited-ness" or Native queer positionality.[64] Estrada evokes Indigenous notions of masculinity and femininity to center himself as a queer Xicano. By incorporating "mythic" notions of pre-Cuauhtemoc sexuality, Estrada begins to reconfigure contemporary gender and sexual inequalities. In "An Aztec Two-Spirit Cosmology," Estrada writes that "because of Catholic influence, Hispanicized people often reject what is not heterosexual and male, although the majority of Indigenous people are traditionally respectful of two-spirit people as a group. In fact, because we, as two-spirits, find misunderstanding in most colonized philosophies, we are often the first ones to defend and embody the ways of our ancestors who accept us for the way we carry all our energies at once—both male and female, day and night."[65] Estrada is not blindly pulling from an isolated past. Instead, Estrada intentionally includes and modifies the Indigenous past ("the ways of our ancestors") in hopes of reconstructing an Indigenous and truly post-colonial future. I would call this future Aztlán, even with all of the baggage associated with the term. Barraza would name it Nepantla, Carlos Cortéz Koyokuikatl would call it Ixachilan. Regardless of their name, each of these speaks to a form of Indigenous Xicano sovereignty.

Incorporating Indigenous and indigenist iconography and worldviews cannot be reduced to an anachronism. Importantly, artists like Barraza use these ancient (and contemporary) Native epistemologies but hold them in tension with the contemporary realities of settler-colonial life. Indigenism is a theme that has been explored expansively in recent Xicana feminist criticism, views particularly seen in Guisela Latorre's *Walls of Empowerment*, Laura E. Pérez's *Chicana Art*, and Sheila Marie Contreras's *Blood Lines*. These progressive directions in Chicano studies intersect Indigenous methodologies and approaches with a Xicanista perspective.

On the other hand, Fregoso and Chabram collapse the unattainability of culture into the monolithic status of custom. Since cultures are processes that draw simultaneously from the past and the present, they must incorporate the past into future movements. Custom, on the other hand, remains

Creating • 167

passively and naively locked into the past. Frantz Fanon understood these complexities. Xicano artists, particularly Barraza, likewise understand this dialectic. Incorporating imagery from the pre-Cuauhtemoc past does not signify that they are entirely vulnerable to appropriation's failures. As an alternative, Barraza appreciates the complexities of Aztlán and other Indigenous manifestations and uses them to extend Xicano sovereignty into the present and future. And this, in the end, is the collective power of Aztlán.

In many regards, Aztlán functions as a form of Anzaldúaian *conocimiento*, an embodied form of spiritual and political knowledge that challenges "official and traditional ways of looking at the world, ways set up by those benefiting from such constructions."[66] Moreover, Anzaldúa posits that

> those carrying conocimiento refuse to accept spirituality as a devalued form of knowledge, and instead elevate it to the same level occupied by science and rationality. A form of spiritual inquiry, conocimiento is reached via creative acts—writing, art-making, dancing, healing, teaching, meditation, and spiritual activism.[67]

By evoking Indigenous spiritualities and epistemologies within her visual language, Santa Barraza's paintings operate as conocimiento and Indigenous knowledge production.

But Barraza moves beyond Aztlán as the single name for Xicano sovereignty (which itself is not a single entity), and into even more abstract territory, particularly toward Nepantla. Similar to the way Anzaldúa and Barraza both view embodied knowledges as forms of conocimiento, Barraza visually manifests Anzaldúa's Nepantla. At the initial point with Nahua-Spanish contact, Nepantla spoke to the liminalities of postcontact Indigenous societies. This Nahua ideal was recontextualized by Anzaldúa to signify "the place where different perspectives come into conflict and where you question the basic ideas, tenets, and identities inherited from your family, your education, and your different cultures."[68] By and large, Nepantla, much like Aztlán, is a utopian site where contestation and synthetic transformation is rooted. In a 1993 article, Anzaldúa discussed Barraza's work in relationship to her own conceptualization of Nepantla. Anzaldúa writes that "Nepantla is the Nahuatl term for an in-between state, that uncertain terrain one crosses when moving from one place to another, when changing from one class, race or gender position to another, when traveling from the present identity into a new identity."[69] Nepantla is the process of lowriding between two spaces. As such, it does not negate Aztlán, but initiates additional Indigenous relationships to territoriality.

In Barraza's work, Aztlán and Nepantla run parallel, although Nepantla is not confined by the potential deficiencies attached to Aztlán. Nepantla enables Barraza to draw from multiple temporalities and sources, without being restricted by them. This, then, is an act of defiance.

Not surprisingly, Barraza states that "my artwork is about Nepantla."[70] She continues:

My art is about resistance, decolonization, self-determination, self-empowerment, and survival. I draw upon myths, family folklore, and *indigenismo* (a native way of being). I reinterpret and register all these as cultural, visual iconographic manifestations of my identity. As the subject matter of my art, I exalt a lineage of women, energized from a sacred space of creation.[71]

Operating in an indigenist space (in its anticolonial particularity), Barraza's creative practice speaks to Aztlán. It exerts Xicano sovereignty. But to make Aztlán tenable within her complex contemporary reality, she transforms its energy into a territory she calls Nepantla. By creating an Aztlán beyond Aztlán, to paraphrase Mario García, Barraza disavows Aztlán's ability to contain and codify her work and instead continues to open new possibilities and futures.

CHAPTER SIX

Revitalizing

Aztlán as Native Land

In this final chapter, I discuss the work of four artists, three of whom are of a younger and emerging generation. Over the course of the previous five chapters, we have lowridden from Aztlán to Tenochtitlán, back to Aztlán and into Nepantla. In this final chapter, we will continue riding through Aztlán, Anishinaabewaki (sovereign Anishinaabeg territory) and into Ixachilan, the Nahuatl-language term for Turtle Island or the Americas. Accordingly, these four artists—two individuals and one two-person collective—respectively transform the nature of Chicano art, but do so in ways that use Indigenous identity and Xicano sovereignty at their core. While certain curatorial projects, such as *Phantom Sightings: Art after the Chicano Movement* or *Leaving Aztlán*, are interested in the way that artists challenge the aesthetics of the Chicano Movement (we could call this the post-identity perspective), the artists in this chapter remain committed to the ideals of the Chicano Movement, while simultaneously pushing its parameters into the present moment. Radical Xicano politics are central to the aesthetics of these artists, as well as to their respective artistic practices. These artists counter post-Chicano aesthetics and affirm Chicano art as Indigenous sovereignty.

I begin "Revitalizing" with a section on printmaker Carlos Cortéz Koyokuikatl, a self-identifying anarcho-syndicalist, before discussing the work of Favianna Rodríguez and Dignidad Rebelde. Building on Santa Barraza's lowriding transition from Aztlán to Nepantla, these respective artists likewise modify Aztlán in new and challenging ways. Cortéz Koyokuikatl develops

a conversation on Ixachilan, while Rodríguez and Dignidad Rebelde reengage Aztlán through heterodox modalities. By sharing their stories with other Third and Fourth World peoples, these artists promote Xicano sovereignty as a dialogue with the struggles of other global movements.

Although Cortéz Koyokuikatl passed into the spirit world in 2005, his radical ideas continue to challenge contemporary Chicano art. His working-class activism and involvement with Anishinaabeg and hemispheric Indigenous issues facilitates an exciting conversation on Great Lakes indigeneity. As an artist of Peruvian descent, Rodríguez allows us to move beyond Aztlán's biological ties to Xicano identity, as well as continue thinking about Cherríe Moraga's proposition of a Queer Aztlán. Finally, Dignidad Rebelde, a collaboration between Melanie Cervantes and Jesús Barraza, evokes the notions of Xicanisma and Zapatismo to forcefully state that "Aztlán is Indian Land." Trained by Bay Area activists, the members of Dignidad Rebelde are unflinching in their political radicalism and their solidarity with Indigenous struggles throughout the world. In fact, Cervantes and Jesús Barraza continue to push Xicano sovereignty in stimulating and untouched directions. I end my discussion on art with Cervantes and Barraza because I feel that their artistic practices and direct-action politics, in relation to Aztlán, make many of the connections that I hope to make in this book.

These three interconnected and stimulating artistic modalities facilitate new modes of understanding Aztlán and Xicano sovereignty vis-à-vis the printed form. While I do not directly address it, the fact that all four of these artists are printmakers is paramount to their artistic practice and activist orientations. As others have rightfully noted, both muralism and printmaking perform irreplaceable roles within Chicano art. These artists emerge in that vein. Through their respective and shared artistic migrations, these artists lead us toward the critical provocations offered in the postscript.

Aztlán, Anishinaabewaki, Ixachilan

Throughout his life, Carlos Cortéz Koyokuikatl (1923–2005) was known as a union activist and ardent indigenist. As an artist, he worked primarily as a printmaker, using his artwork as a prefigurative modality to envision the world within which he so intimately wanted to live. While Cortéz Koyokuikatl has not gained the institutional recognition that his work demands, he has nonetheless gained community notoriety for his service as a mentor, friend, and elder to Xicano, Native, and working-class activists,

service from which I personally benefited. As an artist and poet, his work helps theorize the hemispheric and anticolonial struggles in which he was active. Although pre-dating the global indigenist networks that emerged in the 1990s, Cortéz Koyokuikatl's politics were uniquely Great Lakes in their epistemological base and Xicano in orientation. In this section, I interrogate three relief prints by Cortéz Koyokuikatl, a figure whose caring conversations allowed me access to anarcho-syndicalist perspectives on Indigenous struggles. Through these works, I pay particular attention to his evocation of Indigenous migration histories and their relationship to Native placemaking. In this analysis, I reveal the solidarity-building power embedded within Cortéz Koyokuikatl's work, located in his ability to use his art to theorize hemispheric Indigenous solidarity.[1]

Cortéz Koyokuikatl was born near Milwaukee, Wisconsin, on August 13, 1923, to Alfredo Cortéz and Augusta Ungerecht Cortéz. Alfredo Cortéz was a Mexican of Indigenous ancestry from Sinaloa who worked throughout the United States as a general laborer and was a member of the Industrial Workers of the World (IWW). Augusta Cortéz, the daughter of German émigré parents, was a socialist-pacifist. From the moment of his birth into a radical working-class Native/migrant family, Cortéz Koyokuikatl was initiated into the working-class struggles of early twentieth-century North America.

While always working as a laborer, Cortéz Koyokuikatl became a visual artist whose work drew from historically complex sources. Within his corpora, both visual and literary, Cortéz Koyokuikatl was directly engaged in everyday struggles against capitalism, neocolonialism, imperialism, and, most recently, globalization. His identity as a worker and, more importantly as a Native person, foregrounded the heterodox ways that he envisioned working-class struggles and Indigenous sovereignty. While recognized within the Xicano community in Chicago, Cortéz Koyokuikatl's artwork was never able to fully sustain him economically, forcing him to work a multiplicity of odd jobs throughout his life. As Cortéz Koyokuikatl himself stated, throughout his life he labored as a "harvest hand, construction worker, loafer, jailbird [and] vagabond factory stiff" simply to sustain his proclivity to make art.[2]

Cortéz Koyokuikatl took a uniquely anarcho-syndicalist political position in both his life and labor, artistic and otherwise. On many levels, especially as articulated in manifestos published during the Chicano Movement, both Malaquías Montoya and Cortéz Koyokuikatl engaged in dialogue with their contemporaries about the role of art within revolutionary and anticapitalist societies. Offering his perspective on the role of art, Cortéz Koyokuikatl proposes that art need not be explicitly ideological, but must emerge in

conjunction with social and political movements so that it may liberate human societies from capitalist and state oppression. As Cortéz Koyokuikatl wrote in 1976, "the liberation of art" from capitalist markets must transpire in tandem with directly political movements.[3] In this way, he also believed that "in these days of rising liberation movements, another priority should be the liberation of art. Free it from those who use it as another means of differentiating themselves from those who are of the 'lowah clahses' and bring it back to where it originated and where it belongs, among the people."[4]

From this perspective, Cortéz Koyokuikatl is clear that although not wholly autonomous, as modernist proponents of "art for art's sake" would have it, art may nonetheless be released from oppressive situations, such as its condition under capitalism. Once liberated, it can be used to facilitate emancipation among its subjects. Operating against capitalist market forces allowed him to work outside its repressive grip on art-making and see art as a practice linked to Fourth World struggles.

Cortéz Koyokuikatl theorizes the liberation of art, which I explore in further depth elsewhere; so too does he visually develop a robust language and practice to articulate notions of space and place within Xicano and Anishinaabeg sovereignties. He does this by establishing parallel visualities between these two Indigenous communities. Two images that operate within this hemispheric and continental space are posters that Cortéz Koyokuikatl produced for an exhibition of Chicano and American Indian art entitled *Anišinabe-Waki-Aztlán*. The traveling exhibition was curated in 1977 and, following in the Indigenous solidarity of the American Indian Movement (AIM) and the Chicano Movement, was "a celebration of our indigenous spirit."[5] For Cortéz Koyokuikatl, Indigenous identities—or more appropriately, Indigenous ontologies—were not solely perspectives that operated within identity politics, but were likewise spiritual and political gestures based in land-based social networks. An assertion of his indigeneity was, for Cortéz Koyokuikatl, an anarchist and antigovernmental stance founded in nonhierarchical tribal sociality. In many regards, indigeneity is posited through acts of resistance to colonialism and the revindication of noncapitalist social structures.

In "Poema por el Día de la Raza," Cortéz Koyokuikatl communicates his position in the following verse:

> You see, we were practicing ecology and
> The classless society for
> Thousands of years before
> Our "civilizers" even had words for these things![6]

Revitalizing • 173

Although uncritical of the extreme class distinction practiced by the Mexica and other stratified Native societies (generally viewed as more "advanced" by settler colonialists), it must be noted that Cortéz Koyokuikatl did not identify with the stratified societies of Mesoamerica. On the contrary, he viewed Xicanos as the cultural inheritors of the "barbarous" Chichimecas of northern Mexico, as well as descendents of tribal and detribalized (*genízaro*) peoples of the borderlands.[7] In this way, Cortéz Koyokuikatl was very much in dialogue with the work of Lenape-Delaware historian Jack Forbes, who in 1973 published *Aztecas del Norte*. In this seminal work, Forbes maintained that Xicanos "compose the largest single tribe or nation of Anishinabeg (Indians) found in the United States today." This was also made apparent in the *Handbook of Native American Studies* (1970), in which Forbes acknowledged the very real presence of Xicano difference, stating that "like other Native American groups, the Aztecas of Aztlán are not a completely unified or homogenous people. Some call themselves Chicanos and see themselves as people whose true homeland is Aztlán."[8] This claim for Xicano indigeneity is commonly contested by legacies of mestizaje, a colonial paradigm that Forbes, Cortéz Koyokuikatl, and I work against. In the Postscript, I return to Forbes, his critiques of mestizaje, and what this means for Chicano studies.

In the posters that Cortéz Koyokuikatl produced for the *Anišinabe Waki-Aztlán* exhibition, he drew from and reciprocally produced a hemispheric Indigenous visual language, one tied directly to migration narratives (figures 21 and 22)—what I would call lowriding. Both impressions—one for an opening at the Uptown People's Community Center, the other for events at Harry S. Truman College—are housed at the Center for Southwest Research in Albuquerque. As an exhibition, *Anišinabe Waki-Aztlán* was sponsored by the Movimiento Artístico Chicano (MARCh) and the Chicago Indian Artists' Guild, both important grassroots organizations in the city. As one of the posters proclaims, the exhibition and accompanying activities were "*una celebración de nuestra herencia indígena.*" In both of the images, Cortéz Koyokuikatl collapses the physical Indigenous body into, as Lefebvre would argue, representational space and representations of space.[9] In this manner, Cortéz Koyokuikatl combines the physical Indigenous body with what appears to be a map of North America. As imagined in this work, to be Indigenous is to be intimately coupled to the land, with Native sovereignty being of paramount significance. This, of course, is exactly what Indigenous scholars have been saying for some time.

In the poster for the first exhibition at Harry S. Truman College, a male figure clutching a paintbrush forms the landmass that constitutes

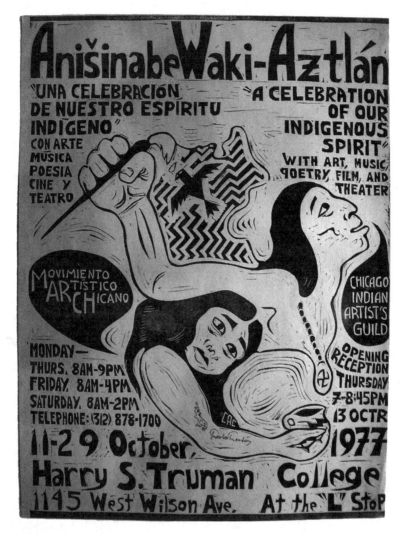

Figure 21. Carlos Cortéz Koyokuikatl, *Anišinabe Waki-Aztlán* (Truman College). Relief print, 1977. Image and photo courtesy of the author.

the present-day United States. From the mouth of this figure emanates the text "Chicago Indian Artist's Guild." Around this figure's neck, descending into what we commonly know as Florida, is a necklace incorporating a swastika-like image popular in American Indian practice. Importantly, Anahuac (Mexico) and the U.S. Southwest are represented by a female figure whose head juts into the underarm of the male figure. Although there

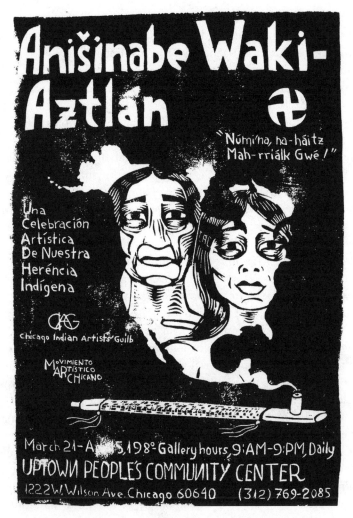

Figure 22. Carlos Cortéz Koyokuikatl, *Anišinabe Waki-Aztlán* (Uptown People's Community Center). Relief print, 1977. Image and photo courtesy of the author.

is a separation between the colonial-states of Canada, the United States, and Mexico, Cortéz Koyokuikatl's borders are fluid and do not match the geopolitical boundaries associated with settler-colonial nation-states. As such, Cortéz Koyokuikatl is in line with El Plan Espiritual de Aztlán, which maintains that Xicanos "do not recognize capricious frontiers on the bronze continent." It is central to appreciate how Cortéz Koyokuikatl—as

a Xicano from rural Wisconsin, but spending much of his adult life in urban Chicago—constructs an intimate relationship to land, particularly to both Aztlán and Anishinaabewaki, the traditional sovereign territory of the Anishinaabeg.

If we turn to the other *Anišinabe Waki-Aztlán* poster, we understand that for Cortéz Koyokuikatl, Aztlán and Anishinaabewaki are one and the same. For the Ojibwa, Ottawa, and Potawatomi peoples of the Great Lakes who self-identify as Anishinaabeg ("the original people" or "good people" in their language), *aki* is the Anishinaabemowin word for "land." In turn, *Anišinabe Waki* (which, using more formalized spelling, would be Anishinaabewaki) refers to "the land of the original people," correlating specifically to the sovereign Anishinaabeg land of the Great Lakes. In fact, when we look at the seven sacred stops during the Anishinaabeg migration (itself a form of Indigenous lowriding), sites like Zhaagawaamikong (Madeline Island), Mooniingwanekaaning-minis (Spirit Island/Duluth), Baawating (Sault Ste. Marie), Manidoo-minising (Manitoulin Island), Waawayeyaattanong (Detroit), Wayaanag-gakaabikaa (Niagara Falls), and Mooniyaa (a turtle-shaped island that is present-day Montreal), we realize that all these locations remain crucial centers of contemporary Anishinaabeg society and many have become important sites for Xicano labor migration. Since time immemorial, Anishinaabewaki has been Aztlán. I say this, not in the colonizing fashion of nineteenth-century archaeologists, but because the reciprocity between Anishinaabeg and Xicano peoples is strong in the Great Lakes, with many tribal members having Spanish surnames, and we can see these concepts as inflecting one another. As articulated in the chapter on Detroit, Xicanishinaabeg history is one that has developed new kin networks between the Xicano and Anishinaabeg communities in Anishinaabewaki. In the way that, for the Mexica, Aztlán and Tenochtitlán were bookends and mirrors of one another, we could say that, for Cortéz Koyokuikatl, Aztlán and Anishinaabewaki are these two spaces.

Since Anishinaabeg migration histories (lowriding) tell of their communal migration from the Eastern Seaboard into Michigan, Minnesota, Wisconsin, Ontario, and Manitoba, Cortéz Koyokuikatl sees the similarities between the Aztlán narrative and Anishinaabeg migration stories. According to Patrick LeBeau (Anishinaabe/Lakota),

> the Ojibwa people have a rich oral history and pictorial tradition regarding their origins and migration from the Atlantic Ocean westward through the St. Lawrence Valley and the Great Lakes to Wisconsin and Minnesota. The tale of this journey over thousands of miles many hundreds of years

ago is vivid and full of myths of good and evil spirits. . . . While written in the symbology of mythology, the maps of the ancient migration of the Ojibwa have identifiable reference points to the modern landscape.[10]

In the Anishinaabeg migration narrative, Cortéz Koyokuikatl saw similarities between the history and colonization of Xicanos with those of the Anishinaabeg, not to mention the other aboriginal people of Turtle Island-the Americas. In fact, he uses migration/lowriding as a trope that may be applied to all tribal and oppressed peoples the world over. Shared stories of migration have particular importance among nearly all Native people of this hemisphere.[11]

Cortéz Koyokuikatl's understanding of migration as an Indigenous conception of identity is one shared by most aboriginal people throughout the hemisphere. Ted Jojola (Isleta Pueblo) posits that the kinship networks of contemporary Pueblo peoples have evolved through various periods of migration and movement. It is through the process of slow movement, of lowriding, that Native peoples construct their unique epistemologies that are intimately tied to a particular chronotope. Lowriding is an Indigenous way of being in the world that contradicts capitalist modes of production and globalized speed of movement. Accordingly, Jojola writes that

> each clan has its unique history. It is embodied in a migration pattern as exemplified by a spiral. . . . A spiral with an outward direction indicates that the clan is journeying outwards, literally, towards the perimeter of human and physical settlement. Such journeys may have extended as far as the farthest land passages of the continent. The purpose of such a journey was to gain experiential knowledge. Once the journey for each of the sacred directions was completed, the clan returned to its origin point.[12]

For Cortéz Koyokuikatl, the Xicano community was doing exactly this: returning to their sacred point of origin through the process of migration/lowriding and continued diaspora. By linking the cultural expressions and political struggles of Xicano and Anishinaabeg peoples, Cortéz Koyokuikatl asserted an Indigenous identity that transcended federally recognized tribal enrollment and instead was based in economic, political, cultural, and kin relationships to the land.

Moreover, his identification as Indigenous was not relegated to some New Age appropriation of postmodern spirituality, cultural practice, or history. Inversely, Cortéz Koyokuikatl espoused an active solidarity network with sovereign tribal nations that applied pan-Indigenous histories, cultures,

178 • *Tlapalli*

and epistemologies in hopes of activating Aztlán (and later Ixachilan) as a working-class utopia. In "Requiem Chant for a Half-Breed Warrior," an homage to Native labor organizer Frank Little, Cortéz Koyokuikatl does not idealize the noble savage of the Anglo-American and the *indio* of the Latin American imaginary. Rather, he dismisses outdated modes of aboriginality in favor of isolating the contemporary bond between indigeneity, class, and solidarity. According to the third verse of this poem,

> For you the lance, the tomahawk and the flintlock
> Were things of the past as your weapon was even greater,
> A weapon feared and hated by the enemy the World over,
> As your weapon was the mightiest one yet:
> The organizing of working men and women
> and the war-cry was SOLIDARITY!![13]

This Indigenous and working-class solidarity is what drives Cortéz Koyokuikatl and his artistic practice. Like artists such as Santa Barraza who begin to replace Aztlán with notions of Nepantla, toward the end of his life Cortéz Koyokuikatl began to reconfigure his relationship to indigeneity in hemispheric fashion. In this process, Cortéz Koyokuikatl transgressed Aztlán and was inclined to develop a more inclusive exaltation of Ixachilan, the Nahuatl word for Turtle Island or the Americas.

His 1991 linoleum-block print *Orgullo Itzachilatleka* (figure 23) prominently features a frontal depiction of a danzante of the Mexicayotl tradition. In this particular impression, the foregrounded human body serves as a partitioning device between the solid black background of the bottom section and the white atmosphere of the top portion. The feathers in the figure's *copili* or headdress extend in an uncontrollable and anarchic fashion, while the subject gazes intimately at the viewer. Although seemingly removed from the radical class-consciousness constructed in his more overtly political work, the title of this object serves an undeniable significance when extending Indigenous solidarity to the continental level.

If we attempt to translate *Orgullo Itzachilatleka*, already a bilingual signifier in Spanish and Nahuatl, we begin to understand the anticolonial stance that Cortéz Koyokuikatl is taking with this image. Itzachilatleka (also spelled Ixachilatleka) denotes a resident of Turtle Island — coming from the Nahuatl root, Ixachilan or Itzachilatlan. In many regards, this term could be directly translated as "American" in the hemispheric sense. *Orgullo*, of course, signifies pride. According to the *Diccionario de Uso del Español de América*, orgullo is a "feeling of satisfaction toward something close to

Revitalizing • 179

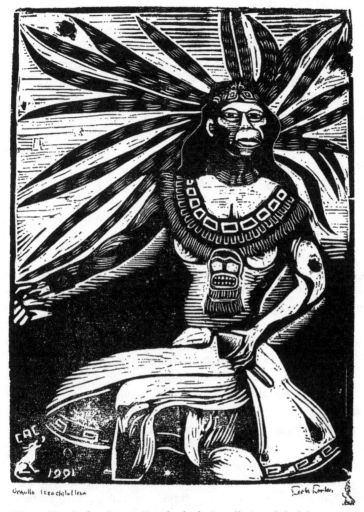

Figure 23. Carlos Cortéz Koyokuikatl, *Orgullo Itzachilatleka*. Relief print, 1991. Image and photo courtesy of the author.

one's self or personal that deserves praise or merit."[14] In this case, the pride derived or emanating from this image is one of continental Indigenous resistance to European colonialism, a colonial process manifest in the eyes of Cortéz Koyokuikatl through capitalist social and economic structures that have continuously oppressed Native peoples.

In *Wretched of the Earth*, Frantz Fanon recognizes the continental nature that resistance movements develop in response to colonialism's

destruction of Native societies, histories, and self-governance. Accordingly, Fanon acknowledges that Native intellectuals, which includes artists, attempt to revitalize the past in their search for "national" culture and identity. He states that "the native intellectual decides to make an inventory of the bad habits drawn from the colonial world, and hastens to remind everyone of the good old customs of the people, that people which he has decided contains all truth and goodness."[15] As an anticolonial critic, Fanon is disapproving of the way that certain Native intellectuals exalt all things "precolonial." Inversely, Fanon views this as a "phase" that anticolonial movements pass through in developing a dialogic and dialectical anticolonialism on both national and continental fronts. It is something we must lowride through, before coming out the other side.

In turn, Fanon argues that history (and its rearticulation) becomes the battleground where "men of culture take their stand."[16] This process, then, is an ongoing dialectic, much like Cortéz Koyokuikatl's work itself. Fanon writes that "colonialism is not satisfied merely with holding a people in its grip and emptying the native's brain of all form and content. By a kind of perverted logic, it turns to the past of the oppressed people, and distorts, disfigures, and destroys it. This work of devaluing precolonial history takes on a dialectical significance today."[17]

By grappling with the complexities of colonialism in a dialectical and continental fashion, the various colonized people will be able to rise in solidarity against colonial oppression. Fanon continues: "colonialism did not dream of wasting its time in denying the existence of one national culture after another. Therefore the reply of the colonized people will be straight away continental in its breadth."[18] It is in this continentality of Indigenous resistance that the work of Cortéz Koyokuikatl finally begins to serve its revolutionary and indigenist function. While concepts like Aztlán were intended to transcend racial, ethnic, and gender divisions in favor of Xicano sovereignty, their specificity to the Xicano community halted any continental application. By turning toward a hemispheric pronouncement (Ixachilan), Cortéz Koyokuikatl taps into the utopian potential of Xicano sovereignty by moving toward Ixachilan as one that builds continental Indigenous solidarity. By looking at his work within the parameters of hemispheric indigeneity, we see both the importance of his visual production and the manner that he was inserting Xicano struggles, as a form of Indigenous uprising, in dialogue with Anishinaabeg and working-class movements. His work, then, allows us to see the direct relationship between Aztlán, Ixachilan, and Anishinaabewaki. After all, he lived in sovereign Anishinaabeg territory, and Cortéz Koyokuikatl was always thoroughly aware

of this. For Cortéz Koyokuikatl—and this is crucial—neither Aztlán nor Ixachilan impinges on Anishinaabeg sovereignty. It is the settler-colonial nation-states that do this. Indigenous sovereignties have always coexisted without fully extinguishing one another. Their territories can mutually exist across one another.

Queer Aztlán and Decolonizing the Earth

"Art alone does not transform the world. . . . It is in the unique collaborations between artists, activists, and people that forge true social change."
— FAVIANNA RODRÍGUEZ

The second U.S. Social Forum (USSF), a gathering of grassroots organizations and activists, was held in Detroit during summer 2010. Indigenous and immigrant organizations, as well as cultural workers of settler-colonial and immigrant backgrounds, played a central role in the weeklong event held throughout a city known for its disproportionate level of unemployment and poverty. Detroit is one of the few global cities to reach more than one million residents before losing approximately one-quarter of its population. Many artists have flocked here for the cheap rent and with the desire to make what critics call "ruin porn"—to aestheticize Detroit's postindustrial presence. Of course, all of this has been critically analyzed.

Detroit is also a sacred Indigenous place, one of seven stops along the Anishinaabeg migration. The Xicano history of Detroit is one that I chronicled in an earlier chapter, as well as in my other published research. Needless to say, Detroit remains an important place for the stories I tell in this book.

At the USSF, I sat down with artists Favianna Rodríguez, Melanie Cervantes, and Jesús Barraza. At the time, they were three emerging Bay Area printmakers. However, by 2014 all three have become well known across Turtle Island-the Americas. I met with these next-generation artists, who also happen to be friends, to record an interview for a special episode of *Radio Free Aztlán*, a Xicano podcast based in Michigan.[19]

During our hour-long conversation, the four of us engaged in dialogue covering a multiplicity of topics, ranging from immigration to the role of art in social justice movements.[20] It became apparent that Aztlán, although very much alive within the Xicano community, has lowrided and shape-shifted into hemispheric and earth-based notions of indigeneity. While Aztlán still performs active roles within the work of Rodríguez and Dignidad Rebelde

(the collective name for work created collaboratively by Cervantes and Barraza), they respectively and simultaneously move beyond its singularity. As Jesús Barraza stated during the interview, his notion of hemispheric indigeneity is grounded in the intellectual labor of figures such as Leslie Marmon Silko, the Laguna-Xicana writer whose nearly eight-hundred-page novel *Almanac of the Dead* develops a transborder and internationalist agenda for Indigenous struggles.[21] For Barraza, Chicano art has gone beyond the particularities of Aztlán and is better situated in a form of "internationalist-indigenism," a modality he locates in the poetic and activist labor of writers like Silko. Evoking the internationalism prominent in Third World-ism, Barraza's internationalist-indigenism is rooted in Aztlán, but is not confined by its particularities.

For Favianna Rodríguez, art operates in conjunction with popular social movements where artists have the capacity to transform the status quo into, borrowing from the Zapatistas, another possible world. While certain modernist theories isolate art from larger radical situations, Rodríguez, as a "future ancestor" of the Chicano Movement (to use the words of Dignidad Rebelde), positions her work (and art in general) at the center of social change. Art, like Aztlán, is the axis mundi.

Born in Oakland to Peruvian immigrant parents, Rodríguez says that she "grew up in a historically Chicano movement neighborhood" in Oakland, as well as, for a time in Mexico City.[22] Regardless of her Peruvian roots, Rodríguez identifies as Xicana, a political and cultural decision. Her childhood experiences with the activist community and its grassroots arts programming instilled within Rodríguez a commitment to the arts, a perspective that can be seen in the type of work she makes today.

After secondary school, Rodríguez attended the University of California, Berkeley, during the late 1990s and early 2000s. Although she did not complete her undergraduate studies, it was in Berkeley that she immersed herself in community struggles and solidarity-building work. While at university, Rodríguez was heavily involved in student activism, particularly among Third and Fourth World students. Her prominence within these organizations is highlighted in a photograph of Rodríguez speaking at a campus protest in Betita Martínez's *500 Years of Chicana History* (2008), the Xicana-centered follow-up to her widely successful publication *500 Years of Chicano History*.[23]

Although only in her thirties, Rodríguez has already established herself as an artist on the move, crisscrossing Turtle Island (with excursions to Europe and Asia) to work in collaboration with Indigenous and "immigrant" youth. Printmaking is Rodríguez's primary media, although she also

practices installation, mural, and digital art. In 2000, alongside Hawai'i-born muralist Estria Miyashiro, Rodríguez cofounded Tumis, a bilingual design firm committed to high-quality graphic design for socially engaged nonprofits and youth organizations. In this capacity, Rodríguez augmented her already keen eye by collaborating with community partners in the Bay Area. Through this experience, Rodríguez's artistic practice materialized in a way that merged digital design skills with fine art print technologies (particularly serigraph, relief print, monoprint, and letterpress).

Working from these differing visual and historical traditions, Rodríguez merges the approaches learned from digital technologies into her print-based work, while also frequently scanning and integrating her fine art prints into digitally designed posters. While her early work during the 1990s and early 2000s was heavily influenced by the visuality of Cuban and Xicano poster traditions, her recent work moves further afield to develop a recognizable style. In summer 2011, Rodríguez studied with master printer Paul Mullowney at Anderson Ranch in Aspen, Colorado. At this time, she commenced new projects working on larger-format relief prints that frequently used her own likeness.

In her artwork, Rodríguez directly references Aztlán only once, in *Resist US Imperialism* (figure 24). This 2003 serigraph is an image that is striking in its simplicity and draws parallels between the U.S. imperial and military aggression in Aztlán with Iraqi experiences of being systematically slaughtered in the name of the "war on terror." This image, although generally acknowledged as Rodríguez's, is in fact a collaboration with Jesús Barraza from Dignidad Rebelde and Estria Miyashiro. The role that Barraza played in making this image can be seen stylistically.

Instantly, this image finds an antecedent in Malaquías Montoya's 1972 image *Viet Nam Aztlán*, an image I discussed in the previous chapter. Rodríguez's politically engaged visuality (in collaboration with Miyashiro and Barraza) ascends to artists like Montoya, who, as Rodríguez attests, was one of her most important mentors (both aesthetically and politically). This relationship plays out in the way this image evokes Aztlán as a political entity and through the way these three artists see Chicano art as an intervention in colonizing practices. Although *Resist US Imperialism* is perhaps Rodríguez's only image to date that directly enunciates the word Aztlán, it is conceptually common for her to use it as an emancipatory and oppositional trope in her work.

In a 2005 interview, Rodríguez maintained: "The reason that I have taken on silkscreening and political graphics as a medium is because for myself I like to create art that is useful to people in my community." Rodríguez

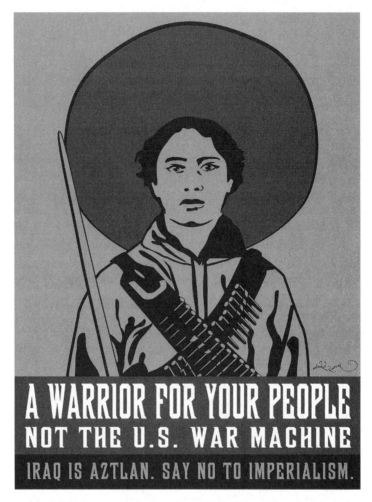

Figure 24. Favianna Rodríguez, Jesús Barraza, and Estria Miyashiro, *Resist US Imperialism*. Serigraph, 2003. Image courtesy of Favianna Rodríguez.

understands the poster's role as one that intervenes in Xicana daily life via Xicano aesthetic sovereignty established by activist-artists during the 1960s. She is not alone in her evocation of Xicano community posters and their importance. As George Lipsitz so powerfully acknowledges:

> Posters functioned as part of the movement itself, as vital forms that performed important work in the struggles for social change. They provide

us with the "material memory" of artifacts that helped call a movement into being through artistic expression. These posters played crucial roles in constructing organic solidarity and in defining collective ideology.[24]

Although critics like Max Benavidez may call current practices "Post-Chicano," intimating that "Chicana" and "Chicano" identities have outgrown their effectiveness, the fact that artists like Rodríguez, and Barraza and Cervantes, continue to work in this vein demonstrates that notions of post-Chicanidad and postsocial movement aesthetics are not entirely applicable.[25] Chiricahua Apache curator Nancy Mithlo argues that "post-Indian" or post-identity exhibitions are, contrary to the intentions of curators, inherently racist. She states that "post-identity claims evidence of a lack of engagement in the concrete realities of racism. A denial of race, either as a biological or social construct, conveniently and effectively silences the realities under which most Native American populations live."[26] Artists like Rodríguez, Barraza, and Cervantes continue to recognize the ongoing realities of racism, especially as perpetrated in the Third and Fourth Worlds.

Resist US Imperialism visualizes the way that shared experiences of oppression oppose capitalist modalities of divide and conquer, a strategy used to segregate Xicanos, Natives, and other Third and Fourth World people. This poster, as Rodríguez herself notes, "symbolically parallels Iraq to Aztlan." She continues: "The invasion of Iraq under the false pretense of 'liberation' reminds me of the invasion of the Southwest, where *Mexicanos* were promised their rights under the Treaty of Guadalupe Hidalgo, . . . promises that were never kept and a treaty that was never upheld."[27] Recalling the illegal and extra-juridical denial of treaty rights, an issue that Indigenous legal scholars continue to challenge, Rodríguez returns to a tactic that lost its importance during the 1970s: treating U.S. treaties, particularly the Treaty of Guadalupe Hidalgo, as legally binding documents.

In this way, Rodríguez, Barraza, and Miyashiro bring the anticolonial logic of the Chicano Movement into the present by inserting the Treaty of Guadalupe and the U.S. government's denial of Indigenous land rights into the militaristic language of Bush-era military doctrine. In this image, Aztlán is situated alongside Iraq, a modern nation-state. Aztlán's subsequent signification becomes unyieldingly "nationalist" in orientation. In fact, these artists believe in Aztlán. But their Aztlán, much like Moraga's Queer Aztlán, is neither narrow nor macho. Instead, Aztlán becomes a form of queer indeterminacy in which sovereignty does not reproduce the nation-state. When this poster is placed in the context of the larger corpora of Rodríguez and Dignidad Rebelde, we see that Xicano art helps transgress the problematics

that some Native studies scholars have about Aztlán's potential disavowal of Native sovereignty (particularly that of federally recognized tribes).

For some Native intellectuals, Aztlán disavows authentic Indigenous sovereignties within the geography that Xicanos have (according to this logic, inappropriately) labeled Aztlán. In "How the Border Lies: Some Historical Reflections," Patricia Penn Hilden (Nez Perce) has written about the ways that certain Xicano readings of history negate existing land (and sovereignty claims) of Indigenous peoples in the Southwest.[28] In this way, Aztlán serves simply as a colonial and "mestizo" masking of existing Native autonomies and sovereignties. In her book *Blood Lines*, Sheila Contreras acknowledges the colonizing language included in the preamble to El Plan Espiritual de Aztlán, when its Xicano framers identify themselves as the "civilizers of the northern lands of Aztlán," actively relegating other Native peoples to the level of savagery. While the tactical rhetoric embodied in this statement makes sense as a way to disrupt settler-colonial society's naming Xicanos as savage, it is nonetheless faulty in its original logic. But, having seen Alurista's indigenist turn, we must read this phrase, within the context of the Plan, as rhetorical and inverting Anglo-American settler-colonialism.

In many ways, I follow ideas proposed by Scott Lauria Morgensen, ones similar to those found in Guiselda Latorre's writings on Chicano art. For Morgensen, "at the moment that they affirmed their own indigeneity, Anzaldúa and Moraga did not claim to be identical to Native American Two-Spirit people."[29] Xicana queer Aztláns are not the same as other Indigenous sovereignties, while at the same time Xicano indigeneity does not extinguish other Indigenous claims to sovereignty and territoriality.

Andrea Smith (Tsalagi), cofounder of *INCITE!: Women of Color Against Violence*, an organization with which Rodríguez has worked extensively, responds to the work of queer Latino critic José Esteban Muñoz. She writes:

> What is erased in this analysis are the land claims of indigenous people who come from the land Chicanos may claim as Aztlán. Of course, Muñoz is not unaware of the anti-indigenous problematics within theoretical configurations of hybridity, but when indigeneity is not foregrounded, it tends to disappear in order to enable the emergence of the hybrid subject.[30]

What Smith's critique lays bare is the need to properly situate Xicano indigeneity at the forefront of Xicano political and cultural projects. In this way, indigeneity becomes the crucible for any radicality to fully embrace anticapitalist transgressions. Smith is clear to highlight the "anti-Indigenous

Revitalizing • 187

problematics within theoretical configurations of hybridity." While a critique of Chicana and Chicano hybridity in the form of mestizaje runs throughout this book, I will advance it even further in the Postscript.

Although Rodríguez would never negate her lineage to the *afroperuano* (Black Peruvian) and *nipoperuano* (Japanese-Peruvian) communities of the Andes, she nonetheless foregrounds her own indigeneity as one tied to hemispheric indigeneities, as well as to the struggles of Third and Fourth World women and global queer issues. Her collaborative work with Native organizations across Turtle Island serves to highlight this mutually intelligible focus on indigeneities.

What, then, are we to take away from her use of Aztlán and its references to Xicano sovereignty? As a queer woman whose Xicana identity transgresses biological and racial notions of Xicanidad, the very essence of Aztlán must never be reduced to a "narrow nationalism" or to a nation-state model of governmentality that dismisses the sovereignty of other Indigenous peoples. What becomes moving about the intention of *Resist U.S. Imperialism* (or rather my reading of its intention) is how Rodríguez, Barraza, and Miyashiro foreground Aztlán as a legitimate organizing principle. Much like its role in the Chicano Movement, Aztlán remains an Indigenous nation. As a Native nation, according to Andrea Smith, its existence is "already queered."[31] By asserting Aztlán as a queer nation, in the vein of Moraga (or, as we will see, of Dignidad Rebelde), these three artists attest to a particular anti-mestizaje (mestizaje inevitably leads to the genocidal appropriation of Native lands) and anticolonial logic.

By evoking Aztlán, this genocidal disappearance of non-Xicano indigeneities is fundamentally transformed. Therefore, indigeneity is enacted and maintained within the guise of Native and anticolonial solidarity. As it has commonly been used in Chicano studies, but not within Native studies, mestizaje (as the logic of hybridity) is located in a queer sociality. However, as my discussion of Forbes will attest, mestizaje is in fact a settler-colonial logic used to legitimize colonial violence and make palatable settler expropriation of Indigenous lands. There is nothing theoretically queer, drawing on its usage in queer theory, about the process of mestizaje. In fact, mestizaje becomes the discursive and structural annihilation of indigeneity and Indigenous ontologies. It becomes structurally normative. What we must be clear about, however, is that by delegitimizing mestizaje we are not denying the very real presence of "racial" or cultural mixing, which is a commonality of all societies, particularly Xicano society. Instead, my argument is based in the viewpoint that mestizaje is an ideology of colonization, not one of transgressive postmodern hybridity or radical queer settler-colonial

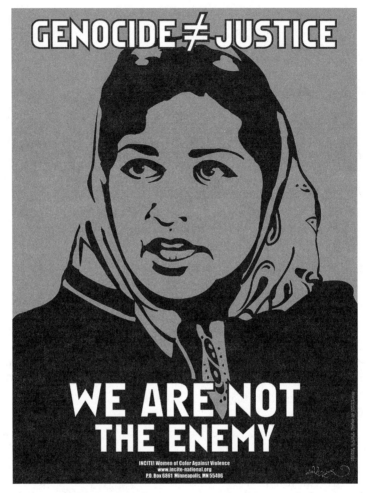

Figure 25. Favianna Rodríguez, *We Are Not the Enemy.* Offset lithograph, 2001. Image courtesy of Favianna Rodríguez.

ideals. Instead, following Andrea Smith, Aztlán foregrounds indigeneity and pushes Chicano studies past mestizaje and its limitations. It asserts Aztlán outside the limits of settler-colonial nationalisms and hetero-patriarchy.

From her earliest collaborative work with Barraza and Miyashiro, we begin to see Rodríguez's queer-feminist perspective, one in which women's issues are foregrounded in struggles against capitalism and colonialism. The political and social issues of Aztlán are those shared with other marginalized communities. Three offset lithograph posters, each produced for

Revitalizing • 189

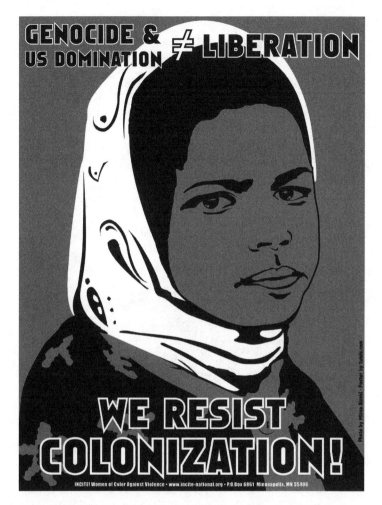

Figure 26. Favianna Rodríguez, *We Resist Colonization.* Offset lithograph, 2002. Image courtesy of Favianna Rodríguez.

INCITE! (*We Are Not the Enemy*, 2001 [figure 25], *We Resist Colonization*, 2002 [figure 26], and *Not in Our Name!* [figure 27]), attest to the centrality of women's struggles within the context of globalized colonial (and military) expansion. Although not engaging Aztlán in an overt way, these images reflect Rodríguez's larger politically engaged motivations, ones which always lead back to Aztlán as an emancipatory trope. Following the 2001 U.S. invasion of Afghanistan, INCITE! commissioned three women of color, including Rodríguez, Samia Saleem, and Cristy C. Road,

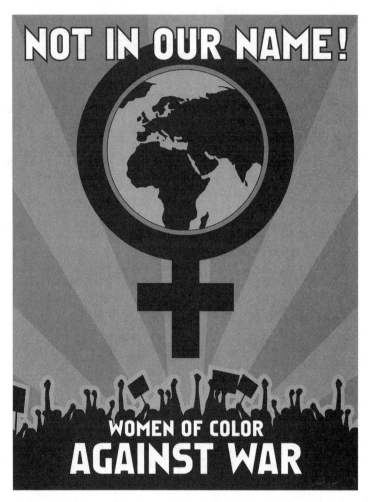

Figure 27. Favianna Rodríguez, *Not in Our Name*. Offset lithograph, 2002. Image courtesy of Favianna Rodríguez.

to produce images against the war and its implications on Third and Fourth World women. These posters, created digitally and distributed as offset lithographs, used the narratives of Palestinian and Afghani women as source material and began telling these significant stories to Western audiences. In *We are Not the Enemy*, Rodríguez recalls the importance of Meena (1956–1987), the martyred founder of RAWA, the Revolutionary Association of Women of Afghanistan, an organization intent on giving voice to silenced women who spoke against the Soviet regime installed in 1971.

Aesthetically, this series pulls equally from Cuban and Xicano serigraphs, hand-cut stencils, and computer-generated graphic traditions. *We Are Not the Enemy* is visually bisected into two nearly equal fields of orange and black, with Rodríguez's illustration of Meena reduced to basic formal elements. Meena's bold eyes look idealistically off into the distance, almost as if Rodríguez is remembering Roland Barthes's theorizing on the semiotics of French political photographs. The figure's black *hijab* juts through the orange background establishing a beautifully arranged composition. White text, outlined in black, clearly reads "Genocide ≠ Justice" at the top of the composition, while "We are Not the Enemy" streaks across the bottom. Through the simple use of two colors on white paper, Rodríguez conjures the impression of a three-color poster. In her direct engagement of these issues, Rodríguez confronts power in an act of opposition. In a 2008 interview, she stated: "My artwork reflects some of the most serious situations confronting our contemporary society. . . . In my artwork I try to critique those issues and offer reflection on how we can progress." By calling out the effects of U.S. military occupation on Third and Fourth World women, Rodríguez amplifies the reach of existing global networks that operate in opposition to patriarchy.

The emotive qualities enacted when seeing the INCITE! posters contrasts greatly with those one may feel when engaging Rodríguez's more visceral use of the relief print as an activist medium. It could be my personal predisposition to the relief print, but through Rodríguez's highly trained command of this technique, she initiates very distinct and well-established meaning. This is telling in two prints in particular: *Fight Patriarchy* (2009, figure 28) and *Fight the Climate Crisis* (2009, figure 29). While her digitally produced offset posters lend themselves to glossy and "professional" qualities, these diminutive relief prints recall one of the most rudimentary print methods available. Art historian Anthony Griffiths notes that this technique is the one of the oldest print technologies utilized today.[32]

Using this ancient technique, Rodríguez situates her relief prints firmly in twenty-first century social and political contexts. With this technique she recollects an oppositional visuality that dates to the radical printmaking tradition of the TGP. In a 1939 interview, Pablo O'Higgins, one of the TGP's founders, stated that the potency of the TGP was located in its collaborative working practices, among artists and between artist and grassroots organizations. For O'Higgins, "the strength of the TGP was based in collective work. Our principal interest is making contact with the people and popular organizations. In this we could not succeed without collective work, work that includes discussion, criticism, and self-criticism."[33] Just as the power

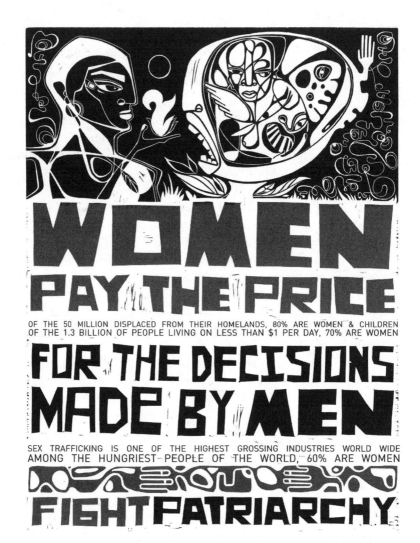

Figure 28. Favianna Rodríguez, *Fight Patriarchy*. Relief print, 2009. Image courtesy of Favianna Rodríguez.

of mid-twentieth-century art-making lay in the capacity of artists to work collectively, artists like Rodríguez have returned to collaborative working processes (what Pablo Helguera calls socially engaged art). Personally, Rodríguez is involved in multiple collectives, including Justseeds, Tumis, and the Taller Tupac Amaru, an organization named after the Qhichwa freedom fighter, and includes both members of Dignidad Rebelde. In 2012,

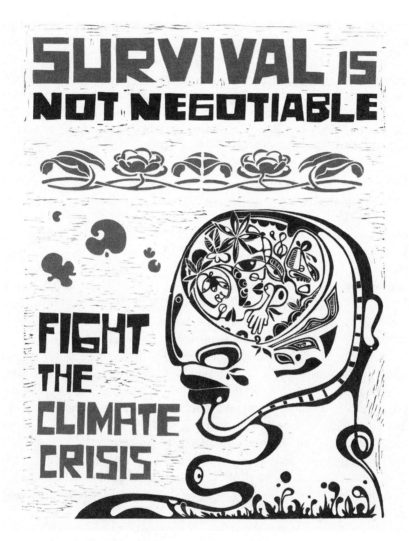

Figure 29. Favianna Rodríguez, *Fight the Climate Crisis*. Relief print, 2009. Image courtesy of Favianna Rodríguez.

Rodríguez was fundamental in organizing a poster campaign and print portfolio for Culturestr/ke, an artists' organization advocating immigrant rights.

In *Fight Patriarchy*, Rodríguez combines digital text with hand-cut illustration work. The computer-generated text integrates statistics related to women's homelessness, refugee diasporas, income disparity, sex trafficking, and women's hunger. Inversely, the hand-cut illustrations include figuration

and two large, blocky headings that read: "Women Pay the Price for the Decisions Made by Men" and "Fight Patriarchy." Throughout the image, one can see the remaining marks in areas where the linoleum was not thoroughly removed. This quality, one where unintended marks are printed in unknown areas, is a hallmark of the relief print and one that Rodríguez utilizes to her advantage. Without interfering with her audience's ability to properly read the image, Rodríguez allows these small organic shapes, known as chatter, to fill in the monotony of the composition's negative space ("white space") in a way that serves to aesthetically challenge whiteness and white privilege. In *Fight the Climate Crisis*, she likewise uses these small marks to intrude into the otherwise alienating white space of the background void.

While Rodríguez returns to Aztlán as a site of building solidarity with other Third and Fourth World peoples and uses Movement-era design techniques to challenge white visualities, she also confronts food justice and food sovereignty in the Third and Fourth Worlds. Working in the vein of Xicano environmental organizations, such as SNEEJ (Southwest Network for Environmental and Economic Justice), SWOP (Southwest Organizing Project) and MELA (Mothers of East Los Angeles), Rodríguez redirects food justice toward an Indigenous and local focus on food sovereignty.

Food justice and food sovereignty, within both urban and rural Xicano communities, are struggles for the land—a place we might call Aztlán. In recent years, Native and Xicano activists have moved to "decolonize" their diets. Linked to internationalist movements, such as the Slow Food Movement, this Indigenous decolonizing trajectory focuses on the way one eats as a way to challenge coloniality. In this way, Xicano and Native youth are connected with their ancestral diets and traditional ecological knowledge. Rarámuri (Tarahumara) ethnobotanist Enrique Salmón discusses this in *Eating the Landscape: American Indian Stories of Food, Identity, and Resilience*. Salmón writes:

> My identity and culture as a Mexican is reaffirmed whenever I eat tamales. . . . My reaffirmation of identity and connection to place is not a direct result of the tamales, but comes more from the processes that surround tamales, beans, raisins inside the tamales, and my grandmother's herbal teas. The processes interconnect family, landscape, collection knowledge, story, and an encoded library of cultural and ecological knowledge, all of which sustain and revitalize a sense of self and place.[34]

Through this food-based activism, Xicanos begin to eat healthier food, turning away from processed food and forming an intimate bond with the

earth. This movement reached an apex when the South Central Farmers, a group of community gardeners in Los Angeles, were evicted from their land when developers bulldozed the entire site to build a warehouse. In the process, 350 (primarily) Indigenous families were evicted from their small plots, on which they grew subsidence crops. This is well-documented in the film *The Garden* (dir. Scott Hamilton Kennedy, 2008). As has been pointed out by figures like Devon Peña, between 100 and 150 varieties of plants were grown in this small space, many of which were heirloom and Indigenous varieties brought from Mexico and throughout Turtle Island.

With food sovereignty at the core of today's Xicano and Native struggles (particularly as communities are forcibly removed from traditional lands due to expanding capitalist markets), Rodríguez's work to address food-based issues becomes all the more relevant. Collaborating with Bryant Terry, an African-American chef and author of *Vegan Soul Food*, Rodríguez produced a series of three offset lithograph posters addressing food justice issues in the urban context. These colorful images employ Rodríguez's stylized figurative drawings merged with layers of scanned and manipulated designs. The individual posters address food deserts, urban gardening, and the need for men to learn traditional cooking techniques. Rodríguez's activism against ecological and agricultural colonization follows in highlighting, as Vandana Shiva attests, the salient role that women play in Third and Fourth World environmental struggles.[35]

While the *Food Justice* series was aimed at a pluriethnic urban audience, her poster *El Maíz es Nuestro* attests to an issue that, although universal, has its origins (literally) within the Indigenous communities of Anahuac and Ixachilan: corn. Gustavo Esteva begins *Sin maíz no hay país*, a cultural and ecological history of corn in Anahuac-Mexico, by writing that "corn is our collective invention. And corn, in its turn, invented us."[36] With much the same dualistic thinking that supplies us with Tlilli Tlapalli, the dualistic nature of creation is seen with corn's creation of humanity tied directly to humanity's creation of corn. We are our food and our food is, quite literally, the ancestors.

For many Indigenous peoples across the continent, corn is central to land-based origin stories about how they came to be in the world as a people. For instance, the Mexica have Quetzalcoatl, while the Kanien'kehá:ka (Mohawk) tell of Aientsik's discovery of corn, beans, and squash. For the aboriginal people of the U.S.-Mexico borderlands—groups like the Hopi, Tohono O'odham, and Yoeme, among others—these stories are likewise crucial. As Dennis Wall and Virgil Masayesva write, "For the people of the mesas corn is sustenance, ceremonial object, prayer offering, symbol,

and sentient being unto itself. Corn is the Mother in the truest sense—the people take in the corn and the corn becomes their flesh."[37] They continue: "The connection between the people and the corn is pervasive and deeply sacred. In a remarkable symbiosis between the physical and the spiritual, the Hopi people sustain the corn and the corn sustains Hopi culture."[38]

Corn, of course, also sustains the Xicano community. Without it, following the metaphor established by Esteva and Marielle, *sin maíz no hay país*. Without corn, there is no country. In turn, *sin maíz no hay Aztlán*. Without corn, there is no Aztlán. Corn, as the basis for life, is what bonds Xicanos together as a people. Without it, Xicanos would cease to exist.[39] Salmón writes that for the Rarámuri "*sunú* (corn) is female. Many of the terms associated with corn suggest that corn is mother's milk and breasts."[40]

So while Rodríguez believes in Aztlán, her work serves to create Aztlán as an inclusive, feminist, and queer site, where internationalist solidarity movements, particularly ones based in food sovereignty, may defend the rights of everyday people. Land is food. Food is sovereignty. And artists aid in creating Aztlán.

Aztlán Is Native Land

"Following principles of Xicanisma and Zapatismo, we create art that translates people's stories into imagery that can be put back into the hands of the communities who inspired it."
—DIGNIDAD REBELDE

From its inception, Dignidad Rebelde—a collaboration between Melanie Cervantes and Jesús Barraza—whose name literally means "Rebel Dignity," emerged as a collective with the intent to employ their artistic practice in a truly transformative and emancipatory manner. Utilizing community stories of struggle and perseverance, Dignidad Rebelde draws its name from Zapatista ontology and focuses its work on visualizing a radical history and a prefigurative present. Coming of age after the "Battle in Seattle," the 1999 confrontation between anticapitalist activists and global powers affiliated with the World Trade Organization, Cervantes and Barraza work in a way that connects Xicano struggles with those of other Indigenous and colonized peoples. As they collectively write in their artists' statement,

We recognize that the history of the majority of people worldwide is a history of colonialism, genocide, and exploitation. Our art is grounded

Revitalizing • 197

in Third World and indigenous movements that build people's power to transform the conditions of fragmentation, displacement and loss of culture that result from this history. Visualizing these movements means connecting struggles through our artwork and seeking to inspire solidarity among communities of struggle worldwide.[41]

Placing their work in the context of Third and Fourth World histories of survivance, their move to "inspire solidarity" is one founded in the urban Native and Xicano radicalism of the Bay area, but also cemented in indigenist and anticolonial practices of the twenty-first century. The fact that the takeover of Alcatraz, the formation of D-QU, and the activities of TWLF were all in the San Francisco Bay Area (traditional Ohlone territory) is not inconsequential. Dignidad Rebelde is the descendent of the Chicano and American Indian movements. To use their own language, they are the "future ancestors." They work in a way that will make, after seven proverbial generations, the most impact on their descendents. As future ancestors who currently have no children of their own, what may their work say to their children's grandchildren's grandchildren's grandchildren? This forward thinking process is crucial to the way Dignidad Rebelde works.

Cervantes, like Favianna Rodríguez, attended the University of California, Berkeley, graduating in 2004 with a degree in ethnic studies. While she remains extremely active as an artist, Cervantes currently works as a program officer for the Akonadi Foundation, which, according to her, "supports a racial justice movement that can finally put an end to the structural racism that lies at the heart of social inequity in the United States." Although based in San Leandro, California, Cervantes came of age in Los Angeles, where she began her informal art training. Her bio notes that her "training as an artist began with her mother and father. She learned color theory while helping her mother select fabric for school clothes at Los Angeles swap meets; and she developed some of her technical skills by watching her dad repurpose neighborhood junk into her childhood treasures." Her work as an artist emerges from her identity as an activist. As she notes in her artist's statement, she translates "the hopes and dreams of justice movements into images that agitate and inspire." Importantly, her work is both local and global. In addition to her notoriety in the Bay Area, Cervantes has worked with communities and exhibited her work in Mexico, Thailand, Slovenia, Palestine, Venezuela, Switzerland, Colombia, Africa, India, and Guatemala, as well as within Indigenous and immigrant communities across Turtle Island.

Her partner, Jesús Barraza, employs "bold colors and high contrast images, his prints reflect both his local and global community and their

resistance in a struggle to create a new world." His training comes from his work as a graphic designer at the Mission Gráfica, where he studied with prominent printmakers Calixto Robles, Juan R. Fuentes, and Michael Román. In 2001, Barraza organized a print portfolio at Mission Gráfica, its first in over a decade. Two years later, his prints were included in Self Help Graphics' *Thirtieth Anniversary Portfolio*; the same year, he organized and printed the *Fifteenth Anniversary Portfolio* for the Center for the Study of Political Graphics. In 2005, he was awarded a residency at San Francisco's prestigious de Young Museum and in the same year received the Art is a Hammer award from the Center for the Study of Political Graphics. As of 2014, Barraza is completing an MFA in social practice at the California College of the Arts. In their own ways, Cervantes and Barraza each bring individual aesthetic programs to their work in Dignidad Rebelde. Working intimately together, Dignidad Rebelde creates work that agitates and challenges its viewers into action, while asserting Xicano sovereignty outside the confinement of capitalism. Although they maintain individual practices, as well as a collective one, their work seamlessly coalesces in a unique aesthetic. In this way, they labor to reconstruct a visual tradition that counteracts the effects of colonial oppression without slipping into notions of victimization and self-marginalization.

In this final section on Chicano art, I will discuss their artistic practice as it lowrides through four brief modalities: Xicanisma, Zapatismo, solidarity with Palestine, and, finally, toward a hemispheric notion of Indigenous (and land-based) sovereignty. Each of these respective modalities, ones founded in Bay Area Xicano ontology, points to visualizing a new world and connecting with popular resistance movements. While not specifically denoting Aztlán, Dignidad Rebelde works in a way that focuses on land, indigeneity, and utopian struggles for justice, issues already embodied within the Xicano pronouncement of Aztlán.

Xicanisma, a concept popularized in Ana Castillo's *Massacre of the Dreamers: Essays on Xicanisma*, is a uniquely indigenist form of Xicana feminism, one rooted in working-class women's strikes, resistance to machismo and heterosexism, earth-based spiritualities, and the poetic employment of Paolo Freire's "conscientización." For Cervantes and Barraza, "following principles of Xicanisma and Zapatismo, we create art that translates people's stories into imagery that can be put back into the hands of the communities who inspired it."[42] In this feminist, indigenist, and nonhierarchical fashion, Dignidad Rebelde works in a way that queers Aztlán, just as Cherríe Moraga did years earlier. In fact, Moraga and her partner Celia Herrera Rodríguez have mentored Cervantes and Barraza.

So their understanding of Aztlán, as an open-ended and queer proposition, has precedence.

That is to say, as queer theorist David Halperin notes, "queer acquires its meaning from its relation to the norm. Queer is by definition whatever is at odds with the normal, the legitimate, the dominant. It is an identity without an essence. 'Queer,' then, demarcates not a positivity but a positionality vis-à-vis the normative."[43] The work of Dignidad Rebelde challenges notions of heterosexist and patriarchal Xicano visualities, ones that many of the artists in this book also confront. They contest settler-colonial normativity within the field of Chicano art history. But as a form of Indigenous sovereignty, it also queers settler-colonial notions of the nation-state.

Working almost exclusively as serigraphers, Cervantes and Barraza create posters that focus on the human form as a way to narrate the stories of individuals and communities. Women, people of color, queer folk, and Native peoples become the subject of their work, always maintaining a sense of individual and collective agency. Initially, their visualizing of women's stories serves to counter patriarchal structures in which women have been systematically eliminated. In *Indigenous Storywork*, Stó:lō intellectual Q'um Q'um Xiiem, also known as Jo-ann Archibald, presents the importance of storytelling within Indigenous communities, where women and elders play an unquestionably esteemed role. Archibald asserts that "after learning how to listen to the stories, I was expected to use their cultural knowledge and to share it with others, thereby ensuring its continuation."[44]

Since Dignidad Rebelde visually narrates Xicano stories, as well as other Third and Fourth World stories, their artworks become stories in and of themselves. What the audience does with these stories is up to them. But it is, then, expected that they share these stories in a good way. In many Indigenous communities, once knowledge is produced, including art and stories, it is the responsibility of both parties to move that knowledge into the future through sharing and education.

While poststructuralist analyses of contemporary art frequently point to the ambiguities and nonnarrativity of contemporary artistic practice, Dignidad Rebelde challenges these nonnarrative practices. In *Phantom Sighting: Art After the Chicano Movement*, the catalogue for the important exhibition at the Los Angeles County Museum of Art (LACMA), Howard N. Fox, curator at LACMA, writes that for those artists included in *Phantom Sighting*,

> the existence of Aztlán remains theoretical and remote. They are less interested in the historical validity of Chicano culture than they are in

its presentness, and they are less interested in Chicanos' distinctiveness and special place than they are in how Mexican Americans experience life and identity in a diverse social multiformity.[45]

Although inaccurate in his assessment that certain Xicano artists are somehow disinterested in Aztlán—as we've seen throughout this book Aztlán is still very much alive—Fox reifies a certain perspective that Chicano art is "American" art, an equally malleable construct. Even if there has been a normative move away from illustrative or narrative work, or work interested in "Chicano distinctiveness," neither Dignidad Rebelde nor Favianna Rodríguez have been entirely affected by this trajectory and remain unflinching in their overtly political practices. Like Montoya and Cortéz Koyokuikatl before them, Dignidad Rebelde continues to work in a tangibly political manner. While Fox discusses certain artists that help tell the story he wants to tell (just as I have), other Xicano artists do not see Aztlán as "theoretical and remote," but envision it as central to their work (and to Xicano sovereignty). Aztlán has never been less remote than it is at this moment. In 2014, the same year this book was published, we also saw the publication of *Return to Aztlán* by Dana Levin Rojo; *Making Aztlán* by Juan Gómez-Quiñones and Irene Vásquez; and *Aztlán Arizona* by Darius V. Echeverría, to name only the most significant.

In *Las Brown Berets* (2008, figure 30), a three-color serigraph, Cervantes utilized archival and contemporary photographs to tell the stories of women Brown Berets, the militant Xicano nationalist organization that I briefly addressed in chapters 2 and 3. In Xicanista fashion, this Dignidad Rebelde poster serves as the visual complement to the written work of Dionne Espinosa, a Xicana historian. In "Revolutionary Sisters," Espinosa reconstructs the history (and exclusion) of Xicanas, as women, in the Brown Berets, an organization that has been frequently considered heterosexist. Espinosa writes that "Chicanas saw themselves as revolutionaries, but because the organization was implicitly and explicitly based in notions of male militancy, Xicana participants were left to construct identities themselves in relation to either male-defined practices or male constructions of women."[46]

Just as Xicana Brown Berets reasserted their own notions of Xicana agency in the face of male constructions of womanhood during the late 1960s, *Las Brown Berets* likewise inserts women into the male space of political militancy, focusing exclusively on women within this space. The print's composition employs two photographs of women Brown Berets, which are then mirrored on the right and left side. In the foreground, as is typical of Cervantes's work, is a stylized drawing of a figure. The figure overlaps significant portions of the dot-matrix photos and directly confronts

Revitalizing • 201

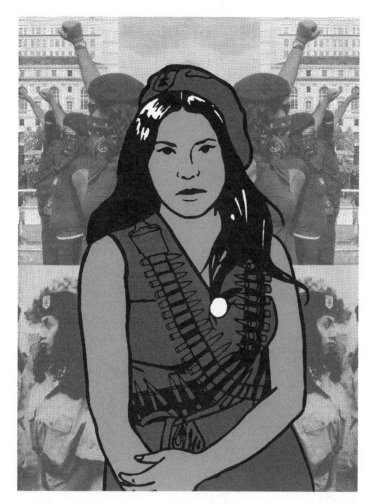

Figure 30. Melanie Cervantes, *Las Brown Berets*. Serigraph, 2008. Image courtesy of Melanie Cervantes.

the viewer. As a form of visual theorizing and historical research, Dignidad Rebelde reformulates how Xicanisma functions visually.

In much the same way that Xicanisma centers the work of Dignidad Rebelde, so too does Zapatismo, the localized (and globalized) form of Indigenous organizing popularized by Maya autonomists in Chiapas. According to the Comité Clandestino Revolucionario Indígena (Clandestine Revolutionary Indigenous Committee), "Zapatismo is not a new political ideology or a rehash of old ideologies.... It only serves as a bridge, to cross from one side to the other. So everyone fits within Zapatismo,

everyone who wants to cross from one side to the other. Everyone has his or her own side and other side. There are no universal recipes, lines, strategies, tactics, laws, rules or slogans. There is only a desire: to build a better world, that is, a new world."[47] Zapatismo is a form of lowriding.

Possibly referencing *This Bridge Called my Back*, or a nonnormative queer space, Zapatismo contrasts with the perceived dogma of its revolutionary ancestors and is inherently heterodox. As such, it allows multivocal ideologies and ontologies to exist within the confines of a single, although not monolithic, emancipatory struggle. In this indeterminacy, Zapatismo parallels the very open-ended nature that was (and is) Aztlán. It is entirely indeterminate and utopian. Emerging from Indigenous responses to the ideologies of late-capitalism, Zapatismo is, first and foremost, a locally situated utopian struggle to construct "*un mundo nuevo.*" What this new world looks like, similar to the utopian implications of Aztlán, is entirely up to those actively working to revitalize it.

While it is not an inherently feminist positionality, Native women have nonetheless shaped Zapatismo in a way that challenges the colonial patriarchal apparatus. For R. Aída Hernádez Castillo,

> since the emergence of Zapatismo, a movement of indigenous women from regions of the country has not only voiced their support of their compañeros and the interests of their communities, but also pressed for the respect of their specific rights as women. Parallel to their participation in the struggle for land and democracy, this wide sector of women has begun to demand the democratization of gender relations within the family, the community, and the organization. The emergence of this new movement is the expression of a long process of organizing and reflection involving Zapatista and non-Zapatista women.[48]

Indigenous struggles for land, democracy, and the abolition of patriarchy form the core principles of Zapatismo. Much like Xicanisma, Zapatismo is somewhat indefinable, yet proposes new ways based on Indigenous ontologies.

Specters of this indiscriminate practice emerge in multiple ways within the work of Dignidad Rebelde. Initially, we see the visual references to masked Zapatistas as a metonym for hemispheric Indigenous struggles, particularly within Mexico and Latin America. That is to say, the image of the Chiapanecan figure immediately conjures emancipatory overtones. Moreover, specific visual reference to the Zapatistas situate their struggle as emblematic of a larger resistance to continued capitalist and colonialist oppression, one foregrounded in nonhierarchical indigeneity.

Revitalizing • 203

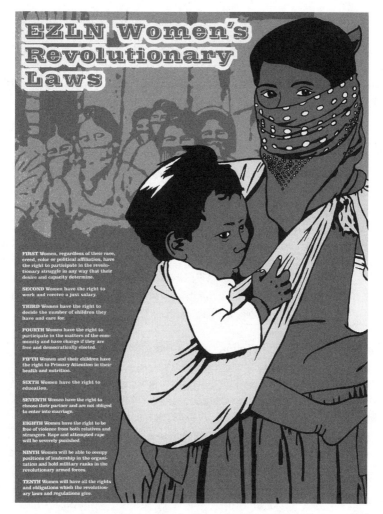

Figure 31. Dignidad Rebelde, *EZLN Women's Revolutionary Laws*. Serigraph, 2007. Image courtesy of Melanie Cervantes and Jesús Barraza.

EZLN Women's Revolutionary Laws (2007, a six-color serigraph, figure 31) was produced as a fundraiser for Colectivo Zapatista Ramona. The screenprint portrays a masked woman and her nursing baby alongside ten laws guaranteed to all women under Chiapas's newly established *caracoles* (autonomous municipalities). The text is taken from the First Declaration from the Lacandon Jungle, an edict announced on January 8, 1994, just one week after the Zapatistas liberated the streets of San Cristobal de las Casas. The revolutionary women's laws cover issues related to equitable

participation in the revolution, gender issues in the workplace, birth control, democratic leadership, healthcare, access to education, freedom from forced marriages and sexual violence, entry into leadership positions in the revolutionary organization, and, most importantly, equal status under the new revolutionary system. While these ten points may seem basic in their protection of women's rights, they are ones that remain entirely unattained, especially in settler-colonial society. For Dignidad Rebelde, Zapatismo reveals an anticolonial and feminist Indigenous pronouncement.

Cervantes's *Indigenous Women Defending Land and Life Since the Beginning of Time* (2009, figure 32) portrays the back of a Mayan woman overlapping a large field of yellow. In the figure's right hand, she clutches a cornstalk; in her left hand is a rifle. Down the back of the figure's *huipil*, we see a single braid running parallel to both the cornstalk and rifle. Importantly, the braid visually leads the viewer's eye toward the noteworthy text at the bottom of the ten-color serigraph. Once the viewer's eye reaches the bottom, she is treated to white text located in a field of red. The text states, as the title intimates, that since time immemorial Native women have been defending land and life. For Cervantes, this image is about how

> as individuals, as organizations, as communities or as a people, indigenous women continually prove their strength in the face of threat and adversity. Our responses show that we are not passive victims of oppression but fierce actors in the indigenous peoples' struggles for survival. We have formed organizations and networks. They have initiated community-based projects to respond to basic needs of our people. We have been in the forefront of numerous actions of indigenous peoples to defend our land, our lives and our livelihood.[49]

Identifying as a "Xicana-Indígena," Cervantes clearly positions herself within the context of Indigenous struggles across Ixachilan, the theme that this poster so confidently attends. Not seeing Indigenous peoples as passive recipients of European colonialism, Dignidad Rebelde situates indigeneity within a structure of active agency, where epistemologies, such as Xicanisma and Zapatismo, serve to combat the encroachment of capitalist ideologies. Here, the visual language of the poster serves as a particular form of feminist theory, based in the language of Xicanisma and Zapatismo.

In *Indigenous Women Defending Land and Life Since the Beginning of Time*, Cervantes tactically employs three vertical lines, a cornstalk, a braid, and a rifle, each implicating Native peoples in their resistance to colonization. In this poster, corn, the life-giving progenitor for aboriginal

Revitalizing • 205

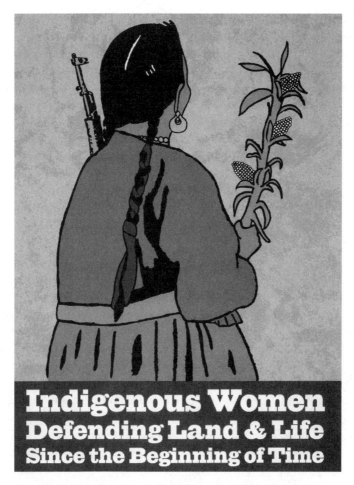

Figure 32. Melanie Cervantes, *Indigenous Women Defending Land and Life Since the Beginning of Time*. Serigraph, 2009. Image courtesy of Melanie Cervantes.

Mesoamerican peoples, directly connects Indigenous peoples to continued earth-based agriculture and food-based practices. Corn, as symbolic of both land and life, intimately ties the anonymous woman to the cultivation of food and the nurturing of cultural lifeways. The evocation of corn, as in Rodríguez's work, recalls the history of creation. The braid, also symbolic, serves to point to "traditional" vestiges, ones which women, as the rifle intimates, have always forcefully defended. Braids, rifles, and corn have a seemingly unfamiliar relationship, yet for Dignidad Rebelde become

signifiers of Native defense of land-based cultural practices, food-systems and, as Zapatismo develops, community autonomy.

While the rifle signifies resistance to state violence, a device borrowed from Cuban poster artists, it does not necessarily symbolize anticolonial violence. Similar to my discussion in the section on Fanon and violence, Dignidad Rebelde does not advocate violence but does firmly promote the rights of Native peoples to "defend land and life." In this image, the rifle appears to signify resistance to power, in all its manifestations. Just as Oakland-based Black Panther artist Emory Douglas represented guns as a form of Black self-defense within his work, so too does Dignidad Rebelde employ this image as one of autonomy and sovereignty.

The work of Dignidad Rebelde, and this poster in particular, begins to serve as a symbol against "power-over" and point toward "power-to," borrowing from the writing of John Holloway. In *Change the World without Taking Power*, Holloway positions power as being, on the one hand, the power to rule over someone else (power-over) and the individual and collective capacity to have agency and make change (power-to).[50] Emerging from an anticapitalist position, the latter form of power does away with the first, a case exemplified in the nonhierarchical and non-nation-state Indigenous revolution based in Chiapas. In this way, the Zapatista struggle for power has never been about the imposition of Maya control over non-Native settlers, but is entirely centered on the self-determination of Native communities, giving Indigenous communities a say in their own collective self-governance. Zapatismo, just like Aztlán, is about sovereignty.

Dignidad Rebelde expands this confrontation with power and assertion of self-determination, where various struggles serve to signify one another, to include Palestine. Dignidad Rebelde sees many similarities between the expropriation of Palestinian lands and what happens to Indigenous communities across Turtle Island. This parallel is one shared with many other Palestinian and Native activists, although Indigenous voices are not unequivocal in their support of Palestinian struggles. Edward Said, the famed Palestinian intellectual and literary critic, saw this similarity and compared the struggle in Palestine with that of the Cherokee. Of course, many other Indigenous nations could serve as an example instead of the Cherokee Nation. However, this pro-Palestinian perspective has been challenged by a small number of Indigenous critics—including blogger Ryan Bellerose (Métis)—critical of making parallels between Indigenous issues in Turtle Island and Palestine.

It should be noted that Indigenous support of Palestine came to a head in 2013 and 2014, when the Native American and Indigenous Studies Association (NAISA) Council supported the U.S. Campaign for the Academic and

Cultural Boycott of Israel. While Israel-Palestine is viewed as a hot-button issue, the general memberships of the American Studies Association and Asian American Studies Association also supported the academic boycott. The Modern Language Association has also seen considerable debate about these issues at its 129th annual conference in Chicago.

NAISA cofounder and founding president Robert Warrior (Osage) has written about NAISA's support of an academic boycott of Israel. Of course, the conversation in Indian Country is not one sided in support of Palestine, yet NAISA's declaration of support demonstrates that many Native American and Indigenous studies scholars are in agreement. In an article reprinted in *Indian Country Today*, Warrior writes: "Israel continues to build settlements on Palestinian lands, and those lands are typically the most resource-rich in Palestine. Those settlements are opposed by nearly every country in the United Nations. . . . The issues of illegal land confiscation and violence-driven occupation resonate with me as an Osage, but I am also concerned as a taxpayer about what the U.S. is doing with my taxes and in my name."[51]

Barraza and Cervantes use their artwork to draw parallels between different Indigenous struggles throughout Turtle Island-the Americas and those in Palestine, just as they link Xicano struggles with Zapatista struggles in Chiapas. In *Chiapas Será Libre, Palestina Será Libre* (2001), Barraza equates Mayan struggles for self-determination with the encroachment on Palestinian territories. Just as Malaquías Montoya visually implied that Viet Nam and Aztlán have shared experiences, equating Xicano issues with those of the Viet Cong, or how Favianna Rodríguez, Jesús Barraza, and Estria Miyashiro literally imagine that "Iraq is Aztlán," Chiapas and Palestine become parallel and mutually intelligible struggles for Dignidad Rebelde. Without collapsing the particularities of each movement, Dignidad Rebelde visually demonstrates how expanding the language of solidarity may be mutually beneficial for both groups. This rhetorical strategy uses the stark torso of an anonymous figure clutching a horizontal rifle to evoke feelings of injustice and ally armed struggle with the defense of one's community.

This parallel between Palestine and Turtle Island is not a perspective that is being developed only by Dignidad Rebelde. In addition to NAISA's statement of solidarity, a 2009 delegation of Native youth traveled from Turtle Island to Palestine. They documented their experiences in *SNAG* (Seventh Native American Generation) magazine, a Bay Area Native youth project. In *SNAG*, one particularly moving series of photographs parallels Native and Palestinian histories, focusing on resettlement of communities and the use of identification cards similar to BIA identification cards.[52]

208 • *Tlapalli*

Additionally, on February 3, 2010, *Indian Country Today* ran as its cover story: "Oglala Lakota Traveler Sees 'Deep Parallels' in Palestine."

For Barraza and Cervantes, the processes of settler-colonialism in Turtle Island are mirrored in the domestic and foreign policies of Israel, which gets large-scale economic support from the United States. The serigraph *Chiapas Será Libre, Palestina Será Libre* is beautiful in its compositional simplicity. Bands of black stretch across the top and bottom quarter, while a red ground is firmly located across the middle-half. Appearing almost like a flag, the red and black bands are divided by the organic black torso, brown rifle, and grey gun strap of the middle ground. While military weaponry, particularly the rifle, may appear to Anglo-American and settler-colonial audiences as the iconography of violence, the artists directly contrast this individual weapon with state-sanctioned weaponry: helicopters and tanks. For Dignidad Rebelde, handheld weaponry connotes popular resistance, while tanks, aircraft, and other heavy artillery connote the power of the nation-state. This visual reference has an antecedent in the Cuban print-making tradition. Of course, this nonetheless raises larger questions of violence, even anticolonial violence, a dialogue significantly addressed by figures like Frantz Fanon.

On several occasions within their work, Dignidad Rebelde evokes the slingshot—even more basic than the rifle—as the nonlethal weapon of Palestinian opposition. In *A Slingshot to Defend your Life?* (Cervantes, 2009), this rudimentary tool becomes the defensive mechanism used to defend oneself against state militarism and the encroachment on one's territories. Visually, the artists transform the slingshot into a phosphoric tool, one which replicates the head of a match, recollecting the incendiary quality of direct action. In this way, the slingshot visually becomes a *mecha*, the Spanish word for match, and therefore possibly links back to MEChA, the Xicano student organization organized at the time that the Plan de Santa Barbara was written in 1969.

These visual and political connections bridge (or lowride across) disparate movements in an internationalist act that positions Xicano struggles as Indigenous and global in scope. This rhetorical and political maneuver is particularly apparent in what becomes the clearest example of hemispheric Xicano indigeneity, one that Cortéz Koyokuikatl was so apt at articulating. In a simple one-color serigraph, Jesús Barraza created *Indian Land* for Indigenous Peoples' Day in 2004 (figure 33). The print, a bold red map of the Americas on white paper, includes the text INDIAN LAND. This text, then, wraps around the Pacific coast of Turtle Island or the Americas. In this way, Aztlán is no longer the single focus of Xicano sovereignty, but the

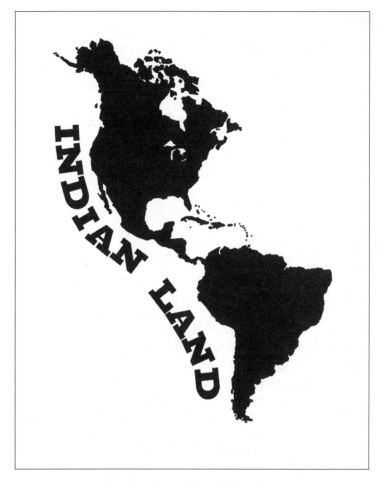

Figure 33. Jesús Barraza, *Indian Land*. Serigraph, 2004. Image courtesy of Jesús Barraza.

focus of Aztlán becomes continental in scope. Native peoples' struggles are, as they have been since the arrival of colonial forces, entirely continental in nature (a view that Fanon advocated decades ago). The Americas, Turtle Island, Ixachilan, however we choose to name this hemisphere, it was, is, and will always be . . . Indian Land. The role Aztlán plays within its liberation is one that may still be played out. While I believe that Aztlán is the name of Xicano sovereignty, Dignidad Rebelde demonstrates that its existence emerges in alliance with continental Indigenous solidarity and also links it with conflicts in other parts of the world.

Conclusion

Each of the preceding seven artists attempt to produce art that is both socially and visually engaging, employing compelling aesthetic compositions to dialogically critique institutional inequalities. Commonly, Chicano art, as well as revolutionary visualities, has been catalogued as "propaganda," due to its overtly political connotation. While propaganda functions at the most basic reactionary level, each of the artists discussed in the second section of *Creating Aztlán* (Tlapalli) need to be analyzed in more complex and nuanced ways. Instead of reactionary propaganda, these artists' works are interested in the reciprocation between political transformation and aesthetic experimentation. In many regards, visual aesthetics remain one of the least understood components of post-1969 Xicano society. Although Montoya is happy to be called a propagandist, his work, like that of the other artists, functions too intricately and complexly to be collapsed to that level.

While many contemporary critics and historians maintain that Aztlán was insular and heterosexist, these case studies, and *Creating Aztlán* in general, begin to convey the open-endedness and indeterminacy embedded in Indigenous concepts like Aztlán. By turning to these diverse artists, we begin to understand that Aztlán functions as a utopian trope because it symbolizes Xicano sovereignty and resists settler-colonial control.

In isolation, each of these Aztláns foregrounds the biases and absences of the individual artist that constructs it. When we place them in dialogue with and among one another they collectively commence a process, as Albert Camus attests, of grand social transformation that was inaccessible prior to their respective creation. Through the dialogue embedded in each Aztlán, as well as the dialogue between them, we begin to finally understand the importance of the Chicano Movement without dismissing it for its prevalent heteronormative absences. In turn, by recognizing the capacity of Aztlán its legacy will not be rejected but will continue to signify Xicano sovereignty.

As this book posits, there are individual and collective differences and multiplicities within the histories of Xicano cultural expressions, particularly from the diverse applications of Aztlán in Chicano artistic practices. As I have displayed, midwestern Xicano visual and performative art maintains a connection to working-class consciousness and Anishinaabe territoriality, while Chicano art also asserts a postcontact indigeneity. However, art is neither symptomatic nor community history nor autobiography.[53] Chicano art, like all art, must not be circumscribed by the social history in which it emerged, but rather it must go beyond. Aztlán (or Nepantla or Ixachilan,

Revitalizing • 211

as others have begun to conceptualize Xicano territoriality) is the device that provides the framework for Xicano sovereignty.

As a utopian space, Aztlán allows dialogical and discursive transgression within the political and civic sphere. By reincorporating and recontextualizing an Indigenous Mesoamerican construct that allowed Mexica elites to maintain political and economic control, working-class Xicano activists have reinscribed Aztlán with an entirely anticolonial sensibility unique to their Indigenous and diasporic experiences on Turtle Island. The palimpsest-like nature of Aztlán can be seen in its multifaceted applicability to an array of locations, periods, and social movements. Understanding this particularly Xicano sensibility inherent in Aztlán—which we might argue, following Osage literary critic Robert Warrior, is a form of "intellectual sovereignty"—is paramount to recognizing its function and historical importance within the vastly dissimilar social systems of Turtle Island-the Americas. By investigating Aztlán as a form of Indigenous sovereignty, this book demonstrates how detribalized and diasporic Indigenous communities maintain precolonial practices, yet do so through the mediation of colonial, modern, and contemporary epistemologies and structures.

By using Aztlán as the base of resistance that lowrides across Turtle Island, Xicano artists struggle to create a more just and equitable society and in turn transform Aztlán from an elite narrative to one of anticapitalist affirmation of Indigenous sovereignty. It is for this reason that we must continually revisit Aztlán's importance within both artistic and political spheres. If Aztlán is sovereignty, we must continue to express self-governance through the act of making art and making Aztlán relevant. Doing such, we will create Aztlán.

POSTSCRIPT

Returning

Jack Forbes, Mestizaje, and Aztlán

At this point, we have intellectually lowridden across great expanses of time and space, as well as asserted Aztlán as the visualization of Xicano sovereignty. This book emerged from a cave on an island and then migrated to the Valley of Mexico with the founding of Tenochtitlan. Afterward, we traversed Spanish and Anglo-American settler-colonial spaces and eventually moved toward a moment of Xicano liberation. We then shifted from Aztlán, as a geographical site, to the Nahua cosmologies of Tenochtitlan as an ontological mirror for Aztlán. Subsequently, I engaged Xicano articulations of Aztlán as the specter of anticolonial deference, interrogated how artists and activists manifest Aztlán along the U.S.-Canada border, and finally analyzed the ways specific artists evoke Aztlán in order to challenge settler-coloniality and capitalist political economies. The work of Carlos Cortéz Koyokuikatl and his evocation of Ixachilan, an Indigenous call for solidarity, is central to understanding Aztlán in the twenty-first century. In a similar way, Anzaldúa and Santa Barraza's Nepantla or Moraga's Queer Aztlán are provocative in their return to Xicano indigeneity through nonnormative and queer nationalisms.

Throughout *Creating Aztlán*, I have negotiated various aesthetico-political projects that connect Aztlán with, as I see it, emancipatory and indigenist ontologies. Of course, this is still an emerging and avant-garde intellectual project, one with Xicana and aligned feminists at its core. The work of Xicana and Latina feminists Laura E. Pérez, Guisela Latorre, and Sheila Contreras, among others, points toward new directions in

understanding Xicana and Xicano artistic practice from an Indigenous and indigenist perspective. The 2012 publication of *Comparative Indigeneities of the Américas: Toward a Hemispheric Approach*, edited by M. Bianet Castellanos, Lourdes Gutiérrez Nájera, and Arturo J. Aldama demonstrates the shifting intellectual and political trajectory that migrates toward comparative and hemispheric Indigenous studies.

In a 2005 essay on the indigenist turn in Chicano studies, Roberto Hernández writes about the Peace and Dignity Journeys, a hemispheric project in which groups of Indigenous (including Xicano) runners travel on foot from North and South America, respectively, converging on Indigenous lands in Central America. Hernández notes that his scholarship was "an attempt to delve into the complex role of indigenismo and indigenous spirituality amongst Chicanas/os specifically, and Latinas/os generally."[1] He continued, writing that "not much scholarly attention has been given to the matter [and] this piece is meant as a starting point that will hopefully lead to more questions, rather than an exhaustive effort."[2] In the same way, I modestly believe my arguments in this book are an emergence place from which subsequent scholars can lowride beyond. As such, *Creating Aztlán* is not without error or omission. In the same way that Indigenous knowledge needs to be reciprocally told, retold, and modified, so must creating Aztlán be.

Laura E. Pérez's *Chicana Art: The Politics of Spiritual and Aesthetic Altarities* attests to the Indigenous spiritualities of Chicana art. She demonstrates that "some Chicana artists have used the Pre-Columbian to destabilize its use in Chicano masculinist nostalgia for a romanticized but dead past, to show both that it isn't dead and that the solidification of patriarchal family and nationalist ideologies were not what Chicana feminists, straight or queer, had in mind when they embraced their ethnic and cultural Indigenousness."[3] Although mistaken in her critique of nationalism, Pérez attests to the critical use of indigeneity in Chicana art.

Similarly, *Creating Aztlán* is intended to be at the forefront of more expanded and in-depth discussions about Aztlán within contemporary Xicano society, as well as to facilitate a move to reposition Chicano studies within Indigenous studies. Although I take no credit for this intellectual return, I hope that this text better situates indigenist methodologies, Indianist responses, and Indigenous ontologies into the study of Chicano art.

I would like to end this book with a series of short thoughts, provocations if you will, on Chicano studies and the potential for this book to serve as an intervention. In this way, this final provocation turns to the work of Jack D. Forbes in hopes of stimulating intellectual debate and provocative shifts

in Chicano studies. This intellectual insurrection includes an Indigenous critique of mestizaje, as a way to return to ideas that are meaningful yet, in fact, seemingly forgotten. By moving "beyond Aztlán," to borrow a phrase from Mario Berrera's canonical work, we in effect prolong the saliency of Aztlán in the present, while expanding its emancipatory potential into the future. Initially, I discuss the work of Jack Forbes, the Indigenous scholar who walked into the spirit world in 2011. Forbes, a foundational figure in Chicano studies, has unfortunately been inadequately integrated and theorized in Chicano studies. By concluding with a section on Forbes's work, I migrate/lowride back toward a Native intellectual place, one where Xicanos emerged as a people.

While Forbes was central to the intellectual development of Chicano studies, he is rarely integrated into the work of contemporary Chicano studies scholarship. As we've seen, Forbes was one of the first (if not *the* first) individuals to utilize Aztlán in reference to Xicano sovereignty. Even so, his place within the Xicano intellectual tradition is neither fully developed nor rightfully acknowledged. With this in mind, I end this book by returning to Forbes's writing as a way to continue dialogue with recent Xicano cultural studies scholarship, expanding the ongoing dialogue between Chicano and Native American studies. This is particularly crucial given the nature of this book and, especially, its critical concerns.

Born in Long Beach, California, in 1934, Forbes was raised in Los Angeles and the San Gabriel Valley before obtaining a PhD from University of Southern California. Beginning in 1969, Forbes taught Native American studies at UC-Davis, where following his retirement he maintained Professor Emeritus status until his death. In Chicano studies circles, Forbes is best known for his pioneering 1973 publication *Aztecas del Norte*, as well as his proposal for and development of D-QU, the American Indian and Xicano university, which I discussed briefly in chapter 3 ("Claiming"). In "Selections from the Brief Proposal for D-QU" (1970), Forbes recognized that "in the United States today there are approximately 7 to 8 million persons of predominately Native American descent, of whom about 1 million are 'Indians' descended from tribes native to the United States area and the balance are 'Mexican-American' or Chicanos descended from tribes native to regions south of the present international boundary or from tribes native to the Southwest (Aztlan)."[4] As a historian who understood the complexities of settler-colonial disenfranchisement, and a diasporic Native himself, Forbes recognized the realities of contemporary Indigenous sovereignty.

As if prefiguring his critics, Forbes concedes the diversity of Xicano peoples, at times even differentiating between recent "immigrant" populations

and those with deep aboriginal roots in places like New Mexico and Texas. As Forbes identifies, "like other Native American groups, the Aztecas of Aztlán are not a completely unified or homogenous people. Some call themselves Chicanos and see themselves as people whose true homeland is Aztlán."[5] This perspective is crucial in how Forbes recognized heterogeneous Xicano identity, a vantage point that is often ignored.

In terms of *Creating Aztlán*, what interests me about Forbes's body of work surfaces in his critical and collective disavowal of *mestizaje* and *métissage* as both racial and/or cultural categories based in settler-colonialism's overdetermining of Indigenous identities and polities. Unlike most scholars writing about Xicano cultural history—and he deserves to be included as one of the discipline's premier thinkers—Forbes writes from a radical indigenist and Indigenous perspective that sees mestizaje for what it is: an act of continued and systematizing colonial violence continually enacted upon Native bodies. In *Aztecas del Norte*, Forbes refers to "the mestizo concept" as "a product of European colonialism."[6]

Since the beginning of the Spanish conquest, and even earlier according to Reginald Horsman, race has been central to the European colonial project and its parallel mission of Manifest Destiny.[7] Whether one interrogates the complexities of sixteenth-century New Spain, Anglo-America's expansion into Indian Country during the last two-and-one-half centuries, or the twentieth-century Belgian exploitation of the "racial" difference between Tutsis and Hutu in Rwanda, race has become a simplified codification of complex categories of identification. Within late-twentieth and early-twenty-first-century Xicano thought, race remains central to both cultural and political discourses, with many intellectuals investigating and problematizing Anglo-American binary racial constructions. Part and parcel to these projects, and rightfully so at times, has been the privileging of hybridity and/or mestizaje as an intervention into hegemonic racial, cultural, and political practices in the United States. At the center of Chicano studies scholarship, intellectuals have been rightly critical of the practice of both indigenismo and mestizaje in Mexico and Latin America, while simultaneously asserting and reifying mestizaje as an alternative to the dogma of North American racial binarism.

One of the most challenging uses of mestizaje comes from literary critic Rafael Pérez-Torres, who maintains that mestizaje "becomes a means of weaving together the traces of a historical-material legacy with the vision of a potential—and potentially resistant—subjectivity."[8] From this same perspective, Pérez-Torres believes that "the terrain crossed by mestizo and mestiza bodies forms a topos overlaid by strategies of survival and triumph."[9]

While I do not deny the validity and discursive function of these intellectual interventions, I am nonetheless weary of the authoritative occupation that mestizaje has claimed within Chicano studies. How do mestizos and mestizas prevail in relationship with Indigenous sovereignty? Not groundbreaking in my analysis by any means, I find myself drawn to antihybridity critiques offered by figures as diverse as Peruvian literary critic Antonio Cornejo Polar and Sweden-based anthropologist Jonathan Friedman, who argue that hybridity and mestizaje are more reductive than they are productive. As Cornejo Polar argues: "what mestizaje does is to offer a harmonious image of what is obviously disjointed and confrontational, proposing representations that deep down are only relevant to those for whom it is convenient to imagine our societies as smooth and non-conflictive spaces of coexistence."[10] It must be noted, however, that many Xicano intellectuals and artists who evoke mestizo discourse and the process of mestizaje (Anzaldúa, Arrizón, Pérez-Torres, etc.) do not presuppose a harmonious image of colonial relations.

Even so, they still evoke mestizaje in a way that dismisses the continuity of Indigenous change to colonial and globalizing transformation. Mestizaje is always implicated in colonialism. Again, Cornejo Polar lends well in this regard when he maintains that the evocation of mestizaje and hybridity always suggest "the sterility of hybrid products."[11] In her critique of Anzaldúa's application of mestizaje, Maria Josefina Saldaña-Portillo writes "mestizaje is incapable of suturing together the heterogeneous positionalities of 'Mexican,' 'Indian,' and 'Chicana/o' that coexist in the United States, or, more importantly, of offering effective political subjectivity to those represented by these positionalities."[12]

Similarly, as part of his critique of the "eternal mestizo," Jack Forbes writes that "since all known cultures are of diverse, mixed origin, it follows that the Mexican culture of today is precisely that, i.e., Mexican culture and not 'mestizo' culture. Change, without borrowing, no matter how great, does not by itself produce a 'mestizo' culture."[13] While there is no doubt that Xicanos are racially mixed people, this fact alone does somehow negate their status as Indigenous. In fact, Canada's recognition of the Michif (legally known as Métis) as a unique postcontact aboriginal population highlights this possibility and prefigures the potentialities of aboriginal nation-building and sovereignty (even if still one based on a settler-colonial recognition model). Of course the Métis, my own community, get their officially recognized name from the French term for "mixed."

Although written nearly four decades ago, Forbes's disavowal of mestizaje follows a strain in contemporary scholarship that has called various

Returning • 217

hybrid tropes (such as hybridity, mestizaje, transculturation, etc.) into question. In this intellectual vein, anthropologist Jonathan Friedman maintains that discourses of "hybridity are identity discourses rather than attempts to understand what the people we are supposed to be studying are up to."[14] From Friedman's perspective, much like Cornejo Polár, mestizaje is reductionist in orientation and therefore incapable to addressing the realities of complex systems, be they political, social, signifying, or so on.

Inversely, by studying Aztlán as Indigenous thought and decolonial practice, we directly engage what Xicano artists are actually up to and how this may articulate Xicano self-determination. While Forbes's critique of mestizaje emerges from a very different political and intellectual position, he nonetheless remains committed to properly analyzing what Indigenous and cross-blood people (as Vizenor proposes) "are up to," as opposed to simply collapsing racial and cultural complexity into a monolithic "hybrid" or mestizo or mestiza identity. Aztlán, as a concept, allows us to see Xicanos as a polity and not simply as a subject or identity position.

The bankruptcy of mestizaje is embodied in its preoccupation with identity politics, a form of discursive maneuvering that marginalizes authentic political and social radicalism. In fact, a focus on mestizaje operates at the inverse of a radical indigenist agenda, one connected to the grassroots efforts of the Chicano Movement. When discussing the importance of posters within the Chicano Movement, George Lipsitz notes that "the movement was an effort to convince people to draw their identity from their politics rather than their politics from their identity."[15] This inversion acknowledges the need to connect research to action and develop collective identities rooted in radical political orientations, as opposed to fixating on identity politics. Aztlán is about sovereignty, not identities as such.

The intricacies of mestizaje within Xicano epistemology and community praxis can be seen at the beginning of Anzaldúa's *Borderlands/La Frontera: The New Mestiza*. The book begins, following an epigraph by Los Tigres del Norte, by citing Forbes's *Aztecas del Norte*. Accordingly, Anzaldúa cites Forbes's text: "The Aztecas del norte . . . compose the largest single tribe or nation of Anishinabeg (Indians) found in the United States today. . . . Some call themselves Chicanos and see themselves as people whose true homeland is Aztlán."[16] Anzaldúa resumes by calling the U.S.-Mexico border "una herida abierta where the Third World grates against the first and bleeds."[17]

Although rhetorically meaningful and a poetic tour de force, at this moment Anzaldúa shifts away from grounding her work in indigeneity and places the border not as a wound between First and Fourth Worlds (settler and Indigenous societies), but First and Third (one tied to the Third World

project of the past five-plus decades). While initially couched in indigenist language, privileging indigeneity as Andrea Smith would contend, Anzaldúa subsequently names the inhabitants of the U.S.-Mexico borderlands "prohibited and forbidden" "atravesidos," "trangressors and aliens," among others. Anzaldúa continues *Borderlands* by developing a complex dialectic between Xicanos as "Indians" and Xicanos as "mestizos," ending the first section by maintaining that

> for Indians, this [northward migration] constituted a return to the place of origin, Aztlán thus making Chicanos originally and secondarily indigenous to the Southwest. Indians and mestizos from central Mexico intermarried with North American Indians. The continual intermarriage between Mexican and American Indians and Spaniards formed an even greater mestizaje.[18]

While I do not want to focus too heavily on Anzaldúa, as there are many scholars better equipped than I to interrogate her work, I do find that certain Xicano intellectual figures like Anzaldúa write from positions that are at times indigenist in orientation, yet are never fully situated in dialogue with tribal epistemologies or ontologies.[19] Saldaña-Portillo maintains that Anzaldúa's "mestizaje is once again deployed to produce a biological tie with pre-Aztec Indians rather than a political tie with contemporary U.S. Native Americans or Mexican Indians."[20]

The function and definition of indigenism is difficult, yet serves at the core of recent Xicano cultural studies. On one hand, it is connected to the systematizing and oppressive state control of Indigenous peoples (in Mexico this is seen as indigenismo); on the other, it connects to a uniquely First Peoples, First Struggles ideology. In contrast to how indigenismo was constructed in Mexico, Ward Churchill's "I Am Indigenist," an important and significant text, evokes indigenism for an entirely distinct and political agenda from that which was proposed by Eurocentric racists like José Vasconcelos, Manuel Gamio, and their bureaucratic peers in Mexico. As you may know, Churchill remains a bifurcating personality in Indian Country, with many Native intellectuals challenging his intellectual/political ideas as well as his identity as a Keetoowah Band Cherokee. Notwithstanding these important discussions, I find his writing polemical and, at times, instructive. In her recent book on indigenist myth in Xicano literature, Sheila Marie Contreras finds Churchill's scholarship problematic in that "his use of the term 'indigenism' suggests that he is unaware both of its complex history and of its interpretation by anthropologists and historians."[21] While there

are many reasons to find Churchill's politically engaged work challenging (Scott Lyons calls him "a ~~Native~~ scholar"), his encyclopedic and extensive background research is beyond reproach. Churchill was certainly aware of indigenismo's complex history in Mexico. Instead, Churchill decides to rhetorically avoid this usage in a unique political and ideological maneuver. His indigenism is more aptly aligned with Indianismo, a bottom-up Indigenous vantage point.

In explaining the importance of indigenism for Chicano studies, Guisela Latorre writes that "generally speaking, 'Indigenism' refers to the act of consciously adopting an indigenous identity—which may otherwise not be fully self-evident for political or strategic purposes. The Indigenist posture often seeks to overturn historical processes in order to exact radical change."[22]

Contreras contends that "Churchill redefines indigenism, transforming it into a leftist mode of action."[23] Notwithstanding Contreras's disregard for Churchill's anarchist tendencies (a political ideology that some theorists would consider non-Left) and his open disdain of many Leftist projects (including his support of the Misurasata armed struggle alongside the Reagan-supported Contras in Nicaragua), it is Churchill's direct-action tactics that make his notion of indigenism and indigeneity intriguing to younger generations of Native activists, much like the ideas of Kanien'kehá:ka political theorist Taiaiake Alfred. In fact, I believe that, if Contreras is correct, it may actually be Churchill's radical notion of indigenism—one tied directly to revolutionary action—that we might want to incorporate into Chicano studies, particularly as related to Aztlán.

Unlike the overtly "indigenist" and anti-mestizaje position of figures such as Churchill and Forbes, most contemporary Chicano studies scholars do not disavow mestizaje, yet actually consign it to a dialectical relationship with indigeneity. Too many scholars remain fixated on identity issues. Inversely, I would like to see us turn more aptly to the works of Indigenous scholars such as Jack Forbes for a variety of reasons, most prominently because Forbes disavows mestizaje in a way that appropriately recognizes the dialectic between the political reality of colonialism and its capacity to detribalize millions of Indigenous peoples. This is particularly poignant in Forbes's *Africans and Native Americans* (1993; previously published as *Black Africans and Native Americans*, 1988), in which he critically analyzes the cross-cultural application of terms such as hybrid, mestizo, métis, mulatto, half-breed, and mustee, among others, as they are applied to the descendents of Africans and Native peoples in Turtle Island-the Americas after the fifteenth century.

One important distinction that Forbes makes is that with the expanded application of the term *mestizo* in the seventeenth century, descriptions of

Red-Black peoples (whom we could call Latino) were being transformed from ones based on phenotype (skin color) or cultural practices to those based in racialist discourse. His interest in the subject of Red-Black relations emerges from his larger interest in demonstrating how Indigenous peoples have remained and resisted, countering the common legacy of Indigenous extinction. In fact, Forbes concludes *Africans and Native Americans* by arguing that through investigations of colonial manifestations of mestizaje, he in fact "establishes, beyond a doubt, that the above picture" of the replacement of Indigenous populations by Africans and African-European mixed-bloods "is erroneous." Instead, he continues: "There has essentially been no replacement of Native Americans (considered on a broad scale). . . . Some areas (such as Mexico and Peru) have become phenotypically 'Indian' while other areas (such as many of the islands) have become phenotypically 'African.'"[24]

Through rhetorically advanced historiographic research, Forbes moves beyond racializing claims to develop his corpus from a decidedly "indigenist" perspective by privileging Indigenous struggles, ontologies, and epistemologies. He does so in a way that anticipates "indigenism" as used by anthropologist Ronald Neizen (*The Origins of Indigenism*) or that of Churchill. Forbes's indigenism pre-dates the expanding global Indigenous sovereignty movement of the twenty-first century. Recognizing the legal and cultural distinctions between "Indians" and "Chicanos," Forbes is unique in his straightforward recognition of Xicanos as Indigenous, as well as the way he simultaneously accepts mestizaje as historical fact yet works against its settler-colonial logic to extinguish Indigenous sovereignty.

With this concluding Postscript, I hope to initiate an engagement with Forbes's work as it relates to mestizaje, indigeneity, and, most importantly, Xicano sovereignty. I believe that his work, if properly interrogated, may help better situate certain Xicano communities to a point where they feel more comfortable asserting their own sovereignty as an Indigenous people. As I've shown, Aztlán names Xicano sovereignty—what we would call the Xicano nation. By naming it, it may be reclaimed. By reclaiming it, and therefore creating Aztlán, Xicanos return home to a new and sovereign existence outside settler-colonial control. Importantly, artists have been facilitating this process, one which, following Louis Riel, gives spirit back to an otherwise colonized people.

Notes

Introduction

1. Ethnic identifiers are complex signifiers, with many reasons to use particular names at specified times. Throughout this book, I engage with Xicano cultural history and Indigenous ontologies. As such, a complication emerges in terms of what names to use at what times throughout the text. I have decided to use the term Xicano to refer to the people generally known as Chicanos or Mexican Americans. When writing on specific academic fields of study, particularly Chicano art, Chicano studies, and the Chicano Movement, I will use the more recognized spelling of the word "Chicano." At most times, however, I will use the spelling Xicano to pay particular attention to the Indigenous and indigenist turn in Xicano identity and politics. From this perspective, to be Xicano is to be Indigenous. This particular spelling pays homage to the use by activists and artists who, for decades, have employed this spelling in reference to written Nahuatl. Moreover, the employment of an "x" signifies a lost or colonized history. By using this spelling, I allude to the political and indigenist orientation of my scholarship.

Feminist Xicana scholars have rightly moved away from the default male-centeredness of the Spanish language, particularly the use of "Chicano" to imply both Chicanas and Chicanos. Many recent scholarly works, precipitated by the work of Xicana artists and activists, have utilized various grammatical ways to dismantle this patriarchal construct. This includes, but is not limited to, the following: Chicana/o, Chican@, and Chicana and Chicano. By writing in such a way, scholars intentionally point to the patriarchal biases of language.

I understand the need for this sort of work and, actually, position myself within this intellectual community. That said, when I recently reread postmodern and poststructural texts written during the 1980s and 1990s, I shuddered at the difficulty in reading through the never-ending hyphens, slashes, and parentheses. Moreover, in *Creating Aztlán* I hope to speak to both Chicano studies and Indigenous studies readers, especially to Native readers outside the academy. Because the latter may be unfamiliar with the ideological reasons that Chicano studies scholars write in this way, I have decided to use the default "Xicano" throughout the text. I understand that this decision may counteract some of the ideas situated within the actual body of the text and, as such, take full responsibility for issues this may cause.

To date, I have spoken with Native community members, including nonacademic Xicanos, who feel alienated and put off by an author's use of Chican@, Chicana/o, or Chicana and Chicano. From their perspective, this linguistic interplay becomes an extratextual argument, one that may undermine the author's more pressing arguments, that may confuse and complicate the author's ideas. I recognize the potential pitfalls in my decision, especially as a cis-gendered, non-Xicano male scholar, and accept all responsibility for the failures that this scholarly decision may provoke.

2. In the same manner that I spell Xicano with an "x," I will capitalize the word Indigenous and use it to describe both Xicano and federally recognized Native nations. For me, Indigenous is a large category used to describe the descendents of the pre-European peoples of Turtle Island-the Americas. Moreover, instead of invoking the problematic terms Native American, American Indian, or Indian, I will also use the less descriptive term Native. I use this particular name (Native), because it is the quotidian way that Indigenous people of my generation speak to one another.

While many Native people use "Indian" when speaking to each other, the term takes on a level of racist ethnocentrism when employed in print. Also, the term Native American is rarely, if ever, used by Native peoples when speaking to one another. The term American Indian will be employed only when it applies to the particular turbulent period of Indigenous activism, which in Canada is known as the Red Power Movement. In the United States, this period is most associated with the American Indian Movement and, in the Bay Area, Indians of All Tribes.

3. Jim Northrup, *Anishinaabe Syndicated: A View from the Rez* (Minneapolis: Minnesota Historical Society Press, 2011), xv.

4. Mishuana Goeman, "From Place to Territories and Back Again: Centering Storied Land in the Discussion of Indigenous Nation-building," *International Journal of Critical Indigenous Studies* 1, no. 1 (2008): 24.

5. Goeman, "From Place to Territories," 24–25.

6. See Anibal Quijano, "Colonialidad y Racionalidad/Modernidad," *Perú Indígena* 29 (1991): 11–29; Anibal Quijano, "Colonialidad del poder y clasificación social," *Journal of World-System Research* 6, no. 2 (2000): 342–86; Walter D. Mignolo, "Colonial and Postcolonial Discourse: Cultural Critique or Academic Colonialism?" *Latin American Research Review* 28, no. 3 (1993): 120–34; and Walter D. Mignolo, *Local Histories/ Global Designs: Coloniality, Subaltern Knowledges, and Border Thinking* (Princeton, NJ: Princeton University Press, 2000).

7. Jenny Western, ed., *Do Not Park Bicycles!* (Brandon, MB: Art Gallery of Southwestern Manitoba, 2007).

8. José Antonio Lucero, "Fanon in the Andes: Fausto Reinaga, Indianismo, and the Black Atlantic," *International Journal of Critical Indigenous Studies* 1, no. 1 (2008): 14.

9. LeAnne Howe, "Tribalography: The Power of Native Stories," *Journal of Dramatic Theory and Criticism* (Fall 1999): 117–25.

10. Jo-ann Archibald, *Indigenous Storywork: Educating the Heart, Mind, Body, and Spirit* (Vancouver: University of British Columbia Press, 2008).

11. Patricia Penn Hilden, "How the Border Lies: Some Historical Reflection," in *Decolonial Voices: Chicana and Chicano Cultural Studies in the 21st Century*, ed. Arturo J. Aldama and Naomi H. Quiñonez (Bloomington: University of Indiana Press, 2002), 152–76.

For census information see *The American Indian and Alaska Native Population: 2010*, available from the U.S. Census Bureau.

12. Alberto Híjar Serrano, "The Latin American Left," *Third Text* 19, no. 6 (2005): 646.

13. George Lipsitz, "Not Just Another Social Movement," in *¿Just Another Poster?: Chicano Graphic Arts in California*, ed. Chon Noriega (Seattle: University of Washington Press, 2001), 79.

14. See Híjar Serrano, "The Latin American Left," 646; and Adolf L. Reed, Jr., *W. E. B. DuBois and American Political Thought: Fabianism and the Color Line* (New York: Oxford University Press, 1999).

15. This does not, however, advocate turning a blind eye to the historical failures of radical social movements. On the contrary, I feel that engaged critics and historians have the obligation to document the absences and failures of past events so that similar errors are not repeated.

16. Paul Willis, *Learning to Labour: How Working-class Boys Get Working-class Jobs*, Morningside edition (New York: Columbia University Press, 1981).

17. Throughout this text, I use the Hispanicized Aztlán, as opposed to Aztlan, even though all Nahuatl words have penultimate accents. Since Aztlán, with an accent on the final syllable, was how the concept emerged during the Chicano Movement, I continue that spelling. So as not to confuse, even where addressing Mexica evocations of Aztlán, I use the common Xicano accented spelling. I do the same for Tenochtitlán.

18. El Plan Espiritual de Aztlán as cited in Rudolfo A. Anaya and Francisco Lomelí, eds., *Aztlán: Essays on the Chicano Homeland* (Albuquerque: University of New Mexico Press, 1991), 1.

19. Shelia Marie Contreras, *Blood Lines: Myth, Indigenism, and Chicana/o Literature* (Austin: University of Texas Press), 99–100.

20. Rafael Pérez-Torres, "Refiguring Aztlán," in *The Chicano Studies Reader: An Anthology of Aztlán, 1971–2001*, ed. Chon A. Noriega, Eric R. Avila, Karen Mary Davalos, Chela Sandoval, and Rafael Pérez-Torres (Los Angeles: UCLA Chicano Studies Research Center, 2001), 213–39.

21. Fredric Jameson, "The Politics of Utopia," *New Left Review* 25 (2004): 54.

22. Linda Tuhiwai Smith, *Decolonizing Methodologies: Research and Indigenous Peoples* (London: Zed Books, 1999).

Chapter 1

1. I will use the term pre-Cuauhtemoc in lieu of the more common pre-Colombian. I apply this particular term, although recognizing its many deficiencies, to focus on the political structures already in place in Anahuac, as opposed to fixating on Columbus's role and the beginning of European colonialism and settler-colonialism.

2. Scholars debate the exact year the Mexica left Aztlán, placing the departure in 1064, 1111, or 1168.

3. Elizabeth Hill Boone, "Migration Histories as Ritual Performance," in *To Change Place: Aztec Ceremonial Landscapes*, ed. Davíd Carrasco (Niwot: University Press of Colorado, 1991), 142.

4. Gerald Vizenor, *Manifest Manners: Narratives on Postindian Survivance* (Lincoln: University of Nebraska Press, 1999).

224 • *Notes to Pages 26–38*

5. LeAnne Howe, "The Story of America: A Tribalography," in *Clearing a Path: Theorizing the Past in Native American Studies*, ed. Nancy Shoemaker (New York: Routledge, 2002), 42.

6. Federico Navarette, "The Hidden Codes of the Codex Azcatitlan." *RES* 45 (Spring 2004): 144–60.

7. Elizabeth Hill Boone, "Aztec Pictorial Histories," in *Writing Without Words: Alternative Literacies in Mesoamerica and the Andes*, ed. Elizabeth Hill Boone and Walter Mignolo (Durham, NC: Duke University Press, 1994), 71.

8. Michael Pina, "The Archaic, Historical and Mythicized Dimensions of Aztlán," in *Aztlán: Essays on the Chicano Homeland*, ed. Rudolfo A. Anaya and Francisco Lomelí (Albuquerque: University of New Mexico Press, 1991), 19.

9. Elizabeth Hill Boone, *Stories in Red and Black: Pictorial Histories of the Aztecs and Mixtecs* (Austin: University of Texas Press, 2000), 213.

10. Boone, *Stories in Red and Black*, 213.

11. Christian Duverger, *El origen de los aztecas* (Mexico City: Editorial Grijalbo, 1987).

12. Benedict Anderson, *Imagined Communities: Reflections on the Origins and Spread of Nationalism*, revised and extended edition (London: Verso, 1991).

13. Richard Townsend, "State and Cosmos in the Art of Tenochtitlan," *Dumbarton Oaks Studies in Pre-Columbian Art and Archaeology* 29 (1979).

14. Henri Lefebvre, *The Production of Space* (Oxford and Malden, MA: Blackwell, 1991 [1974]), 38–39.

15. Boone, "Migration Histories as Ritual Performance," 144.

16. Federico Navarrete, "The Path from Aztlán to Mexico: On Visual Narration in Mesoamerican Codices." *RES* 37 (Spring 2000): 40.

17. Navarrete, "Path from Aztlán to Mexico."

18. Boone, "Migration Histories as Ritual Performance."

19. Navarette, "The Hidden Codes," 159.

20. Diana Taylor, "Scenes of Cognition," *Theatre Journal* 56, no. 3 (2004): 360.

21. Taylor, "Scenes of Cognition," 363.

22. Thomas More, *Utopia* (New Haven: Yale University Press, 2001), 12.

23. William C. Sturtevant, "The Sources for European Imagery of Native Americans," in *New World of Wonders: European Images of the Americas, 1492–1700*, ed. Rachel Doggett (Seattle: University of Washington Press, 1992), 32.

24. Alicia Barabas, *Utopias indias: Movimientos sociorreligiosos en México* (second edition, Mexico City: Instituto Nacional de Anthropología e Historia (INAH), 2002, 76.

25. Donna Pierce, "The Mission: Evangelical Utopianism in the New World (1523–1600)," in *Mexico: Splendors of Thirty Centuries* (New York: Metropolitan Museum of Art, 1990).

26. Clarence H. Miller, "Introduction," in *Utopia*, by Thomas More (New Haven, CT: Yale University Press, 2001), ix.

27. Edward Surtz, "Introduction," in *Utopia*, by Thomas More (New Haven: Yale University Press, 1964), xxvi.

28. Surtz, "Introduction."

29. More, *Utopia* (1964).

30. Fray Diego Durán, *History of the Indies of New Spain* (Norman: University of Oklahoma Press, 1994 [1588]). Because the text would have circulated as *Historia de*

las Indias de Nueva-España y islas de Tierra Firme, I refer to it as *Historia* in the body of the text.

31. Barbara E. Mundy, *The Mapping of New Spain: Indigenous Cartography and the Maps of the Relaciones Geográficas* (Chicago: University of Chicago Press, 1996), xvi.

32. Mundy, *The Mapping of New Spain*, xix.

33. Mary L. Pratt, *Imperial Eyes: Travel Writing and Transculturation* (New York: Routledge, 1992).

34. David J. Weber, *The Spanish Frontier in North America* (New Haven: Yale University Press, 1992), 25.

35. In a traditionally colonial manner, the majority of texts refer to Esteban simply by one name. Although he certainly had a surname, texts identify him as "the Black slave Esteban."

36. Weber, *Spanish Frontier in North America*, 46.

37. Weber, *Spanish Frontier in North America*, 46.

38. David Rojinski, *Companion to Empire: A Genealogy of the Written Word in Spain and New Spain, c. 550–1550* (New York: Rodopi, 2010).

39. Georges Baudot, "Amerindian Image and Utopian Project: Motolinía and Millenarian Discourse," in *Amerindian Images and The Legacy of Columbus*, ed. René Jara and Nicholas Spadaccini (Minneapolis: University of Minnesota Press, 1992), 379.

40. José Rabasa, *Inventing America: Spanish Historiography and the Formation of Eurocentrism* (Norman: University of Oklahoma Press, 1993). Rabasa refers to the anthropological work of Clifford Geertz when discussing "thick description." See Geertz, *The Interpretation of Cultures* (New York: Basic Books, 1973).

41. Rabasa, *Inventing America*, 27.

42. Malcolm Andrews, *Landscape and Western Art* (Oxford: Oxford University Press, 1999), 28.

43. Andrews, *Landscape and Western Art*.

44. John Barell, *The Dark Side of the Landscape* (Cambridge: Cambridge University Press, 1980).

45. Andrews, *Landscape and Western Art*, 175.

46. Andrews, *Landscape and Western Art*.

47. Frantz Fanon, *The Wretched of the Earth* (New York: Grove, 1963 [1961]), 38.

48. Mundy, *The Mapping of New Spain*, 61.

49. Mundy, *The Mapping of New Spain*, 215.

50. John McIntosh, *The Origin of the North American Indians* (Nafis and Cornish: New York, 1844), 289. This also appeared in his earlier *The Discovery of America by Christopher Columbus*.

51. William Hickling Prescott, *The Conquest of Mexico* (New York: Simon, 1934); William G. Ritch, *Aztlan: The History, Resources, and Attractions of New Mexico* (Boston: D. Lothrop and Co., 1885); Thomas Stewart Dennison, *The Primitive Aryans of America: Origin of the Aztecs and Kindred Tribes, Showing Their Relationship to the Indo-Iranians and the Place of the Nahuatl or Mexican in the Aryan Group of Languages* (Chicago: T. S. Dennison, 1908); George Hartmann, *Wooed by a Sphinx of Aztlan: The Romance of A Hero of Our Late Spanish-American War and Incidents of Interest from the Life of a Western Pioneer* (Prescott, AZ: Hartmann, 1907).

52. Jack D. Rittenhouse, *Disturnell's Treaty Map: The Map that was Part of the Guadalupe Hidalgo Treaty on Southwestern Boundaries, 1848* (Santa Fe: Stagecoach Press, 1965), 10.

226 • *Notes to Pages 45–56*

53. Rodríguez, "Introduction," in *Canto al Sexto Sol: An Anthology of Aztlanahuac Writing*, ed. Cecilio García-Camarillo, Roberto Rodríguez, and Patrisia Gonzales (San Antonio: Wings Press, 2002), xxxvi.

54. Obituary, *New York Times* (February 15,1999), accessed July 1, 2012, http://www.nytimes.com/1999/02/15/us/thomas-banyacya-89-teller-of-hopi-prophecy-to-world.html?pagewanted=1 (accessed July 1, 2012).

55. Peter Nabokov, *A Forest of Time: American Indian Ways and History* (Cambridge: Cambridge University Press, 2002), 220.

56. Patrisia Gonzales, *Red Medicine: Traditional Indigenous Rites of Birthing and Healing* (Tucson: University of Arizona Press, 2012).

57. Patrisia Gonzales and Roberto Rodríguez, *Column of the Américas*, available online at www.mexica.net/nahuatl/map.php (accessed April 2, 2014).

58. Raymond B. Craib, "A Nationalist Metaphysics: State Fixations, National Maps, and the Geo-Historical Imagination in Nineteenth-Century Mexico," *Hispanic American Historical Review* 82, no. 1 (2002): 38.

59. Rittenhouse, *Disturnell's Treaty Map*, 12.

60. Rittenhouse, *Disturnell's Treaty Map*.

61. Rittenhouse, *Disturnell's Treaty Map*, 14.

62. This anti-Indianism, as a form of state indigenismo, was at the foundation of settler-colonial ideas of Mexican nationalism.

63. Leslie Marmon Silko, *Yellow Woman and a Beauty of the Spirit: Essays on Native American Life Today* (New York: Touchstone, 1996), 85.

64. Alicia Arrizón, "Mythical Performativity: Relocating Aztlán in Chicana Feminist Cultural Productions," *Theatre Journal* 52 (2000): 23.

65. Eric Cheyfitz, "What Is a Just Society? Native American Philosophies and the Limits of Capitalism's Imagination: A Brief Manifesto," *South Atlantic Quarterly* 110, no. 2 (Spring 2011): 299.

66. Sheila Marie Contreras, *Blood Lines: Myth, Indigenism, and Chicana/o Literature* (Austin: University of Texas Press, 2008), 100.

Chapter 2

1. Clara Sue Kidwell and Alan Velie, *Native American Studies* (Lincoln: University of Nebraska Press, 2005), 22.

2. Kidwell and Velie, *Native American Studies*, 23.

3. Leslie Marmon Silko, *Yellow Woman and a Beauty of the Spirit: Essays on Native American Life Today* (New York: Touchstone, 1996), 36.

4. Silko, *Yellow Woman*.

5. Marilyn Notah Verney, "On Authenticity," in *American Indian Thought*, ed. Anne Waters (Malden, MA: Blackwell, 2004), 134.

6. Taiaiake Alfred and Jeff Corntassel, "Being Indigenous: Resurgences against Contemporary Colonialism," *Government and Opposition* 40, no. 4 (2005): 597.

7. *Chicano!: History of the Mexican American Civil Rights Movement*, directed by Hector Galán, (Los Angeles: National Latino Communications Center and Galán Productions, 1996).

8. Alurista testimony in *Chicano!: History of the Mexican American Civil Rights Movement*.

9. It would make sense for there to be a significant Xicano population in Kansas, since there is a popular folk song entitled *Corrido de Kansas* that narrates the *vaquero* experience. Moreover, see Larry G. Rutter's "Mexican Americans in Kansas: A Survey and Social Mobility Study, 1900–1970" and Valerie M. Mendoza's "They Came to Kansas Searching for a Better Life," which explicate the particularities of the Kansas Chicano history and experience. Moreover, the primary Chicano studies text, Américo Paredes's *With His Pistol in His Hand* discusses the role of vaqueros in Kansas as documented in Chicano oral tradition.

10. Armando Navarro, *Mexicano Political Experience in Occupied Aztlán: Struggles and Change* (Walnut Creek, CA: Altamira, 2005), 337.

11. During the conference there was a split in the Chicana caucus between those that maintained that "la Chicana does not want to be liberated" and those maintaining a feminist position.

12. Ignacio M. García, *Chicanismo: The Forging of a Militant Ethos* (Tucson: University of Arizona Press, 1997), 94.

13. Anonymous, "Statement of the Revolutionary Caucus at Denver's Chicano Youth Liberation Conference," *El Pocho Ché* 1, no. 1 (July 1969): n.p.

14. Anonymous, "Statement of the Revolutionary Caucus."

15. Eric Cheyfitz, "What is a Just Society? Native American Philosophies and the Limits of Capitalism's Imagination: A Brief Manifesto," *The South Atlantic Quarterly* 110, no. 2 (2011): 291–307.

16. Cheyfitz, "What is a Just Society?" 300.

17. Chon A. Noriega and Wendy Belcher, eds., *I am Aztlán: The Personal Essay in Chicano Studies* (Los Angeles: UCLA Chicano Studies Research Center, 2004), v.

18. Alurista, *Nationchild Plumaroja* (San Diego: Toltecas en Aztlán, 1972), 3.

19. Contreras, *Blood Lines*, 101–2.

20. Guillermo Bonfil Batalla, *México Profundo: Reclaiming a Civilization* (Austin: University of Texas Press, 1996). I return to Forbes's important work in the last chapter of this book. However, it must be pointed out that mestizo identities have two very different functions. In much of Latin American, to be mestizo is to deny one's indigeneity, while in the United States and Canada, mestizaje and métissage are the acceptance and affirmation of indigenousness. The key distinction of these two structural differences is based in the forms of colonialism that transpire in Anglo-America compared with that in Latin America. In the United States and Canada, settler colonialism supplants colonialism and therefore needs to dismantle Indigenous systems, peoples, and identities to allow the legal taking over of land. In Mexico, for instance, Spanish colonialism was mapped onto existing Indigenous hierarchies.

21. Mario Barrera, *Beyond Aztlán: Ethnic Autonomy in Comparative Perspective* (New York: Praeger, 1988), 41–44.

22. Chicano Coordinating Council on Higher Education, *El Plan de Santa Barbara: A Chicano Plan for Higher Education* (Oakland: La Causa, 1969).

23. Chicano Coordinating Council on Higher Education, *El Plan de Santa Barbara*.

24. F. A. Rosales, *Chicano!: The History of the Mexican American Civil Rights Movement* (Houston: Arte Público, 1997), 181.

25. Alicia Gaspar de Alba, "There's No Place Like Aztlán: Embodied Aesthetics in Chicana Art," *CR: The New Centennial Review* 4, no. 2 (2004): 104–5.

26. Alurista, as quoted in Cecilio García-Camarillo, Roberto Rodríguez, and Patrisia Gonzales, eds., *Canto al Sexto Sol: An Anthology of Aztlanahuac Writing* (San Antonio: Wings Press, 2002), 327.

27. Alurista, as quoted in Cecilio García-Camarillo, Roberto Rodríguez, and Patrisia Gonzales, *Canto al Sexto Sol*, 327.

28. Smith, *Decolonizing Methodologies*, 157–58.

29. Rudolfo Anaya, "Aztlán," in *The Anaya Reader* (New York: Warner Books, 1995), 369.

30. Anaya, "Aztlán," 369–70.

31. Armando B. Rendón, *Chicano Manifesto* (New York: Macmillan, 1971), 9.

32. W. E. Garret, "Mexico's Little Venice," *National Geographic* 133, no. 6 (1968): 876–88.

33. Gutierre Tibón, "Aztatlan-Aztlan," *Archivo internationale di etnografia e preistoria* (1962), 100.

34. Indigenous scholar Jack D. Forbes maintains that he was using Aztlán to signify the Xicano nation during the mid-1960s in his courses at the University of California-Davis. This begins to locate the discursive origins of a Xicano Aztlán to the mid-1960s.

35. Taiaiake Alfred, *Peace, Power, and Righteousness: An Indigenous Manifesto* (New York: Oxford University Press, 1999), 25.

36. Alfred, *Peace, Power, and Righteousness*, 25.

37. Cheyfitz, "What Is a Just Society?"

38. Pérez-Torres, "Refiguring Aztlán," 218.

39. Daniel C. Alarcón, *The Aztec Palimpsest: Mexico in the Modern Imagination* (Tucson: University of Arizona Press, 1997), 11.

40. Alurista, "The History of Aztlán," Alurista Papers, Benson Latin American Collection, University of Texas, Austin.

41. W. B. Worthen, "Disciplines of the Text: Sites of Performance," *TDR* 39, no. 1 (1995): 11.

42. Henri Lefebvre, *The Production of Space*, trans. Donald Nicholson-Smith (Malden, MA and Oxford: Blackwell, 1991 [1974]).

43. Lefebvre, *The Production of Space*, 199.

44. J. Jorge Klor de Alva, "Mestizaje from New Spain to Aztlán: On the Control and Classification of Collective Identities," in *New World Orders: Casta Painting and Colonial Latin America*, ed. Ilona Katzew (New York: Americas Society, 1996), 70.

45. Arrizón, "Mythical Performativity," 23, 26.

46. Arrizón, "Mythical Performativity," 29.

47. Michel de Certeau, *The Practice of Everyday Life* (Berkeley: University of California Press, 1984), 129.

48. Jo-ann Archibald, *Indigenous Storywork: Educating the Heart, Mind, Body, and Spirit* (Vancouver: University of British Columbia Press, 2008), 2.

49. Dwight Conquergood, "Performance Studies: Interventions and Radical Research," *TDR* 46, no. 2 (2002): 145.

50. Quoted in Kimberly M. Blaeser, *Gerald Vizenor: Writing in the Oral Tradition* (Norman: University of Oklahoma Press, 2012), 25.

51. Basil Johnston, "Summer Holidays in Spanish," in *All My Relations: An Anthology of Contemporary Canadian Fiction*, ed. Thomas King (Toronto: McClelland and Stewart, 1990), 12–13.

Notes to Pages 69–79 • 229

52. Edward Soja, *Postmodern Geographies: The Reassertion of Space in Critical Social Theory* (New York: Verson, 1989), 122.

53. David Halpin, "Utopianism and Education: The Legacy of Thomas More," *British Journal of Educational Studies* 49, no. 3 (2001): 303.

54. Halpin, "Utopianism and Education," 303.

55. Halpin, "Utopianism and Education," 304.

56. Mignolo, *Local Histories/Global Designs*.

57. Jameson, "The Politics of Utopia," 35.

58. Jameson, "The Politics of Utopia," 35.

59. Gaspar de Alba, "There's No Place Like Aztlán," 103.

60. I would like to thank David Craven for his help in "retranslating" the frequently cited mistranslation of Marx's Eleventh Thesis on Feuerbach. The original German-language text of this passage is posted at Humboldt-Universität zu Berlin to foment an open-ended dialogue such as Marx himself appreciated.

61. Darren Webb, *Marx, Marxism and Utopia* (Burlington, VT: Ashgate, 2000), 1.

62. Ruth Levitas, *The Concept of Utopia* (Syracuse: Syracuse University Press, 1990), 35–36.

63. Mikhail Bakhtin, *The Dialogic Imagination: Four Essays*, ed. Michael Holquist, trans. Caryl Emerson and Michael Holquist (Austin: University of Texas Press, 1981).

64. Jean Baudrillard, *Utopia Deferred* (New York: Semiotext(e), 2006), 32.

65. Baudrillard, *Utopia Deferred*, 288.

66. Glen S. Coulthard, "Subjects of Empire: Indigenous Peoples and the 'Politics of Recognition' in Canada," *Contemporary Political Theory* 6 (2007): 439.

67. Coulthard, "Subjects of Empire," 438–39.

68. Jorge Mariscal, *Brown-eyed Children of the Sun: Lessons from the Chicano Movement, 1965–1975* (Albuquerque: University of New Mexico Press, 2005), 12.

69. Mariscal, *Brown-eyed Children*, 12.

70. Armando B. Rendón, *Chicano Manifesto: The History and Aspirations of the Second Largest Minority in America* (New York: Macmillan, 1971), 95.

71. Rendón, *Chicano Manifesto*, 95.

72. Cynthia Orozco, "Sexism in Chicano Studies and in the Community," in *Chicana Feminist Thought: The Basic Historical Writings*, ed. Alma M. García (New York and London: Routledge Press, 1997), 265–70.

73. The August Twenty-Ninth Movement was named after the date of the Chicano Moratorium, where at least three Chicanos were murdered by police forces in Los Angeles.

74. Elizabeth "Betita" Martínez, "A View from New Mexico: Recollections from the *Movimiento* Left," *Monthly Review* (July-August 2002): 84.

75. Elizabeth Sutherland Martínez and Enriqueta Longeaux y Vásquez, *Viva la Raza! The Struggle of the Mexican-American People* (Garden City, NY: Doubleday, 1974), 160.

76. Elizabeth Martínez, "Viva la Chicana and All Brave Women of La Causa," in *Chicana Feminist Thought: The Basic Historical Writings*, ed. Alma M. García (New York: Routledge, 1997), 80.

77. Martínez, "A View from New Mexico," 81.

78. Martínez, "A View from New Mexico," 81.

79. *Encuentro Feminil: The First Chicana Feminist Journal* 1, no. 2 (1973): 5.

80. Vicki L. Ruiz, *From out of the Shadows: Mexican Women in Twentieth-Century America* (New York: Oxford, 1998), 107.

81. Ruiz, *From out of the Shadows*, 107–8.

82. Published in *Voces del Norte: A Chicano/Raza Art and Literary Journal* 2 (1979): np.

83. *Voces del Norte.*

84. Edward McCaughan, "Art and Identity in Mexican and Chicano Social Movements," in *Research in Social Movements, Conflicts and Change*, ed. Patrick E. Coy (San Diego: JAI Press, 2007).

85. Karen Mary Dávalos, *Exhibiting Mestizaje: Mexican (American) Museums in the Diaspora* (Albuquerque: University of New Mexico Press, 2001), 59.

86. Dávalos, *Exhibiting Mestizaje*, 59.

87. Lina Sunseri, "Moving Beyond the Feminism Versus Nationalism Dichotomy: An Anti-Colonial Feminist Perspective on Aboriginal Liberation Struggles," *Canadian Woman Studies/Les Cahiers de la Femme* 20, no. 2 (2000): 145.

88. Cherríe Moraga, *The Last Generation* (Cambridge: South End Press, 1999), 150.

89. McCaughan, "Art and Identity," 4.

90. McCaughan, "Art and Identity," 4.

91. McCaughan, "Art and Identity" (see chart 1). Using a category constructed by Janet Wolff in *The Social Production of Art*, second edition (Washington Square: New York University Press, 1993), McCaughan concurs that images "projecting a feminist perspective" are those that include "depictions of strong women engaged in struggle or work and images promoting a liberated female sexuality, and 'deconstructed' imagery referencing patriarchy and machismo."

92. Dionne Espinosa, "'Revolutionary Sisters': Women's Solidarity and Collective Identification among Chicana Brown Berets in East Los Angeles, 1967–1970," *Aztlán* 26, no. 1 (2001): 32.

93. Mariscal, *Brown-eyed Children of the Sun.*

Chapter 3

1. Scott Richard Lyons, *X-marks: Native Signatures of Assent* (Minneapolis: University of Minnesota Press, 2010), 76.

2. Lyons, *X-marks.*

3. Lyons, *X-marks.*

4. Lyons, *X-marks.*

5. William V. Flores and Rina Benmayor, eds., *Latino Cultural Citizenship: Claiming Identity, Space, and Rights* (Boston: Beacon, 1997).

6. Alurista, "Aztlán: Myth or Reality," Alurista Papers, Benson Latin American Collection, University of Texas, 1971.

7. Alurista, "Aztlán: Myth or Reality."

8. Alurista, "Cultural Nationalism and Xicano Literature during the Decade of 1965–1975," *MELUS* 8, no. 2 (1981): 22–34.

9. Raymond Williams, *Keywords: A Vocabulary of Culture and Society* (London: Fontana/Croon Helm, 1976).

10. Andrew Edgar and Peter Sedgwick, eds., *Key Concepts in Cultural Theory* (London: Routledge, 1999), 102.

11. Clifford Geertz, *The Interpretation of Cultures* (New York: Basic Books, 1973), 14.

Notes to Pages 85–92 • 231

12. Stuart Hall, "Notes on Deconstructing 'The Popular,'" in *People's History and Socialist Theory*, ed. Raphael Samuel (London: Kegan Paul-Routledge, 1981), 239.

13. Renato Rosaldo, *Culture and Truth: The Remaking of Social Analysis*, second edition (Boston: Beacon, 1993), 199.

14. This notion of "irrational culture" was perpetuated in the 1980s by the exhibition of "Hispanic art." Here the rationality of Western aesthetic knowledge was superseded by the irrational use of bright colors and figurative compositions.

15. Here I am referencing the Aztlanahuac Project of Patrisia Gonzales and Roberto Rodríguez. Although I have been critical of the project at times, I likewise understand the political environment within which the project operates. As such, the Aztlanahuac Project continues the Movement struggles to claim cultural citizenship.

16. Flores and Benmayor, *Latino Cultural Citizenship*, 1.

17. Flores and Benmayor, *Latino Cultural Citizenship*, 5.

18. Lipsitz, "Not Just Another Social Movement," 84.

19. Arnold Hauser, *The Philosophy of Art History* (Evanston, IL: Northwestern University Press, 1985), 285.

20. Alurista, "Cultural Nationalism and Xicano Literature," 25.

21. Tomás Ybarra-Frausto, "Alurista's Poetics: The Oral, the Bilingual, the Pre-Columbian," in *Modern Chicano Writers: A Collection of Critical Essays*, ed. Joseph Sommers and Tomás Ybarra Frausto (Englewood, CA: Prentice-Hall, 1979), 119.

22. Fanon, *Wretched of the Earth*, 224.

23. Alfred, *Peace, Power, and Righteousness*, xviii.

24. Alfred, *Peace, Power, and Righteousness*, xviii.

25. Howard Adams, *Tortured People: The Politics of Colonization*, revised edition (Peniction, BC: Theytus, 1999), 196. Also see Howard Adams, *Prison of Grass: Canada from a Native Point of View* (Toronto: General, 1975).

26. Adams, *Tortured People*.

27. This is not to insinuate that decolonial expressions and movements had not been ongoing since the beginning of colonial expansion. Inversely, I believe that this period is marked with a high level of resistance and solidarity among previously separate groups. I maintain that it is these intraclass and interethnic alliances that facilitate the success of each respective movement.

28. Smith, *Decolonizing Methodologies*.

29. Fanon, *Wretched of the Earth*, 35.

30. Immanuel Wallerstein, "Reading Fanon in the 21st Century," *New Left Review* 57 (May/June 2009): 120.

31. Wallerstein, "Reading Fanon."

32. I am critical of all forms of violence.

33. Philip S. Foner, ed., *The Black Panthers Speak* (Philadelphia: J. B. Lippincott, 1970), 19.

34. AIM documents, American Radicalism Collection, Michigan State University.

35. Based on comments made by David Hilliard, Elaine Brown, Erick Huggins, and Fredrika Newton during a five-day colloquium honoring the fortieth anniversary of the Black Panther Party, the University of New Mexico, February 16–21, 2006.

36. In this context, I apply the term "Third World peoples" to name the historically oppressed and colonized peoples living both within and outside the United States. I choose this phrase because it was commonly used in an act of solidarity by Xicano,

Native, Black, and Asian American intellectuals during the 1960s, 1970s, and 1980s. The term was particularly privileged by Bay Area activists. It has a specific relationship to the Third World Liberation Front (TWLF), which staged student strikes at the University of California, Berkeley, and San Francisco State University in 1968–1969. Since the occupation of Alcatraz and the foundation of D-QU both occurred in the Bay Area, ideological as well as membership crossover was certain. Therefore, by applying the idiom "Third World peoples," I posit a reciprocity between the diverse ethnic groups that identifying them individually would not do.

37. Native Alliance for Red Power, *NARP Newsletter* 4 (June/July 1969): 5.

38. Donna Hightower Langston, "American Indian Women's Activism in the 1960s and 1970s," *Hypatia* 18, no. 2 (2003): 114.

39. Haunani-Kay Trask., *From a Native Daughter: Colonialism and Sovereignty in Hawai'i*, revised ed. (Honolulu: University of Hawai'i Press, 1999), 26.

40. AIM movement documents, American Radicalism Collection, Michigan State University.

41. William D. Carrigan and Clive Webb, "The Lynchings of Persons of Mexican Origin or Descent in the United States, 1848 to 1928," *Journal of Social History* 37, no. 2 (2003): 414.

42. Ward Churchill, *Struggle for the Land: Indigenous Resistance to Genocide, Ecocide, and Expropriation in Contemporary North America* (Monroe, ME: Common Courage, 1993).

43. Smith, *Decolonizing Methodologies*.

44. The Alianza was also known as the Alianza de Federal de Mercedes in reference to the land grants or mercedes.

45. Mariscal, *Brown-eyed Children*, 193.

46. Rafael Pérez-Torres, *Mestizaje: Critical Uses of Race in Chicano Culture* (Minneapolis: University of Minnesota Press, 2006), 115.

47. Langston, "American Indian Women's Activism," 115.

48. Langston, "American Indian Women's Activism," 115.

49. Langston, "American Indian Women's Activism," 115.

50. United Nations. *Declaration on the Rights of Indigenous Peoples*, GA Res. 61/295 (2007). Available online: http://www.un.org/esa/socdev/unpfii/en/drip.html (accessed June 2009).

51. Adams, *Tortured People*, 194.

52. *La voz del pueblo*, Berkeley, California (June 1971): 5.

53. Lisa Brooks, "Afterword," in *American Indian Literary Nationalism*, ed. Jace Weaver, Craig Womack, and Robert Warrior (Albuquerque: University of New Mexico Press, 2006), 244.

54. Sunseri, "Moving Beyond," 144.

55. Sunseri, "Moving Beyond," 145.

56. Gerald R. (Taiaiake) Alfred, *Heeding the Voices of Our Ancestors: Kahnawake Mohawk Politics and the Rise of Native Nationalism* (Toronto: Oxford University Press, 1995), 14.

57. D-QU has a longer and more formal name, although some maintain that the first part of its name should only be used by tribal members in ceremonial situations. Out of respect for the individuals and the institution, I will refer to the university only as D-QU.

Notes to Pages 98–106 • 233

58. Brenda Norrell, "D-Q University Students Left in the Cold," *Indian Country Today*, March 4, 2005.

59. Jack Forbes, "DQU Rebel Takeover Group at DQU Now Being Picketed," December 2005.

60. Guisela Latorre, *Walls of Empowerment: Chicana/o Indigenist Murals of California* (Austin: University of Texas Press, 2008).

61. Eva Sperling Cockcroft and Holly Barnet-Sánchez, eds., *Signs from the Heart: California Chicano Murals* (Albuquerque: University of New Mexico, 1993); Victor A. Sorell, "Articulate Signs of Resistance and Affirmation in Chicano Public Art, in *Chicano Art: Resistance and Affirmation, 1965–1985*," ed. Richard Griswold del Castillo, Teresa McKenna, Yvonne, Yarbro-Bejarano (Los Angeles: Wight Art Gallery, University of California, Los Angeles), 148.

62. Alan W. Barnet, *Community Murals: The People's Art* (Philadelphia: Art Alliance Press, 1984), 11.

63. T. V. Reed, *The Art of Protest: Culture and Activism from the Civil Rights Movement to the Streets of Seattle* (Minneapolis: University of Minnesota Press, 2005), 105.

64. Latorre, *Walls of Empowerment*, 71.

65. Shifra Goldman, "The Iconography of Chicano Self-Determination: Race, Ethnicity, and Class," *Art Journal* 49 (Summer 1990): 167–73.

66. Shifra Goldman and Tomás Ybarrra-Frausto, *Arte Chicano: A Comprehensive Annotated Bibliography of Chicano Art, 1965–1981* (Berkeley: Chicano Studies Library Publication Series, 1985), 40.

67. Latorre, *Walls of Empowerment*.

68. Here I am referring to the work of radical dramaturge Berthold Brecht. See Carol Martin and Henry Bial, eds., *Brecht Sourcebook* (New York: Routledge, 2000).

69. Latorre, *Walls of Empowerment*, 68.

70. Latorre, *Walls of Empowerment*, 68.

71. During the years of the Chicano Movement, Quirarte was employed at the U.S. Embassy. Moreover, in 1964, Quirarte commenced work at the Foreign Service in Caracas, Venezuela, where he served until 1966. Through his friendship with renowned pre-Cuauhtemoc art historian George Kubler, Quirarte served a one-year academic appointment at Yale University before teaching Mexican art at the University of Texas, Austin.

72. Jacinto Quirarte, interview in Smithsonian Archives of American Art.

73. César Martínez, "Artist's Statement," reprinted in Griswold del Castillo, McKenna, and Yarbro-Bejarano, *Chicano Art: Resistance and Affirmation*, 22.

74. César Martínez, "Artist's Statement."

75. Bakhtin, *The Dialogic Imagination*.

76. While many of Goldman's writings were published during this period, she actively continued writing well into the 1990s and even 2000s. Like any periodization, the dates that I supply are not fixed, yet offer a rough outline for understanding the concepts developed by individuals in relation to larger social, cultural, and political events. Although Goldman's scholarship goes beyond the dates I have chosen, her theoretical methodologies change little in her later work.

77. Goldman and Ybarra-Frausto, *Arte Chicano*.

78. Anonymous, "Five Styles of Chicano Art," *El Grito* 6, no. 1 (1972): 88–92.

79. Santiago Boiton and Susan Stechnij, "Editorial," *ABRAZO* 1, no. 1 (1976): 4.

234 • *Notes to Pages 106–119*

80. *Machetazo* translates as the "blow from a Machete" and is in reference to a radical publication that at varying times served as the "organo central" of the *Sindicato de Obreros Técnicos, Pintores y Escultores* (Technical Workers, Painters, and Sculptors Union), as well as the Partido Comunista de México.

81. Carlos Cortéz [Koyokuikatl], "El Machetazo," *ABRAZO* 1 (1976): 25.

82. George Vargas, "The Aesthetic(s) of History of Art Books," *Raza Art and Media Collective Journal* 2, no. 1 (1977): 19.

83. Carlos Almaraz, "The Artist as Revolutionary," *Chisméarte* 1, no. 1 (1976): 47–55. Almaraz states that "if revolution is simply no more than society rapidly changing (which I doubt), then, art could be the catalyst that brings about that change, or to put it more modestly, some of that change" (50).

84. Almarez, "Artist as Revolutionary," 50.

85. Sybil Venegas, "Conditions for Producing Chicana Art, *Chisméarte* 1, no. 4 (1977): 2–4; and Sybil Venegas, "The Artists and Their Work—The Role of the Chicana Artist," *Chisméarte* 1, no. 4 (1977): 3–5.

86. Venegas, "Conditions," 4.

87. Venegas, "The Artists and Their Work," 5.

88. Marcela Trujillo Gaitan, "The Dilemma of the Modern Chicana Artist and Writer," *De Colores* 3, no. 3 (1977): 46.

89. Antonio Gramsci, *Selections from the Prison Notebooks* (New York: International Publishers, 1971), 333.

90. Jacinto Quirarte, *Chicano Art History: A Book of Selected Writings* (San Antonio: Research Center for the Arts and Humanities, University of Texas, San Antonio, 1984).

91. Malaquías Montoya and Lezlie Salkowitz-Montoya, "A Critical Perspective on the State of Chicano Art," *Metamorfosis* 1, no.1 (1980): 5.

92. Montoya and Salkowitz-Montoya, "A Critical Perspective," 4.

93. Shifra Goldman, "Response: Another Opinion on the State of Chicano Art," *Metamorfosis* 1, no. 2 (1980/81): 5.

94. Goldman, "Response."

95. Goldman, "Response," 6.

96. Montoya and Salkowitz-Montoya, "A Critical Perspective," 4.

97. Montoya and Salkowitz-Montoya, "A Critical Perspective," 4.

Chapter 4

1. Yolanda Broyles-González, *Lydia Mendoza's Life in Music: La historia de Lydia Mendoza* (Oxford: Oxford University Press, 2003).

2. Dylan A. T. Miner, "El Renegado Comunista: Diego Rivera, La Liga de Obreros y Campesinos, and Mexican Repatriation in Detroit," *Third Text* 19, no. 6 (2005): 647–60.

3. Chela Sandoval, "U.S. Third World Feminism: The Theory and Method of Oppositional Consciousness in the Postmodern World," *Genders* 10 (1991): 14.

4. Gramsci, *Selections from the Prison Notebooks*, 333.

5. Ursula Murray, *Tenth Annual Michigan Hispanic Artists Exhibition Catalogue* (Detroit: Hispanic Arts and Education Center, 2000), 12.

6. See the work of Ward Churchill, as well as Sheila Contreras.

7. Examples of such reductionism are unfortunately quite frequent. For instance, the work of Carmen Lomas Garza is commonly positioned as "folk art"; in *Arte Latino:*

Treasures from the Smithsonian American Art Museum (2001, 46), Jonathan Yorba considers her paintings "delightful works," as if the work of Lomas Garza serves no other purpose but to "delight"!

8. Amber Arrellano, "Artist's Healing Spirit: Self-Taught Painter Blossoms to Aid Hispanics in Area," *Detroit Free Press*, September 22, 2000.

9. It is interesting to note that while Santa Barraza calls South Texas her home, Carmen Lomas Garza produces her images about South Texas from San Francisco.

10. Henri Lefebvre, *The Production of Space*, trans. Donald Nicholson-Smith (Malden, MA, and Oxford: Blackwell, 1991 [1974]), 286.

11. Dennis Valdés, *Al Norte: Agricultural Workers in the Great Lakes Region, 1917–1970* (Austin: University of Texas Press, 1991).

12. Ramón Saldívar, *Chicano Narrative: The Dialectics of Difference* (Madison: University of Wisconsin Press, 1990), 99.

13. A reference to Michigan does appear on page 137 of *Chicano Narrative*. This is in relation to Rolando Hinojosa's evocation of Michigan in *Estampas del Valle* (1973), which was later rewritten in English and reissued as *The Valley* (1983).

14. George Vargas, "Contemporary Latino Art in Michigan, the Midwest, and the Southwest," PhD diss. (University of Michigan, 1988), 253.

15. Pérez-Torres, *Mestizaje*, 115.

16. This is discussed in my article in *Third Text*.

17. Armando Navarro, *Mexicano Political Experience in Occupied Aztlán: Struggles and Change* (Walnut Creek, CA: Altamira, 2005).

18. It must be noted that some artists and activists were complicit in producing an essentialized Aztlán. These artworks are commonly addressed in Chicano art historical literature. Here, I am interested in explicating the complexities and multiple Aztláns, as opposed to a monolithic Aztlán.

19. Although little has been written about the history and activism of the XDC, many of its core organizers are presently working on various historical projects that address Chicano history and activism in Michigan and the Midwest. After its reestablishment, I served on the XDC board. Ernesto Todd Mireles, a professor at Prescott College in Arizona, and Nora Salas, a professor at Grand Valley State University in Michigan, are both former XDC cofounders; Luis Moreno, who joined the XDC at a later date, teaches ethnic studies at Bowling Green State University.

20. Pérez-Torrez, *Mestizaje*, 235.

21. Taiaiake Alfred, *Wasáse: Indigenous Pathways of Action and Freedom* (Peterborough, ON: Broadview, 2005), 19.

22. Alfred, *Wasáse*, 20.

23. I have recently begun speaking with Prof. Margaret Noodin (Anishinaabe) about Anishinaabeg and Michif anarchisms.

24. Latorre, *Walls of Empowerment*.

25. Rita González, "Archiving the Latino Arts Before It is Too Late," *Latino Issues and Policy Brief* 6: (April 2003).

26. René H. Arceo Frutos, "Introduction," in *The Barrio Murals / Murales del Barrio Catalogue* (Chicago: Mexican Fine Arts Center Museum, 1987), 2.

27. Tracy Grimm and Olga Herrera, "Midwest Latino Arts Documentary Heritage Initiative," Notre Dame, IN: Institute for Latino Studies, University of Notre Dame, http://www.nd.edu/~latino/arts/larp.htm (accessed May 1, 2007).

28. For information on the Midwest Latino Arts Documentary Heritage Initiative, see the project's website at http://www.midlad.org.

29. Vargas, "Contemporary Latino Art," 313–15.

30. Karen Mary Davalos, *Exhibiting Mestizaje: Mexican (American) Museums in the Diaspora* (Albuquerque: University of New Mexico Press, 2001), 78.

31. Arceo Frutos, *Barrio Murals*, 1.

32. Lipsitz, "Not Just Another Movement," 173.

33. Dennis Valdés, *Barrios Norteños: St. Paul and Midwestern Mexican Communities in the Twentieth Century* (Austin: University of Texas Press, 2000), 19.

34. The work of Estrella Torrez, Assistant Professor in the Residential College in the Arts and Humanities at Michigan State University, delineates how Mexican and Xicano agricultural laborers have been systematically stripped of language sovereignty through educational policies.

35. Zaragosa Vargas, "Mexican Auto Workers at Ford Motor Company, 1918–1933," PhD diss., University of Michigan (1984), 1.

36. While the term *colonia* (colony) usually demarcates a rural community, within Michigan both rural and urban Xicano communities have been considered colonias. Within the historiography of the region, some of the earliest English-language texts about MiXicanos refer to the "Detroit Mexican colony." Therefore, in this chapter I use the terms colonia and barrio interchangeably. Similarly, Ignacio M. García (1997) uses colonia when discussing urban Mexican communities in the Midwest.

37. Norman Humphrey, "The Migration and Settlement of Detroit Mexicans," *Economic Geography* 19, no. 4 (1943).

38. Gloria Anzaldúa, *Borderlands/La Frontera: The New Mestiza* (San Francisco: Aunt Lute, 1987), 3.

39. Anzaldúa, *Borderlands/La Frontera*, 3.

40. Michelle Habell-Palán, *Loca Motion: The Travels of Chicana and Latina Popular Culture* (New York: New York University Press, 2005), 207.

41. Davalos, *Exhibiting Mestizaje*, 67.

42. Similarly, Wayne State University's Center for Latino/a and Latin American Studies Program was originally named the Center for Chicano-Boricua Studies, highlighting Latino solidarity in the city of Detroit. During a panel on the Midwest Chicano Studies Program, at NACCS 2012, I learned that Chicano-Boricua Studies changed its name to Latino/a and Latin American Studies.

43. George Vargas, unpublished, untitled, unpaginated essay available at Bagley Housing Association, Detroit.

44. Murray, *Hispanic Artists Exhibition*.

45. Rudolph Valier Alvarado and Sonya Yvette Alvarado, *Mexicans and Mexican Americans in Michigan* (East Lansing: Michigan State University Press, 2003), 64.

46. A sustained study of the history and role of the Bagley Housing Association gallery and La Casa de Unidad is a project that should be undertaken, but the specific role of these institutions within the Chicano art movement in Detroit falls outside the scope of this book. I mention the gallery so that readers can place *CitySpirit* in relation to important community institutions.

47. Raúl Homero Villa, *Barrio Logos: Place and Space in Urban Chicano Literature and Culture* (Austin: University of Texas Press, 2000), 5.

48. George Vargas, "A Historical Overview/Update on the State of Chicano Art," in *Chicano Renaissance: Contemporary Cultural Trends*, ed. David R. Maciel, Isidro D. Ortiz, and María Herrera-Sobek (Tucson: University of Arizona Press, 2003).

49. Vargas, "A Historical Overview/Update."

50. Miner, "El Renegado Comunista," 647–60.

51. Miner, "El Renegado Comunista."

52. Goldman and Ybarra-Frausto, *Arte Chicano*, 40.

53. Francis V. O'Connor, "An Iconographic Interpretation of Diego Rivera's Detroit Industry Murals in Terms of Their Orientation to the Cardinal Points of the Compass," *Diego Rivera: A Retrospective* (Detroit: Founders Society Detroit Institute of Arts, 1986), 218.

54. Fanon, *Wrtetched of the Earth*, 224.

55. Linda Bank Downs, "Introduction," *Diego Rivera: A Retrospective* (Detroit: Founders Society Detroit Institute of Arts, 1986), 5.

56. Vargas, "A Historical Overview/Update."

57. Villa, *Barrio Logos*, 5.

Chapter 5

1. Michelle Kuo and David Graeber, "Another World: Michelle Kuo and David Graeber," *Artforum* (Summer 2012): 269.

2. Lipsitz, "Not Just Another Social Movement," 84.

3. Gilbert Luján interview with Jeffery Rangel conducted in Los Angeles, CA, and La Mesa, NM, November 1997. Available at the Smithsonian Archives of American Art.

4. Rangel interview.

5. Personal communication, October 9, 2006.

6. Personal communication, October 9, 2006.

7. Rangel interview.

8. Rangel interview.

9. Rangel interview.

10. Rangel interview.

11. Personal communication, fall 2006.

12. Alberto Híjar, "Los Torcidos Caminos de la utopia estética," *Arte y Utopía en América Latina* (Mexico City: Instituto Nacional de Bellas Artes, 2000), 13. My translation.

13. Personal communication, October 5, 2006.

14. Personal communication, October 5, 2006.

15. Personal communication, October 5, 2006.

16. Harry Gamboa, "In the City of Angels, Chameleons, and Phantoms: Asco, a Case Study of Chicano Art in Urban Tones (or Asco was a Four-Member Word)," in *CARA: Chicano Art Resistance and Affirmation* (Los Angeles: Wight Art Gallery, 1995), 125.

17. Gamboa, "In the City of Angels," 125.

18. Quirarte, "Exhibitions of Chicano Art: 1965 to the Present," in *CARA: Chicano Art Resistance and Affirmation* (Los Angeles: Wight Art Gallery, 1995), 170.

19. Rangel interview.

20. John Berger, *Ways of Seeing* (New York: Penguin, 1977), 16.

238 • *Notes to Pages 151–161*

21. Mary P. Brady, *Extinct Lands, Temporal Geographies: Chicana Literature and the Urgency of Space* (Durham, NC: Duke University Press, 2002), 146.

22. Brady, *Extinct Lands, Temporal Geographies*.

23. Pérez-Torres, *Mestizaje*, 150.

24. Personal communication, October 6, 2006.

25. Personal communication, September 29, 2006.

26. Montoya, unpublished Curriculum Vitae, 2006.

27. Montoya, unpublished Curriculum Vitae, 2006.

28. Terezita Romo, *Malaquías Montoya* (Los Angeles: UCLA Chicano Studies Research Center, 2011), 115.

29. Romo, *Malaquías Montoya*, 115–116.

30. This important artwork was only included in the exhibition under a glass-enclosed vitrine that contained ephemera. In other words, this print was never accepted as a work of art, but rather as a document. This was a decision of the museum staff, not the curatorial collective.

31. Lincoln Cushing, "The Legacy of Cuban Poster Art: The Graphic Explosion that Rocked the World," lecture, October 26, 2006, University of New Mexico.

32. Shifra Goldman, "A Public Voice: Fifteen Years of Chicano Posters," *Art Journal* 44, no. 1 (1984): 52.

33. Lincoln Cushing, *Revolución!: Cuban Poster Art* (San Francisco: Chronicle Books, 2003).

34. Malaquías Montoya, "Objectives," unpublished document.

35. Montoya and Salkowitz-Montoya, "A Critical Perspective," 6.

36. Montoya and Salkowitz-Montoya, "A Critical Perspective," 7.

37. Albert Camus, *Between Hell and Reason: Essays from the Resistance Newspaper Combat, 1944–1947* (Hanover: Wesleyan University Press, 1991), 121.

38. Kuo and Graeber, "Another World," 271.

39. Camus, *Between Hell and Reason*, 120.

40. Camus, *Resistance, Rebellion, and Death* (New York: Alfred A. Knopf Inc., 1960), 199. Cited in Montoya, *Premeditated*.

41. Montoya, "Objectives," unpublished document.

42. Charles R. Loving, "Introduction," in *Premeditated: Meditations on Capital Punishment* (Notre Dame: Institute for Latino Studies, University of Notre Dame, 2004), 3.

43. Herbert Read, "Foreword," in *The Revolt*, by Albert Camus (New York: Knopf, 1954), np.

44. Robert Henkes, *Latin American Women Artists of the United States: The Works of 33 Twentieth-Century Women* (Jefferson, NC: McFarland and Company, 1999), 33.

45. María Herrera-Sobek, ed., *Santa Barraza, Artist of the Borderlands* (College Station: Texas A&M Press, 2001), 89.

46. Santa Barraza, "Santa Barraza: An Autobiography," in *Santa Barraza, Artist of the Borderlands*, ed. María Herrera-Sobek (College Station: Texas A&M Press, 2001), 28.

47. Barraza, "Santa Barraza," 35.

48. Barraza, "Santa Barraza," 35.

49. Barraza, "Santa Barraza," 36.

50. Barraza, "Santa Barraza," 36.

51. Barraza, "Santa Barraza."

Notes to Pages 162–171 • 239

52. Barraza, "Santa Barraza," 39.

53. Constance Cortéz, "Aztlán in Tejás: Chicano/a Art from the Third Coast," in *Chicano Visions: American Painters on the Verge*, ed. Cheech Marín (New York: Bulfinch, 2002), 34.

54. Goldman, "'When the Earth(ly) Saints Come Marching In': The Life and Art of Santa Barraza," in *Santa Barraza, Artist of the Borderlands*, ed. María Herrera-Sobek (College Station: Texas A&M, 2001), 52.

55. 1992 citation quoted in Herrera-Sobek, *Santa Barraza*, 51.

56. Laura E. Pérez, *Chicana Art: The Politics of Spiritual and Aesthetic Altarities* (Durham, NC: Duke University Press, 2007), 108.

57. Cortéz, "Aztlán in Tejás, 42.

58. Andrea Smith, "Queer Theory and Native Studies: The Heteronormativity of Settler Colonialism," *GLQ* 16, nos. 1–2 (2010): 54.

59. Pérez-Torres, *Mestizaje*, 146.

60. Fregoso and Chabram, "Chicana/o Cultural Representations: Reframing Alternative Critical Discourses," *Cultural Studies* 4, no. 3 (1990): 206.

61. Cherríe Moraga, "Queer Aztlán: The Re-formation of Chicano Tribe," in *Re-Emerging Native Women of the Americas: Native Chicana Latina Women's Studies*, ed. Yolanda Broyles-González (Dubuque, IA: Kendall/Hunt, 2001), 236–53.

62. Moraga, "Queer Aztlán."

63. Artists Irene Pérez and Celia Rodriguez both do something similar within their visual work. Pérez has reconstructed Coyoxauhqui, while Rodriguez helps La Lorona find her lost children. Both of these projects go beyond simple artistic expression and serve as ways to heal deeply rooted psychic wounds.

64. Gabriel S. Estrada, "An Aztec Two-Spirited Cosmology: Re-sounding Nahuatl Masculinities, Elders, Femininities, and Youth," *Frontiers* 24, nos. 2–3 (2003): 10–14.

65. Estrada, "An Aztec Two-Spirited Cosmology," 12.

66. Gloria Anzaldúa, "now let us shift . . . the path of conocimiento . . . inner work, public action," in *This Bridge We Call Home: Radical Visions for Transformation*, ed. Gloria Anzaldúa and A. Keating (New York: Routledge, 2002), 542.

67. Anzaldúa, "now let us shift," 542.

68. Anzaldúa, "now let us shift," 548.

69. Gloria Anzaldúa, "Chicana Artists: Exploring Nepantla, El Lugar de la Frontera," *NACLA: Report on the Americas* 26, no. 1 (1993): 39

70. Barraza, "Santa Barraza," 48.

71. Barraza, "Santa Barraza," 48.

Chapter 6

1. Some of the ideas in this chapter were developed for a pamphlet commemorating the one hundredth anniversary of the Industrial Workers of the World. The pamphlet accompanied a touring exhibition of Cortéz Koyokuikatl's and my artwork. The exhibition was organized by Prof. Paul Buhle, Senior Lecturer Emeritus at Brown University. This work also appears in a revised version in *Comparative Indigeneities of the Americas: Toward a Hemispheric Approach*, ed. M. Bianet Castellanos, Lourdes Gutiérrez Nájera, and Arturo J. Aldama (Tucson: University of Arizona Press, 2012).

240 • Notes to Pages 171–182

2. Carlos Cortéz, *Organise! For Class Struggle Anarchism* 43 (Summer 1996), 61.

3. See Carlos Cortéz [Koyokuikatl], "El Machetazo," *ABRAZO* 1, no. 1 (1976): 25; and Montoya and Salkowitz-Montoya, "A Critical Perspective," 5.

4. Carlos Cortéz [Koyokuikatl], "El Machetazo," *ABRAZO* 1, no. 1 (1976): 25.

5. The poster for the exhibition at Harry S. Truman College calls the exhibition "a celebration of our indigenous spirit," while the Uptown People's Community Center poster affirms that the exhibition is "una celebración artística de nuestra heréncia indígena."

6. Carlos Cortéz, *De Kansas a Califas* (Chicago: MARCh/Abrazo, 1992), 47–48.

7. Personal conversations with Carlos Cortéz Koyokuikatl, 1998–2004.

8. Jack Forbes, *Handbook of Native American Studies and Native American Chronology* (Davis: University of California, Tecumseh Center, 1971), 13.

9. Lefebvre, *The Production of Space.*

10. Patrick R. LeBeau, *Rethinking Michigan Indian History* (East Lansing: Michigan State University Press, 2005), 198.

11. Recently, with Don Lyons and Ahz Teeple, I co-coordinated an urban Anishinaabeg oral history project. In this capacity, it became clear how interconnected the histories of Xicanos and Anishinaabe are in the state of Michigan. Although outside the scope of this project, the shared history of Red and Brown people in the Great Lakes needs to be further explored.

12. Ted Jojola, "Notes on Identity, Time, Space, and Place," *American Indian Thought*, ed. Anne Waters (New York: Blackwell, 2004), 90–91.

13. Carlos Cortéz, *Crystal-Gazing the Amber Fluid and Other Wobbly Poems* (Chicago: Charles H. Kerr, 1997), 42–43.

14. *Diccionario de Uso del Español de América* is available online at www. diccionarios.com (accessed May 1, 2010); my translation.

15. Fanon, *The Wretched of the Earth*, 221.

16. Fanon, *The Wretched of the Earth*, 209.

17. Fanon, *The Wretched of the Earth*, 210.

18. Fanon, *The Wretched of the Earth*, 212.

19. The podcast is available for download from the Xicano Development Center (xicanocenter.org).

20. Unlike the four previously discussed artists, whom I know only through extended artistic, academic, and activist networks, I have developed a strong working relationship with Rodríguez, collaborating with her on multiple projects, inviting her for a residency at Michigan State University, and participating with her as faculty in a summer institute for Indigenous artists, as well as both being members of the artists' collective Justseeds (in which both Cervantes and Barraza also participate).

I inform you of my relationship to Rodríguez, as well as to Cervantes and Barraza, because I believe that through these experiences with them I have come to know their work in an intimate and compelling way that allows me a particular reading of the work grounded both in critical theory and in our collaborative experiences.

21. Leslie Marmon Silko, *Almanac of the Dead* (New York: Penguin, 1992).

22. Sofía Quintero, "Favianna Rodríguez: Murals for the Masses," *Fuego* (Summer 2005): 46.

23. In fact, alongside Jesús Barraza, one-half of Dignidad Rebelde, Rodríguez designed Martínez's recent publication, demonstrating not only her commitment to

structural change at the grassroots level, but also to the ways in which she is adamant that mujeres are properly documented in Xicano history.

24. Lipsitz, "Not Just Another Social Movement," 73.

25. Max Benavidez, "The Post-Chicano Aesthetic: Making Sense of the Art World," in *Post-Chicano Generation in Art: Breaking Boundaries* (Phoenix: MARS Artspace, 1990).

26. Nancy Marie Mithlo, "No Word for Art in Our Language? Old Questions, New Paradigms," *Wicazo Sa Review* 25 (2012): 118.

27. http://www.favianna.com/port_prints/prints8.php (accessed May 1, 2010).

28. Patricia Penn Hilden, "How the Border Lies: Some Historical Reflections," in *Decolonial Voices: Chicana and Chicano Cultural Studies in the 21st Century*, ed. Arturo J. Aldama and Naomi H. Quiñonez (Bloomington: University of Indiana Press, 2002).

29. Scott Lauria Morgensen, "Unsettling Queer Politics: What Can Non-Natives Learn from Two-Spirit Organizing?" in *Queer Indigenous Studies: Critical Interventions in Theory, Politics, and Literature*, ed. Qwo-li Driskill, Chris Finley, Brian Joseph Gilley, and Scott Lauria Morgensen (Tucson: University of Arizona Press, 2011), 141.

30. Smith, "Queer Theory and Native Studies," 57.

31. Smith, "Queer Theory and Native Studies," 54.

32. Anthony Griffiths, *Prints and Printmaking: An Introduction to the History and Techniques* (Berkeley: University of California Press, 1996), 16.

33. Cited in Deborah Caplow, *Leopoldo Méndez: Revolutionary Art and the Mexican Print* (Austin: University of Texas Press, 2007), 127.

34. Enrique Salmón, *Eating the Landscape: American Indian Stories of Food, Identity, and Resilience* (Tucson: University of Arizona Press, 2012), 8.

35. Vandana Shiva, *The Violence of the Green Revolution: Third World Agriculture, Ecology, and Politics* (London: Zed Books, 1992). Also see, Vandana Shiva, "Women's Indigenous Knowledge and Biodiversity Conservation," in *Ecofeminism*, ed. Maria Mies and Vandana Shiva (London: Zed Books 1993).

36. Gustavo Esteva, "Introduction," in *Sin maíz no hay país*, ed. Gustavo Esteva and Catherine Mareille (Mexico City: Consejo Nacional para la Cultura y las Artes, 2003), 11.

37. Dennis Wall and Virgil Masayesva, "People of the Corn: Teachings in Hopi Traditional Agriculture, Spirituality, and Sustainability," *The American Indian Quarterly* 28, nos. 3–4 (2004): 436.

38. Wall and Masayesva, "People of the Corn," 436.

39. The reality of this statement rang true for me during the summer of 2008, while teaching a study-abroad course on art and Indigenous activism in Oaxaca, Mexico. Alongside another faculty member, I traveled to Oaxaca with a group of two dozen incoming university freshmen, a task that alone would scare any sane professor. The course on art and activism was properly situated in Oaxaca, as the 2006–2007 confrontation between teachers and the state had only recently subsided. In fact, while the university would not allow trips to either Juárez or Mexico City, both Oaxaca and Chiapas, sites of ongoing Native repression and resistance, were welcome locations for study abroad.

With this university's approval, I traveled to Oaxaca de Juárez to work with local artists and artisans. One evening, while hanging out in the *xócalo*, surrounded by the repressive police state that was still actively patrolling dissident activity, I decided to eat an *elote* (roasted corn), while watching the local entertainment and enjoying the activities in

the plaza. What happened next shocked me more than the omnipotence of the Ruíz government and the presence of the police state. When I bit into my corn, I was amazed at the texture, flavor, and kernel size, unlike any corn I had previously eaten in Mexico.

This juicy, hypersweet corn I was eating, nothing like the elotes I knew from Mexico—the large-kernelled, mealy elotes of Mesoamerica—tasted oddly like the sweetcorn varieties I had enjoyed as a child growing up in Michigan. Having eaten enough Michigan and Indiana sweet corn to know their particular taste, I remain convinced that there, in the location where *maíz criollo* (heirloom corn) is still a vibrant crop, the realities of U.S. corn and ethanol subsidies made it cheaper for vendors to import U.S.-grown corn from the Heartland than to purchase heirloom varieties grown locally.

This was, after all, at a time of intense corn inflation in Mexico, with countless citizens unable to purchase even the most basic foodstuffs, mainly tortillas. As I finished my chile-coated elote, I thought about the work of artists in Oaxaca, much like Rodríguez, whose work is committed to combating the ever-encroaching capitalist model of food production.

40. Salmón, *Eating the Landscape*, 17.

41. Artists' statement supplied by Dignidad Rebelde, June 15, 2010.

42. Artists' statement supplied by Dignidad Rebelde, June 15, 2010.

43. David Halperin, *Saint Foucault: Towards a Gay Hagiography* (New York: Oxford University Press, 1997), 62.

44. Archibald, *Indigenous Storywork*, 3.

45. Howard N. Fox, "Theater of the Inauthentic," in *Phantom Sighting: Art After the Chicano Movement*, ed. Chon Noriega, Rita González and Howard N. Fox (Berkeley: University of California Press, 2008), 76.

46. Espinosa, "Revolutionary Sisters," 27–28.

47. Clandestine Revolutionary Indigenous Committee cited in Luis Hernández Navarro, *Zapatismo Today and Tomorrow* (Interhemispheric Resource Center), http://www.organicconsumers.org/chiapas/zapatismo.cfm (accessed May 1, 2010).

48. R. Aída Hernández Castillo, "Zapatismo and the Emergence of Indigenous Feminism," *NACLA: Report on the Americas* 35, no. 6 (2002): 39.

49. Melanie Cervantes as posted on DignidadRebelde.com (accessed May 1, 2010).

50. John Holloway, *Change the World Without Taking Power: The Meaning of Revolution Today* (Ann Arbor, MI: Pluto, 2002).

51. Robert Warrior, "Native Critics in the World: Edward Said and Nationalism," in *American Indian Literary Nationalism*, ed. Craig Womack, Robert Warrior, and Jace Weaver (Albuquerque: University of New Mexico Press, 2006), 218.

52. *SNAG* magazine, 2009. The youth presented their experiences, alongside a video presentation with their peers in Palestine, in a moving and heartfelt panel at the 2010 Allied Media Conference in Detroit.

53. This commonly occurs in the study of Xicano, Native, and Black artists in the United States. The artwork, which stands in for the artist, signifies the common experiences of that "community."

Postscript

1. Roberto Hernández, "Running for Peace and Dignity: From Traditionally Radical Chicanas/os to Radically Traditional Xicanas/os," in *Latin@s in the World-System:*

Decolonization in the Twenty-First Century U.S. Empire, ed. Ramón Grosfugel, Nelson Maldonado-Torrez, and José David Saldivár (Boulder, CO: Paradigm Publishers, 2005), 123.

2. Hernández, "Running for Peace and Dignity."

3. Laura E. Pérez, *Chicana Art: The Politics of Spiritual and Aesthetic Altarities* (Durham, NC: Duke University Press, 2007), 4.

4. Jack Forbes, Carl N. Horman, Kenneth R. Martin, and David Risling, "Selections from the Brief Proposal for Deganawidah-Quetzalcoatl University" (Davis: University of California Press, 1970), 46.

5. Forbes, "Selections from the Brief Proposal," 13.

6. Jack Forbes, *Aztecas del Norte: The Chicanos of Aztlán* (New York: Fawcett, 1973), 170.

7. Reginald Horsman, *Race and Manifest Destiny: The Origins of American Racial Anglo-Saxonism* (Cambridge, MA: Harvard University Press, 1981).

8. Pérez-Torres, *Mestizaje,* 54.

9. Pérez-Torres, *Mestizaje,* 54.

10. Antonio Cornejo Polar, "Mestizaje and Hybridity: The Risks of Metaphors— Notes," in *The Latin American Cultural Studies Reader,* ed. Ana del Sarto, Alicia Ríos, and Abril Trigo (Durham, NC: Duke University Press, 2004), 761.

11. Cornejo Polar, "Mestizaje and Hybridity," 760.

12. Maria Josefina Saldaña-Portillo, *The Revolutionary Imagination in Latin America and the Age of Development* (Durham, NC: Duke University Press, 2003), 279.

13. Forbes, *Aztecas del Norte.*

14. Jonathan Friedman, "Culture and Global Systems," *Theory, Culture & Society* 23, nos. 2–3 (2008): 404.

15. Lipsitz, "Not Just Another Social Movement," 79.

16. Anzaldúa, *Borderlands/La Frontera,* 23.

17. Anzaldúa, *Borderlands/La Frontera,* 25.

18. Anzaldúa, *Borderlands/La Frontera,* 27.

19. While indigenismo held a particular place within Mexican national identity, indigenism has developed a new and very distinct application as used by figures as diverse as Ward Churchill and Ronald Niezen.

20. Saldaña-Portillo, *The Revolutionary Imagination,* 282.

21. Sheila Marie Contreras, *Blood Lines: Myth, Indigenism, and Chicana/o Literature* (Austin: University of Texas Press, 2009).

22. Latorre, *Walls of Empowerment,* 2.

23. Contreras, *Blood Lines,* 27.

24. Forbes, *Africans and Native Americans,* 270.

Works Cited

Adams, Howard. *Prison of Grass: Canada from a Native Point of View.* Toronto: General, 1975.

———. *Tortured People: The Politics of Colonization.* Revised edition. Penicton, BC: Theytus, 1999.

Adorno, Theodor. *Aesthetic Theory.* London: Routledge and Kegan Paul, 1984 [1970].

AIM documents. American Radicalism Collection, Michigan State University.

Alarcón, Daniel C. *The Aztec Palimpsest: Mexico in the Modern Imagination.* Tucson: University of Arizona Press, 1997.

Alfred, Gerald R. (Taiaiake). *Heeding the Voices of Our Ancestors: Kahnawake Mohawk Politics and the Rise of Native Nationalism.* Toronto: Oxford University Press, 1995.

Alfred, Taiaiake. *Peace, Power, and Righteousness: An Indigenous Manifesto.* New York: Oxford University Press, 1999.

———. *Wasáse: Indigenous Pathways of Action and Freedom.* Peterborough, ON: Broadview, 2005.

Alfred, Taiaiake, and Jeff Corntassel. "Being Indigenous: Resurgences against Contemporary Colonialism." *Government and Opposition* 40, no. 4 (Autumn 2005): 597–614.

Almaraz, Carlos. "The Artist as Revolutionary." *Chisméarte* 1, no. 1 (1976): 47–55.

Alurista. "Aztlán: Myth or Reality." Alurista Papers, Benson Latin American Collection, University of Texas, 1971.

———. "Cultural Nationalism and Xicano Literature during the Decade of 1965–1975." *MELUS* 8, no. 2 (Summer 1981): 22–34.

———. *Nationchild Plumaroja.* San Diego, CA: Toltecas en Aztlán, 1972.

Alvarado, Rudolph V., and Sonya Y. Alvarado. *Mexicans and Mexican Americans in Michigan.* East Lansing: Michigan State University Press, 2003.

Anaya, Rudolfo. "Aztlán." In *The Anaya Reader.* New York: Warner Books, 1995.

Anaya, Rudolfo A., and Francisco Lomelí, eds. *Aztlán: Essays on the Chicano Homeland.* Albuquerque: University of New Mexico Press, 1991.

Anderson, Benedict. *Imagined Communities: Reflections on the Origins and Spread of Nationalism.* Revised and extended edition. London: Verso, 1991.

Andrews, Malcolm. *Landscape and Western Art.* Oxford: Oxford University Press, 1999.

Anonymous. "Five Styles of Chicano Art." *El Grito* 6, no. 1 (1972): 88–92.

246 • Works Cited

Anonymous. "Statement of the Revolutionary Caucus at Denver's Chicano Youth Liberation Conference." *El Pocho Ché* 1, no. 1 (July 1969): np.

Anzaldúa, Gloria. *Borderlands/La Frontera: The New Mestiza*. San Francisco: Aunt Lute, 1987.

———. "Chicana Artists: Exploring Nepantla, El Lugar de la Frontera." *NACLA: Report on the Americas* 26, no. 1 (1993): 37–45.

———. "now let us shift . . . the path of conocimiento . . . inner work, public action." In *This Bridge We Call Home: Radical Visions for Transformation*, edited by Gloria Anzaldúa and A. Keating. New York: Routledge, 2002.

Archibald, Jo-ann. *Indigenous Storywork: Educating the Heart, Mind, Body, and Spirit.* Vancouver: University of British Columbia Press, 2008.

Arrellano, Amber. "Artist's Healing Spirit: Self-Taught Painter Blossoms to Aid Hispanics in Area." *Detroit Free Press* (September 22, 2000).

Arrizón, Alicia. "Mythical Performativity: Relocating Aztlán in Chicana Feminist Cultural Productions." *Theatre Journal* 52 (2000): 23–49.

Bailey, Gauvin A. *Art of Colonial Latin America*. London: Phaidon, 2005.

Bakhtin, Mikhail. *The Dialogic Imagination: Four Essays*, edited by Michael Holquist, translated by Caryl Emerson and Michael Holquist. Austin: University of Texas Press, 1981.

Barabas, Alicia M. *Utopías Indias: Movimientos Sociorreligiosos en México*. Second edition. Mexico City: Instituto Nacional de Anthropología e Historia (INAH), 2002.

Barell, John. *The Dark Side of the Landscape*. Cambridge: Cambridge University Press, 1980.

Barnard, Malcolm. *Approaches to Understanding Visual Culture*. New York: Palgrave, 2001.

Barnet, Alan W. *Community Murals: The People's Art*. Philadelphia: Art Alliance Press, 1984.

Barnet-Sánchez, Holly. "Where are the Chicana Printmakers?" In *¿Just Another Poster?: Chicano Graphic Arts in California*. Edited by Chon Noriega. Seattle: University of Washington Press, 2001.

Barraza, Santa. "Santa Barraza: An Autobiography." In *Santa Barraza, Artist of the Borderlands*, edited by María Herrera-Sobek. College Station: Texas A&M Press, 2001.

Barrera, Mario. *Beyond Aztlán: Ethnic Autonomy in Comparative Perspective*. New York: Praeger, 1988.

Batalla, Guillermo Bonfil, *México Profundo: Reclaiming a Civilization*. Austin: University of Texas Press, 1996.

Baudot, Georges. "Amerindian Image and Utopian Project: Motolinía and Millenarian Discourse." Translated by Donna Buhl LeGrand. In *Amerindian Images and The Legacy of Columbus*, edited by René Jara and Nicholas Spadaccini, 375–400. Minneapolis: University of Minnesota Press, 1992.

———. *Utopie et histoire en Mexique* [*Utopia and History in Mexico*]. Translated by Bernard R. Ortiz de Montellano and Thelma Ortiz de Montellano. Niwot: University Press of Colorado, 1995 [1977].

Baudrillard, Jean. *Utopia Deferred*. New York: Semiotext(e), 2006.

Baxandall, Michael. *Patterns of Intention: On the Historical Explanation of Pictures*. New Haven: Yale University Press, 1985.

Works Cited • 247

Beardsley, John, and Jane Livingston, eds. *Hispanic Arts of the United States: Thirty Contemporary Painters and Sculptors*. Houston: Museum of Fine Arts, 1987.

Benavidez, Max. "The Post-Chicano Aesthetic: Making Sense of the Art World." In *Post-Chicano Generation in Art: Breaking Boundaries*. Phoenix: MARS Artspace, 1990.

Benjamin, Walter. "Das Kunstwerk im Zeitalter seiner technischen Reproduzierbarkeit." In *Illuminations*. New York: Harcourt, Brace, Jovanovich, 1968.

Berger, John. *Ways of Seeing*. New York: Penguin, 1977.

Berman, Marshall. *All that is Solid Melts into Air: The Experience of Modernity*. New York: Penguin, 1988.

Bhabha, Homi. *The Location of Culture*. New York: Routledge, 1994.

Bingaman, Amy, Lise Sanders, and Rebecca Zorach. *Embodied Utopias: Gender, Social Change and the Modern Metropolis*. New York: Routledge, 2002.

Blaeser, Kimberly M. *Gerald Vizenor: Writing in the Oral Tradition*. Norman: University of Oklahoma Press, 2012.

Bloch, Ernst. *El principio esperanza*. Madrid: Aguilar, 1980.

Boiton, Santiago, and Susan Stechnij. "Editorial." *ABRAZO* 1, no. 1 (1976): 4.

Bonfil Batalla, Guillermo. *México Profundo: Reclaiming a Civilization*. Austin: University of Texas Press, 1996.

Boone, Elizabeth Hill. "Migration Histories as Ritual Performance." In *To Change Place: Aztec Ceremonial Landscapes*, edited by Davíd Carrasco, 121–52. Niwot: University Press of Colorado, 1991.

———. *Stories in Red and Black: Pictorial Histories of the Aztecs and Mixtecs*. Austin: University of Texas Press, 2000.

Boone, Elizabeth Hill, and Walter Mignolo, eds. *Writing Without Words: Alternative Literacies in Mesoamerica and the Andes*. Durham, NC: Duke University Press, 1994.

Brady, Mary P. *Extinct Lands, Temporal Geographies: Chicana Literature and the Urgency of Space*. Durham, NC: Duke University Press, 2002.

Brooks, Lisa. "Afterword." In *American Indian Literary Nationalism*, edited by Jace Weaver, Craig Womack, and Robert Warrior. Lincoln: University of Nebraska Press, 2008.

Brotherton, Gordon. *Painted Books from Mexico: Codices in UK Collections and the World They Represent*. London: British Museum, 1995.

Broyles-González, Yolanda. *Lydia Mendoza's Life in Music: La historia de Lydia Mendoza*. Oxford: Oxford University Press, 2003.

Buck-Morss, Susan. *Dreamworld and Catastrophe: The Passing of Mass Utopia in East and West*. Cambridge, MA: MIT Press, 2000.

Bufe, Chaz, and Mitchell Cowen Verter, eds. *Dreams of Freedom: A Ricardo Flores Magón Reader*. San Francisco: AK Press, 2005.

Camus, Albert. *Between Hell and Reason: Essays from the Resistance Newspaper Combat, 1944–1947*. Hanover: Wesleyan University Press, 1991.

———. *Resistance, Rebellion, and Death*. New York: Alfred A. Knopf Inc., 1960.

———. *The Revolt*. New York: Alfred A. Knopf Inc., 1954.

Caplow, Deborah. *Leopoldo Méndez: Revolutionary Art and the Mexican Print*. Austin: University of Texas Press, 2007.

248 • Works Cited

CARA Executive Committee. "Preface: The CARA Exhibition." In *Chicano Art: Resistance and Affirmation, 1965–1985*, catalogue. Los Angeles: Wight Art Gallery, University of California, 1991.

Cardenas, Gilbert. "*Los Desarraigados*: Chicanos in the Midwestern Region of the United States." *Aztlán: A Journal of Chicano Studies* 7 , no. 2 (1976): 153–86.

Carlos Cortéz Koyokuikatl: Soapbox Artist and Poet. Chicago: Mexican Fine Arts Center Museum, 2001.

Carrigan, William D., and Clive Webb. "The Lynchings of Persons of Mexican Origin or Descent in the United States, 1848 to 1928." *Journal of Social History* 37, no.2 (Winter 2003): 411–38.

Castellanos, M. Bianet, Lourdes Gutiérrez Nájera, and Arturo J. Aldama. *Comparative Indigeneities of the Americas: Toward a Hemispheric Approach.* Tucson: University of Arizona Press, 2012.

Certeau, Michel de. *The Practice of Everyday Life.* Translated by Steven Rendell. Berkeley: University of California Press, 1984.

Chanan, Michael. *The Cuban Image: Cinema and Cultural Politics in Cuba.* London: British Film Institute, 1986.

Cheyfitz, Eric. "What is a Just Society? Native American Philosophies and the Limits of Capitalism's Imagination: A Brief Manifesto." *South Atlantic Quarterly* 110, no. 2 (Spring 2011): 291–307.

Chicano Coordinating Council on Higher Education. *El Plan de Santa Barbara: A Chicano Plan for Higher Education.* Oakland: La Causa, 1969.

Churchill, Ward. "I am Indigenist." *From a Native Son: Selected Essays on Indigenism, 1985–1995.* Cambridge, MA: South End Press.

———. *Struggle for the Land: Indigenous Resistance to Genocide, Ecocide, and Expropriation in Contemporary North America.* Monroe, ME: Common Courage, 1993.

Conquergood, Dwight. "Performance Studies: Interventions and Radical Research." *TDR* 46, no. 2 (2002): 149–56.

Contreras, Sheila Marie. *Blood Lines: Myth, Indigenism, and Chicana/o Literature.* Austin: University of Texas Press, 2008.

Cordova, Rubén, ed. *¡Arte Caliente!: Selections from the Joe A. Díaz Collection.* Corpus Christi: South Texas Institute for the Arts, 2004.

Cornejo Polár, Antonio. "Mestizaje and Hybridity: The Risks of Metaphors—Notes." In *The Latin American Cultural Studies Reader*, edited by Ana del Sarto, Alicia Ríos, and Abril Trigo. Durham, NC: Duke University Press, 2004.

Corntassell, Jeff B. "An Activist Posing as an Academic?" *American Indian Quarterly* 27, nos. 1 and 2 (Winter and Spring 2003): 160–71.

Cortéz, Carlos. *Crystal-Gazing the Amber Fluid and Other Wobbly Poems.* Chicago: Charles H. Kerr, 1997.

———. *De Kansas a Califas.* MARCh/Abrazo: Chicago, 1992.

———. "El Machetazo." *ABRAZO* 1, no.1 (1976): 25.

———. *Organise! For Class Struggle Anarchism* 43 (Summer 1996).

Cortéz, Constance. "Aztlán in Tejás: Chicano/a Art from the Third Coast." In *Chicano Visions: American Painters on the Verge*, edited by Cheech Marín. New York: Bulfinch, 2002.

Coulthard, Glen. "Subjects of Empire: Indigenous Peoples and the 'Politics of Recognition' in Canada." *Contemporary Political Theory* 6, no. 4 (2007): 437–60.

Works Cited • 249

Craib, Raymond B. "A Nationalist Metaphysics: State Fixations, National Maps, and the Geo-Historical Imagination in Nineteenth-Century Mexico." *Hispanic American Historical Review* 82, no. 1 (2002): 34–68.

Craven, David. *Art and Revolution in Latin America, 1910–1990*. New Haven: Yale University Press, 2002.

———. "C. L. R. James as a Critical Theorist of Modernist Art." In *Cosmopolitan Modernisms*, edited by Kobena Mercer. Cambridge, MA: MIT Press, 2005.

———. "Marxism and Critical Art History." In *A Companion to Art Theory*, edited by Paul Smith and Carolyn Wilde. Oxford: Blackwell, 2002.

———. "Meyer Shapiro." In *Key Writers on Art: The Twentieth Century*, edited by Chris Murray. London and New York: Routledge, 2003.

Cushing, Lincoln. *Revolución!: Cuban Poster Art*. San Francisco: Chronicle Books, 2003.

Dávalos, Karen Mary. *Exhibiting Mestizaje: Mexican (American) Museums in the Diaspora*. Albuquerque: University of New Mexico Press, 2001.

Deleuze, Gilles, and Félix Guattari. *Capitalisme et Schizophrénie 2: Mille Plateaux*. Paris: Les Éditions de Minuit, 1980.

Dennison, Thomas Stewart. *The Primitive Aryans of America: Origin of the Aztecs and Kindred Tribes, Showing Their Relationship to the Indo-Iranians and the Place of the Nahuatl or Mexican in the Aryan Group of Languages*. Chicago: T. S. Dennison, 1908.

Downs, Linda B. *The Detroit Industry Frescoes*. Detroit: Detroit Institute of Arts, 1994.

Driskill, Qwo-li, Chris Finley, Brian Joseph Gilley, and Scott Lauria Morgensen, eds. *Queer Indigenous Studies: Critical Interventions in Theory, Politics, and Literature*. Tucson: University of Arizona Press, 2011.

Durán, Fray Diego. *History of the Indies of New Spain*. Norman: University of Oklahoma Press, 1994 [1588].

Durón, Armando. "Chicano Visions: American Painters on the Verge." *Aztlán: A Journal of Chicano Studies* 29, no.2 (2004): 233–37.

Duverger, Christian. *El origen de los aztecas*. Mexico City: Editorial Grijalbo, 1987.

Eagleton, Terry. *After Theory*. New York: Basic Books, 2003.

Elkins, James. *Stories of Art*. New York: Routledge, 2002.

Equipo Editorial. Introduction to "A Critical Perspective on the State of Chicano Art." *Metamorfosis* 1, no. 1 (1980): 4.

Espinosa, Dionne. "'Revolutionary Sisters': Women's Solidarity and Collective Identification among Chicana Brown Berets in East Los Angeles, 1967–1970." *Aztlán* 26, no. 1 (Spring 2001): 17–59.

Esteva, Gustavo, and Catherine Mareille, eds. *Sin maíz no hay país*. Mexico City: Consejo Nacional para la Cultura y las Artes, 2003.

Estrada, Gabriel S. "An Aztec Two-Spirited Cosmology: Re-sounding Nahuatl Masculinities, Elders, Femininities, and Youth." *Frontiers* 24, nos. 2 and 3 (2003): 10–14.

Fanon, Frantz. *The Wretched of the Earth*. New York: Grove, 1963 [1961].

Fernández, Justino. *Arte mexicano, de sus orígenes a nuestros días*. Mexico City: Porrua, 1968.

Ferriss, Susan, and Ricardo Sandovál. *The Fight in the Fields: César Chávez and the Farmworkers Movement*. New York: Harcourt Brace, 1997.

Flores, William V., and Rina Benmayor, eds. *Latino Cultural Citizenship: Claiming Identity, Space, and Rights*. Boston: Beacon, 1997.

Florescano, Enrique. "Mito e historia en la memoria nahua." *Historia mexicana* 39, no. 3 (1990): 607–61.

250 • *Works Cited*

Foner, Philip S., ed. *The Black Panthers Speak*. Philadelphia: J. B. Lippincott, 1970.

Forbes, Jack. *Africans and Native Americans: The Language of Race and the Evolution of Red-Black Peoples*. Champaign-Urbana: University of Illinois Press, 1993; previously published as *Black Africans and Native Americans*, 1988.

———. *Aztecas del Norte: The Chicanos of Aztlán*. New York: Fawcett, 1973.

———. "DQU Rebel Takeover Group at DQU Now Being Picketed." December 2005. http://www.learningace.com/doc/5580532/bbedf4dfa94f37b48a6ea52d9354ade2/dqu-rebel-takeover-group-at-dqu-now-being-picketed. Accessed March 31, 2014.

———. *Handbook of Native American Studies and Native American Chronology*. Davis: University of California, Tecumseh Center, 1971.

Forbes, Jack, Carl N. Horman, Kenneth R. Martin, and David Risling, eds. "Selections from the Brief Proposal for Deganawidah-Quetzalcoatl University." Davis: University of California, 1970.

Foucault, Michel. "Des espaces autres." *Architecture | Mouvement | Continuité* 5 (October 1984 [1967]): 46–49.

Fox, Howard N. "Theater of the Inauthentic." In *Phantom Sighting: Art After the Chicano Movement*, edited by Chon Noriega, Rita González, and Howard N. Fox. Berkeley: University of California Press, 2008.

Fregoso, Rosa Linda, and Angie Chabram. "Chicana/o Cultural Representations: Reframing Alternative Critical Discourses." *Cultural Studies* 4, no. 3 (October 1990): 206.

Friedman, Jonathan. "Culture and Global Systems." *Theory, Culture & Society* 23, nos. 2–3 (2008): 404–6.

Frutos, Réne H. Arceo. "Introduction." In *The Barrio Murals / Murales del Barrio Catalogue*. Chicago: Mexican Fine Arts Center Museum, 1987.

Gallo, Rubén. *New Tendencies in Mexican Art*. New York: Palgrave MacMillan, 2004.

Galván, Roberto. *The Dictionary of Chicano Spanish/ El Diccionario del Español Chicano*. Lincolnwood, IL: National Textbook Company, 1995.

Gamboa, Harry. "In the City of Angels, Chameleons, and Phantoms: Asco, a Case Study of Chicano Art in Urban Tones (or Asco was a Four-Member Word)." In *CARA: Chicano Art Resistance and Affirmation*. Los Angeles: Wight Art Gallery, 1995.

García, Alma M., ed. *Chicana Feminist Thought: The Basic Historical Writings*. New York: Routledge, 1997.

García, Ignacio M. *Chicanismo: The Forging of a Militant Ethos*. Tucson: University of Arizona Press, 1997.

García, Mario. *Mexican Americans: Leadership, Ideology, and Identity, 1930–1960*. New Haven: Yale University Press, 1989.

García-Camarillo, Cecilio, Roberto Rodríguez, and Patrisia Gonzales, eds. *Canto al Sexto Sol: An Anthology of Aztlanahuac Writing*. San Antonio: Wings Press, 2002.

García Canclini, Néstor. *Culturas híbridas: Estrategias para entrar y salir de la modernidad*. Mexico City: Grijalbo, 1990.

Garret, W. E. "Mexico's Little Venice." *National Geographic* 133, no. 6 (1968): 876–88.

Gaspar de Alba, Alicia. "Mi Casa [No] es Su Casa: The Cultural Politics of the Chicano Art Resistance and Affirmation, 1965–1985 Exhibition." PhD diss, University of New Mexico, 1994.

———. *Chicano Art Inside/Outside the Master's House*. Albuquerque: University of New Mexico Press, 1998.

Works Cited • 251

———. "From CARA to CACA: The Multiple Anatomies of Chicano/a Art at the Turn of the New Century." *Aztlán* 26, no. 1 (2001): 205–31.

———. "There's No Place Like Aztlán: Embodied Aesthetics in Chicana Art." *CR: New Centennial Review* (2004): 103–40.

Geertz, Clifford. *The Interpretation of Cultures*. New York: Basic Books, 1973.

Goeman, Mishuana. "From Place to Territories and Back Again: Centering Storied Land in the Discussion of Indigenous Nation-building." *International Journal of Critical Indigenous Studies* 1, no. 1 (2008): 23–24.

Goldman, Shifra. "A Public Voice: Fifteen Years of Chicano Posters." *Art Journal* 44, no. 1 (1984): 50–57.

———. *Contemporary Mexican Painting in a Time of Change*. Austin: University of Texas Press, 1979 [reprinted, Albuquerque: University of New Mexico, 1981].

———. "The Iconography of Chicano Self-Determination: Race, Ethnicity, and Class." *Art Journal* 49 (Summer 1990): 167–73.

———. "Mexican Muralism: Its Social-Educative Roles in Latin America and the United States." *Aztlán* 13 (1982): 111–33.

———. "Response: Another Opinion on the State of Chicano Art." *Metamorfosis* 1, no. 2 (1980–1981).

———. "When the Earth(ly) Saints Come Marching In: The Life and Art of Santa Barraza." In *Santa Barraza, Artist of the Borderlands*, edited by María Herrera-Sobek. College Station: Texas A&M, 2001.

Goldman, Shifra, and Tomás Ybarrra-Frausto. *Arte Chicano: A Comprehensive Annotated Bibliography of Chicano Art, 1965–1981*. Berkeley: Chicano Studies Library Publication Series, 1985.

Gonzáles, Jesse. "Michicano/Betabelero." *Voces del Norte: A Chicano/Raza Art and Literary Journal* 2 (1979): 15.

Gonzales, Patrisia. *Red Medicine: Traditional Indigenous Rites of Birthing and Healing*. Tucson: University of Arizona Press, 2012.

González, Rita. "An Undocumented History: A Survey of Index Citations for Latino and Latina Artists." *CSRC Research Report* no. 2 (2003).

———. "Archiving the Latino Arts Before It is Too Late." *Latino Issues and Policy Brief* 6 (April 2003).

Gramsci, Antonio. *Selections from the Prison Notebooks*. New York: International Publishers, 1971.

Griffiths, Anthony. *Prints and Printmaking: An Introduction to the History and Techniques*. Berkeley: University of California Press, 1996.

Grimm, Tracey, and Olga Herrera. "Midwest Latino Arts Documentary Heritage Initiative." Notre Dame, IN: Institute for Latino Studies, University of Notre Dame, 2006.

Griswold del Castillo, Richard, Teresa McKenna, and Yvonne Yarbro-Bejarano, eds. *Chicano Art: Resistance and Affirmation, 1965–1995*. Los Angeles: Wight Art Gallery, 1991.

Griswold del Castillo, Richard, and Arnoldo de León. *North to Aztlán: A History of Mexican Americans in the United States*. New York: Prentice Hall, 1996.

Habell-Palán, Michelle. *Loca Motion: The Travels of Chicana and Latina Popular Culture*. New York: New York University Press, 2005.

Hall, Stuart. "The Local and the Global: Globalization and Ethnicity." In *Culture, Globalization and the World-System: Contemporary Conditions for the Representation*

of Identity, edited by Anthony D. King. Minneapolis: University of Minnesota Press, 1997.

———. "Notes on Deconstructing 'The Popular.'" In *People's History and Socialist Theory*, edited by Raphael Samuel. London: Kegan Paul-Routledge, 1981.

Halperin, David. *Saint Foucault: Towards a Gay Hagiography*. New York: Oxford University Press, 1997.

Halpin, David. "Utopianism and Education: The Legacy of Thomas More." *British Journal of Educational Studies* 49, no. 3 (2001): 299–315.

Hardt, Michael, and Antonio Negri. *Empire*. Cambridge: Harvard University Press, 2000.

Hartmann, George. *Wooed by a Sphinx of Aztlan: The Romance of A Hero of Our Late Spanish-American War and Incidents of Interest from the Life of a Western Pioneer*. Prescott, AZ: Hartmann, 1907.

Hauser, Arnold. *The Philosophy of Art History*. Evanston: Northwestern University Press, 1985.

Hayden, Dolores. *The Power of Place: Urban Landscapes as Public History*. Cambridge, MA: MIT Press, 1995.

Henkes, Robert. *Latin American Women Artists of the United States: The Works of 33 Twentieth-Century Women*. Jefferson, NC: McFarland and Company, 1999.

Hernández, Roberto. "Running for Peace and Dignity: From Traditionally Radical Chicanas/os to Radically Traditional Xicanas/os." In *Latin@s in the World-System: Decolonization in the Twenty-First Century U.S. Empire*, edited by Ramón Grosfugel, Nelson Maldonado-Torrez, and José David Saldivár. Boulder, CO: Paradigm Publishers, 2005.

Hernández Castillo, R. Aída. "Zapatismo and the Emergence of Indigenous Feminism." *NACLA: Report on the Americas* 35 (2002): 6.

Herrera-Sobek, María., ed. *Santa Barraza, Artist of the Borderlands*. College Station: Texas A&M Press, 2001.

Híjar, Alberto. *Arte y Utopía en América Latina*. Mexico City: Instituto Nacional de Bellas Artes, 2000.

Híjar Serrano, Alberto. "The Latin American Left and the Contribution of Diego Rivera to National Liberation." Translated by Dylan A. T. Miner. *Third Text* 19, no. 6 (November 2005): 637–46.

Hinojosa, Rolando. *The Valley*. Ypsilanti: Bilingual Press, 1983.

Holloway, John. *Change the World Without Taking Power: The Meaning of Revolution Today*. Ann Arbor: Pluto, 2002.

Horsman, Reginald. *Race and Manifest Destiny: The Origins of American Racial Anglo-Saxonism*. Cambridge: Harvard University Press, 1981.

Howe, LeAnne. "The Story of America: A Tribalography." In *Clearing a Path: Theorizing the Past in Native American Studies*, edited by Nancy Shoemaker. New York: Routledge, 2002.

———. "Tribalography: The Power of Native Stories." *Journal of Dramatic Theory and Criticism* (Fall 1999): 117–25.

Humphrey, Norman D. "The Migration and Settlement of Detroit Mexicans." *Economic Geography* 19, no. 4 (1943).

Huntington, Samuel. "The Hispanic Challenge." *Foreign Policy*, March/April 2004: 30–45.

Hurlbert, Laurence. *The Mexican Muralists in the United States*. Albuquerque: University of New Mexico Press, 1989.

Jameson, Fredric. "The Politics of Utopia." *New Left Review* 25 (2004): 35–54.

———. *Postmodernism, or the Cultural Logic of Late Capitalism.* Durham: Duke University Press, 1991.

Johnson, Kaytie. *Leaving Aztlán (redux).* Exhibition Announcement, 2006.

Johnston, Basil. "Summer Holidays in Spanish." In *All My Relations: An Anthology of Contemporary Canadian Fiction,* edited by Thomas King, 12–13. Toronto: McClelland and Stewart, 1990.

Jojola, Ted. "Notes on Identity, Time, Space, and Place." In *American Indian Thought,* edited by Anne Waters. New York: Blackwell, 2004.

Kagan, Richard L. *Urban Images of the Hispanic World, 1493–1793.* New Haven: Yale University Press, 2000.

Kaplan, Karen, Norma Alarcón, and Minoo Moallem, eds. *Between Woman and Nation: Nationalisms, Transnational Feminisms, and the State.* Durham, NC: Duke University Press, 1999.

Katzew, Ilona. *Casta Painting: Images of Race in Eighteenth-Century Mexico.* New Haven: Yale University Press, 2005.

Keller, Gary D. *Contemporary Chicana and Chicano Art: Artists, Works, Culture, and Education.* Vol. 1. Tempe, AZ: Bilingual Press, 2002.

———. *Contemporary Chicana and Chicano Art: Artists, Works, Culture, and Education.* Vol. 2. Tempe, AZ: Bilingual Press, 2002.

Keller, Gary D., Mary Erickson, and Pat Villenueve. *Chicano Art for Our Millennium: Collected Works from the Arizona State University Community.* Tempe, AZ: Bilingual Press, 2004.

Khader, Jamil. "Transnationalizing Aztlán: Anaya's *Heart of Aztlán* and US Proletarian Literature." *MELUS* 27, no. 1 (Spring 2002), 83–106.

Khatibi, Abdelkébir. *La langue de l'autre.* New York: Centre d'Études sur les Littératures Francophones d'Afrique du Nord, 1999.

Kidwell, Clara Sue, and Alan Velie. *Native American Studies.* Lincoln: University of Nebraska Press, 2005.

Klor de Alva, J. Jorge. "Mestizaje from New Spain to Aztlán: On the Control and Classification of Collective Identities." In *New World Orders: Casta Painting and Colonial Latin America,* edited by Ilona Katzew. New York: Americas Society, 1996.

Kraniauskas, John. "Hybridity in a Transnational Framework: Latin Americanist and Postcolonial Perspectives on Cultural Studies." In *The Latin American Cultural Studies Reader,* edited by Ana del Sarto, Alicia Ríos, and Abril Trigo, 736–59. Durham, NC: Duke University Press, 2004 [2000].

Kunzle, David. "Art and Revolution in Latin America." *Art Journal* 64, no. 2 (2005): 109–11.

Kuo, Michelle, and David Graeber. "Another World: Michelle Kuo and David Graeber." *Artforum* (Summer 2012).

Langston, Donna Hightower. "American Indian Women's Activism in the 1960s and 1970s." *Hypatia* 18, no. 2 (Spring 2003): 114–32.

Latorre, Guisela. *Walls of Empowerment: Chicana/o Indigenist Murals of California.* Austin: University of Texas Press, 2008.

Leal, Luis. "In Search of Aztlán." In *Aztlán: Essays on the Chicano Homeland,* edited by Rudolfo Anaya and Luis Leal. Albuquerque: University of New Mexico Press, 1989 [1981].

254 • *Works Cited*

LeBeau, Patrick R. *Rethinking Michigan Indian History*. East Lansing: Michigan State University Press, 2005.

Lefebvre, Henri. *The Production of Space*. Translated by Donald Nicholson-Smith. Malden, MA, and Oxford: Blackwell, 1991 [1974].

Lejeune, Jean-François. "Dreams of Order: Utopia, Cruelty, and Modernity." In *Cruelty and Utopia: Cities and Landscapes of Latin America*, edited by Jean-François Lejeune. New York: Princeton Architectural, 2005.

Leval, Susana T. *Míra: The Canadian Club Hispanic Art Tour III, 1988–1989*. Farmington Hills, MI: Hiram Walker, 1988.

Levitas, Ruth. *The Concept of Utopia*. Syracuse: Syracuse University Press, 1990.

Lipsitz, George. "Not Just Another Social Movement: Poster Art and the Movimiento Chicano." In *¿Just Another Poster?: Chicano Graphic Arts in California*, edited by Chon Noriega. Seattle: University of Washington Press, 2001.

Lomnitz, Claudio. *Deep Mexico, Silent Mexico: An Anthropology of Nationalism*. Minneapolis: University of Minnesota Press, 2001.

Lorde, Audre. "The Master's Tools Will Never Dismantle the Master's House." In *This Bridge Called My Back: Writings by Radical Women of Color*, 2nd edition, edited by Cherríe Moraga and Gloria Anzaldúa. New York: Kitchen Table, 1983.

Loving, Charles R. "Introduction." In *Premeditated: Meditations on Capital Punishment*, by Malaquías Montoy and Lezlie Salkowitz-Montoya. Notre Dame, IN: Institute for Latino Studies, University of Notre Dame, 2004.

Lubin, David M. *Picturing a Nation: Art and Social Change in Nineteenth-Century America*. New Haven: Yale University Press, 1994.

Lucero, José Antonio. "Fanon in the Andes: Fausto Reinaga, Indianismo, and the Black Atlantic." *International Journal of Critical Indigenous Studies* 1, no. 1 (2008): 13–22.

Lyons, Scott Richard. *X-Marks: Native Signatures of Assent*. Minneapolis: University of Minnesota Press, 2010.

Maiz, Apaxu. *Looking 4 Aztlan: Birthright or Right 4 Birth*. Lansing, MI: Sun Dog Press, 2004.

Marín, Cheech, ed. *Chicano Visions: American Painters on the Verge*. Boston: Bulfinch, 2002.

Mariscal, Jorge. *Brown-eyed Children of the Sun: Lessons from the Chicano Movement, 1965–1975*. Albuquerque: University of New Mexico Press, 2005.

———. "Negotiating César: César Chávez in the Chicano Movement." *Aztlán* 29, no. 1 (2004): 21–56.

Martí, José. *Nuestra América*. Havana: Casa de las Américas, 1991.

Martin, Carol, and Henry Bial, eds. *Brecht Sourcebook*. New York: Routledge, 2000.

Martínez, Elizabeth "Betita." "A View from New Mexico: Recollections from the Movimiento Left." *Monthly Review* (July-August 2002): 79–86.

Martínez, Elizabeth. "Viva la Chicana and All Brave Women of La Causa." In *Chicana Feminist Thought: The Basic Historical Writings*, edited by Alma M. García, 80–81. New York: Routledge, 1997.

Martínez, Elizabeth Sutherland, and Enriqueta Longeaux y Vásquez. *Viva la Raza! The Struggle of the Mexican-American People*. Garden City, NY: Doubleday, 1974.

Martínez, Santos. *Dále Gas: Chicano Art of Texas*. Houston: Contemporary Arts Museum, 1977.

Mathey-White, Pat. *Bibliography of Chicano/Latino Art and Culture in the Pacific Northwest*. Olympia, WA: Evergreen State College Library, 1982.

Works Cited • 255

McCaughan, Edward. "Art and Identity in Mexican and Chicano Social Movements." In *Research in Social Movements, Conflicts and Change*, edited by Patrick E. Coy. San Diego: JAI Press, 2007.

McIntosh, John. *The Origin of the North American Indians*. New York: Nafis and Cornish, 1844.

Mendoza, Valerie M. "They Came to Kansas Searching for a Better Life." *Kansas Quarterly* 25, no. 2 (1994): 97–106.

Mesa-Bains, Amalia. "Domesticana: The Sensibility of Chicana Rasquache." In *Distant Relations: Chicano, Irish, Mexican Art and Critical Writing*, edited by Tricia Ziffe. New York: Smart Art Press, 1995.

Mignolo, Walter D. "Colonial and Postcolonial Discourse: Cultural Critique or Academic Colonialism?" *Latin American Research Review* 28, no. 3 (1993): 120–34.

———. *Local Histories/Global Designs: Coloniality, Subaltern Knowledges, and Border Thinking*. Princeton: Princeton University Press, 2000.

Miller, Clarence H. "Introduction." In More, *Utopia*. New Haven: Yale, 2001.

Miner, Dylan A. T. "Carlos Cortéz Koyokuikatl: Wobbly Heir to the TGP." In *Yours for the One Big Union: The Radical Wobbly Traditions of Carlos Cortéz Koyokuikatl and Dylan AT Miner*. Albuquerque, NM: Amoxtli, 2005.

———. "El Renegado Comunista: Diego Rivera, La Liga de Obreros y Campesinos and Mexican Repatriation in Detroit." *Third Text* 19, no. 6 (November 2005): 647–60.

Mitchell, W. J. T. *Landscape and Power*. Chicago: University of Chicago Press, 1994.

Mithlo, Nancy Marie. "No Word for Art in our Language? Old Questions, New Paradigms." *Wicazo Sa Review* 25 (2012): 1.

Montoya, Malaquías, and Lezlie Salkowitz-Montoya. "A Critical Perspective on the State of Chicano Art." *Metamorfosis* 1, no. 1 (1980).

Moraga, Cherríe. "Queer Aztlán: The Re-formation of Chicano Tribe." In *Re-Emerging Native Women of the Americas: Native Chicana Latina Women's Studies*, edited by Yolanda Broyles-González, 236–53. Dubuque, IA: Kendall/Hunt, 2001.

———. *The Last Generation*. Cambridge, MA: South End Press, 1999.

More, Thomas. *Utopia*. New Haven: Yale University Press, 2001.

———. *Utopia*. New Haven: Yale University Press, 1964.

Moreiras, Alberto. "Hybridity and Double Consciousness." *Cultural Studies* 13 (1999): 373–407.

Morgensen, Scott Lauria. "Unsettling Queer Politics: What Can Non-Natives Learn from Two-Spirit Organizing?" In *Queer Indigenous Studies: Critical Interventions in Theory, Politics, and Literature*, edited by Qwo-li Driskill, Chris Finley, Brian Joseph Gilley, and Scott Laura Morgensen. Tucson: University of Arizona Press, 2011.

Morín, Raúl. *Among the Valiant*. Los Angeles: Border Publishing, 1963.

Mosquera, Gerardo, ed. *Beyond the Fantastic: Contemporary Art Criticism from Latin America*. Cambridge, MA: MIT Press, 1996.

———. "Good-Bye Identity, Welcome Difference: From Latin American Art to Art from Latin America." *Third Text* 56 (2001): 25–33.

Mundy, Barbara E. *The Mapping of New Spain: Indigenous Cartography and the Maps of the Relaciones Geográficas*. Chicago: University of Chicago Press, 1996.

Murray, Chris. *Key Writers on Art: The Twentieth Century*. London and New York: Routledge, 2003.

256 • Works Cited

Murray, Ursula R. *Tenth Annual Michigan Hispanic Artists Exhibition Catalogue*. Detroit: Hispanic Arts and Education Center, 2000.

Nabokov, Peter. *A Forest of Time: American Indian Ways and History*. Cambridge: Cambridge University Press, 2002.

National Latino Communications Center and Galán Productions. *Chicano!: History of the Mexican American Civil Rights Movement*. Los Angeles: NLCC, 1996.

Native Alliance for Red Power, *NARP Newsletter* 4 (June/July 1969): 5.

Navarette, Federico. "The Hidden Codes of the Codex Azcatitlan." *RES* 45 (Spring 2004).

———. "The Path from Aztlan to Mexico: On Visual Narration in Mesoamerican Codices." *RES* 37 (Spring 2000): 31–48.

Navarro, Armando. *Mexican American Youth Organization: Avant-Garde of the Chicano Movement in Texas*. Austin: University of Texas Press, 1995.

———. *Mexicano Political Experience in Occupied Aztlán: Struggles and Change*. Walnut Creek, CA: Altamira, 2005.

Nieto-Phillips, John. "Spanish American Ethnic Identity and New Mexico's Statehood Struggle." In *The Contested Homeland: A Chicano History of New Mexico*, edited by Erlinda González-Berry and David R. Maciel. Albuquerque: University of New Mexico Press, 2001.

Noriega, Chon, Rita González, and Howard N. Fox, eds. *Phantom Sighting: Art After the Chicano Movement*. Berkeley: University of California Press, 2008.

Noriega, Chon A., and Wendy Belcher, eds. *I am Aztlán: The Personal Essay in Chicano Studies*. Los Angeles: UCLA Chicano Studies Research Center, 2004.

Noriega, Chon A., Eric R. Avila, Karen Mary Davalos, Chela Sandoval, and Rafael Pérez-Torres, eds. *The Chicano Studies Reader: An Anthology of Aztlán, 1970–2000*. Los Angeles: UCLA Chicano Studies Research Center, 2001.

Norrell, Brenda. "D-Q University Students Left in the Cold." *Indian Country Today* (March 4, 2005).

Northrup, Jim. *Anishinaabe Syndicated: A View from the Rez*. Minneapolis: Minnesota Historical Society Press, 2011.

Ocasio Rizzo, Holly. "Local Gem to National Treasure." *Hispanic Business*, October 2005.

O'Connor, Francis V. "An Iconographic Interpretation of Diego Rivera's Detroit Industry Murals in Terms of Their Orientation to the Cardinal Points of the Compass." In *Diego Rivera: A Retrospective*, edited by Cynthia Newman Helms, 157–83. Detroit: Founders Society Detroit Institute of Arts, 1986.

Orozco, Cynthia. "Sexism in Chicano Studies and in the Community." In *Chicana Feminist Thought: The Basic Historical Writings*, edited by Alma M. García, 265–70. New York and London: Routledge Press, 1997.

Paredes, Américo. *With His Pistol in His Hand: A Border Ballad and Its Hero*. Austin: University of Texas Press, 1958.

Pellicer, Manuel. "Epilogue: El Chicanismo frente a los reacciones." In *Dále Gas: Chicano Art of Texas*, np. Houston: Contemporary Arts Museum, 1977.

Penn Hilden, Patricia. "How the Border Lies: Some Historical Reflections." In *Decolonial Voices: Chicana and Chicano Cultural Studies in the 21st Century*, edited by Arturo J. Aldama and Naomi H. Quiñonez, 152–76. Bloomington: University of Indiana Press, 2002.

Pérez, Emma. *The Decolonial Imaginary: Writing Chicanas into History*. Bloomington: University of Indiana Press, 1999.

Pérez, Laura E. *Chicana Art: The Politics of Spiritual and Aesthetic Altarities*. Durham, NC: Duke University Press, 2007.

———. "El Desorden, Nationalism, and Chicana/o Aesthetics." In *Between Woman and Nation: Nationalisms, Transnational Feminisms, and the State*, edited by Caren Kaplan, Norma Alarcon, and Minoo Moallem. Durham, NC: Duke University Press, 1999.

Pérez-Torres, Rafael. *Mestizaje: Critical Uses of Race in Chicano Culture*. Minneapolis: University of Minnesota Press, 2006.

———. "Refiguring Aztlán." In *The Chicano Studies Reader: An Anthology of Aztlán, 1971–2001*, edited by Chon A. Noriega, Eric R. Avila, Karen Mary Davalos, Chela Sandoval, and Rafael Pérez-Torres, 213–39. Los Angeles: UCLA Chicano Studies Research Center, 2001.

Pierce, Donna. "The Mission: Evangelical Utopianism in the New World (1523–1600)." In *Mexico: Splendors of Thirty Centuries*. New York: Metropolitan Museum of Art, 1990.

Pina, Michael. "The Archaic, Historical and Mythicized Dimensions of Aztlán." In *Aztlán: Essays on the Chicano Homeland*, edited by Rudolfo A. Anaya and Francisco Lomelí. Albuquerque: University of New Mexico Press, 1991.

Pohl, Frances. *Framing America: A Social History of American Art*. New York: Thames and Hudson, 2002.

Pratt, Mary L. *Imperial Eyes: Travel Writing and Transculturation*. New York: Routledge, 1992.

Prescott, William Hickling. *The Conquest of Mexico*. New York: Simon, 1934.

Quijano, Anibal. "Colonialidad del poder y clasificación social." *Journal of World-System Research* 6, no. 2 (2000): 342–86.

———. "Colonialidad y racionalidad/modernidad." *Perú Indígena* 29 (1991): 11–29.

Quintanilla, Raúl. "A Suspended Dialogue: The Nicaraguan Revolution and the Arts." *Third Text* 24 (Autumn 1993): 25–33.

Quintero, Sofía. "Favianna Rodríguez: Murals for the Masses." *Fuego* (Summer 2005): 46.

Quirarte, Jacinto. "The Art of Mexican-America." *Humble Oil and Refining Co., Second Quarter* 9, no. 2 (1970): 2–9.

———, ed. *Chicano Art History: A Book of Selected Writings*. San Antonio: Research Center for the Arts and Humanities, University of Texas, 1984.

———. "Exhibitions of Chicano Art: 1965 to the Present." In *CARA: Chicano Art Resistance and Affirmation*. Los Angeles: Wight Art Gallery, 1995.

———. *Mexican American Artists*. Austin: University of Texas Press, 1973.

Rabasa, José. *Inventing America: Spanish Historiography and the Formation of Eurocentrism*. Norman: University of Oklahoma Press, 1993.

Rama, Angel. *La Ciudad Letrada*. Hanover, NH: Ediciones del Norte, 1984.

Ramírez, Mari C. "Beyond 'the Fantastic': Framing Identity in US Exhibitions of Latin American Art." In *Beyond the Fantastic: Contemporary Art Criticism from Latin America*, edited by Gerardo Mosquera, 229–46. Cambridge, MA: MIT Press, 1996.

Read, Herbert. "Foreword." In *The Revolt*, by Albert Camus. New York: Knopf, 1954.

Reed, Adolf L., Jr. *W. E. B. DuBois and American Political Thought: Fabianism and the Color Line*. New York: Oxford University Press, 1999.

Reed, T. V. *The Art of Protest: Culture and Activism from the Civil Rights Movement to the Streets of Seattle*. Minneapolis: University of Minnesota Press, 2005.

258 • Works Cited

Rendón, Armando B. *Chicano Manifesto: The History and Aspirations of the Second Largest Minority in America*. New York: Macmillan, 1971.

Ritch, William G. *Aztlan: the History, Resources, and Attractions of New Mexico*. Boston: D. Lothrop and Co., 1885.

Rittenhouse, Jack D. *Disturnell's Treaty Map: The Map that was Part of the Guadalupe Hidalgo Treaty on Southwestern Boundaries, 1848*. Santa Fe: Stagecoach Press, 1965.

Roberts, John. "The Labour of Subjectivity, The Subjectivity of Labour: Reflections on Contemporary Political Theory and Culture." *Third Text* 16, no. 4 (2002): 367–85.

Rochín, Refugio, and Dennis Valdés. *Voices of a New Chicana/o History*. East Lansing: Michigan State University Press, 2000.

Rojinski, David. *Companion to Empire: A Genealogy of the Written Word in Spain and New Spain, c. 550–1550*. New York: Rodopi, 2010.

Romo, Terezita. *Malaquías Montoya*. Los Angeles: UCLA Chicano Studies Research Center, 2011.

Rosaldo, Renato. *Culture and Truth: The Remaking of Social Analysis*. Second edition. Boston: Beacon, 1993.

Rosales, F. A. *Chicano!: The History of the Mexican American Civil Rights Movement*. Houston, TX: Arte Público, 1997.

Ross, Fred. *Conquering Goliath: César Chávez at the Beginning*. Keene, CA: El Taller Gráfico, 1989.

Ruiz, Vicki L. *From out of the Shadows: Mexican Women in Twentieth-Century America*. New York: Oxford University Press, 1998.

Rutter, Larry G. "Mexican Americans in Kansas: A Survey and Social Mobility Study, 1900–1970." Master's thesis, Kansas State University, 1972.

Saldaña-Portillo, Maria Josefina. *The Revolutionary Imagination in Latin America and the Age of Development*. Durham, NC: Duke University Press, 2003.

Saldívar, Ramón. *Chicano Narrative: The Dialectics of Difference*. Madison: University of Wisconsin Press, 1990.

Salmón, Enrique. *Eating the Landscape: American Indian Stories of Food, Identity, and Resilience*. Tucson: University of Arizona Press, 2012.

Sánchez-Tranquilino, Marcos. "Space, Power, and Youth Culture: Mexican American Graffiti and Chicano Murals in East Los Angeles, 1972–1978." In *Looking High and Low: Art and Cultural Identity*, edited by Brenda Jo Bright and Elizabeth Bakewell. Tucson: University of Arizona Press, 1995.

Sandoval, Chela. *Methodology of the Oppressed*. Minneapolis: University of Minnesota Press, 2000.

———. "U.S. Third World Feminism: The Theory and Method of Oppositional Consciousness in the Postmodern World." *Genders* 10 (1991): 1–24.

Sarto, Ana del, Alicia Ríos, and Abril Trigo, eds. *The Latin American Cultural Studies Reader*. Durham, NC: Duke University Press, 2004.

Sartre, Jean-Paul. "Colonialisme est une systeme." *Les Temps Modernes* 123 (March-April 1953).

Schwartz, Robert, ed. *Perception*. Oxford: Blackwell, 2004.

Sedgwick, Peter. Encyclopedia entry for "utopia/nism." In *Key Concepts in Cultural Theory*, edited by Andrew Edgar and Peter Sedgwick, 428. London: Routledge, 1999.

Shiva, Vandana. "Women's Indigenous Knowledge and Biodiversity Conservation." In *Ecofeminism*, edited by Maria Mies and Vandana Shiva. London: Zed Books, 1993.

———. *The Violence of the Green Revolution: Third World Agriculture, Ecology, and Politics*. London: Zed Books, 1992.

Silko, Leslie Marmon. *Almanac of the Dead*. New York: Penguin, 1992.

———. *Yellow Woman and a Beauty of the Spirit: Essays on Native American Life Today*. New York: Touchstone, 1996.

Silverstein, Jay. "Aztec Imperialism at Oztuma, Guerrero: Aztec-Chontal Relations during the Late Postclassic and Early Colonial Periods." *Ancient Mesoamerica* 12 (2001): 31–48.

Smith, Andrea. "Queer Theory and Native Studies: The Heteronormativity of Settler Colonialism." *GLQ: A Journal of Lesbian and Gay Studies* 16, nos. 1–2 (2010): 41–68.

Smith, Linda Tuhiwai. *Decolonizing Methodologies: Research and Indigenous Peoples*. London: Zed Books, 1999.

Smith, Michael E. "The Aztec Marketing System and Settlement Patterns of the Valley of Mexico: A Central Place Analysis." *American Antiquity* 44 (1979): 110–25.

Soja, Edward. *Postmodern Geographies: The Reassertion of Space in Critical Social Theory*. New York: Verson, 1989.

Sorell, Victor A. "Articulate Signs of Resistance and Affirmation in Chicano Public Art." In *Chicano Art: Resistance and Affirmation, 1965–1985*, edited by Richard Griswold del Castillo, Teresa McKenna, and Yvonne Yarbro-Bejarano. Los Angeles: Wight Art Gallery, University of California.

———. "Discursive Images and Resonant Words Address the Vox Populi: The Visceral Art of Carlos Cortéz." In *Carlos Cortéz Koyokuikatl: Soapbox Artist and Poet*. Chicago: MFACM, 2001.

Sperling Cockcroft, Eva, and Holly Barnet-Sánchez, eds. *Signs from the Heart: California Chicano Murals*. Albuquerque: University of New Mexico Press, 1993.

Sturtevant, William C. "The Sources for European Imagery of Native Americans." In *New World of Wonders: European Images of the Americas, 1492–1700*, edited by Rachel Doggett. Seattle: University of Washington Press, 1992.

Sunseri, Lina. "Moving Beyond the Feminism Versus Nationalism Dichotomy: An Anti-Colonial Feminist Perspective on Aboriginal Liberation Struggles." *Canadian Woman Studies* 20, no. 2 (2000): 143–48.

Surtz, Edward. "Introduction." In More, *Utopia*. New Haven: Yale University Press, 1964.

Taylor, Diana. "Scenes of Cognition." *Theatre Journal* 56, no. 3 (2004): 353–72.

Taylor, Joshua C. *A Guide to Mexican Art: From its Beginning to the Present*. Chicago: University of Chicago Press, 1969.

———. *Raíces y visiones/Roots and Visions*. Washington, DC: Smithsonian, 1977.

Tibón, Gutierre. "Aztatlan-Aztlan." *Archivo internationale di etnografia e preistoria* (1962): 100.

Townsend, Richard F. *The Aztecs*. Revised edition. London: Thames and Hudson, 2000.

———. "State and Cosmos in the Art of Tenochtitlan." *Dumbarton Oaks Studies in Pre-Columbian Art and Archaeology* 29 (1979).

Trask, Haunani-Kay. *From a Native Daughter: Colonialism and Sovereignty in Hawai'i*. Honolulu: University of Hawai'i Press, 1999.

Trujillo Gaitan, Marcela. "The Dilemma of the Modern Chicana Artist and Writer." *De Colores* 3, no. 3 (1977).

Valdés, Dennis. *Al Norte: Agricultural Workers in the Great Lakes Region, 1917–1970*. Austin: University of Texas Press, 1991.

―――. *Barrios Norteños: St. Paul and Midwestern Mexican Communities in the Twentieth Century*. Austin: University of Texas Press, 2000.

―――. "Region, Nation, and World-System: Perspectives on Midwestern Chicana/o History." In *Voices of a New Chicana/o History*, edited by Refugio Rochín and Dennis Valdés. East Lansing: Michigan State University Press, 2000.

Vargas, George. "The Aesthetic(s) of History of Art Books." *Raza Art and Media Collective Journal* 2, no. 1 (1977).

―――. "Carlos Lópes: A Forgotten Michigan Painter." Julián Samora Research Institute, Occasional Paper 56 (February 1999).

―――. "Contemporary Latino Art in Michigan, the Midwest, and the Southwest." PhD diss., University of Michigan, 1988.

―――. "A Historical Overview/Update on the State of Chicano Art." In *Chicano Renaissance: Contemporary Cultural Trends*, edited by David R. Maciel, Isidro D. Ortiz, and María Herrera-Sobek. Tucson: University of Arizona Press, 2003.

―――. Unpublished essay available at Bagley Housing Association. Detroit, 2000.

Vargas, Zaragosa. "Mexican Auto Workers at Ford Motor Company, 1918–1933." PhD diss., University of Michigan, 1984.

Venegas, Sybil. "Conditions for Producing Chicana Art." *Chisméarte* 1, no. 4 (1977): 2–4.

―――. "The Artists and Their Work: The Role of the Chicana Artist." *Chisméarte* 1, no. 4 (1977): 3–5.

Verney, Marilyn Notah. "On Authenticity." In *American Indian Thought*, edited by Anne Waters. Malden, MA: Blackwell, 2004.

Villa, Raúl H. *Barrio Logos: Place and Space in Urban Chicano Literature and Culture*. Austin: University of Texas Press, 2000.

Vizenor, Gerald. *Manifest Manners: Narratives on Postindian Survivance*. Lincoln: University of Nebraska Press, 1999.

―――. *Survivance: Narratives of Native Presence*. Lincoln: University of Nebraska Press, 2008.

Wall, Dennis, and Virgil Masayesva. "People of the Corn: Teachings in Hopi Traditional Agriculture, Spirituality, and Sustainability." *The American Indian Quarterly* 28 (2004): 3–4.

Wallach, Alan. "Marxism and Art History." In *The Left Academy*, vol.2, edited by Bertell Ollman. New York: McGraw-Hill, 1984.

Wallerstein, Immanuel. *The Modern World System: Capitalist Agriculture and the Origins of the European World Economy in the Sixteenth Century*. New York: Academic Press, 1974.

―――. "Reading Fanon in the 21st Century." *New Left Review* 57 (May/June 2009): 117–25.

Warrior, Robert. "Native Critics in the World: Edward Said and Nationalism." In *American Indian Literary Nationalism*, edited by Craig Womack, Jace Weaver, and Robert Warrior. Albuquerque: University of New Mexico Press, 2006.

Webb, Darren. *Marx, Marxism and Utopia*. Burlington, VT: Ashgate, 2000.

Weber, David J. *The Spanish Frontier in North America*. New Haven, CT: Yale University Press, 1992.

Werckmeister, O. K. "Radical Art History." *Art Journal* 42, no. 4 (Winter 1982): 284–91.

Western, Jenny, ed. *Do Not Park Bicycles!* Brandon, MB: Art Gallery of Southwestern Manitoba, 2007.

White, Hayden. *Metahistory: The Historical Imagination in Nineteenth-Century Europe.* Baltimore, MD: The Johns Hopkins University Press, 1975.

Williams, Raymond. *Keywords: A Vocabulary of Culture and Society.* London: Fontana/Croon Helm, 1976.

Willis, Paul. *Learning to Labour: How Working-class Boys Get Working-class Jobs.* Morningside edition. New York: Columbia University Press, 1981.

Wolff, Janet. *The Social Production of Art.* Second edition. Washington Square: New York University Press, 1993.

Womack, Craig S., Robert Warrior, and Jace Weaver. *American Indian Literary Nationalism.* Albuquerque: University of New Mexico Press, 2006.

Worthen, W. B. "Disciplines of the Text: Sites of Performance." *TDR* 39, no. 1 (1995): 13–28.

Ybarra-Frausto, Tomás. "Alurista's Poetics: The Oral, the Bilingual, the Pre-Columbian." In *Modern Chicano Writers: A Collection of Critical Essays,* edited by Joseph Sommers and Tomás Ybarra Frausto. Englewood, CA: Prentice-Hall, 1979.

Yorba, Jonathan. *Arte Latino: Treasures from the Smithsonian American Art Museum.* New York: Watson-Guptill, 2001.

Index

Page numbers in italics indicate illustrations.

Alurista (Alberto Urista), 14, 52, 59–60, 64–67, 66–67, 84–85, 228n34. *See also* El Plan Espiritual de Aztlán
American Indian (term), 222n2
American Indians, 45–48. *See also* Indigenous people
Americas. *See* Turtle Island-the Americas
anarchism, 126–27
Anaya, Rudolfo, 64
Anishinaabeg, 11–12, 115, 176
Anishinaabewaki, 120
Anishnaabensag Biimskowebshkigewag (Native Kids Ride Bikes) (Miner, 2011), 4–6, *5*, 8
Anišinabe-Waki-Aztlán (Cortéz Koyokui-katl, 1977), 172, 173–76, *174*, *175*
Anzaldúa, Gloria, 217–18
Arrizón, Alicia, 68
art: Chicano, 10, 84–87, 104–10, 169–209; as Indigenous, 88–90, 169–209; Indigenous motifs in, 100–101, *102*, *103*; MiXicano, 116–17, 128–32; as open-ended, 88–90, 109; as political, 16, 83, 84–87, 145–46, 148, 210; and sovereignty, 84–87, 145–46, 169–209; study of, 104–10, 118, 128–29. *See also* artists; community mural movement; murals; posters; prints and print-making

artists, 15–16, 18–19, 84–87, 106, 107, 234n83. *See also* community mural movement
ASCO, 150
axis mundi, 32–34, *33*
Aztlán: Alurista's vision of, 14, 64–67; Mexica version of, 16, 24–33, 51; MiXicano version of, 116, 119, 132–37; naming of, 63–67; overview of its manifestations, 210–11; as performed, 18, 31–34, 66–70; political activism and, 58–61, 63, 147, 152; settler-colonialism and, 37–40, 42, 55, 70–75; as space and place, 31–34, 38, 50–52, 163; spelling of, 223n17; theorizing, 21–112; as tribalography, 25–31; as utopian, 16–19, 39, 40, 70–73, 157; visualizing, 113–211; working class and, 58–60, 126; Xicano sovereignty asserted by, 55, 74–75, 84–85, 87, 126–28, 185–88
Aztlanahuac Project, 45, 47–48, 231n15
Aztlán Annals. *See* Codex Boturini
Aztlán Bicycle Company, 8

Banyacya, Thomas, 45–48, 61
Barraza, Jesús, 19, 181, 183–85, 187, 197–209, 240n20; works by, *184*, *201*, *203*, *205*, *209*. *See also* Dignidad Rebelde
Barraza, Santa, 160–68, *164*
Baudot, Georges, 40
Baudrillard, Jean, 73

263

Bernal, Antonio, 97, 101–3, *102, 103,* 131
black and red, 17
Black Panthers, 91–92
Boone, Elizabeth Hill, 25–26, 29
borders, 12, 15, 115, 133–34
braids, 204, 205, *205*
Brooks, Lisa, 96
Brown Berets, 81, 91–92, 200–201, *201*

Camus, Albert, 157–58, 159
Canada, 134. See also *la otra frontera*
capitalism, alternatives to, 58–60,
 70–72
CARA. See *Chicano Art: Resistance
 and Affirmation*
cartographic space. *See* space
cartography, 38–39, 42–44, 48–50,
 68–69, 151
caves, 54–55
Cervantes, Melanie, 15, 19, 181, 197–209,
 240n20; works by, *201, 203, 205. See
 also* Dignidad Rebelde
Cheyfitz, Eric, 52, 59
Chiapas Será Libre, Palestina Será Libre
 (J. Barraza, 2001), 207, 208
Chicanas. *See* Xicana; Xicanas
Chicanismo, 75–81
Chicano (term), 221n1
Chicano Art: Resistance and Affirmation
 (CARA), 129
Chicano Movement, 9–11, 18–19, 55–63,
 75–81, 84–87, 94–95
Chicano Progress through Education. *See*
 Chispa
Chicanos. *See* Xicano; Xicanos
Chicano studies, 60, 62, 212–20. See also
 mestizaje
Chicano Youth Liberation Conference,
 12–13, 56, 62. *See also* El Plan Espiri-
 tual de Aztlán
Chicomoztoc, 29–30. *See also* caves
Chisméarte, 106–7
Chispa (Chicano Progress through
 Education), 79
cholo (term), 150
Churchill, Ward, 93, 218, 219
Cíbola, 39–40

CitySpirit (Moreno and Vargas, 1979),
 113, *114,* 115, *116,* 135–43
Codex Aubin, 26, 28, 28, 33–34
Codex Boturini, 26, 27, 32–33, 33
codices, 16, 26–29, 27, 28, 32–34, 33, 163
colonia (term), 236n36
community mural movement, 100–104.
 See also art; artists; murals
Conferencia Plástica Chicana, 162
Contreras, Sheila Marie, 14, 52, 60, 186,
 218, 219
corn, 194–96, 204, 205, *205,* 241n39
Cornfield, The (Valdéz and Puntigam,
 1998), 113, *114, 116,* 135–37
Corntassel, Jeff, 55
Cortés, Hernán, 38
Cortéz, Constance, 163–64
Cortéz Koyokuikatl, Carlos, 19, 106,
 170–81, 234n80, 239n1; works by, *174,
 175, 179*
Cosmic Tree. *See* trees
Creating Aztlán (Miner, 2014), 15, 17–20
culture, 85–87, 231n14

Declaration on the Rights of Indigenous
 Peoples (United Nations, 2007), 95
de la Rocha, Beto, 149–50
Denver conference. *See* Chicano Youth
 Liberation Conference
deportation, 123–24, *124*
Detroit, 12, 113, *116,* 117, 132–37, 181.
 See also Michigan; MiXicanos
Dignidad Rebelde, 183–85, 187, 196–209;
 works by, *184, 201, 203, 205, 209.
 See also* Barraza, Jesús; Cervantes,
 Melanie
Disturnell, John, 48, 49
Disturnell's Treaty Map, 45–50, *46. See
 also* cartography; Treaty of Guadalupe
 Hidalgo
D-QU, 62, 97, 98, 214, 232n57
Duverger, Christian, 30
dystopia. *See* utopia

Eden, 40–42
El Garage Cultural, 136–37
El Grito, 105

Index • 265

El Grito del Norte, 76–78
El Plan de Santa Barbara, 60, 62, 153
El Plan Espiritual de Aztlán, 13, 14,
 51–52, 54, 55, 63–64, 186
emergence, 54–55
Employment Agency (Mendoza, 1990),
 121–23, *122*
Esteban, 40, 225n35
ethnogenesis, 18, 25–31, 54–55, 65–67
EZLN Women's Revolutionary Laws
 (Dignidad Rebelde, 2007), *203*, 203–4

Fanon, Frantz, 43, 88–89, 90–91, 141,
 179–80
farmworkers, 121–22, *122*, 132–33,
 236n34; artists' experiences as, 11,
 120, 130, 147, 153, 171. *See also*
 workers
feminism and feminists, 14–15, 75–81
Fight Patriarchy (F. Rodríguez, 2009),
 191–93, *192*
Fight the Climate Crisis (F. Rodríguez,
 2009), 191–93, *193*
fire, 60–61
flor y canto, 17. *See also in xochitl in
 cuicatl*; performance and performativity
food, 194–96, 204, 205, *205*, 241n39
Food Justice series (F. Rodríguez), 195
Forbes, Jack D., 9, 60, 64, 98, 173, 213–15,
 216–17, 219–20
Four Corners, 47
fundamentalism, 82–83

Gaspar de Alba, Alicia, 63
Goldman, Shifra, 100–101, 104, 105,
 108–9, 140, 233n76
Gonzales, Patrisia, 48. *See also* Aztlana-
 huac Project

herida abierta, 133–34. *See also* borders
Híjar Serrano, Alberto, 9
*Historia de las Indias de Nueva España
 e Islas de Tierra Firme* (Durán, 1581),
 37–39
Homage to Diego Rivera (Raya, 1973),
 138, *138*
Hopi, 47–48. *See also* Indigenous people

Howe, LeAnne, 26
Huitzilopochtli, 24, 32–33, *33*

INCITE!: Women of Color Against
 Violence, *188*, 188–91, *189, 190*
indianismo, 6–7
Indian Land (J. Barraza, 2004), 208–9, *209*
indigeneity: evoked in art, 165–68, 172; as
 hemispheric, 172–81, *174, 175*, 196–97,
 202, 204–6, 208–9, *209*, 213; in tension
 with *mestizaje*, 212–20
indigenism, 218–19, 243n19
indigenismo, 6–7, 218, 226n62, 243n19
Indigenous (term), 222n2
Indigenous people: activism of, 142,
 204–6; beliefs and philosophies of,
 139–41, 165–67; rights and sovereignty
 of, 66, 68–71, 95, 179–81. *See also* land,
 Indigenous
*Indigenous Women Defending Land
 and Life Since the Beginning of Time*
 (Cervantes, 2009), 204–6, *205*
in xochitl in cuicatl, 33–34. See also *flor y
 canto*; performance and performativity
iron ore, 142–43. *See also* minerals and
 mining
Ixachilan, 158, 212

Kansas, 227n9
Kingsville, Texas, 162
Klor de Alva, J. Jorge, 68

La Casa de Unidad, 136
LACMA. *See* Los Angeles County
 Museum of Art
land, Indigenous: Aztlán as, 169–211;
 claims on, 40–42, 48–50, 94–99; Native
 relationships with, 51, 53, 94, 142, 163;
 women and, 163, 204–6, *205*
land grant movement, 76–78
landscape, 42
Langston, Donna Hightower, 94–95
la otra frontera (U.S.-Canada border),
 12, 113, 115, 134–35, 137–43. *See
 also* borders
Las Brown Berets (Cervantes, 2008),
 200, *201*

Latorre, Guisela, 103–4
La Virgen (S. Barraza, 1990), 163–64, *164*
Lefebvre, Henri, 31–34, 67–68, 173
Los Angeles County Museum of Art (LACMA), 149–50
Los Four, 149–50
Los Repatriados (Mendoza, 2001), 123–24, *124*
lowrider automobiles, 150, 151
lowrider bicycles, 4–8, 23–24
lowriding, 3, 4–8, 15, 23–24, 73, 115
Luján, Gilbert "Magú," 147–52
Lyons, Scott Richard, 82–83

machismo, 75–81
Magú. *See* Luján, Gilbert "Magú"
El Maíz es Nuestro (F. Rodríguez), 195
Mapa Sigüenza, 26, 27
maps. *See* cartography
Marcos de Niza, 40
Martínez, Elizabeth "Betita," 76–78
Martínez, Emanuel, 56
Marx, Karl, 36–37, 72
McCaughan, Edward, 80, 81
mecha (match or wick), 60
MEChA (Movimiento Estudiantil Chicano de Aztlán), 60–63, 91–92, 125–26, *127*. *See also* El Plan de Santa Barbara; El Plan Espiritual de Aztlán
Meena, *188*, 190–91
Mendoza, Nora Chapa, 19, 118–28, *122*, *124*, 125
mestizaje, 6–7, 60, 68, 83, 187–88, 214–20, 227n20
Mestizo Banner (Emanuel Martínez), 56, *57*
Mexica, 7, 24–25, 30–31, 61, 223n2
Michif (Métis), 11–12. *See also* Indigenous people
Michigan, 121–23, *122*, 142. See also *CitySpirit*; Midwest; MiXicanos
Midwest, 14, 113–43, 227n9. *See also* MiXicanos
migration, 11–12, 23–25, 47–48, 123–24, 132–33, 176–77
Miller, Clarence H., 36

Miner, Dylan, 4–8, 11–13, 181, 240n11, 240n20, 242n39
minerals and mining, 141–43
MiXicanos (Michigan Xicanos), 113–43. *See also* Xicanos
Miyashiro, Estria, 183–85, *184*, 187
Montoya, Malaquías, 108–9, 153–60, *155*, 183, 238n30
Moraga, Cherríe, 80, 165–66, 198
More, Thomas, 17, 34–37, 70
Moreno, Martín, 113, 117, 130, 131, 137
Movimiento Estudiantil Chicano de Aztlán. *See* MEChA
Mundy, Barbara, 43–44
murals, 99–104, 128–29, 131

NAISA. *See* Native American and Indigenous Studies Association
naming, 61, 63–67
nationalism, 9–10, 18, 66, 75–81, 96–97
Nationchild Plumaroja (Alurista, 1972), 59–60
Native (term), 222n2
Native American and Indigenous Studies Association (NAISA), 206–7
Nepantla, 145, 147, 158, 165, 167–68, 212
New Mexico, 47, 61–62, 76–78, 94
newspapers and periodicals, 76–79, 105–7
Nieto Gómez, Ana, 78–79
Not in Our Name! (F. Rodríguez, 2002), 188–91, *190*

Orgullo Itzachilatleka (Cortéz Koyokuikatl, 1991), 178–79, *179*

Palestine, 198, 206–8
Peace-Metafísica (Castillo, 1968), 101, *103*, 131
performance and performativity, 29, 33–34, 67–70
Pina, Michael, 29
place, 121–23, *122*. *See also* space
posters, 131–32, 155–56, 183–85, 188–91, 206, 208. *See also* prints and print-making
Premeditated: Meditations on Capital Punishment (Montoya), 159

prints and print-making, 170, 191, *192, 193*, 194. *See also* posters

queer theorists, 14–15
Quirarte, Jacinto, 104, 161, 233n71

Rabasa, José, 41, *41*
race and racism, 92–93, 132–33, 185, 215, 220. *See also* mestizaje
ranflas. See lowrider automobiles
Raya, Marcos, 138, *138*
red and black, 17
Relaciones Geográficas, 39, 43–44, 68
Renaissance perspective, 150–51
repatriation. *See* deportation
representational space. *See* space
representations of space. *See* space
Resist US Imperialism (F. Rodríguez, J. Barraza, Miyashiro, 2003), 183–85, *184*, 187
Returning to Aztlán (Luján, 1983), 150–52
Rivera, Diego, 9, 138, 141–42
Rodríguez, Favianna, 19, 181–96, 240n23; works by, *184, 188, 189, 190, 192, 193*
Rodríguez, Roberto, 45, 48. *See also* Aztlanahuac Project
Romero, Frank, 149–50

Said, Edward, 206
Salkowitz-Montoya, Lezlie, 108–9
segregation, 92, 93, 94–95
settler-colonialism, 38–39, 42–43, 70–73, 84–85, 90–93, 179–80, 215
Silko, Leslie Marmon, 50, 54, 182
Smith, Linda Tuhiwai, 15, 20, 64, 90
South Central Farmers, 195
sovereignty, 50, 90–99, 179–81, 185–88, 194–96; art and artists' role in, 16, 84–87, 131, 204–9, *209*; relationship to Aztlán, 13, 50, 55, 58, 86–87
space, 31–32, 38–39, 42–52, 67–70, 133–34. *See also* place
Spanish colonization, 25, 37–44, 227n20. *See also* Relaciones Geográficas
spatial practice. *See* space
storytelling and stories, 8, 24–25, 47–48, 49–50, 53–55, 66–70

Stradanus, Johannes. *See* van der Straet, Jan
student activism, 60–63. *See also* MEChA
Sunseri, Lina, 80, 96–97
Surtz, Edward, 36–37

Taller de Gráfica Popular. *See* TGP
Tenochtitlán, 24–25, 31, 32–34, 38, 73–74, 223n17
Texas, 162
TGP, 191
Third World, 185, 188–91, 196–97, 231n36
Third World Liberation Front (TWLF), 231n36
Tijerina, Reies López, 77
Tira de la Peregrinación. *See* Codex Boturini
tlacuilome, 31, 32–33
tlilli tlapalli, 17
traditionalism, 87–90
transportation. *See* lowriding
Treaty of Guadalupe Hidalgo, 45, 49, 54, 78, 95, 185. *See also* Disturnell's Treaty Map
trees, 138, 139–41
tribalography, 25–31
Trujillo Gaitan, Marcella, 107
Turtle Island-the Americas, 35–36, 40–42, *41*, 147, 206–8. *See also* Ixachilan
TWLF. *See* Third World Liberation Front

Urista, Alberto. *See* Alurista
utopia, 17–18, 34–37, 70–73, 157–58
Utopia (More, 1516), 17, 34–37, 70

Valdés, Dennis, 132
van der Straet, Jan, 41, *41*
Vargas, George, 106, 113, 117, 130, 136, 137
Vibration of a New Awakening (Moreno, 1978), 131
Viet Nam Aztlán (Montoya, 1972), 154–56, *155*, 183, 238n30
violence, 18, 90–93, 206. *See also* weaponry

weaponry, 204, *205*, 206, 208. *See also* violence

We Are Not the Enemy (F. Rodríguez, 2001), *188*, 188–91

We Resist Colonization (F. Rodríguez, 2002), 188–91, *189*

women, *203*, 203–4. *See also* feminism; Xicanas

workers: activism of, 58–60; agricultural, 121–22, *122*, 132–33, 236n34; artists' experiences as, 11, 120, 130, 147, 153, 171; industrial, 133, 141–42, 171

Xhisméarte. See Chisméarte

Xicana (term), 221n1

Xicanas, 75–81, 107, 163, 188–95, 200–201, 227n11; depictions of, *102, 164, 174, 175, 190, 192, 201, 203, 205*

Xicanishinaabeg, 115

Xicanisma, 198, 200–201, *201, 203,* 204–6, *205*

Xicano (term), 55–56, 221n1

Xicano Development Center (XDC), 19, 117, 125–28, *127,* 235n19

Xicanos: alliances with other Indigenous people, 45–48, 172, 179–80; citizenship of, 85–87, 94–95; culture and, 85–87, 148; ethnogenesis of, 54–55, 65–67, 148; in higher education, 62, 153–54, 160–61; indigeneity of, 14–16, 45–50, 55, 58–60, 74–75, 179–80; as Indigenous people, 7, 9, 51, 56, 60, 74, 85–86, 214–15; migrations of, 11–12, 47–48, 123–24, *124,* 132–33, 176; outside the Southwest, 14, 56, 113–43, *115,* 227n9; sovereignty of, 18, 58–60, 63–64, 119; violence against, 93; youth organizations of, 60–63, 154

Zapatismo, 198, 201–6, *203*

Zapatistas, 202–4, *203*

About the Author

Dylan A. T. Miner (Michif) is an associate professor at Michigan State University, where he coordinates a Indigenous contemporary art initiative and is adjunct curator of Indigenous art at the MSU Museum. He holds a PhD in art history from the University of New Mexico and has published extensively, including more than fifty journal articles, book chapters, critical essays, and encyclopedia entries. He was awarded an Artist Leadership Fellowship from the National Museum of the American Indian, Smithsonian Institution. In 2012, he exhibited at *The Dreaming: Australia's International Indigenous Festival* and hung solo exhibitions in Norway and Canada. Since 2010 he has hung more than a dozen solo exhibitions. His project *Anishinaabensag Biimskowebshkigewag (Native Kids Ride Bikes)*, a collaboration with urban Indigenous youth, is presently touring North America. In 2014, Miner was artist-in-residence at the Klondike Institute of Art and Culture in the Yukon, where he exhibited work on Indigenous medicinal knowledge. Miner has been an artist-in-residence at numerous esteemed institutions, including the School of the Art Institute of Chicago; École Superieure des Beaux-Artes in Nantes, France; and Santa Fe Art Institute, among others. His artwork is written about in publications such as *ARTnews, Indian Country Today, First American Art Magazine, Globe and Mail, The Guardian*, and *Chicago Sun-Times*, among others.